VISHNU

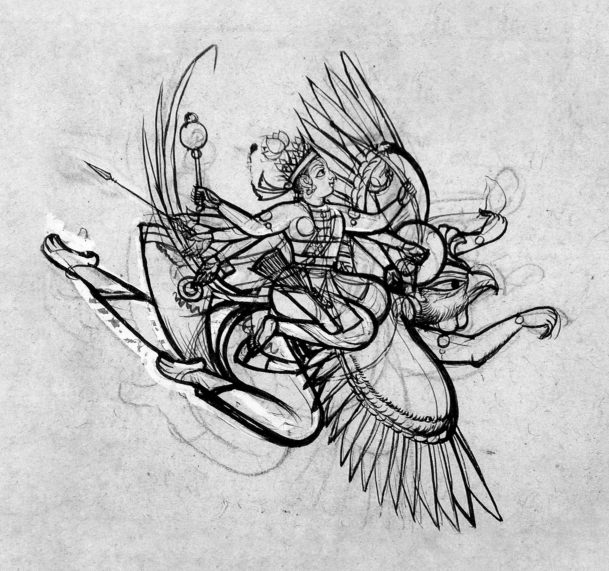

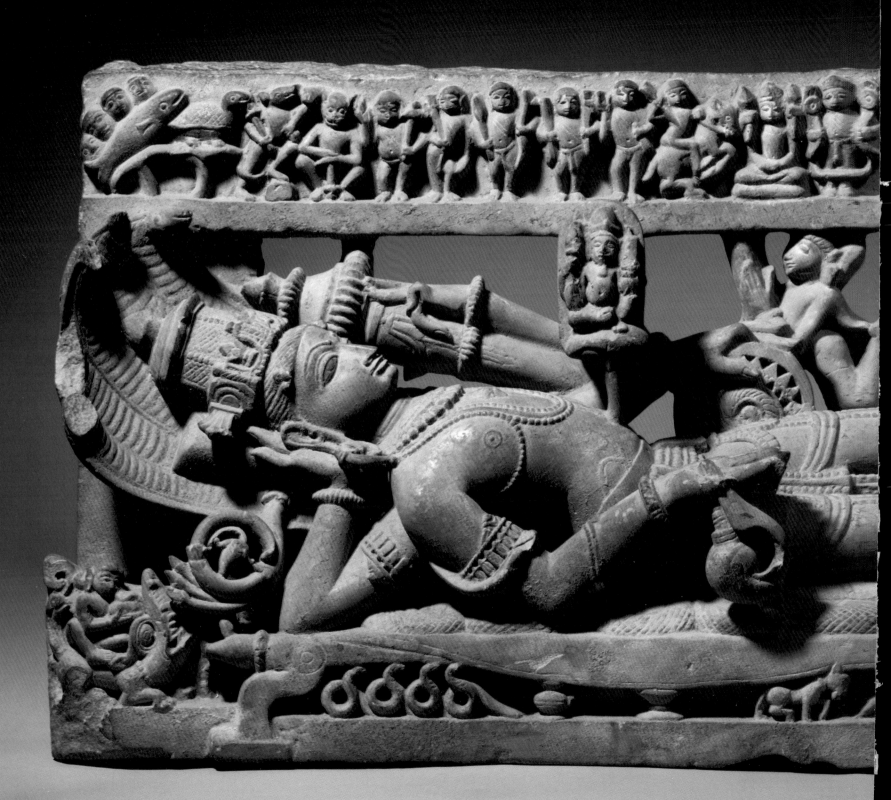

VISHNU
Hinduism's Blue-Skinned Savior

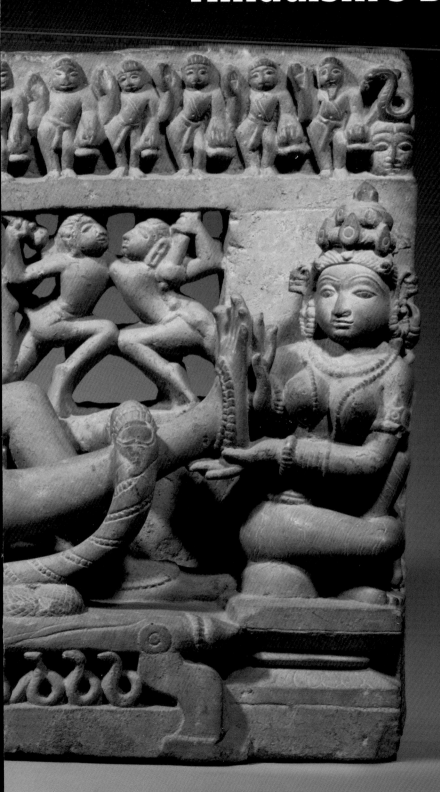

Edited by Joan Cummins

With contributions by

Doris Meth Srinivasan
Leslie C. Orr
Cynthia Packert
Neeraja Poddar

Frist Center for the Visual Arts
in association with
Mapin Publishing

Published in conjunction with the exhibition
Vishnu: Hinduism's Blue-Skinned Savior
Organized by the Frist Center for the Visual Arts
with guest curator Joan Cummins, Ph.D.

Frist Center for the Visual Arts
February 20–May 29, 2011

Brooklyn Museum
June 24–October 2, 2011

This exhibition is supported in part by an award from the
National Endowment for the Arts

NATIONAL
ENDOWMENT
FOR THE ARTS

First published in India in 2011 by
Mapin Publishing Pvt. Ltd
502 Paritosh, Near Darpana Academy, Usmanpura Riverside,
Ahmedabad 380013
T: 91 79 40 228 228 • F: 91 79 40 228 201 • E: mapin@mapinpub.com
www.mapinpub.com

in association with
Frist Center for the Visual Arts
919 Broadway, Nashville, TN, 37203-3822 USA
T: 1 615 244 3340 • www.fristcenter.org

Simultaneously published in the
United States of America in 2011 by
Grantha Corporation
77 Daniele Drive, Hidden Meadows, Ocean Township, NJ 07712
E: mapin@mapinpub.com

Distribution
North America
Antique Collectors' Club, USA
T: 1 800 252 5231 • F: 1 413 529 0862 • E: info@antiquecc.com
www.antiquecollectorsclub.com

Australia & New Zealand
Peribo Pty Ltd., Australia
T: 61 2 9457 0011 F: 61 2 9457 00228 • E: michael.coffey@peribo.com.au

Southeast Asia
Paragon Asia Co. Ltd, Thailand
T: 66 2877 7755 • F: 66 2468 9636 • E: info@paragonasia.com

Rest of the world
Mapin Publishing Pvt. Ltd

Compilation © 2011 Frist Center for the Visual Arts
Photographs and digital Images © as listed. Artworks in public domain.

ISBN: 978-81-89995-48-5 hc (Mapin)
ISBN: 978-1-935677-08-6 hc (Grantha)
ISBN: 978-1-935677-09-3 pb (Grantha)
LCCN: 2010937798

Editor: Joseph N. Newland, Q.E.D.
Design and Production: Paulomi Shah / Mapin Design Studio

Processed in India and Printed in Italy

Note to the Reader

All catalogue entries and section introductions are by Joan Cummins unless followed by NP, which indicates that Neeraja Poddar is the author.

Indic language terms and names have been rendered phonetically in the roman alphabet. Diacritical marks are omitted, and "s" is added for the plural. Words that have been incorporated into English are presented in their modern, popular form. Place names follow current usage, although often alternate spellings are possible.

Indian works of art were rarely assigned titles by their makers. Titles used in this publication are descriptive. For clarity and consistency, the authors have on occasion translated or reworded the title of an object from that found in other publications and digital resources.

In the catalogue captions and entries, attributions of place are given first by region and/or modern state, then city or court of origin, where known.

Dates given are of the Common Era (abbr. CE = AD) unless otherwise stated.

For sculptural figures, *right* and *left* refer to the sculpture's own right and left hands.

The term *bronze* is used for all alloys of copper.

In all dimensions, height precedes width precedes depth (in inches and centimeters). Dimensions for paintings are for the full sheet (including margins where they are present) unless otherwise noted.

In entries discussing more than one object parenthetical numbers (44) distinguish each one. References to other items catalogued herein are generally in this form: (cat. 44). In citations to other books, images are referred to as cat. no. 44 or pl. 44.

Captions
Cover front: **Vishnu Flanked by His Personified Attributes** (detail), cat. 13
Cover back: **Pendant Depicting the Avatars of Vishnu** (reverse), cat. 44
Page 1: **Vishnu on Garuda**, cat. 29
Page 2–3: **Vishnu in His Cosmic Sleep**, cat. 30
Pages 5: **Rasamandala** (detail), cat. 114
Page 6: **Infant Krishna Dancing**, cat. 94
Page 7: **Mask of Ravana**, cat. 169
Page 11: **Standing Vishnu** (detail), cat. 3
Page 24: **Four-faced Vishnu** (detail), cat. 145
Page 34: **Standing Vishnu** (detail), cat. 4
Page 45: **Sharada Purnima Picchawai** (detail), cat. 158
Page 58: **Lakshmi-Narayana** (detail), cat. 14
Page 114: **Fragment of a Lampas-Weave Textile Depicting Avatars of Vishnu** (detail), cat. 45
Page 250: **Picchawai Depicting the Annakut Festival** (detail), cat. 157

Lenders to the Exhibition

The James W. and Marilynn Alsdorf Collection
American Museum of Natural History, New York
The Art Institute of Chicago
Asia Society, New York
Asian Art Museum, San Francisco
Dr. and Mrs. Frederick Baekeland
Susan L. Beningson
Catherine and Ralph Benkaim
Brooklyn Museum
Trammell and Margaret Crow Collection of Asian Art, Dallas
Dayton Art Institute
Robert J. Del Bontà
The Denver Art Museum
Anthony d'Offay, London
Samuel P. Harn Museum of Art, University of Florida, Gainesville
Ramesh and Urmil Kapoor
Subhash Kapoor
Kimbell Art Museum, Fort Worth
The Kronos Collections
Krannert Art Museum and Kinkead Pavilion, University of Illinois, Urbana-Champaign
Arnold Lieberman
Los Angeles County Museum of Art
The Metropolitan Museum of Art, New York
Minneapolis Institute of Arts
Museum für Asiatische Kunst, Berlin
Museum of Fine Arts, Boston
Museum Rietberg, Zurich
Eberhard Rist
Norton Simon Museum, Pasadena
Peabody Essex Museum, Salem, Massachusetts
Philadelphia Museum of Art
Private collections
Kenneth and Joyce Robbins
Rubin Museum of Art, New York
Arthur M. Sackler Gallery, Smithsonian Institution, Washington, D.C.
San Diego Museum of Art
Peggy Scott and David Treplitzky
Seattle Art Museum
Smithsonian American Art Museum, Washington, D.C.
Toledo Museum of Art
University of Michigan Museum of Art, Ann Arbor
Virginia Museum of Fine Arts, Richmond
The Walters Art Museum, Baltimore
Nancy Wiener Gallery, Inc.

Contents

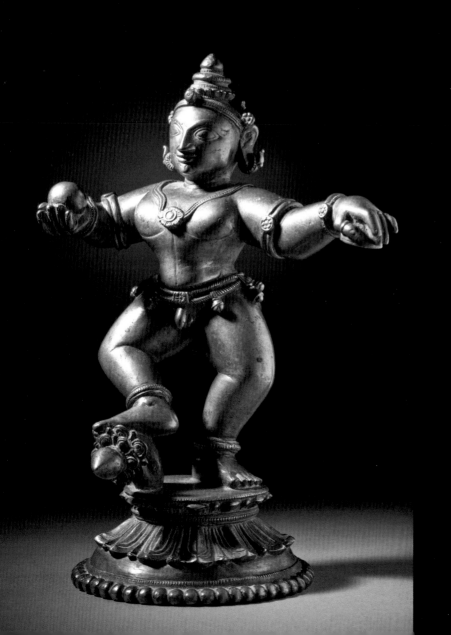

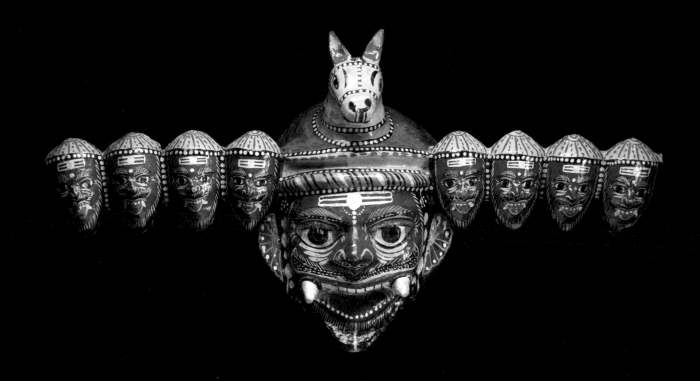

CATALOGUE
Joan Cummins with Neeraja Poddar

Foreword and Acknowledgments

Hinduism, with its mutable deities and overtly sensual art and artifacts, may be puzzling to the uninitiated American, but the investigation of its theology and its expressive visual culture is endlessly rewarding. In myth and legend, the figure of Vishnu, one of the three principal deities of Hinduism, takes many forms and is known by many names. There have been monographic exhibitions focusing on the deities Shiva and Devi, but *Vishnu: Hinduism's Blue-Skinned Savior* is the first major exhibition in North America devoted to the intriguing and complex manifestations of Vishnu. The exhibition and the accompanying catalogue were conceived, organized, and coordinated for the Frist Center for the Visual Arts by guest curator Joan Cummins.

We thank Nancy Cason, formerly on the curatorial staff at the Frist Center, for identifying and making the initial contact with Dr. Cummins, who started this project as an independent scholar and curator. In 2007, Joan Cummins was appointed the Lisa and Bernard Selz Curator of Asian Art at the Brooklyn Museum. To assure the best possible exhibition and to develop a catalogue of unquestionable merit, Cummins called on her connections and her considerable reserve of good will among curators, scholars, and collectors of Indian and Southeast Asian art. Her ideas impressed museum professionals and scholars, inspiring them to respond to our requests with generosity and enthusiasm. As a result, the exhibition she assembled presents the most compelling South Asian examples of the art of Vishnu available for loan. This book enhances the exhibition visitors' experience and will reach a larger audience in a lasting document of the current scholarship on images of Vishnu as they are understood within the context of their creation.

In her essay, Cummins draws from both the scriptures and the history of India to contextualize the roles and manifestations of Vishnu in Hinduism's polytheistic pantheon. Independent scholar Doris Meth Srinivasan describes some of the earliest attributes and icons of Vishnu and explains how the merger of three deities into Vishnu during the formation of the Hindu sect of Vaishnavism informs many subsequent Vishnu images. Based on careful study of devotional poetry and sectarian literature, Leslie C. Orr, associate professor of religion, Concordia University, Montreal, investigates the god in image form at the places sacred to him in Tamil country, in southern India's modern state of Tamil Nadu. Cynthia Packert, professor of the history of art and architecture, Middlebury College, Vermont, demonstrates how Vishnu's avatar Krishna continues to make his presence known in northern India through a multitude of varied forms, which are ultimately expressive of his one true reality. We would like to thank the essayists for their scholarship, and we would like to acknowledge the considerable contributions of Neeraja Poddar, who researched and wrote many of the entries for the catalogue.

Joseph N. Newland brought considerable knowledge to the editorial process. We are grateful for his suggestions, corrections, thoroughness, and wit, all of which were well received. For his able assistance, we extend our gratitude to Bipin Shah of Mapin Publishing and to his colleagues in Ahmedabad for all of their attention to detail in the design and production of the catalogue.

After closing in Nashville, *Vishnu: Hinduism's Blue-Skinned Savior* travels to the Brooklyn Museum. We thank Arnold L. Lehman, director, and Charles Desmarais, deputy director, for their early interest and encouragement. We also gratefully acknowledge the assistance of Katie Apsey, curatorial assistant, and Rebecca Solverson, intern for asian art. Frist Center staff members Katie Delmez, curator; Amie Germia, registrar; and Tabitha Griffith Loyal, curatorial assistant, deserve special recognition. Their dedication, steady nerves, and good humor kept a complex project on even keel throughout its development and execution. The success of the exhibition is due in no small part to the dedication of staff members and colleagues at both venues whose creativity has set the stage and interpreted the underpinning ideas of the exhibition. We thank them as well as those key staff members at institutions around the world who assisted with the myriad details of processing loans and providing materials for the catalogue.

As the organizing institution for *Vishnu: Hinduism's Blue-Skinned Savior,* the Frist Center for the Visual Arts is indebted to all of the lenders, public and private, who have parted with objects from their collections to make the exhibition and its national tour possible. We gratefully acknowledge the early and enthusiastic support of Billy Frist, chairman and president of the board of trustees of the Frist Center; Thomas F. Frist, chairman emeritus; and Kenneth L. Roberts, president emeritus, as well as the trustees of the Frist Foundation. We are especially grateful and honored to have been awarded a generous grant for this project by the National Endowment for the Arts.

Joan Cummins gratefully acknowledges the support of John Eskenazi, Fabio Rossi, the Indian and Southeast Asian Art division of Christie's, Brendan Lynch, and Carol and John Rutherfurd. Our greatest debt of gratitude is, of course, to Joan Cummins for her professionalism and for creating such an illuminating and important study of Vishnu.

Susan H. Edwards, Ph.D.
Executive Director and CEO
Frist Center for the Visual Arts

AFGHANISTAN

CHINA

JAMMU AND KASHMIR

Bahu
Basohli
Chamba
Jammu
Nurpur
Mankot
Kangra
HIMACHAL PRADESH
TIBET
Lahore
Guler
Mandi
Bilaspur
UTTARAKHAND
PUNJAB HILLS
Garhwal
Mt. Kailasha

PAKISTAN

PUNJAB

Kurukshetra

HIMALAYAS

SIKKIM

ARUNACHAL PRADESH

HARYANA

DELHI

NEPAL

Indus River

Bikaner

Ganges (Ganga) River

ASSAM

NAGALAND

Vrindavan
Amber
BRAJ
RAJASTHAN
Mathura
Agra
UTTAR PRADESH
Lucknow
Ayodhya
Madhubani
MEGHALAYA
MANIPUR

Osian
Kishangarh
Jaipur
Ajmer
Fatehpur-Sikri
Yamuna River
Allahabad
BIHAR
MITHILA
Jodhpur
Gadhwa
Patna
Apsadi
BANGLADESH

Nathdwara
Bundi
Kota
Varanasi (Benares)
TRIPURA
Udaipur
Deogarh
Khajuraho
Gaya
Birbhum
Mora
Bharhut
JHARKHAND

MEWAR
Eran
WEST BENGAL

GUJARAT
MALWA
Besnagar
Vidisha
MADHYA PRADESH
Kolkata (Calcutta)
Ahmedabad
Ujjain
Udayagiri

Dwarka
Vadodara (Baroda)
CHATTISGARH

SAURASHTRA

INDIA

Bhubaneshwar
Chandanpur
Puri

MAHARASHTRA
ORISSA

Ellora
DECCAN
Mumbai (Bombay)
Lonavala
Pune

Bay of Bengal

Arabian Sea
Hyderabad
TELANGANA

Kondamotu

Krishna River

GOA
Aihole
ANDHRA PRADESH
Badami
Pattadakal

KARNATAKA
Tirupati

Kaveri River
Bangalore
Mysore
Chennai (Madras)
Kanchipuram
TAMIL NADU
Mamallapuram
Namakkal

KERALA
Srirangam
Thanjavur (Tanjore)
Tirukoshtiyur
Kochi (Cochin)
Srivilliputtur
Anaimalai
Madurai
Alagarkoyil
Thiruvananthapuram
Srivaikuntam

LAKSHADWEEP

ANDAMAN AND NICOBAR ISLANDS

SRI LANKA

INDIAN OCEAN

Multiplicity and Grandeur
An Introduction to Vishnu

Joan Cummins

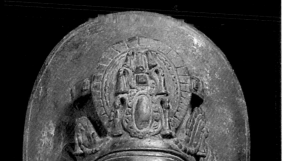

A beautiful male figure sleeps peacefully on a giant serpent, dreaming the universe into being.

A ferocious creature, half human, half-lion, bursts from a pillar and tears the entrails from a demon.

A level-headed prince enlists an army of monkeys and bears to help save his kidnapped wife.

A charming infant steals butter from the churns of milkmaids.

All of these characters, large and small, fierce and gentle, are manifestations of a single divine force, the Hindu god Vishnu. When these personae are depicted in paintings, they share the same distinctive skin tone: a dusky shade of blue. But beyond this trait, mutual characteristics are difficult to discern. Vishnu has been described as Hinduism's most peaceful, moderate, and compassionate deity, but in some forms he is downright frenzied and bloodthirsty. The many manifestations of Vishnu reveal the god's intellectual, physical, and moral powers, and they illustrate the god's genuine concern for the universe he created, but they differ so radically from one another in form and temperament that it hardly seems possible that they sprang from the same source.

In Hindu mythology Vishnu is first and foremost a savior, sweeping down from his lofty abode to bring peace and balance to a beleaguered earth. Sometimes he remains in his heavenly form when saving the day: four-armed, holding a discus and a conch shell, and riding on his man-eagle, Garuda. But more often, he assumes an earthly form appropriate to the precise task at hand. These temporary manifestations are called avatars (Sanskrit *avatara*). In Hinduism, the great deities are said to be boundless in size and influence, nonspecific in character or form or location because they embody all things and concepts. With an avatar, that omnipresent force distills itself into a bodily form so it can descend to earth. Although Hindu legends tell of many different deities mingling with humankind on various occasions, the avatar is truly the *modus operandi* of Vishnu, and the term is used almost exclusively to refer to his exploits. Vishnu becomes a giant fish (Matsya), a vengeful Brahmin (Parashurama), or some other character, not always charitable in nature but necessary to the maintenance of order in the cosmos.

Hinduism is an extremely complex religion, and Vishnu is probably the religion's most complex deity. We have all heard that India is the land of 10,000 gods. Some worshippers of Vishnu would argue that these 10,000 gods are simply the many faces of Vishnu. Other Hindus would argue that the faces belong to other Supreme Gods or Goddesses, or to 10,000 separate deities working within a sort of divine matrix. In any case, Hinduism's pantheon is only one aspect of the religion's complexity: Hinduism also offers innumerable philosophical interpretations and a diverse selection of ritual options, ethical systems, therapeutic practices, and artistic and literary representations, all filtered through the traditions of different regional and socioeconomic groups.

There are various reasons for Hinduism's emphasis on multiplicity. One is historical: the chronicle of Hinduism's mother country, India, is long and runs in many intertwining strands. A story first told in Sanskrit in the second century BCE might be retold over and over again in each of India's many dialects, and with every generation the story might change slightly until, 1,000 years later, several different versions exist, some of them diverging radically from the original. The religion we know as Hinduism has no single prophet or founder, no single moment of revelation, no single authoritative scripture. Ever since its earliest period, Hinduism's development has been a cumulative process, absorbing new beliefs and approaches while continuing to acknowledge the sanctity of older traditions. Although the many schools of Hinduism have certainly clashed on occasion, there is a tendency within the religion to accept discrepant teachings as paths to the same goal. As in any religion, adherents approach spirituality with varying degrees of engagement and sophistication. As a result, two people might find themselves praying next to each other in a Vishnu temple, repeating the same words and looking at the same sculpted icon, while holding radically different visions of the god and completely divergent spiritual objectives.

Another reason for Hinduism's complexity could be called pedagogical: when looking for ways of describing the divine, the religion's teachers typically found multiplicity more evocative than unity. Some argued that the divine can be expressed with a single word or image, but most countered that a paltry human mind could only conceive of the scope of a god's power by collecting various small glimpses, provided by many words, images, or stories. Instead of saying that God is one, a single, vast thing, they say that God is everything. A favorite form of worship in Hinduism consists of the recitation of hundreds of names for a single god. The list of titles—often descriptive epithets like Lotus-Eyed (Pushkaraksha) and Dispeller of Darkness (Sampramardana)—reminds the participants of the god's many roles and qualities. We will find that multiplicity is the favorite trope for describing Vishnu in particular, and that in recounting Vishnu's many deeds and faces we achieve a broader understanding of the god's true nature and influence.

Vishnu is one of Hinduism's most prominent and most frequently worshipped deities. He is often described as part of a trinity consisting of Brahma the Creator, Vishnu

the Preserver, and Shiva the Destroyer.[1] As the Preserver, Vishnu is responsible for maintaining balance, combating the forces of chaos, and ensuring that heaven and earth continue to progress on their preordained course. As a defining role, preservation may sound rather quiet and insignificant compared to creation and destruction, and indeed Vishnu is often presented as a tranquil god with considerable self-control. But the legends of Vishnu reveal just how often the order of things has been threatened and what dramatic lengths the god has taken to protect it.

While many Hindus worship the various gods equally, some focus their devotions on a single deity. For the worshippers of Vishnu, known as Vaishnavas or Vaishnavites, his role expands considerably: he is Creator, Preserver, and Destroyer, with the other two gods (and all other deities) simply doing his bidding. He is the embodiment of all light, the ultimate truth, the locus of limitless power, the soul within all of us, a formless entity beyond human comprehension. But Vishnu was not always celebrated as the Supreme God. His character and nature have changed substantially over time, growing more complex and more nuanced with every century. Vishnu is today the most multifaceted and subtle of the Hindu gods, the deity most difficult for the uninitiated to grasp, even while his legends offer such engaging windows into the god's character.

The purpose of this exhibition and catalogue is to introduce the multiplicity of Vishnu to a new audience using great works of art. Through examination of the various icons, myths, and ritual traditions of Vishnu, it should be possible to develop some sense of a broader, pan-Hindu tradition, but because our focus is limited to the art objects included in a temporary exhibition, there are many aspects of Hinduism that cannot be touched upon here, including Yoga, Tantra, Ayurveda, most of the great philosophical schools, performing arts, and village and tribal traditions. We have also neglected a considerable body of art coming from the areas outside of India that have worshipped—or continue to worship—Vishnu and his avatars. Nepal, Sri Lanka, Thailand, Cambodia, Indonesia, and Vietnam have all been home to Hindu art patronage, but they are omitted here because the selection of objects from India (and in a few cases what is now Bangladesh or Pakistan) already offered a mind-boggling diversity of forms, styles, and media.

This catalogue and the exhibition are organized according to theme, so objects from radically different eras and regions, large and small, flat and three-dimensional, are mixed together. We have attempted to represent as many of India's major art-making traditions as possible, with works of art from many different sites, dynasties, regional idioms, sectarian groups, and time periods. However, the selection of objects falls short of encyclopedic because in some cases the salient subjects simply were not well represented in certain styles or media. It is hoped that novice viewers will marvel at the diversity of India's visual arts but not let the particulars of attribution and style interfere with their enjoyment of the stories and characters, and the broader worldview that they illustrate.

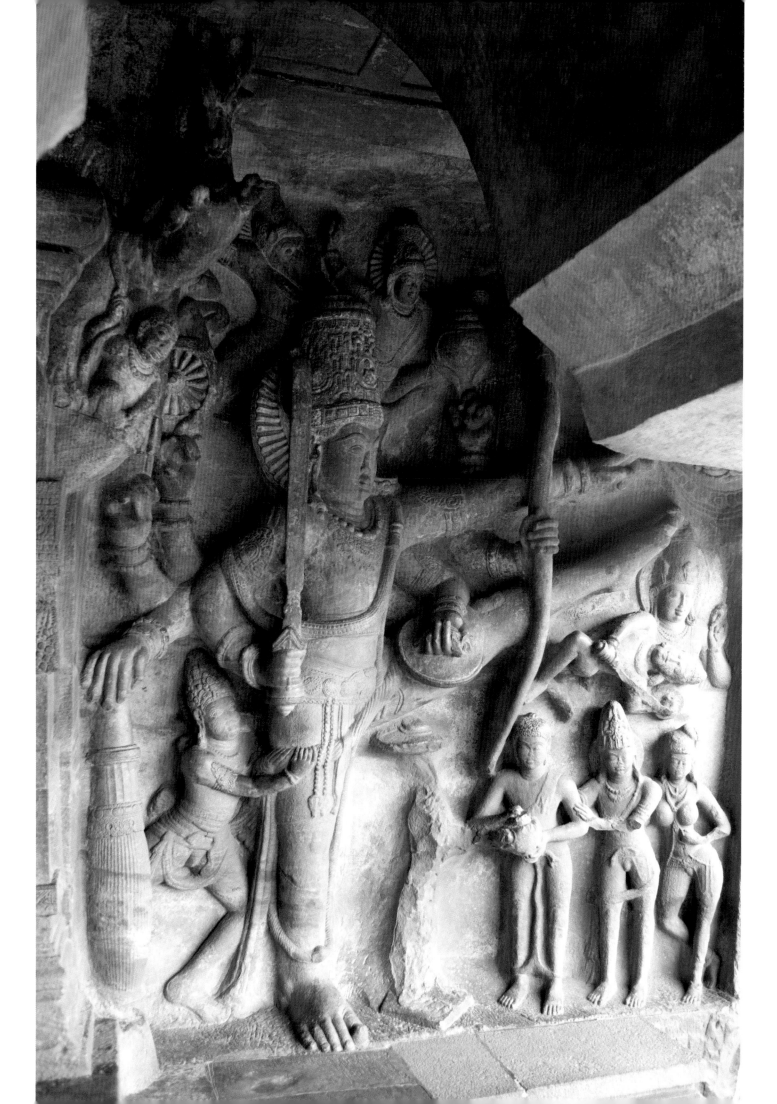

Vishnu's Place in the Development of Hinduism—Textual Evidence

Vishnu's importance and complexity grows over time. He is mentioned in Hinduism's earliest scripture, the *Rig Veda*, a group of hymns that was compiled around 1300–1000 BCE.[2] However, in the *Rig Veda* Vishnu is a minor figure compared with deities such as Agni, the god of fire, and Indra, a great warrior god who wields the lightning bolt as his weapon. The early religion that accompanied the recitation of the Vedas centered on the making of sacrifices to the gods. Vedic Hinduism did not make use of temples or icons of any kind: all one needed for worship was a fire, the proper offerings, and the assistance of highly trained priests.

The Vedas portray Vishnu as one of several solar deities, but a glimpse of his future supremacy comes in verses that describe the god as taking three great strides: stepping across the earth, sky, and heaven and thereby laying claim to each of these realms (see fig. 1 for a later representation of this story).[3] While the solar association would lose prominence in later characterizations of Vishnu,[4] the story of the three steps would be repeated and elaborated in numerous scriptures. One of the favorite epithets for the god, Trivikrama, can be translated as "Taker of Three Steps."

Vedic Hinduism continues to be practiced today, in both pure and altered forms, but numerous other, more modern practices and beliefs have been added to Hinduism, so that now Vedism is but one of many forms of worship. Around 500 BCE, a philosophical component was introduced with the compilation of the Upanishads, a series of dialogues targeting such sophisticated issues as the meaning and nature of existence. With the Upanishads important new goals and practices were introduced: through meditation and renunciation one could seek the realization of truth, which was thought to bring a final escape to a higher realm. The truths on which one meditated were largely not associated with specific deities, although later traditions would identify God as the embodiment or locus of Truth.

The big questions addressed by the Upanishads would continue to form the center of Hindu philosophical debate for centuries, but only a very sophisticated few were capable of, or interested in, the life of abstract thought prescribed for seekers of enlightenment. For the vast majority of other Hindus, religious practice took the form of praising and beseeching specific deities. And for this large group perhaps the most dramatic change in post-Vedic Hinduism was to the roster of most-revered gods, as Vishnu and Shiva replaced Agni and Indra as the recipients of prayer.

Vishnu and Shiva's rise to prominence took place over the course of more than 500 years. We do not have accounts of the process of transformation, but we assume that the impetus came from outside the priestly orthodoxy, from the general populace, as filtered through the aristocracy. The lowly have influenced the lofty over and over again in the history of Hinduism, but the scriptures generally do not acknowledge it.[5]

Figure 1 | Relief depicting Vishnu as Trivikrama, Cave 2, Badami, Karnataka, late 6th century. The relief also depicts an earlier episode in the story as Vishnu's dwarf avatar, Vamana (carrying a parasol) speaks with King Bali, who carries a water pot.
© *Dinodia / Photos India*

When Vishnu and Shiva appear with prominence in Hindu texts, they are already the supreme gods; the battle to raise them to that status had already been fought, and won, long ago on the nonliterate fringes of orthodoxy.

We first receive indication of the importance of Vishnu and Shiva in the two great epics of Hinduism: the *Ramayana* (*Deeds of Rama*) and the *Mahabharata* (*Great Story of India*). Although both of these texts feature heroes who were identified as avatars of Vishnu, neither is really dedicated to him, and Shiva appears in both as a powerful force.

In the epics and in some earlier literature, Vishnu is known by several names, and at times he appears to be not one god, but three, named Vishnu, Narayana, and Vasudeva. It is quite likely that early Hindus thought of the god named Vishnu (described in the Vedas) as a great but relatively specific deity who stepped across the three realms. Then they knew another god, Narayana, who had created the cosmos while floating on the primordial ocean (see fig. 2). The third god, Vasudeva, is best understood as an early form of Krishna, a divine hero who lived on earth and who was worshipped primarily by the Vrishni clan, a group based around the city of Mathura in central northern India. In the epics the three gods are treated as alternately distinct and related, but in later texts we find the three names being used almost interchangeably to refer to one Supreme God that we now know primarily as Vishnu. So the evolution of Vishnu's identity is one of both merging and splitting. In her essay Doris Meth Srinivasan looks at artistic manifestations for the three early identities of Vishnu.

Figure 2 | Vishnu as Narayana creating the universe while reclining on the serpent Shesha, Dashavatara Temple, Deogarh, Uttar Pradesh, 6th century. © Dinodia/Photos India

Even in these early accounts, we hear that Vishnu, Narayana, and Vasudeva are blue. There is remarkably little explanation given for Vishnu's distinctive skin color; it is treated as a simple fact. The most common interpretation offered today is that blue is the color of the infinite, but this of course begs the question of why the followers of other deities do not also depict their supreme gods as blue. More appropriate, perhaps, is to point to Vishnu's association with the great blue expanses of sky and water. As Trivikrama, he claims the firmament by stepping across it, and as Narayana he creates the cosmos while floating on a primordial ocean. It has also been suggested that Vishnu's blue color is something of a euphemism for swarthiness, and that the god might be affiliated with the darker-skinned races of India. Certainly, the name Krishna literally translates as

"Dark" or "Black." South Asian culture has been pigmentation obsessed for millennia, so we might expect to find discussion of Vishnu's race in scriptural accounts, but instead Hindus have tended to take Vishnu's blue color at face value. It distinguishes him as something other than human, and the color suits him as he remains calm and cool in the face of near disaster.

The *Ramayana* and *Mahabharata* not only treat Vishnu and Shiva as superior gods, but they also begin to individualize the gods so that they become what might be called protagonist deities: no longer identified with a single natural phenomenon like Vayu the wind god or Varuna the god of waters (both prominent in the Vedic pantheon), these deities interact with humanity and with each other in an intricate system of legends through which distinct personalities emerge. We learn that the gods have preferences, tendencies, and associates whose traits further reflect the subtle aspects of their master. A dichotomy of character develops in which Shiva is described as a god of passionate extremes and Vishnu is described as a god of balance and pacifism (although both stray from these defining qualities in numerous legends). This specificity of character might seem to contradict the simultaneously emerging trend toward calling Vishnu or Shiva a Supreme God, all-encompassing and beyond description, but their distinct characters reflect a theological trend that would be spelled out quite vividly in the *Mahabharata*: the trend toward devotionalism.

Vedic Hinduism promoted the fulfillment of sacrificial duties; the Upanishads introduced a contemplative approach to transcendence; still other texts known as the Dharmashastras prescribed appropriate day-to-day behavior for all righteous Hindus; next, a text within the *Mahabharata* introduced yet another religious approach or mindset that would influence later Hinduism profoundly. That text is the *Bhagavad Gita (Blessed Song),* and the new form of Hindu practice is devotion, best known by the Sanskrit term *bhakti*. The *Bhagavad Gita* is a lesson taught by Krishna just prior to the greatest and bloodiest battle in the *Mahabharata*. Krishna will emerge as Vishnu's most multifaceted and significant manifestation, but this message reflected a sea change in Hinduism that would reach far beyond the community of Vishnu worshippers. The message is that there is salvation for those who dedicate both mind and heart to a charismatic deity, interacting with God on an intimate level. Practitioners of bhakti require their god to have a fully developed personality that is similar in complexity to that of a human, but superior in wisdom and grace.

Bhakti would inspire some of premodern India's greatest literature, as poet-saints in many regions composed songs describing their relationship with God. The most common analogy for religious devotion was romantic love, replete with heartbreaks, longing, and rapture. Krishna became the most popular focus for bhakti, but the idea of interacting with God on a personal level pervaded the practices of other sects, both Vaishnava and non-Vaishnava.

An appendix to the *Mahabharata*, called the *Harivamsha (Lineage of Hari)*, tells the story of the youth of Krishna. This text paves the way for a great wealth of literature relating to Krishna, who is sometimes treated as an avatar of Vishnu and sometimes understood as something far greater than an avatar, either equivalent or identical to Vishnu. Most scholars date the *Harivamsha* to the beginning of the Common Era, which puts it slightly earlier than the next great body of texts that will discuss Vishnu in far greater detail. These texts are the Puranas, literally "ancient texts," great compendiums of knowledge that treat everything from philosophical questions to instructions for particular rituals to stories about the gods and heroes of yore. Most of the Puranas are dedicated to either Shiva or Vishnu, and they reflect a rise in sectarian preference while also providing a nearly full picture of what it meant to be a worshipper of these gods. The most extensive Vaishnava Puranas are the *Vishnu Purana*, which is datable to about 500–700 CE, and the *Bhagavata Purana*, which is datable to about 800–1000 CE, although it includes elements that some scholars date to a later period. The vast majority of the information provided in the following catalogue entries and descriptions of Vishnu's attributes and avatars comes from Puranic sources.

In the *Vishnu Purana* we get our first full discussion of the avatars and why each of them came to earth, as well as accounts of Vishnu's creation of the universe, his interactions with wives and devotees, and descriptions of his appearance, all more fully spelled out than in previous texts. It prescribes different types of worship of the god, discusses his relationship with the soul and the heavens, and lists cities that were important pilgrimage centers in its time. The *Bhagavata Purana* is similar but longer, with greater detail in its narration of some stories, particularly that of Krishna, to whom the text is dedicated. The most significant aspect in which the *Bhagavata Purana* differs from the *Vishnu Purana* is in its conception of Krishna: in the earlier text, he is an avatar, a mere earthly manifestation of Vishnu and therefore to be understood as embodying some limited quantity of the god's unlimited presence and influence, whereas in the later text he is the Supreme God who took form on earth but who is far more pervasive than this manifestation would suggest.

The differences between the *Vishnu* and *Bhagavata Purana*s reflect relatively broad divisions of belief within the ranks of Vishnu worshippers. A large number of Vaishnava sects developed over time, often based on the teachings of a great spiritual leader. In addition to those who practiced bhakti—northern and southern manifestations of the bhakti movement are discussed in the essays by Cynthia Packert and Leslie Orr—there was the early school known as Pancharatra, which was influential in its promotion of worship before icons, and, somewhat later, Tantric teachings, which were generally secret but promised more immediate experiences of the divine. There were sects dedicated to the Rama avatar and those that disdained the use of icons. For the most part, however, the differences between the various Vaishnava schools were philosophical in nature and were only reflected in ritual practice or art-making in relatively subtle ways.

Despite doctrinal differences, the Vaishnavas of various sects share certain beliefs that distinguish them from followers of other Hindu deities. Most promote nonviolence and vegetarianism and disapprove of the animal sacrifices practiced by some worshippers of other gods and goddesses. Although most Vaishnavas worship Lakshmi or the other consorts of Vishnu, they are interested in the feminine primarily as a complement to the masculine and place little emphasis on *shakti*, the powerful feminine energy embodied in warrior goddesses (some interesting exceptions are included in this exhibition, cats. 20–22). Vaishnavas are considerably less likely to pursue the esoteric practices of Tantra than worshippers of Shiva or the Goddess are, and they are considerably more likely to pursue the personal devotion of bhakti.

Vishnu in the Art of India

The first worship of Vishnu almost certainly took place around a sacrificial fire in the Vedic manner, without a temple or even an image of the god. The earliest known representations of Vishnu date to the first centuries of the Common Era, when much of northern India was under the rule of the Kushana dynasty. Prior to the Kushana period (first through third centuries CE), Vishnu was described in texts but apparently not depicted, at least not in durable media. The same is true of other Hindu and Buddhist deities. The only gods represented in stone in an earlier period were protective or fertility gods, known as *yakshas*, whose worship existed outside of orthodox Hinduism and Buddhism. It appears that the scripture-citing religions gradually accepted a more popular urge to make and worship icons, and not surprisingly the first representations of Vishnu and other gods resemble the earlier images of yakshas. The essay by Srinivasan offers an account of the varied forms taken by the earliest icons of Vishnu.

The first surviving temples dedicated to Vishnu date to a much later period, around the fourth century, during the reign of the Gupta dynasty. Prior to the Gupta period (c. 320–550 CE), it is likely that icons of Vishnu were installed either out-of-doors on freestanding altars or in structures made of nondurable materials. Some of the earliest surviving temples are man-made caves excavated into cliff faces and usually lined with large reliefs depicting the gods in both narrative and iconic forms (see fig. 1, cat. figs. 1–1, 55–1).[6] The taste for cave temples ended around the eighth century, after the technology for building stone or brick structures had been more fully developed.

From the start, all such structural temples—dedicated to Vishnu or any other Hindu deity—share the same basic elements: a small, enclosed sanctum where the primary icon of the god is enshrined (known as the "womb chamber" or *garbha griha*), a tower (*shikhara*) immediately over the sanctum, and a foyer or antechamber (*mandapa*) in front of the shrine room. Most temples are ornamented with carvings depicting floral motifs and auspicious emblems (usually relating to abundance) as well as a population of figures including gods, unnamed heavenly beings, mythical beasts, men and women, and earthly creatures. The majority of carved detail appears on select areas of the temple,

mostly in and around niches located at the center of each exterior wall, and around the shrine doorway. Over time, the basic structure was elaborated with bump-outs on the exterior walls, creating staggered surfaces onto which more and more sculpture was introduced. This elaboration can be seen by comparing the eighth-century Vishnu temple at Osian (fig. 3) to the eleventh-century Devi Jagadamba temple at Khajuraho (fig. 4).[7] The vast majority of Indian stone sculpture in museums—and in this exhibition —comes from the exterior of temple buildings that have fallen into ruins.

When visiting a structural temple, a worshipper often begins by walking around the exterior, usually in a clockwise direction. He or she admires and briefly invokes the various deities displayed on the walls. On Vishnu temples these exterior images might depict the avatars or other important legends of the god, as seen in figures 2 and 3. Or the outer images might depict Shiva and Brahma in a brief iconographic acknowledgment of other deities. In either case, the images on the outside are usually understood to be extensions or emanations of the god enshrined within, who manifests himself in many forms, large and small. Many Vishnu temples have an image of the man-eagle Garuda,

Figure 3 | Trivikrama image in central niche, Vishnu Temple 1, Osian, Rajasthan, 8th century; partial view of the exterior from the south.
Photograph by Joan Cummins

Figure 4 | Jagadamba Temple,
Khajuraho, Madhya Pradesh, c. 1025;
partial view of the exterior from the
southwest.
Photograph by Joan Cummins

Vishnu's mount, installed in front, facing into the temple. It is common practice to stop and pray to Garuda before going inside. In more elaborate temple complexes, one might stop in several smaller shrines to pay homage to various gods before moving on to the main temple. This is particularly true in the South, where temples can stretch for acres within enclosures entered via monumental gateways, called *gopuram*s (see fig. 5).

After a brief journey past the subsidiary images, the visitor's mind is prepared for the main ritual of worship, known as *puja*, so he or she enters the temple and approaches the sanctum. The interior of the building is much darker and less elaborate, so the worshipper can concentrate solely on the icon installed on the altar. That icon might be stone or bronze, or there might be several icons in various media (as in fig. 6). Puja begins by calling the god to be present in the icon, which is understood as his temporary body, after which the worshiper makes offerings of food, fire, and flowers. Sometimes the worshipper touches the icon, anointing it or draping it with garlands. Often the icon has been dressed and only its face is readily visible. Prayers consist of praise and requests. Then the god is given leave, and the ritual is over. The process is understood as a meeting in which the mere act of seeing and being seen by the god—known as *darshan*—brings insight and spiritual merit.

Relatively few of the stone sculptures in this exhibition are likely to have received puja. Most were probably part of the large display of subsidiary images that were honored

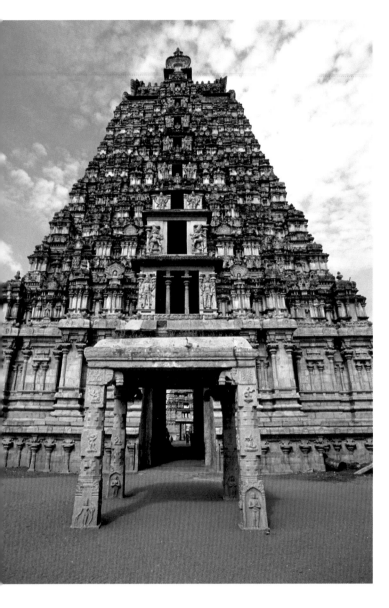

Figure 5 I East *gopuram*, fifth enclosure, Ranganathaswamy Temple, Srirangam, Tamil Nadu, early 15th century.
© *Frédéric Soltan/Sygma/Corbis*

briefly outside. The Garuda in catatogue 27 is clearly an exception, as it still sports the spots of color applied by a devotee during worship. By contrast, the vast majority of the bronze images in the exhibition were probably made for worship and installed on altars in temples or in domestic shrines, where they served as the embodiments of the gods during puja. Bronze images are somewhat more portable than their stone counterparts, and in many temples—especially in southern India—these icons were paraded on litters or floats during festivals.

We know from literary descriptions that painting was a thriving art form in premodern India. Very little remains from before the eleventh century; we know from traces of pigment that the interiors of some temples had wall paintings, and it is likely that paintings were made on cloth and/or wood panels. All of the paintings in this exhibition were made after 1400 CE. Most of these paintings are on paper and were made as illustrations for manuscripts; they were originally supposed to be examined in sequence, held in the hands of the viewer. Because they were bound into books or stored in wrapped piles, these paintings (sometimes called miniatures, though some are quite large) have survived far better than murals, and they provide our best evidence for Indian painting traditions. Worship of Vishnu, and especially of Krishna, was prevalent among the Rajput rulers of northern India, who were the most active patrons for manuscript painting, so this medium provides a great wealth of Vaishnava imagery.

We should keep in mind that every work of art illustrated here was a product of the collaboration between a patron who paid for the materials and labor, artists who carried out the commission, and priests who advised on the subject matter. Most of the artists who created the objects illustrated in this catalogue worked anonymously and in teams. They strove to capture the valor, grace, and energy of Vishnu and his avatars using a combination of expressive forms and legible emblems, but they were usually following directions from their patron and his or her spiritual advisor. Sculptors also abided by the rules set out by iconographic texts that were hundreds of years old and often very exacting (manuscript painters seem to have paid less attention to these texts), but they managed to create fresh and lively images nonetheless. Artists were well paid for their efforts because patrons wanted to reserve for themselves the spiritual benefits of creating art. Commissioning a work of art was like saying a prayer that continued to sound for centuries. The prayer was heard by anyone who visited the temple or opened the manuscript, and it was heard by the gods; and in the case of the objects illustrated here, it continues to be heard today. Hence the multiplicity and grandeur to be found in this exhibition lie not only in the many forms of Vishnu but also in the many voices that explain, celebrate, and wonder over those forms.

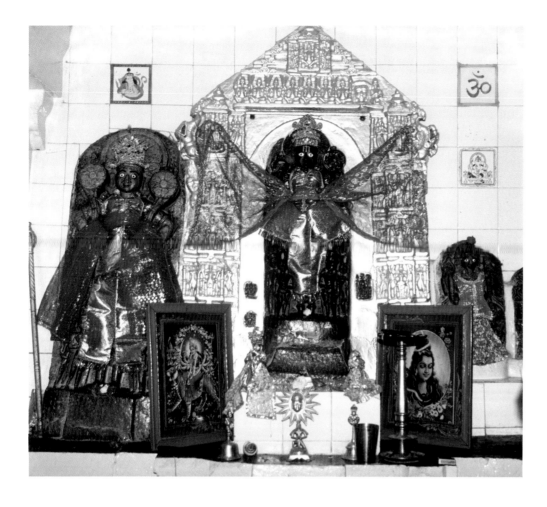

Figure 6 | Sanctum images, Surya-Narayana Temple, Pindwara, Rajasthan, 11th century and later.
Photograph by Joan Cummins

Notes

1 The god Brahma has very, very few dedicated followers. If we want to talk about a trinity of the most prominent, or most worshipped, deities, it would be more appropriate to describe it as Vishnu, Shiva, and the Goddess (Devi).

2 Please note that in the study of the history of ancient and premodern India there are few occurrences, works of art, or literary texts that can be dated with any confidence to a particular year or even decade. Hindus believe that the Vedas were spoken by the god Brahma many millennia ago and that the approximate date given today is only for the period when they were first gathered in an organized and authoritative fashion by man.

3 Vishnu is celebrated in *Rig Veda* book 1, hymns 22 and 154, and book 7, hymns 99 and 100, and elsewhere.

4 Vishnu's solar aspect would re-emerge most clearly with the development of the deity Surya-Narayana, an amalgam of Vishnu and Surya the sun god. An image of this composite god appears at the top of the *parikara*, cat. 7 herein.

5 Wendy Doniger's *The Hindus: An Alternative History* (New York: Penguin, 2009) parses the great texts in search of evidence for the influence of the disenfranchised, but even she admits that in Hinduism the will of the people is best discerned in the aftermath rather than at the moment of its pronouncement.

6 With the move from cave temples carved into cliff-faces to temples constructed from quarried stone, the typical scale of stone sculpture became much smaller because it was generally confined to a single block or slab; some of the most dramatic early sculpture survives in cave-temple settings and can only be seen on site.

7 The Devi Jagadamba temple is currently dedicated to the goddess Parvati, but its iconography indicates that it was originally built as a Vishnu temple.

Becoming Vishnu

Doris Meth Srinivasan

It used to be presumed that Vishnu is the placid god while Shiva is the terrific one. Though Vishnu does not have the fearful edge that Shiva does, he is by no means passive. Vishnu is a god of energy even in the early period. He and the divinities that come together to comprise his nature are characterized by energetic motion. Their action is beneficial and foretells the later hallmark of Vishnu's divine power. His capacity to accomplish universal creation, to transform and preserve, and to achieve heroic feats for the sake of humanity explain, in part, the fervent devotion which prevails to this day among Vaishnavas, that is, those who give worship to Vishnu.

The study of Vaishnavism demonstrates that these characteristics of the god were slow to cluster around Vishnu. Probably by the fourth century CE, especially in northern and central India, a theological evolution had achieved foundational stability, and Gupta art reflects the Vaishnava synthesis. Earlier, from about the second century BCE through the second to third centuries CE, the above-named beneficial characteristics defined three different deities who would slowly merge to become the Supreme God. These deities are Vedic Vishnu; Narayana, a deified ancient Brahmanic sage; and a group of deified clan heroes known as the Vrishni Viras. Each arose out of a different religious group; some may have been a different sect. This essay describes the imagery pertaining to Vedic Vishnu, Narayana, and the Vrishni Viras in order to show how their depictions merged and contributed to the subsequent splendid visions of Vishnu in Gupta art and beyond.

It should come as no surprise that various beliefs held by different groups would coalesce to establish the Vaishnava tradition. Surely the incorporation of the Buddha as a descent (avatar) of Vishnu in the established Vaishnava tradition implies that numbers of Buddhists adopted Vaishnavism, which, accordingly, accommodated them. This followed the earlier assimilation of devotees of Vedic Vishnu, the ascetic Narayana, and the Vrishnis with one another to establish the greatness of Hindu Vishnu. Distinctive imagery for each was formed during a time when separate teachings were merging into the doctrines of an all-inclusive Vaishnavism that is the focus here.

Vedic Vishnu epitomizes motion. In the *Rig Veda*, the earliest Brahmanic collection of hymns, hymn number 6.49.13 extols Vishnu who takes three strides in three earthly regions (earth, atmosphere, heaven). The reason for his action is to aid "man in distress." The *Rig Veda*, dated about 1300–1000 BCE, contains hymns to Vishnu who, far from

being the Supreme God of later Hinduism, nevertheless is lauded with core concepts that will remain and intensify in Vaishnavism and Vaishnava imagery. Remarkably, more than a millennium before the fashioning of Vishnu's image as Trivikrama (He Who Strides over the Three Worlds in Three Steps), and before the incorporation of the belief in Vishnu's periodic descents (avatars) into the world for the benefit of mankind, the words of the *Rig Veda* seem to foresee it all:

> Vishnu, who thrice traversed the earthly regions for man in
> distress, in this, your offered protection, may we rejoice with
> our wealth, we ourselves and our offspring.
> —*Rig Veda* hymn no. 6.49.13 (hereinafter "RV")

From the beginning, Vedic Vishnu has the power to pervade space and act for the benefit of man. The same Veda also asserts that he can assume different forms (RV 7.100.6). In short, the groundwork is laid for the later development of Vishnu's Trivikrama form. However, between the three strides of Vedic Vishnu and those of Trivikrama, an important transfer occurs. The three strides are transferred from the god himself to his avatar as the dwarf (Vamana), who in this guise tricks a demon named Bali in order to regain the organized world for gods and men. This transference is developed further in several later Vedic texts dating from the beginning to the middle of the first millennium BCE. The *Mahabharata* picks up these Vedic threads and relates the avatar story wherein the little dwarf asks Bali for as much of the world as his three paces can measure. When Bali agrees, then the dwarf assumes his true divine size and covers the entire world with his three steps.

Images of Trivikrama can be distinguished into three different types depending on the height of the striding leg; raised to the level of the other knee, the image represents the regaining of the earth; raised to the level of the navel, signifies the mid-region or the sky; and to the level of the god's forehead, means the regaining of the heavenly regions, that is, repossession of the totality of earthly spheres.

An early image of Trivikrama raising his leg to his navel comes from Mathura and was fashioned during the Kushana period (fig. 1). Originally the god would have had eight arms, though four remain only on the right side. In descending order, starting from the top, the four hands hold a rock, a sword, arrows, and, held close to the chest, by the natural hand, a round object.

Figure 1 | Trivikrama, Mathura, Uttar Pradesh, c. 2nd–3rd century. Government Museum, Mathura. *Photograph by Doris Meth Srinivasan*

Much of the narrative drama is encoded into the numerology of the fragment. A supranormal number of arms probably signifies the capacity to engage in supranormal action. The number eight qualifies the nature of the action. There could hardly be a number whose symbolism is better suited to the Trivikrama myth. Being the double of four—a number closely associated with phenomenal space and recalling the four directions—eight emphasizes the doubling of terrestrial space (the four quarters plus the four interstices).

Eight can also be read as seven plus one. In this reading, all of horizontal space (i.e., the four directions) and the three upper regions (earth, atmosphere, and heaven) can symbolize world space. When the number one (expressing all, completeness, unity) is added to seven, symbolic of world space, the resultant number eight conveys the meaning of spatial totality. The conquest of all space for the benefit of mankind encapsulates Vishnu's great achievement as Trivikrama and brings to fruition the seed planted in the Rig Vedic hymn of praise.

An extraordinary colossus depicting a Brahman ascetic offers a glimpse of Narayana as he looked to his worshippers at Nadan (near Firozabad, Agra district), where the statue was found (fig. 2). The figure originally stood over eight feet tall, and although it has few attributes, all are earmarks solely of an ascetic, writ large, thus a Divine Ascetic.[1] Lord Narayana has generous facial hair. He has a *tilak* mark between the eyebrows, and his long ascetic locks are twisted around his head like a turban. The ears are unadorned, and judging from the unpierced lobes, were never decorated with earrings. Over the powerful nude chest, a sacred (Brahmanic) thread is suspended, as well as the skin of an antelope. The skin is symbolic of Vedic culture, for it is associated with ritual purity and asceticism in the Vedic context. A skin of this animal is given to a Brahman boy at the time of his initiation rite. The antelope skin is spread on the ground, purifying the space upon which a worshipper sits, as he performs his rites. This colossal sandstone figure made during the second to third century CE (during the Kushana period) was originally two-armed and held two attributes that can still be discerned; the ascetic's water pot (*kamandalu*) is on his left and the remains of a rosary is in his right hand. The lower garment, tied by a knotted rope around the hips, is made of a fibrous substance; evidently it is meant to represent the typical ascetic's garment made of bark, hemp, or *kusha* grass. As such, every aspect of this impressive personage bespeaks a Brahman Ascetic.

The fact that this Brahman Ascetic once stood more than eight feet tall mandates that this is the figure of a god, and not a mortal, no matter how venerated or legendary. Although there are other gods that can exhibit the features of a Brahmanic ascetic, gigantic size is characteristic only of Narayana. He is the divinity who appears as a gigantic ascetic. The height of the statue is therefore a lithic translation of Narayana's designation as large or great, *maha*, Narayana. Indeed *Mahanarayana* is the title of an

Figure 2 | Narayana, Nadan, Agra district, Uttar Pradesh, c. 2nd–3rd century. Government Museum, Mathura.
Photograph courtesy Government Museum, Mathura

Upanishad that discusses, in part, the nature of this god. In this text of about the third century BCE, Narayana is called Purusha, a name that recalls the huge Vedic Primeval Male, out of whom the entire universe was fashioned. In the *Mahabharata*, Narayana is called Maha Purusha (The Large Male), thus affirming both his creative energy and his claim to the colossal proportions of Cosmic Purusha. In addition, numerous passages in the *Mahabharata* praise him as the personification of the Vedic sacrifice, its cause, heart, origin, and so on, a claim that Narayana himself confirms in this same epic. And in a section of the *Mahabharata* describing the god's epiphany as seen by a true devotee, it is precisely in this manner that Narayana shows himself (see MhBh 12.326.9). This section also provides clear evidence of the existence of a Narayana cult requiring icons such as this impressive sculpture from Nadan.

Narayana became an important component in early Vaishnava theology and imagery. As Maha Purusha, Narayana represents the cosmogonic totality of a Vaishnava sect called the Pancharatra. This sect postulates that all of creation unfurls when the transcendental Narayana begins to manifest himself. His first manifestation is called Para Vasudeva (Highest Vasudeva). Cosmogony continues as this manifestation differentiates himself into four emanations, called *chatur-vyuhas* (literally, "four-emanations"). An early icon of Narayana's revelation can be identified thanks to a remarkable Kashmiri bronze of the fifth century (fig. 3). The bronze has an inscription on the base of the image that names the figure Narayana; it shows the godhead's supreme manifestation, Para Vasudeva, plus two other emanations, or *vyuhas*.

Narayana's assimilation into the Vaishnava mainstream should have started considerably earlier than the fifth century CE. Possibly this was aided by the suitability of Narayana's huge dimensions to the expansive capability of Vedic Vishnu. The character of Vedic Vishnu contains another influential kernel. Implicit in the myth is Vishnu's capacity to become (or project) a form that expands and transforms. This power may be seen as a complement to the cosmogonic energy of Narayana, who activates a series of *vyuhas*. The names of the four (*chatur*) *vyuhas*—Vasudeva, Samkarshana, Pradyumna, and Aniruddha—are first mentioned in the *Narayaniya* account of the *Mahabharata*. They are the names of four of the five Vrishni Viras and as such represent the third group of deities drawn into becoming Vishnu.

Figure 3 | Para Vasudeva–Narayana, *vyuha* of Narayana, from east of the Indus River, perhaps Kashmir, reportedly found at Kashmir Smast, Pakistan, 5th century. National Palace Museum, Taipei, Taiwan, Republic of China.
Photograph courtesy private collection, Tokyo

The Vrishni Viras were an actual ruling clan in the town of Mathura, probably their ancestral home. Seven miles from the town an inscription was found which names five Vrishni Viras, all related by blood or marriage.[2] By the time of the inscription, dating to the early decades of the Common Era, these Vrishnis had become deified. But they are still named according to importance in the Vrishni lineage system, not according to religious popularity. The senior-most person listed is the elder brother Samkarshana/Balarama; his younger brother is Vasudeva-Krishna, destined to become one of the most important gods in Hinduism and an avatar of Vishnu; the others named are

Pradyumna, Samba, and Aniruddha. The Vrishni gods belong to the third religious tradition influencing Vaishnavism, namely the Bhagavata religion.

An early icon intimating the association of Narayana with the Bhagavata movement comes from Bhita, in Uttar Pradesh; it seems to depict a Proto-*Chaturvyuha*, and dates to about the second century BCE. By around 50 BCE these two belief systems—the Bhagavata and the Pancharatra—seem to have formed some connection. An inscription, found in Rajasthan, records that a stone pathway for the place of worship to Samkarshana and Vasudeva was erected within Narayana's stone enclosure.

Vasudeva-Krishna of the Vrishnis contributed features that were to become prime factors in Vishnu's appeal and strength. Vasudeva-Krishna, the Supreme Godhead of the Bhagavatas, in their text the *Bhagavad Gita,* declares his readiness to become immanent in the world, age after age, to protect the good, should they be threatened:

> For whenever right languishes and unright shows its head,
> then I send forth Myself.
> To save the righteous and destroy the wicked, to establish
> the right, I come into being age after age.
> —*Bhagavad Gita* 4.7,8[3]

Figure 4 | The Five Vrishni Viras flanking Narasimha, Kondamotu, Andhra Pradesh, c. early 4th century. State Museum, Hyderabad.
Photograph courtesy Archaeological Survey of India

Surely these are the words of a compassionate god, ready to descend into the world in some earthly form for the benefit of mankind. This declaration is often taken as the beginning of the avatar notion that plays such a critical part in Vishnu's later imagery and theology.

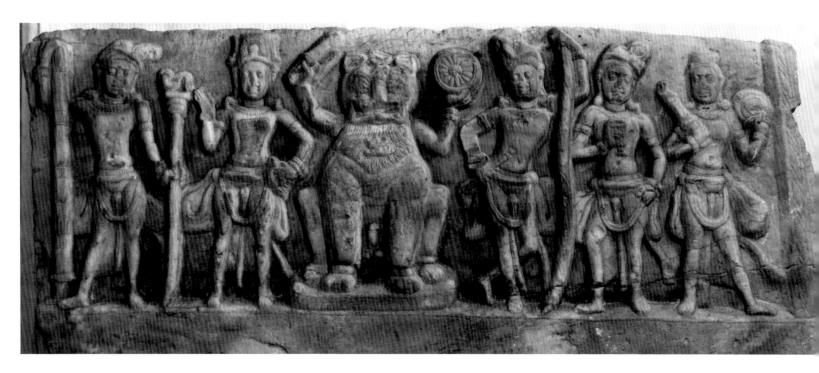

Vasudeva-Krishna's readiness to enter the world and even become responsive and accessible to devotees complements the powers inhering in Vedic Vishnu and Narayana. The accessibility of this god differs from the transformative energy of Vedic Vishnu and the creative energy of Narayana, although it must quickly be added that these complex deities wield powers in domains that overlap.

It is not hard to see that the fusion of powers belonging to the main gods of these three early religious traditions could eventually produce a great god who captured the minds and spirits of kings and commoners. By the early years of the Common Era, the process leading to the assimilation of Vedic Vishnu, Narayana, and Vasudeva-Krishna with one another was nearing its conclusion.

A relief from Kondamotu, Andhra Pradesh, offers a window into this process, apparently still ongoing in the southerly region in the early fourth century CE, the date given to this relief (fig. 4). The stone image is a rare example depicting the cult of the five Vrishni Viras. First stands Samkarshana/Balarama, identified by the club and lion-plough he holds; next to him stands Vasudeva-Krishna with one hand raised but slightly turned inward (*vyavritta mudra*) and the other with the conch shell; Pradyumna stands with a bundle of arrows, or quiver, and bow; Samba has an indistinct attribute; and Aniruddha holds a sword and shield. But between Vasudeva and Pradyumna there appears an avatar of Vishnu. Vishnu is shown as the Man-Lion, that is, Narasimha. His body and face are those of a lion but the two arms are those of a human.[4] According to legend, the god becomes half-man half-lion in order to confound the near-invincible demon Hiranyakashipu. The Man-Lion, with the *shrivatsa* emblem on his chest, is seated amidst the Vrishnis, yet he is as tall as they. The *shrivatsa*, the outward sign of a great being, becomes Vishnu's auspicious mark. The Man-Lion holds the *chakra*, or wheel, and the *gada,* or mace, in his human hands. Narasimha's central position, his specific attributes, and his emblem suggest his prominence is equal to, if not greater than the Vrishnis, who are arrayed not according to their religious prominence but rather according to their status within the Vrishni clan. The Kondamotu relief is thus a visual benchmark indicating how the integration of different cults slowly consolidated and melded into the overarching Vaishnava system. Michael Meister proposes that this relief may also provide a commentary on one meaning of *narasimha*, namely "lion among men"; this relief does show Vishnu as a theriomorphic god surrounded by heroes.[5] This suggestion may recall that the Vrishis had been, at one time, considered mortal.

A sweeping glance at the main trends that lead to the arising of Vishnu between the second century BCE and around the fourth century CE enables us now to look more closely at a few remarkable images within this time span. The images selected are noteworthy reference points that lay the foundation for Vaishnava art.

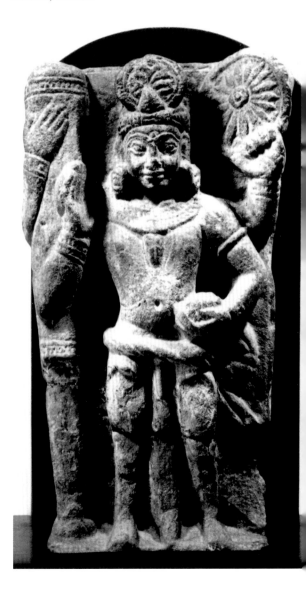

Figure 5 | Vasudeva-Krishna Mathura, Uttar Pradesh, c. 2nd century. Government Museum, Mathura.
Photograph courtesy Government Museum, Mathura

The most popular Vaishnava icons made in Mathura during the Kushana age can be identified as representations of Vasudeva-Krishna. The god is four-armed and holds the mace and *chakra* in his upper right and left hands, respectively. The natural lower right gestures reassuringly and the left may hold a flask or a conch, as in figure 5. The identification of this type of image is virtually assured because it matches the way Vasudeva-Krishna appears in a series of Kushana Vrishni kinship reliefs also made in Mathura. Furthermore, when a worshipper of Vasudeva-Krishna asks, in the *Bhagavad Gita* (11.46), for the god to show himself in his usual form, that form equates with the icon made by Mathura craftsmen during Kushana times:

> I wish now to see you as before
> With your crown, mace and wheel in hand
> Become again the four-armed form…

In asking to see this four-armed form, the worshipper in effect craves to see the humane form of Vasudeva-Krishna. The supranormal number of arms probably signifies the ability to engage in supranormal action. Four qualifies the nature of the extraordinary action possible. Four is a terrestrial number which evokes the four directions and thus the human sphere. Accordingly, the "four-armed form" suggests a god who can benefit mankind. The attributes of crown, mace, and wheel are basically royal insignia and probably reflect the actual hero cult that initially centered around the Vrishni warriors deified in the Mathura region. The humane form of the great god of the *Bhagavad Gita* appears to be based on the heroic model; Vasudeva-Krishna is the apotheosis of the Great Hero. The Gupta standing images of four-armed Vishnu in the exhibition (cats. 1–3) probably developed from this earlier model.

The avatar concept that took shape around Vasudeva-Krishna, and in accordance with the personality and renowned deed of Vedic Vishnu, inspired the early production of avatar icons. Four such icons of avatars can be dated to the Kushana period. The Kushana image depicting Trivikrama's act (see fig. 1), which was incorporated into the myth of the dwarf, or Vamana avatar, has already been mentioned. The image of the Narasimha avatar in the fourth-century Kondamotu relief has also been noted (see fig. 4). Another, probably late third–early fourth century stone Narasimha depicts this avatar with the head of a lion and the body of a man disemboweling Hiranyakashipu (cat. 62). The ferocity of this Man-Lion is a trait at variance from the beneficent Vedic Vishnu and the compassionate deified warrior Vasudeva-Krishna. The rudimentary form of this myth and the figure of the Man-Lion remain enigmatic.[6]

Two other pre-Gupta avatar depictions have ancient antecedents. The seeds for the Varaha, or boar, incarnation occur in early Vedic texts (the *Taittiriya Samhita* and the *Satapatha Brahmana*). In these texts, as in the later mythology pertaining to Vishnu, the earth needs to be rescued. In the Vaishnava tale, the Lord, taking the shape of

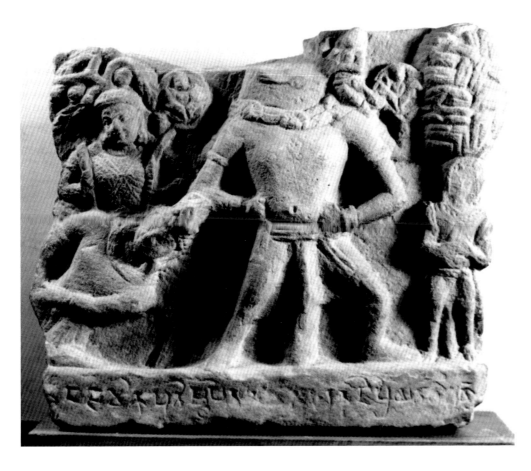

Figure 6 | Varaha, Mathura,
Uttar Pradesh, c. 2nd–3rd century.
Government Museum, Mathura.
Photograph by Doris Meth Srinivasan

Figure 7 | Hayagriva, Mathura,
Uttar Pradesh, c. 2nd–3rd century.
Bharat Kala Bhavan, Benares Hindu
University, Varanasi.
*Photograph courtesy Digital South Asian
Library, American Institute of Indian
Studies*

a powerful boar, enters the nether world in order to raise the earth up from the sea into which she has sunk. A Kushana relief from Mathura (fig. 6) represents the boar's success in clear visual terms: a tiny, pliant earth in the form of a delicate female rests close to the vast shape of the boar, partially a man with four arms and partially an animal with a mighty boar's head. (The Mathura Museum also houses a Kushana relief of an all-animal Varaha, no. 1254). Hayagriva, the avatar with a horse's head, is portrayed in a relief now in the Bharat Kala Bhavan, Varanasi (no. 4846, fig. 7). Legends in the epic connect this avatar with the rescue of the Vedas and indeed, aspects of the legend continue in later Puranic mythology.

It does not seem accidental that Varaha, Hayagriva, Trivikrama (or Vamana), and Narasimha are the earliest avatars depicted. Not only is the avatar notion current in the Kushana age, but also most of these avatars germinate out of prior myths mentioned in sacred or secular literature. There is some merit therefore in postulating

Figure 8 | Vishvarupa, detail from a lintel, Gadhwa, Allahabad district, Uttar Pradesh, c. 5th century. State Museum, Lucknow.
Photograph courtesy Digital South Asian Library, American Institute of Indian Studies

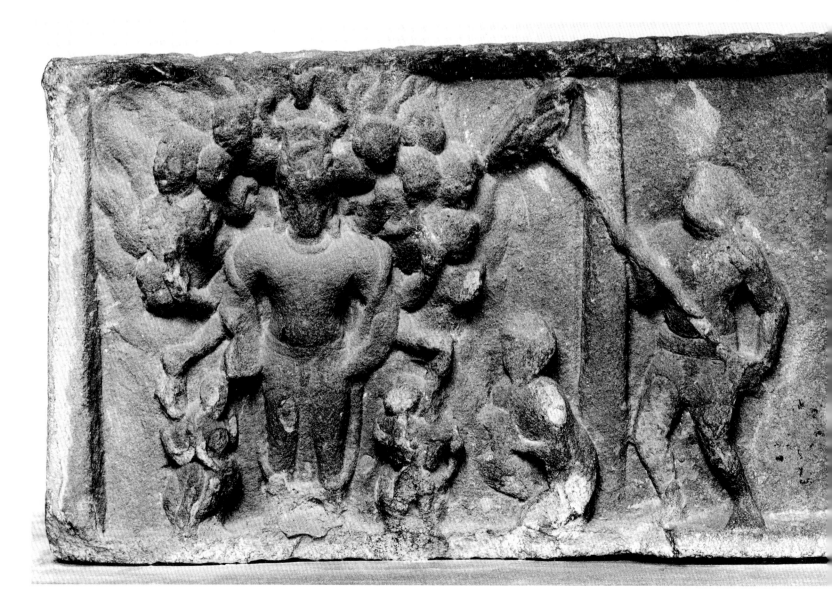

that the avatar concept assisted in the amalgamating process which established the great Hindu Vishnu. Nor is it accidental that most of the avatars have four arms. As discussed above, "four" and "arms" symbolically express the mission of an avatar, namely humane action in the phenomenal world.

The most spectacular visual image invented in Hinduism gives an explanation for the creation of the phenomenal world. The whole world lies within the Creator and is born when the Creator ejects all these phenomenal forms. An image of the "Omniformed One," or Vishvarupa, is literally extra-ordinary: it portrays a profusion of animals, nature, beings, all within the bodily confines of a giant possessing a profusion of multiple bodily parts. The earliest sculptural Vishvarupa brings us to the doorstep of Gupta art, as Vishvarupa Vishnu is seen on a fifth-century Gupta lintel from Gadhwa (Allahabad District, fig. 8), and this concept continues to inspire visual renderings, as the paintings in the exhibition demonstrate (cats. 131–33, as well as a print, cat. 173).

With the advent of the Gupta era, different sectarian currents merge. As an inexhaustible, bottomless lake fed by myriad streams, so different revelations meld and flow forth from pervading Vedic Vishnu, creative Narayana, and humane Vasudeva-Krishna, the Vrishni Vira. Superb concretizations depicting qualities of Omnipresent Vishnu—pervasive, creative, and loving, are thereby ushered in.

Notes

1 The image has been discussed at length elsewhere by this author. See "God as Brahmanical Ascetic: A Colossal Kushan Icon of the Mathura School," *Journal of the Indian Society of Oriental Art*, n.s. 10 (1978–79), 1–16; "Bhagavan Narayana: A Colossal Kushan Icon," *Pakistan Archaeology* no. 26 (1991), 263–71; and "Vaisnava Art and Iconography at Mathura," in Srinivasan, ed., *Mathura: The Cultural Heritage* (New Delhi: American Institute of Indian Studies, 1989), 389–90. For other colossal early images of Narayana, see Srinivasan, *Many Heads, Arms, and Eyes: Origin, Meaning, and Form in Indian Art* (Leiden: Brill, 1997), 136.

2 The inscription was found at Mora, seven miles from Mathura. It states that images of the blessed or deified five Vrishni Viras or Heroes were installed in a stone shrine of a person called Tosa. See Heinrich Lüders,

Mathura Inscriptions. Unpublished papers edited by Klaus L. Janert, Göttingen, 1961, page 155, no. 115. The five Vrishni Viras are also listed in the *Vayu Purana*, 97.1–2.

3 *The Bhagavad Gita*, translated by Franklin Edgerton (New York: Harper Torchbooks, 1964), 155.

4 This is a correction of a statement in my 1997 book *Many Heads, Arms, and Eyes* (242), where I said Narasimha has four arms. Actually, the avatar has two human hands, plus the two front paws of the lion.

5 Michael W. Meister, "Man and Man-Lion: The Philadelphia Narasimha," *Artibus Asiae* 56, no. 3/4 (1996), 291–301; see 297.

6 Deborah A. Soifer, *The Myths of Narasimha and Vamana, Two Avatars in Cosmological Perspective* (Albany: State University of New York Press, 1991), 73; and Meister, "Man-Lion," 297.

Vishnu's Manifestations in the Tamil Country

Leslie C. Orr

That part of South India known today as Tamil Nadu is often regarded as a stronghold of the god Shiva, yet the worship of Vishnu is deeply rooted there. For over fifteen hundred years, devotees have gathered at sites sacred to Vishnu spread across the Tamil country to honor this god in his various forms, in manifestations that have a special connection to the Tamil landscape. The image of Vishnu reclining on the serpent in the milk ocean has been for centuries close to the hearts of Tamil Vaishnavas, who regard this form of the god as being especially attached to Srirangam. Krishna is also completely at home in the Tamil country, and it seems, in fact, that many elements of the mythology of Krishna as cowherd—child and lover—first appeared in Tamil literature and iconography. Other aspects and avatars, and consorts, of Vishnu also found their place in (or emerged from) the Tamil landscape. As Vaishnava theology and temple worship developed, especially from the twelfth century onward, the teachers of the emerging tradition known as Shrivaishnavism paid particular attention to the significance and character of the image of the deity and its importance in making god present to his worshippers. In the course of time, certain sites gained prominence and great temple complexes were built up there, teachers and saints were enshrined, and festivals were established. To this day, these centers of architectural splendor continue to draw worshippers and to testify to the skill of craftsmen and the devotion of patrons who contributed to their beauty and to the elaboration of their ritual and imagery. But we should begin with an earlier and simpler time.

Vishnu's Early History—Literary Portraits

The first brief references to Vishnu in Tamil literature—in the classical "Sangam" poetry of the first to seventh centuries—are not at all concerned with temples constructed for him, but there are several specific places that are said to be his abodes, places that in later times are sites where major temples are built. The Sangam poems, and especially those composed later in the period (e.g., *Silappadikaram,* of perhaps the sixth century), also give us an idea of the Vaishnava myths that were then current in the Tamil country and suggest that Vishnu received worship in image form, although the earliest sculptures that have been preserved date only from the seventh century. The most explicit references to Vishnu's physical presence describe him as reclining on the coils of the serpent—that is, in the form of Anantashayana—at Kanchipuram, Srirangam, and Thiruvananthapuram. It is significant that these three sites are strung across the

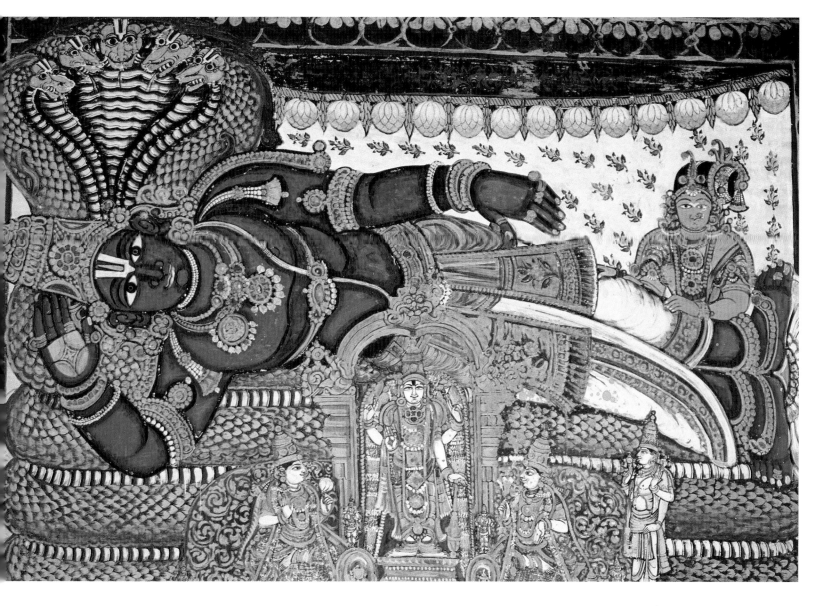

whole of the Tamil country, from the north to the farthest south. This cosmic form of Vishnu-Narayana seems to have been known and honored throughout the region very early on, although in the course of time this image was increasingly identified as that of Ranganatha, the Lord of Srirangam, an island in the Kaveri River (fig. 1).

Early Tamil literature is often referred to as secular since it is primarily concerned either with the various phases of love or with the praise of a chief or king and the realm that he rules. So the mention of gods and the places where they dwell, or their worship, is quite rare. Nonetheless, we find a few references to Vishnu, called Mal or Tirumal in early Tamil sources, or to the deeds of his incarnations—Varaha, Narasimha, Vamana, Rama, and Balarama, and, somewhat more frequently, Krishna. In the late Sangam literature Krishna appears among the cowherds; as a child he steals butter and as a young man he enchants by playing the flute and dancing with the girls of the village—whose clothes he steals while they bathe. This image and these myths

Figure 1 | Ranganatha in the form appearing in the inner sanctum, painting on enclosure wall, Ranganathaswamy Temple, Srirangam, Tamil Nadu, 19th century.
© *Frédéric Soltan/Sygma/Corbis*

Figure 2 | The poet-saint Andal in a contemporary painting on metal in the Andal Temple, Srivilliputtur, Tamil Nadu.
Photograph by and courtesy of Archana Venkatesan

of Krishna became well known through their later telling in the *Bhagavata Purana*, but seem to appear here for the first time. Some other features of Krishna depicted in the Tamil literature do not seem to spread outside the South—notably Krishna's dance with pots, and his association with Nappinnai, a cowherd girl whose affections he gains by engaging in a bullfight.[1]

Following the late Sangam period, and to some degree overlapping with it, we have Tamil poetry that is explicitly religious, including the extensive corpus of the poems of the *alvar*s, composed probably in the sixth to ninth centuries and dedicated to Vishnu. These authors of devotional poetry are twelve in number, and are regarded as saints by the Vaishnavas of South India. Among the poets are Nammalvar, whose poems are said to constitute a "Tamil Veda"; Tirumangai Alvar, who wrote in praise of scores of sites throughout the Tamil landscape where Vishnu was said to dwell; and Andal, the only female poet-saint of the group, who in later times came to be worshipped in temples as the consort of Vishnu (fig. 2).

The poems of the *alvar*s describe the devotee's experience of the quest for and encounter with Lord Vishnu—often coming into his presence at one of the places sacred to him in the Tamil country, amid fertile fields, on forested hillsides, or in prosperous towns. Those sites mentioned in the *alvar*s' poems came to be known in the later tradition as the 108 divine places, or *divyadesha*s. The places most often mentioned in the *alvar*s' poems as the abodes of Vishnu are Srirangam; Tirupati, where the god Venkatesvara dwells; and Kanchipuram, which is filled with numerous sites sacred to Vishnu.[2] The poems celebrate the god's power and his unfathomable nature, his dark-hued beauty, and his attachment to the goddess Lakshmi. We also see a rich mixture of images of Vishnu, drawn from both pan-Indian and local Tamil traditions; there is the frequent mention of Vishnu's incarnations as Vamana, Narasimha, and Rama—but the mythology of Krishna as the cowherd is particularly prominent, and especially Krishna the lover.

> When Govinda plays the flute, his left chin resting on his left shoulder and
> his hands folding around it,
> his eyebrows arching and turning upwards and his belly puffed up like a pot
> [from a deep breath]
> —the girls stand there with eyes darting, their braided hair, adorned with
> flowers, loosens,
> and while holding their slipping garments with one hand, they become
> languid.
> —*Tiruvaymoli* 3.6.2, by Nammalvar[3]

The music of Krishna's flute is irresistible to the girls of the village, who lose themselves in longing for the handsome cowherd. This longing is shared by the poet-devotee, who often takes on the voice of one of the characters in the dramatic scene depicted by the poem—for example, the girl in love with Krishna, or the girl's friend, or even Krishna's mother—drawing not only on mythological motifs, but on the conventions of earlier Sangam love poetry.

> Three loves never part from him—
> Lakshmi, goddess of all good things,
> the Earth [Bhu Devi],
> and the simple cowherd girl
> Ruling three worlds,
> devouring them altogether,
> my lord rests on a banyan leaf:
> darker than the sea,
> Kannan, child perching on my hip.
> —*Tiruvaymoli* 1.9.4, by Nammalvar[4]

In this poem about Krishna (called Kannan in Tamil), Nammalvar speaks in the voice of Yashoda, the cowherd woman who is Krishna's mother. Krishna is here depicted as a baby, riding on her hip, but he is shown also in at least three other aspects. He is not only a child but a grown man, inseparable in love from three women. One of these women belongs to the setting of the cowherd village—this is Nappinnai, whom we have already met in the late Sangam literature. The other two are part of a quite different context, in which Krishna is identified as the Supreme Vishnu, with his two consorts Lakshmi and Bhu Devi, the goddesses of good fortune and of the earth. This more transcendent setting also may be seen as overlapping with the context of the temple, where Vishnu is worshipped in image form with the two goddesses standing on either side of him. Whether or not this type of iconography and ritual practice had been established by Nammalvar's time, his poem points toward a further dimension, in which the god as child reappears but now in cosmic space and time. The *alvar*s frequently evoke the image of the baby lying on the banyan leaf, floating on a vast ocean—Vatapatrashayana—this child who has swallowed all of the seven worlds in order to protect them from the great flood that has overtaken the cosmos, keeping them within his body until it is time for the universe to come into being once again. This image of the god allows for the playful reversals of the *alvar*s' poetry—Vishnu is both the baby whom his mother has to tenderly care for and the cosmic "child" who holds the entire universe within his body—but also points toward that form of god as Anantashayana, the Lord reclining on the coils of the serpent in the milk ocean who is the originator of the universe.

The reclining form of Vishnu is very often invoked in the poems of the *alvar*s, and more often than not is identified with the god's location in Srirangam—although, as

we have seen and shall further see, the image itself is ubiquitous in the Tamil country. Andal, in her poems, depicts herself as the devotee of this particular Lord, and has, indeed, chosen him as her bridegroom.

> My lord of cool Arankam
> where live men of virtue,
> he whose couch is the serpent—
> long ago in the deceptive form of dwarf
> he received in his hands
> the gift-giving waters,
> took possession of all the worlds.
> If now he takes the little wealth of my hands,
> he takes that which naught enriches him
> —*Nacciyar Tirumoli* 11.5, by Andal[5]

Here Andal complains that Ranganatha has stolen her bangles, figuratively speaking, evoking the image frequently found in Tamil poetry of the lovesick woman who is wasting away to the extent that her bangles slip from her arms, in the absence of her beloved. She feels this is unjust, because the Lord she has fallen in love with is none other than Vamana, Vishnu incarnating as a dwarf who grew into a giant, striding in three steps across the three worlds to claim them all as his own. Here we have a wonderful example of how the *alvar*s' poems weave together multiple mythic themes, the devotee's emotions and responses to god, and the idea of god's real presence in a specific place.

Vishnu in Stone and Bronze, Vishnu Enshrined

The earliest physical evidence that we have for Vishnu's presence in the Tamil country in image form dates from the seventh century—and thus is contemporaneous with the early *alvar*s. Most of the early images are carved onto the walls of rock-cut caves or appear as relief sculptures on rock faces, and are found especially in the northern part of Tamil Nadu, in the area where the kings of the Pallava dynasty were dominant. Especially rich in early Vaishnava imagery is Mamallapuram, whose treasures include several impressive sculptures of Anantashayana and of Vishnu's Varaha incarnation, as well as the depiction of Krishna holding up Mount Govardhana to shelter the cowherd villagers from the terrible storm sent by a wrathful god Indra (fig. 3).

> The benevolent lord Tirumal upturned a mount like an umbrella,
> spread the five fingers of his lotus-hand under it like the spokes
> and held up his beautiful long arm like its stem.
> The streams of cool water flowing down over the rim formed a tassel;
> the spray formed a jacket of pearls over him.
> That mount is Govardhana, the lord's victory-umbrella.
> —*Tirumoli* 3.5.6, by Periyalvar[6]

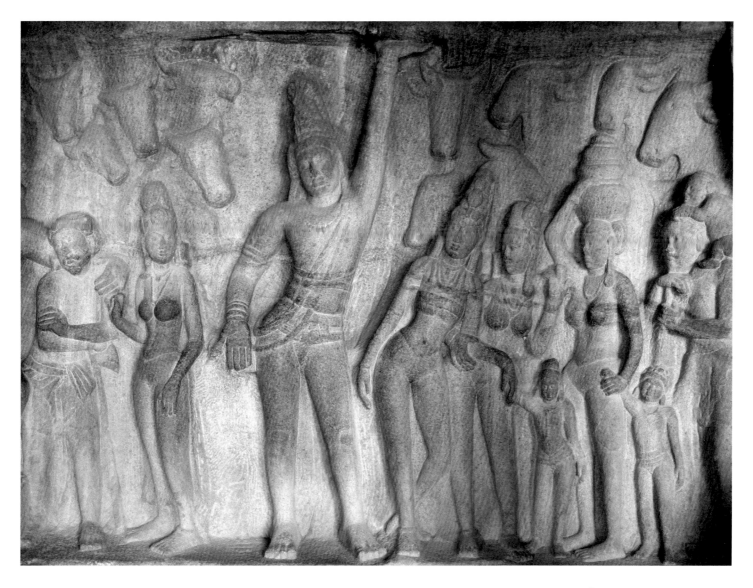

More shrines with images of Vishnu were established in the eighth and ninth centuries. Many of these are in Pallava territory, but several are found farther afield—for example, the eighth-century rock-cut temple for Narasimha at Anaimalai, near Madurai in the far south, and a pair of shrines, one for Narasimha and one for Ranganatha, carved out of the opposite sides of a rocky hill at Namakkal in the western part of the Tamil country. From the eighth century onward, we also find freestanding stone images of Vishnu which would have served as fixed images, or *mulamurti*s, in the inner sanctum of structural temples.

Figure 3 | Krishna holding up Mount Govardhana, stone relief sculpture at Mamallapuram, Tamil Nadu, 7th century.
Photograph by and courtesy of Charlotte Schmid

> Who can fathom the illusions
> conjured by Mal on this earth,
> the woman with long arms
> locked tightly in his embrace?
> He measured the world with his strides,
> he became a boar
> and scooped up the earth from the depths of the sea.

He reclines, sits, and stands
on the very earth he swallowed
and spewed up once more.
　　　　　　—*Tiruvaymoli* 2.8.7, by Nammalvar[7]

The central image of a temple dedicated to Vishnu is usually a multi-armed, regal figure, carved in stone and in the posture either of reclining—like Ranganatha—sitting (cat. 5), or standing (cat. 4). The sculptures that have survived from the period of the eighth to tenth centuries are remarkable for their size. The standing Vishnu now in Seattle, just over five feet tall, is nearly life-sized, and there are other examples whose proportions are even more massive, like a granite seated Vishnu now in the Metropolitan Museum of Art, New York, which is close to ten feet high. Another striking aspect of these *mulamurti*s is their resemblance to Buddha images produced in the Tamil country in the same period and somewhat earlier. Similar in their impressive size, the stone Buddhas, seated or standing, have the same rigid posture, broad shoulders, and square impassive face as the Vishnu figures, and often present the same "fear-not" gesture with their right hand.

The bronze images of medieval Tamil Nadu are better known than the stone sculptures; even though they may be three feet or more in height and made of solid metal, they were in fact designed to be portable—as images to be carried in processions—and have found their way into museum collections around the world. These sculptures began to be fashioned in large numbers in the eleventh century, during the period that the Chola kings ruled much of the Tamil country, and while Shaiva images are more commonly encountered, there are many fine examples of Vaishnava bronzes. These include images of Vishnu in a seated or standing posture (cat. 6), which are invariably accompanied by smaller bronze sculptures of his two consorts, Lakshmi and Bhu Devi. In the context of the temple, this trio of figures may be found going in procession, splendidly adorned and borne on palanquins or in great wooden chariots in the streets around the walls of the temple compound. But usually these sculptures are found placed within the central shrine of the temple, just in front of the great stone *mulamurti*, and it is the bronze image of Vishnu that is the focus of the ritual ministrations of the temple priests, who bathe and clothe it and make offerings to it.

Meanwhile, other types of bronze images might be used in various rituals—for example, images of the *chakra*, Vishnu's discus weapon, are used in bathing ceremonies—or worshipped in shrines of their own, as are images of the *alvar*s. Among Vishnu's incarnations, we find a number of bronze sculptures of Rama, together with his wife Sita and brother Lakshmana. Krishna, especially, is often represented in bronze. The child Krishna is a favorite theme, shown crawling or dancing, engaged in the various pranks and exploits associated with his young life among the cowherds. But another form of Krishna also comes to be represented in the metal temple images—Krishna

crowned as a king, flanked by his two consorts, Rukmini and Satyabhama, his left elbow raised to rest on the shoulder of his favorite, Satyabhama (fig. 4).[8] This image is known as King of the Cowherds, *Rajagopala*, and combines mythic references to Krishna's assumption of his royal birthright and marriage to his two queens with those which evoke his youth as a cowherd, most evident in the position of his right hand, which is meant to hold a cowherd's staff.

The Vaishnavas of South India developed an extensive theology and an elaborate typology related to the images of Vishnu. In the eleventh and twelfth centuries—just as bronze images were proliferating and more and more temples were being built in stone—Ramanuja and others counted among the great Vaishnava teachers (*acharyas*) were producing philosophical works and writing commentaries on the *alvars*' poems; they started to formulate the key features of what was to become known as the Shrivaishnava tradition. In the same period, as well, the Sanskrit treatises known as the Agamas were coming to be increasingly oriented toward the context of the temple. Within this emergent Shrivaishnava tradition, the image of Vishnu under worship in the temple sanctum was conceived of being the deity himself—the god was fully present in physical form just as he was when incarnated as Rama or Krishna, and the material of the image was understood as having been transformed into a type of divine substance at the time of consecration. That the transcendent Lord made himself manifest in this manner, as though he were actually dependent on the services offered him in the temple, was seen by the Shrivaishnavas as a mark of his grace, allowing his devotees to encounter him directly.[9]

Since the consecrated image of Vishnu in each of his abodes was regarded as a unique presence, Shrivaishnavas made every effort to visit these places. It seems likely that a number of the 108 *divyadeshas*—the places praised by the *alvars*—began to receive special attention in the eleventh and twelfth centuries. However, most of the early evidence, from the seventh to ninth centuries, for the excavation of rock-cut shrines or of temple building is not found at the *divyadeshas*. No doubt, there were structures of some sort established at many of the *divyadeshas* which subsequent building could have obliterated—for instance, at Srirangam and Tirupati, there are vestiges dating back to the ninth and tenth centuries that belong to structures long ago torn down to serve the extensive programs of rebuilding and expansion which these great temple complexes enjoyed. Nonetheless, it is noteworthy that—in the time of the *alvars*—there were many more places than those mentioned by these poets that were held to be sacred to Vishnu and that attracted the attention of devotees and patrons.

Following the seventh through ninth centuries, when numerous Vaishnava shrines were excavated in various places in the Tamil country, and the beautiful Vaikuntha Perumal was constructed at Kanchipuram, the next important phase of temple building begins in the tenth and eleventh centuries. Although temples dedicated to

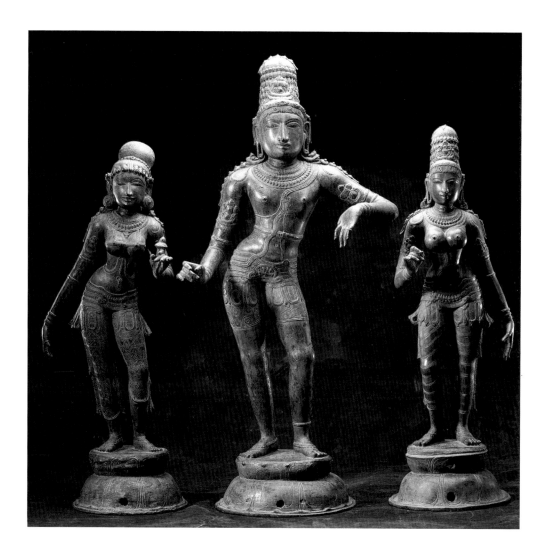

Figure 4 | Krishna as King of the Cowherds (*Rajagopala*), with consorts Rukmini and Satyabhama, Tamil Nadu, 13th century, bronze, H. 34, 27, and 28 in., respectively. Los Angeles County Museum of Art, gift of Mr and Mrs. Hal B. Wallis. *Digital image © 2009 Museum Associates/LACMA/Art Resource NY*

Figure 5 | Four-armed Krishna with flute, holding up Mount Govardhana; sculpture on a pillar of the *kalyanamandapa*, Varadaraja Perumal Temple, Kanchipuram, Tamil Nadu, c. 1600. *Photograph by and courtesy of Charlotte Schmid*

Vishnu certainly were erected in this period, some of the most interesting Vaishnava art is found in the context of temples where Shiva was the deity housed in the central shrine. Small narrative reliefs were sculpted on the walls of these temples, which depicted the story of Rama, scenes from the *Mahabharata*—and especially episodes from the childhood of Krishna, many of which seem connected to the particularly "Tamil" images of Krishna of late Sangam literature and of the *alvars*' poems, including Krishna as the pot-dancer, the butter thief, and the flute player.[10] The eleventh century saw the establishment of stone temples in the *divyadesha*s of the far south, such as Srivaikuntam, Tirukoshtiyur, and Alagarkoyil; the building of the core of the Varadaraja Perumal temple in Kanchipuram; and the expansion of the temple complex that was taking shape at Srirangam. In the twelfth and thirteenth centuries, many Vaishnava temples—like their Shaiva counterparts—saw the addition of separate goddess shrines within the temple compound. Just as the image of Vishnu at each of his temples was understood to have a unique identity, so too did that of his consort, a manifestation of Lakshmi, placed in a shrine on his own right side. The central shrine in which Vishnu dwells is very often flanked on the left side by a shrine for the poet-saint Andal, imaged as the consort who seems to take the place of Bhu Devi.

The second half of the thirteenth century and the first half of the fourteenth was a time of shifting and uncertain political circumstances in Tamil Nadu, with the collapse of the Chola dynasty and the entrance onto the scene of a number of new players, including local chiefs as well as warlords from outside the Tamil country. The changing political situation gave rise to new modes of temple patronage, with what appears to be a kind of competition among the would-be rulers to offer support to the important temples in the territory they were laying claim to. Among the beneficiaries of this support, which contributed both to new construction and to the institution of more and more elaborate rituals and festivals, were Vishnu's temples at Tirupati and Srirangam, and the Varadaraja Perumal temple in Kanchipuram. But the making of the "classic" South Indian temple—with its tall, colorful gateway towers (*gopuras*), series of concentric courtyards, pillared corridors, and festival pavilions—took place in the sixteenth and seventeenth centuries, a time, again, of political instability but great cultural vitality.[11]

These temple complexes, built both at *divyadeshas* that had long been held to be sacred and at completely new sites, produced a synthesis, in stone, which paralleled the crystallization of the Shrivaishnava tradition itself in this period. The image of Krishna that we see in figure 5 serves as a sort of emblem of this amalgamation in terms of iconography: Krishna's "Tamil" persona as the seductive flute player is combined with his representation as the holder of Mount Govardhana with its distant roots in Sanskrit literature, and with the evocation of his transcendent four-armed form as it appears in Vishnu's heavenly abode—as well as in the temple's central shrine. The temple's integration of myth and ritual, devotion and excited activity, is also suggested by the placement of this image on a pillar in a festival pavilion (*mandapa*) used for the celebration of the marriage of the god and goddess. As the context for encounter with the many manifestations of Vishnu, the great temple complexes of the South display the richness, complexity, and depth of Vishnu's presence in the Tamil country.

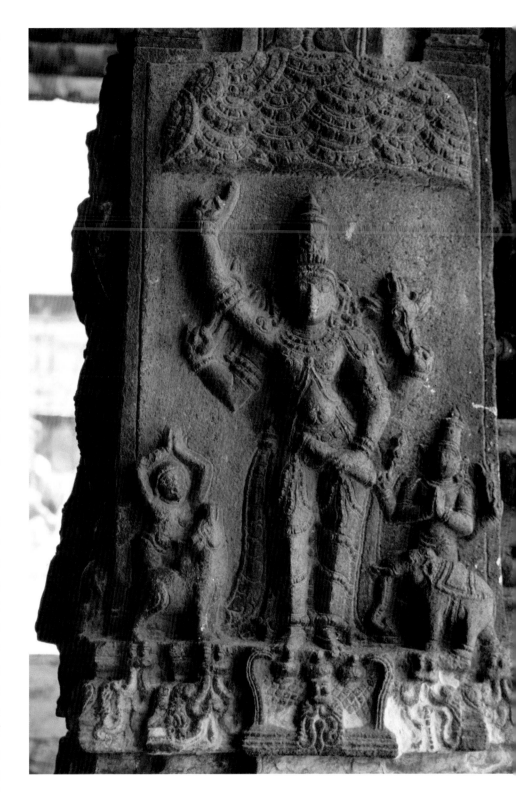

Notes

1 Friedhelm Hardy provides details about the imaging of Krishna in the Sangam literature, and the Tamil precedents for motifs found in the *Bhagavata Purana*, in his *Viraha-Bhakti: The Early History of Krsna Devotion in South India* (New Delhi: Oxford University Press, 1983). More recently, Charlotte Schmid has demonstrated that the iconography of Krishna as flute player and butter thief is first found in the Tamil country (see her "Aventures divines de Krsna: La lila et les traditions narratives des temples cola" in *Arts asiatiques* 57 (2002), 33–50; and "Aux confins du paysage krishnaite," forthcoming in *Arts asiatiques*).

2 See Katherine K. Young, "Beloved Places (*ukantarulinanilankal*): The Correlation of Topography and Theology in the Srivaisnava Tradition of South India," Ph.D. diss., McGill University, Montreal, 1978.

3 Translation by Hardy, *Viraha-Bhakti*, 409–10. Hardy has an extended discussion of the *alvars*' expression of the devotional attitude of love-in-separation, the woman longing for her beloved without being able to unite with him.

4 Translation by A.K. Ramanujan, in *Hymns for the Drowning: Poems for Visnu by Nammalvar* (Princeton, NJ: Princeton University Press, 1981), 51. See R. Champakalakshmi's *Vaisnava Iconography in the Tamil Country* (New Delhi: Orient Longman, 1981) for the myths and images associated with various forms of Vishnu, including that of the child lying on the banyan leaf.

5 Translation by Vidya Dehejia, in *Antal and Her Path of Love: Poems of a Woman Saint from South India* (Albany: State University of New York Press, 1990), 116.

6 Translation by Srirama Bharati, in *The Sacred Book of Four Thousand: Nalayira Divya Prabandham Rendered in English with Tamil Original* (Chennai: Sri Sadagopan Tirunarayanaswami Divya Prabandha Pathasala, 2000), 52.

7 Translation by Norman Cutler, in *Songs of Experience: The Poetics of Tamil Devotion* (Bloomington: Indiana University Press, 1987), 144–45.

8 Schmid (in "Aux confins du paysage krishnaite") discusses the earliest appearances and antecedents in early South Indian stone sculpture of the image of *Rajagopala*. For the importance of this figure as an object of worship in sixteenth- and seventeenth-century Tamil Nadu, see D. Shulman and V. Narayana Rao, "Marriage-Broker for a God: The Tanjavur Nayakas and the Mannarkuti Temple," in *The Sacred Centre as the Focus of Political Interest*, ed. Hans Bakker (Groningen, the Netherlands: E. Forsten, 1992), 179–204.

9 On the South Indian theology and typology of Vishnu's image, see Young, "Beloved Places"; Vasudha Narayanan, "Arcavatara: On Earth as He is in Heaven," in *Gods of Flesh, Gods of Stone: The Embodiment of Divinity in India*, ed. Joanne Punzo Waghorne and Norman Cutler (Chambersburg, PA: Anima, 1985), 53–66; and Gérard Colas, *Visnu, ses images et ses feux: Les métamorphoses du dieu chez les vaikhanasa* (Paris: Presses de l'Ecole française d'Extrême-Orient, 1996).

10 See Schmid's "Aventures divines de Krsna."

11 Crispin Branfoot, *Gods on the Move: Architecture and Ritual in the South Indian Temple* (London: British Society for South Asian Studies and British Academy, 2007).

Networks of Devotion
The Art and Practice of Vaishnavism in Western India

Cynthia Packert

Shrinathaji, a special black stone form of the god Krishna now enshrined in a temple in the pilgrimage town of Nathadwara, in southern Rajasthan, is instantly recognizable to his devotees by his solid, upright stance with left arm raised high and right fist resting against his hip. In the painted cloth example (known as a *picchawai*) now in the Denver Art Museum (cat. 158), Shrinathaji is represented outdoors, dressed in a full dancing skirt, in a garden setting lush with banana plants. Above his elaborately crowned head, a silvery autumnal full moon illuminates a star-studded sky and a collection of attendant deities who shower flowers upon his head. Flanking Shrinathaji, colorfully attired female attendants energetically dance, raising their hands in celebration. Below his feet is a pastoral landscape setting with peacocks, cows, clusters of people, and representations of shrines and a temple. Framing this composition on three sides are numerous miniature representations of Shrinathaji being venerated in a variety of different ritual contexts (e.g., fig. 1), and at the center top is an image of the baby Krishna sucking on his toe.[1] In addition to being visually arresting, this single painting tells us volumes about a rich world of religious practice that focuses on elaborate visualizations and artistic representations to fuel a far-flung network of devotion to this special manifestation of the god Krishna.

Most museum visitors are attuned to appreciating works of art as unique, individually presented objects worthy of sustained contemplation. Looking and appreciating are activities generally cultivated in quiet, controlled, distraction-free settings. Nothing, however, could be further from this viewing experience than the original context that nurtured the production and reception of this image and many others like it in this exhibition. To begin with, this is no ordinary Krishna image, nor is it an ordinary work of art. This is a painted likeness of a specific type of Krishna representation—a *svarupa*, or "self-manifestation"—believed to have not been sculpted or fashioned by human hands, but divinely revealed, under exceptional circumstances.

Historical Context

The *svarupa* of Shrinathaji is but one—albeit the most renowned—of an interconnected group of potent sculptural representations of the god Krishna that similarly manifested themselves in the late fifteenth and early sixteenth centuries in the area around

Mathura and Vrindaban (in modern Uttar Pradesh), where Krishna is said to have been born and grew up. Known as Braj or Vraja, this region of northern India witnessed great religious and cultural transformations in the fifteenth and sixteenth centuries: the fledgling Mughal dynasty was growing in importance and power in nearby Delhi, Agra, and Fatehpur-Sikri, threatening the long-established dominion of the hereditary Rajput kingdoms that had ruled over this region for centuries. The Mughals were Central Asian Muslims who imported new beliefs, customs, culture, and arts to northern India. As the Braj region was brought under their power, the Rajput rulers had to adapt by forging individual alliances and agreements with their new Mughal overlords.

Such new relationships and cultural stimuli among the Hindu populace spurred a creative flowering in the arts and in religion, centered in particular on Krishna. Against the backdrop of burgeoning Mughal sovereignty, in Braj there was a concurrent—and vitally significant—revival of long-dormant Krishna worship. Whether coincidentally, or reactively, a veritable explosion of Krishna devotionalism (*bhakti*) grew in importance and visibility from the sixteenth century, catalyzed by the teaching and leadership of several charismatic religious leaders and holy men, many of whom were miraculously granted special visions and personal sculptural manifestations of their god. Shrinathaji was one such divine embodiment, and there were numerous others, each equipped with its own story and, once installed as objects of veneration, its own specially crafted patterns of worship.

Consequently, different sectarian approaches to the veneration of Krishna arose in the Braj region, and, while the various sects share much in common in terms of liturgy and ritual care, there are notable distinctions. For devotees of all sects, however, retelling and remembering the hagiographies of the religious leaders who founded the different lineages, termed *sampradaya*s, is a central priority. Without an understanding of the origins of the various movements, as well as the departures and connections between them, the myriad forms and images of Krishna worship can be bewildering. All of the major sects have self-manifest images upon which they lavish their devotional attention, and the temples and shrines that house these images have been in active worship for close to five hundred years—and still are.

Prominent among the founders of the different sectarian movements is the Bengali saint Chaitanya (1486–1533), who set in motion the establishment of the Gaudiya Vaishnava sect, which was primarily centered in the pilgrimage town of Vrindaban and

Figure 2 | Radharamana Krishna in winter attire with special crown worn on *ekadashi*, the eleventh day of the lunar fortnight, accompanied by a symbolic form of Radha, Radharamana Temple, Vrindaban, Uttar Pradesh, January 2000.
Photograph by Cynthia Packert

later in Bengal (Gauda is an ancient name for Bengal). Several of Chaitanya's disciples were blessed, while in Braj, with their own self-revealed sculptural manifestations, including the important forms of Radharamana Krishna (fig. 2) and Govindadeva Krishna (fig. 3). Vallabha (also known as Vallabhacharya; 1479–1530), who discovered the image of Shrinathaji Krishna and initiated the Vallabha sect, is also enormously important in this sectarian matrix. So too is Hit Harivansha, a sixteenth-century poet-saint (c. 1502–1552) from the Braj region, who came to Vrindaban at about the same time as Chaitanya and his followers; he was the discoverer of the self-manifest image of Radhavallabha, considered to be a dual incarnation of Radha and Krishna in one body (fig. 4). His contemporary Swami Haridasa is credited with finding the self-revealed image of Banke Bihari, also a conjoint form of Radha and Krishna.

All of these teachers focused their attentions on devotional worship of different manifestations of Krishna; the major distinctions between them settle on the forms Krishna takes for his devotees. To Shrinathaji's adherents, he is mostly understood as "Bal-Krishna," the child Krishna. Followers of Chaitanya's approach focus more on the loving, erotically charged, and emotionally fraught relationship between Krishna and his beloved milkmaid Radha. Hit Harivansha proclaimed instead that Radha reigned supreme over Krishna, and that their relationship was not filled with tension, but with deep, mystical, loving fulfillment. This approach was also adopted by Swami Haridasa. Thus, in the most simplistic of terms, the major sectarian differences hinge upon a devotee's understanding of, and devotional relationship to, Krishna: as mother to a beloved child, as cowherding friend (*gopa*), as milkmaid or female friend (*gopi*, *sakhi*), or as Radha, whose lover may be fickle or constant.

Figure 3 | Govindadeva Krishna
and Radha in decorative stage set
(*bangala*), Govindadeva Temple,
Jaipur, Rajasthan, August 2006.
Photograph by Cynthia Packert

Figure 4 | Radhavallabha Krishna
accompanied by a symbolic
form of Radha in a floral swing,
Radhavallabha Temple, Vrindaban,
Uttar Pradesh, August 2006.
Photograph by Cynthia Packert

Sectarian allegiance depends upon many factors. For, while Krishna continues to make his presence known on earth through a multitude of varied forms, they all are ultimately expressive of his one true reality. Therefore, how one chooses which version of Krishna to worship varies according to such factors as personal choice, family history, or regional tradition. A plethora of sectarian perspectives was developed through the sixteenth century and later that outlined—in a rich collection of literature, poetry, philosophy, and aesthetic theory—a variety of different ways to love Krishna. Because sculptural representations were a primary focus of devotion, pilgrimage, and artistic attention, the performing and visual arts provide valuable information about their relative importance, specific histories, and varying modes of veneration. The worship of such divine self-manifestations is effected through elaborate aesthetic practices that included the arts in every form: poetry, music, dance, painting, stage setting, clothing, and a wide spectrum of ornamentation. All the senses—sound, sight, touch, smell—are engaged in an effort to provide pleasure for Krishna and create an emotionally charged context for ritual appreciation.

Shrinathaji's Story

Shrinathaji is the presiding deity of the large, visible, and very active denomination known as the Vallabha, or, more commonly, the Pushtimarg (Path of Grace) sect.[2] The pilgrimage town of Nathadwara is home base for his temple (*haveli*), which is maintained by a hereditary priesthood dedicated to the god's constant care. As a *svarupa*, Shrinathaji is considered to be fully present at all times; thus his needs must be attended around the clock. Shrinathaji is not just a sculpture—he is god incarnate in this form, and in his devotees' eyes he is envisaged as the young seven-year-old child Krishna reared as the naughty and endearing son of a cowherding family in the village of Gokul (cats. 95, 96; see also, from South India, cats. 91–93). His temple is his home: termed a *haveli*—a traditional courtyard-style residence common to this part of northern India—and not a *mandir*, a sacred temple structure. Although his *haveli* is now in Nathadwara (in modern Rajasthan), Shrinathaji's story started further north in Braj, and devotees are mindful of that connection back to Krishna's childhood home. Recounting the tale of Shrinathaji's divine revelation comprises an integral part of how devotees respond to their beloved god, and an important component of the imagery of the sect.

Shrinathaji was not always present among humanity. Instead, he made his appearance known in stages, waiting for a particular auspicious moment to reveal his true identity. Devotees learn that in 1410, a Braj cowherd noticed that one of his cows was not giving enough milk. He thus followed her to a spot at the top of Mount Govardhana, the hill in Braj that Krishna lifted to protect the villagers from the violent rainstorm sent down by the god Indra in a jealous rage (see cat. 105). He was amazed to see her pouring her milk on an upraised, bent, black stone that had newly materialized from the depths of the hill. This form was mistaken for a *naga*, a protective type of snake deity, and initially venerated with milk offerings.

Shrinathaji was worshiped in this *naga*-form for close to seventy years, whereupon he chose to reveal more of himself. That moment coincided with the divinely ordained birth of a special boy, Vallabha, to a South Indian Brahmin couple that was traveling through central India. His birth—at midnight on a particular day in the month of Vaishaka (April–May), 1479—mirrored the exact moment when Shrinathaji's image suddenly emerged from Mount Govardhana, revealing his face and some of his arm. Shrinathaji, however, was still not fully recognized as a manifestation of Krishna; that task was left up to Vallabha, and it would take many more years. Vallabha's hagiography identifies him as an avatar of Krishna. When the boy was fourteen years old, Krishna himself appeared to him. He directed Vallabha to travel to Mount Govardhana and correctly identify the partially revealed image as a self-manifestation. Vallabha thus made his way to Braj to carry out his mission. In 1494, at Krishna's natal village of Gokul, the god once again made an appearance, granting to Vallabha a special initiation mantra (*brahmasambandha mantra*), which Vallabha used to initiate the first member of the lineage that now bears his name.

A Family Relationship

In addition, Vallabha ensured that a shelter was built on Mount Govardhana to protect the figure of Shrinathaji and establish his proper worship. The original shrine was later renovated and enlarged into a temple by 1520; this structure is represented in the Denver painting and in another picchawai depicting the Annakut festival, now in the Smithsonian's Sackler Gallery (cat. 157; fig. 5). Shrinathaji was worshiped at that temple until 1670, when political friction between Hindus and the Muslim Mughals resulted in the destruction of some Hindu temples in the Braj region. Fearing for his safety, Shrinathaji's priestly caretakers smuggled him away from Mount Govardhana, and after two years of peripatetic journeying, with many stops along the way, Shrinathaji was ultimately resettled in the town of Nathadwara in southern Rajasthan.

Vallabha established a lineage whose descendants continue to be the caretakers of Shrinathaji, in addition to a coterie of six other *svarupa*s who appeared to Vallabha under various miraculous circumstances. He passed them on to his son Vittalnath (1516–1586), who in turn willed them to his seven sons; eventually two other images were added to the group (cat. 157 represents Vittalnath's descendants, as well as images of the seven main Krishna *svarupa*s, including Shrinathaji).[3] Of these Nine Treasures (*navanidhi*), as the full collection is known, Shrinathaji is the most important, but he shares quarters in Nathadwara with two of these *svarupa*-brethren. The others are enshrined in various other places in Braj, Rajasthan, and Gujarat; all of these continue to function as active locales of pilgrimage and worship. Vallabha is also credited with distributing

Figure 5 | Representation of the temple for Shrinathaji on Mount Govardhana, detail of *Picchawai Depicting the Annakut Festival* (Arthur M. Sackler Gallery, Smithsonian Institution), cat. 157.

numerous other less important images, thus creating a web of interconnected and related sculptures that participate in a familial and ritual relationship with one another.

Serving Krishna

For Shrinathaji's followers, the story of his discovery is a central component of an entire spectrum of devotional actions. The god resides eternally in a special sanctum in his *haveli*, and, for devotees who are fortunate enough to be in Nathadwara, the most important activity is viewing (having *darshan* of) Shrinathaji. He is periodically displayed to the public, clad in an extraordinary range of beautiful clothing and ornamentation and surrounded by artful stage presentations. Access to him is very carefully controlled; when he is not on view to the public he is kept behind closed doors. The care and decoration of Shrinathaji is performed by hereditary priests known as *goswami*, or *gosain* (see cat. 154, a priest's portrait), who are entrusted with the handling of the divine manifestation. For, although Shrinathaji is a self-revealed figure, once he came into being, he could not exist without proper attention and nurturing. Thus Shrinathaji is, as are the other special emanations under the care of the Pushtimarg sect, the beloved ward of a lineage of special caretakers who perform loving service (*seva*) to him through every day, through every season, and through all the festivals and activities of his ritual year. Throughout the day and evening, the priests share their ministrations to the god through regularly scheduled public viewings, *darshan*, in which devotees can behold the god in all of his finery; a selection of such displays are represented in miniature on the Denver painting (fig. 1; cat. 158) and also in catalogue 157.

Because Shrinathaji is imagined as a small child, the daily schedule that he follows generally reflects this. Although he never physically moves from his *haveli* dwelling, the ritual stage is set anew for each *darshan* by the temple priests, triggering imaginative visions of his daily activities for the benefit of the god and his adoring worshipers. Shrinathaji is slowly and gently awakened by his caretakers very early in the morning, and coddled with great affection. He is then dressed up and sent out to play with his friends. The gopis bring him snacks, and he joyfully plays his flute for Radha. He moves on to the pastures to graze the cows, returning for an elaborate lunch. Following this, he takes a midafternoon nap. After resting, he is awakened, and somewhat later, he is given a light meal. At dusk, he finally returns home from the fields, and is welcomed and fussed over with maternal emotions. Finally, he is put to bed with everything he needs. During the night, he may wander with the gopis or rendezvous with Radha in Braj. This schedule is repeated anew every day, and for each watch, the priests dress Shrinathaji in the appropriate clothing, headgear, and jewelry—minutely adjusted, added, or removed according to the occasion. In addition, the child-god is provided with all manner of constantly changing thematic accessories: seasonal foods and fruits, fresh flower garlands, miniature representations of cows, peacocks and other birds, toys, fans, mirrors to admire himself with, musical instruments, and so on.

An Aesthetic of Love

Just as every day has its set schedule, so too are there other temporal occasions that need to be celebrated and made manifest through the temple arts: different phases of the moon, lunar and solar eclipses, the god's birthday, and seasonal pastimes. The heat of the summer is offset by dressing the god in the lightest of clothing, decorating him with fragrant flowers (see cat. 159), and surrounding him with temporary arbors of fruits and leaves to simulate the forests of Braj. He is bathed with cooling, perfumed water and fanned with sprays of peacock feathers. In the winter, he is provided with thick, warm quilts, and a brazier of hot coals is placed in front of his sanctum. Throughout the ritual year, the displays also find Shrinathaji dressed as a bridegroom, celebrating the onset of spring; playing Holi, the festival of colors (see fig. 1); observing the birthdays of the founding members of the lineage; and much more—there is never a hiatus in the ritual calendar. On and on it goes: the visual and sensory spectacle is rich, variable, and constantly changing. There is always something new and inventive to delight god and devotee alike.

In response to these *darshan*-displays, Shrinathaji's worshipers express their devotional fervor with emotional intensity: they weep, exclaim, pray, beseech, sing, and do everything they can to prolong the viewing experience. This is not easy, because the crowds who gather at Shrinathaji's temple are legendary, and the *darshan* times are fleeting and quick.[4] The sensory combination of art, theater, and religion is concentrated and powerful; it must be experienced in the moment for its full impact.

Music, poetry, and song are also vitally important art forms that accompany these *darshans*, but the Pushtimarg denomination is especially renowned for the emphasis it places on the visual arts. More than any of the other sectarian traditions, this lineage (*sampradaya*) has sponsored the production of lavish and detailed paintings that record the details of the *darshans* and that often feature patrons and priests with the god, serving as records or snapshots of acts of sponsorship and piety. Photography is not allowed in Shrinathaji's temple, and even now only the painted images remain as witness to the ongoing visual spectacle that centers on his care and worship. Similar rituals and decorations are also provided for Shrinathaji's sectarian relatives; thus there are myriad paintings that also feature the other *svarupas* worshiped by Pushtimarg devotees.

The arts—temple hangings, lavish temple displays, elegant offerings, music, poetry, and innumerable small-scale paintings—are the conduits for proclaiming all the love and care that is lavished upon this god. These serve as visual devices that not only narrate Shrinathaji's sacred biography but also form the focus of collective and personal devotion. As an aid to worship, the *Picchawai Depicting the Festival of Sharada Purnima* in Denver may have been displayed in a temple or personal shrine to Krishna, providing a visual context or backdrop for imagining the god's history and pastimes throughout

the ritual year. Toward this end, the Pushtimarg tradition makes ample information available for devotees to assemble their own personal altars, with proper accessories and appropriate details. Printed guides, such as the ritual manual *The Light of Vallabha's Grace* (*Vallabhapushtiprakash*) also aid worshipers in organizing their own *darshan*-displays, with descriptive explanations and diagrams for all the daily ministrations, as well as for the myriad celebrations that occur during the ritual year.[5]

Chaitanya and the Bengali Tradition

The Pushtimarg tradition is centered around the prominent *svarupa* of Shrinathaji, and its visual displays and traditions are codified, relatively predictable, and made available through a longstanding and organized painting tradition. Followers of the Chaitanyaite, or the so-called Bengali Gaudiya, Vaishnava denomination similarly observe most of the same daily cyclical patterns and annual ritual celebrations. But, in contrast to the Pushtimarg sect, there is no one single form of the deity who serves as a central focus—instead, there are a several individual, yet associated, sculptural self-manifestations of Krishna that attract devotional allegiance. Moreover, in the Gaudiya *sampradaya*, Krishna is imaginatively envisaged not as a young, seven-year-old boy, but instead as an alluring adolescent who is partnered with his lover Radha. Yet another distinction is that the visual embellishments for image worship in the Gaudiya tradition are less prescriptive and more flexible than with the Pushtimarg's; there is, for example, no equivalent painting tradition recording the *seva*s and *darshan*-displays, nor are there published guides that outline the various accoutrements of ritual. Photography is permitted in many temples in Vrindaban, but the resulting visual records are not systematized. Nonetheless, the Gaudiya Vaishnava sect is as artistically attuned to creating sensitive and beautiful *darshan*s and visualizations as the Pushtimarg denomination, even if its practices are more spontaneous.

Yet another differentiation between sectarian orientations is that the primary geographical locus for the Gaudiya *sampradaya* is in the pilgrimage town of Vrindaban, and not Govardhana, Gokul, and Nathadwara. This is because Vrindaban's history is deeply sedimented with the connection to Chaitanya and the work of his disciples. Shri Chaitanya Mahaprabhu—his full devotional appellation—journeyed far and wide across India from his original homeland in Bengal in search of the original abode of Krishna and Radha's love play. After eventually finding his way to the Braj region in 1515, he recognized several sites important to their love affair that had, it is said, long been forgotten about and lost to memory. Chaitanya's hagiography relates that his arrival coincided with the autumnal full moon (*ras purnima*)—the night when Krishna dances in a great circle (*rasalila*) with all the gopis, magically replicating himself so that each dancer believes that she alone is dancing with him. Chaitanya also identified the *kadamba* tree from whose branches Krishna had teasingly suspended the clothes he had stolen from the gopis (cats. 115–18).[6] Indeed, his visionary attunement to Krishna and Radha was especially acute because he himself is considered the embodiment of both deities.

Chaitanya's reanimation of the landscape of Braj provided the momentum for a groundswell of Krishna worship that flourished in Braj and, especially, in Vrindaban. While he did not stay in the area to see the full flowering of his visions—he ultimately left Vrindaban for Orissa, to worship at the great temple of Jagannatha in Puri—the process of imaginative unveiling that Chaitanya had initiated in Braj did not come to a halt with his departure. Remaining behind was a group of handpicked disciples, known as the Six Goswamis, whom he had called to Vrindaban. These learned men further developed his visionary insights and extended his teachings in important ways by setting the Bengali mystic's theology and insights down in writing.[7]

Emotion and Devotion

One of the most important theorists of the Six Goswami group was Rupa Goswami, who in 1541 authored the important text *The Ocean of the Essence of Devotional Rasa* (*Bhaktirasamritasindhu*).[8] This treatise considered, in a systematic way, how human emotions could be channeled toward the deepest levels of love for the divine. The basis of Rupa's study was *rasa*-theory—the classical Indian system of aesthetics that had long informed drama, dance, and musical performances. In this text, and in the ritual practices and theology that developed from it, emphasis is placed on the exposition of the different types and hierarchies of aesthetic modes (what he terms *bhakti rasas*) through which the devotee may experience the joy and love of Lord Krishna and his beloved Radha.

For Rupa Goswami, one particular emotional aesthetic reigned supreme as the one best suited for experiencing the full potential of Krishna devotion: that of the "amorous mode" (*madhura bhakti rasa*), whereby the erotically charged relationship of the divine couple provides an emotional template for the structuring of the devotee's own particular relationship to Krishna. This extraordinarily sensual dynamic between Radha and Krishna is beautifully articulated in the *Gita Govinda* (*Song of Govinda*), the twelfth-century poem by Jayadeva that had provided centuries of highly charged visualizations for devotees.[9] Rupa, and other Gaudiya practitioners, adopted this model of relationship as a basis for channeling intimate emotion into devotion: as Radha and Krishna respond to each other, so too does the devotee savor Krishna as his or her own beloved. Moreover, all the trials and tribulations that plague the divine couple's relationship are also harnessed for their full affective potential. In particular, the pain of separation (*viraha*) from one's lover becomes a vehicle for expressing the pain of the devotee when parted from Krishna. Equally important is the thrill of the illicitness of Radha and Krishna's passionate union; this creates all the more fuel for the devotional fire (cat. 121). The elevated message of the Gaudiya theorists cautioned, however, that the couple's transgressive relationship was not to be viewed as indulging base sexual lust: rather, it is meant to be understood as pure desire, selflessly directed toward the pleasure of the beloved. The potency of surrender and emotional vulnerability that Krishna and Radha share with one another thus serves as the purest template for their worshipers.

Much of this devotional attention is directed toward the worship of Krishna in physical form. Just as Vallabha had been granted the *svarupa* of Shrinathaji, so too did many of these holy men receive their own black stone sculptural self-manifestations of Krishna, which were duly enshrined and worshiped as living forms of the god. The deity Govindadeva manifested himself to Rupa Goswami in 1534; Sanatana Goswami was blessed with the form of Madanmohana; Gopal Bhatt Goswami received the form of Radharamana in 1542; and there are several others.[10] As is Shrinathaji, they continue to be objects of devotion even today, worshiped in their own temples (fig. 6), with their every need administered to by hereditary priests who trace their lineages back to the founding holy men to whom these varying forms of Krishna manifested themselves. While the Pushtimarg and Gaudiya Vaishnava sects share a very similar approach to visualizing how Krishna lived and spent his youth in ancient Braj, a major distinction between the two is how they view the role of Radha. Shrinathaji, the upholder of Mount Govardhana, is a child-god, and not accompanied in his sanctum by Radha. All of the self-manifested sculptural images in the Gaudiya sect took on partners, even though they originally materialized as single forms of Krishna. In some cases, Radha's presence is denoted by a symbolic stand-in (as a decorated symbolic shape sharing the altar with Krishna in figs. 2, 4); in other instances, the self-manifest form of Krishna is joined by an additional sculptural figure of his beloved, replicating the manner in which the couple is frequently depicted in paintings (see fig. 3; see also the Jaipur paintings of the couple, cats. 129, 130).

Yet other sectarian approaches centering on the loving relationship between Krishna and Radha were established in the early sixteenth century in Vrindaban, and continue to be important additions to the lively mix of temples and religious practice in that town.[11] The poet-visionary Hit Harivansha was gifted with the self-manifested black stone image of Radhavallabha Krishna in 1535, and he established the self-named Radhavallabha *sampradaya* and temple. A Braj inhabitant, Hit Harivansha claimed that his approach to worship was superior to Chaitanya's, and that he was divinely guided by Radha herself. He propounded that Radha reigns supreme over Krishna; indeed, Krishna is incomplete without Radha, so much so that the sculptural manifestation of Radhavallabha is a representation of the two joined in one body (fig. 4). Instead of the couple living out their relationship in a state of perpetual longing and anguished separation, Hit Harivansha taught that they were always united. Krishna and Radha never leave each other's sides, and blissfully live together in the most sacred and celestial of love bowers, in the mystical heart of Braj. In this sectarian tradition, Krishna's flirtations with the gopis have no place, nor do his childish antics attract devotional fervor. Rather, the ideal role for the devotee is that of a *sakhi*, a handmaiden and girlfriend of Radha. *Sakhi*s were the only ones allowed access to the divine couple in their sacred love bower, and when Hit Harivansha left the world, it is believed that he "entered the bower" in the form of Krishna's flute. The flute, which is normally Krishna's characteristic tool of seduction, is thus seen in this denomination as a

Figure 6 | Radharamana Temple, Vrindaban, Uttar Pradesh.
Photograph by Cynthia Packert

symbol of their founder, eternally bonded to his beloved Radha and Krishna in the form of Radhavallabha.

This mystical elevation of Radha over Krishna, and the insistence on their exclusive, wholly conjoined relationship was also shared by Hit Harivansha's contemporary Swami Haridasa, who is credited with the discovery of the self-manifest image of Krishna as the "Crooked Lover," Banke Bihari, and whose temple is a major destination for today's pilgrims to Vrindaban. Both of these *sampradaya*s, their temples, and their *goswami* lineages remained local to Vrindaban, even through the turbulent events of the late seventeenth century.

The Cowherd and the Kings
Political turmoil under later Mughal rulers in the late seventeenth and early eighteenth centuries forced the scattering and relocation of many important images westward and southward from Krishna's Uttar Pradesh homeland into Rajasthan and Gujarat; these erstwhile Rajput territories were deemed safer havens than Mughal-dominated Braj.[12] Despite the traumas of dislocation, the mobility of images forged important new connections between regions. Two of the most prominent self-manifestations to flee the political troubles of this era were Vallabhacharya's Shrinathaji—removed from his original temple on Mount Govardhana and reinstalled in Nathadwara—and Rupa Goswami's Govindadeva, originally housed in a magnificent red sandstone temple in Vrindaban and eventually relocated in the city of Jaipur. Rupa Goswami's Govindadeva manifestation also traveled far afield outside the bounds of Braj, eventually finding his way to the Rajput kingdom of the Amber Kacchawahas, where he was enshrined by the ruler Sawai Jai Singh II (1688–1743) as the spiritual foundation of his brand-new capital city of Jaipur.

Shrinathaji's final destination of Nathadwara, after journeying hither and yon, resulted in the development there of a productive school of painting that is renowned for the picchawais and other images of the god that are represented in the exhibition. In addition to spurring a distinctive genre of artistic expression, Shrinathaji's presence in southern Rajasthan was also instrumental in cementing political alliances among other Rajput kingdoms, especially those that claimed ownership of their own self-manifestations that belonged to the Vallabhaite network of sacred images.

In the days when Rajasthan had kingdoms, politics and piety went hand in hand. Kings overtly displayed their connection to their chosen tutelary deity, to whom they believed they owed spiritual authority to rule. They demonstrated their piety through painted depictions and the construction of magnificently endowed temples. The ritual arts accordingly absorbed new aesthetic practices and vocabularies, and a rich visual creativity developed in different regional and cultural contexts. Yet, even as the *svarupa*s became individual centerpieces of sectarian attention in different

areas of western India, they remained, and still do, ritually and visually interconnected by their shared genesis in the fertile period of Krishna revivalism in Braj in the sixteenth century.

Notes

1 For several strikingly close examples, see Joanna Williams et al., *Kingdom of the Sun: Indian Court and Village Art from the Princely State of Mewar* (San Francisco: Asian Art Museum of San Francisco, 2007): 192–93, cat. no. 53; Kalyan Krishna and Kay Talwar, *In Adoration of Krishna: Pichhwais of Shrinathji, Tapi Collection* (Surat, Gujarat: Garden Silk Mills, 2007): 72–79, cat. nos. 16–19; Robert Skelton, *Rajasthani Temple Hangings of the Krishna Cult from the Collection of Karl Mann, New York* (New York: American Federation of Arts, 1973): 42–49, cat. nos. 6–9.

2 Richard Barz, *The Bhakti Sect of Vallabhacarya* (Faridabad: Thomson Press [India], 1976), provides a detailed history.

3 Shrinathaji, Shri Navnitpriyaji, and Shri Vittalnathaji are in Nathadwara, Rajasthan; Shri Mathureshji is in Jatipur, Braj, Uttar Pradesh; Shri Dwarkadishji is in Kankroli, Rajasthan; Shri Gokulnathaji is in the village of Gokul, Braj, Uttar Pradesh; Shri Gokulchandramaji and Shri Madanmohanji are in Kamvan [Kamban], Rajasthan; Shri Balkrishnaji is in Surat, Gujarat. See Skelton, *Rajasthani Temple Hangings*, 82–83. The Annakut festival example, cat. 157 herein, formerly was in the Karl Mann collection and is featured on the cover of Skelton's *Rajasthani Temple Hangings* and as "Annakut," cat. no. 14, p. 58; see also Krishna and Talwar, *In Adoration of Krishna*, 23.

4 For a lively account of all aspects of the *darshan*-experience, see Ann-Marie Gaston, *Krishna's Musicians: Music and Music Making in the Temples of Nathdvara Rajasthan* (New Delhi: Manohar, 1997): 77–88.

5 Paul Arney, "The *Bade Shikshapatra*: A Vallabhite Guide to the Worship of Krishna's Divine Images," in *Krishna: A Sourcebook,* ed. Edwin. F. Bryant (New York: Oxford University Press, 2007): 505–36.

6 David L. Haberman, *Journey through the Twelve Forests: An Encounter with Krishna* (New York: Oxford University Press, 1994), 64–66, discusses Chaitanya's Braj itinerary and rediscoveries.

7 David Haberman, *Acting as a Way of Salvation* (New York: Oxford University Press, 1988), 30–39.

8 The meaning and history of this text is explained by David L. Haberman, trans., *The Bhaktirasamrtasindhu of Rupa Goswamin* (New Delhi: Indira Gandhi National Centre for the Arts with Motilal Banarsidass, 2003); see p. xxx for a concise explanation of the work's scope.

9 *Love Song of the Dark Lord: Jayadeva's Gitagovinda,* ed. and trans. Barbara Stoler Miller (20th anniversary edition; New York: Columbia University Press, 1998).

10 Margaret H. Case, *Seeing Krishna: The Religious World of a Brahman Family in Vrindaban* (New York: Oxford University Press, 2000) provides a clear history of Chaitanya and his followers during this important time in Vrindaban. Haberman, *Journey through Twelve Forests,* 32–33, provides a beautiful rendition of the discovery by Rupa Goswami of Govindadeva.

11 In my *The Art of Loving Krishna: Ornamentation and Devotion* (Bloomington: Indiana University Press, 2010), I provide a detailed study of the aesthetics of image worship in the Radharamana, Radhavallabha, and Govindadeva temples; I also analyze the significance and meaning of ornamentation for the Gaudiya and Radhavallabha sects.

12 See ibid., chapter 3 for an overview of this history.

The Image of Vishnu

Introduction

Vishnu has many guises, but he also often appears simply as himself. This non-narrative form is known as his supreme, or *para*, form, and among Vishnu images, those depicting this form are most often installed on the altars of Vishnu temples as the focal points for worship. If we examine icons of other Hindu gods and goddesses, as well as those of Vishnu's avatars, we find that most appear in a swaying posture called *tribhunga* (three bend), with the weight shifted so that one hip juts out slightly. By contrast, the primary form of Vishnu is usually shown standing straight and unbending. This posture reflects the god's role as maintainer of balance. It is a testament to the Indian sculptor that so many Vishnu icons manage to look lively and graceful despite this potentially rigid stance.

Hindu icons can usually be identified by various aspects of physical appearance, what they hold and wear, and by whom they are accompanied. The study of these identifying features, called iconography, has been the subject of innumerable Hindu texts. Vishnu's most distinctive physical feature is his blue skin, which is not present in most ancient sculptural depictions.[1] He is most often shown with four arms, although any even number of arms is possible. The extra arms offer a relatively straightforward indication of supernatural power: the god can complete many tasks at once, can reach many directions at once, can touch many worshippers at once. In his four hands Vishnu usually carries a conch-shell trumpet, a wheel-shaped form called a *chakra*, a lotus flower, and a clublike mace. All of these attributes will be discussed in a subsequent section. Vishnu is always shown dressed as a prince, with a tall crown, extensive jewelry, flower garlands, and/or scarves, and a traditional *dhoti*, or wrapped skirt. Iconographic texts call for Vishnu images to wear a special jewel or mark (known as the *shrivatsa* and said to represent his consort, Lakshmi) at the center of his chest, but this feature is often neglected by sculptors. Because his physical attributes are relatively nondescript, damaged images of Vishnu (i.e., missing their weapons or attendant figures) can be very difficult to identify and are easily mistaken for other deities, particularly Buddhist Bodhisattvas.

The following section offers a small selection of images of Vishnu in which the god appears alone, providing the simplest possible introduction to the deity before we meet his avatars, consorts, and other subsidiary figures. Although the perceptible character of the god might change somewhat with variants in style and medium, there is a remarkable uniformity in the overall presentation and interpretation of Vishnu images, indicating a shared sense among Hindu sculptors of different eras and regions that this primary form of the god should be calm, regal, and somewhat distant in his transcendence. This primary form is rarely the most approachable manifestation of the god.

1 Vishnu

Northern central India; early Gupta period, late 4th century CE
Sandstone; 9 x 5 ¹¹⁄₁₆ x 1 ⁹⁄₁₆ in. (23.5 x 14.5 x 3.9 cm)
Museum of Fine Arts, Boston. Thomas Oakes Rogers Fund, 25.452

2 Vishnu (*facing page*)

Northern central India; Gupta period, late 4th–early 5th century
Sandstone; 27 x 16 ½ x 5 ¾ in. (68.5 x 41.9 x 14.6 cm)
Brooklyn Museum. Anonymous Donors, 81.203

Among the earliest pieces in the exhibition, these two images (1, 2) represent Vishnu in four-armed form. Around the first century CE, sculptors in northern India began to give recognizable form to Hindu deities previously known only from verbal descriptions. The great gods of the Vedic and epic traditions had not been represented in sculpture, presumably because the rituals of worship prescribed by orthodox Hinduism did not call for icons. However, the practice of carving and worshipping figural images existed long before this, in religious traditions that thrived throughout northern India. It is inferred that the idea of creating and worshipping icons of Hindu deities was informed by these "popular" practices.

The first icons of Vishnu date to around the first or second century CE. They are typically four-armed, like these, with all four hands held at about hip height, whereas later examples would have some hands raised to shoulder height. The earliest Vishnu images are in the distinctive pink sandstones that were quarried at various sites in northern central India, particularly around the city of Mathura. The rudimentary carving and oversized hands and feet of the Boston piece (1) have led previous generations of scholars to attribute it to this earliest phase of icon-making.[2] However, it more closely resembles images known to date to about 400 CE, including the Brooklyn torso (2).

Perhaps the best datable comparative example for both objects is the standing Vishnu that appears beside the entrance to Cave 6 at Udayagiri, a site with several large sculptures and caves cut into a cliff face in central India, near the ancient city of Vidisha (fig. 1–1).[3] Although the Udayagiri image is more intact than either of the images discussed here, the three share features of costume, such as the streamers billowing at either side of the crown (much longer but more shallowly carved on both the Boston and Brooklyn examples) and the thick garland that drapes over the upper arms like a stole and then hangs across the knees (the upper part just barely indicated as incisions on the

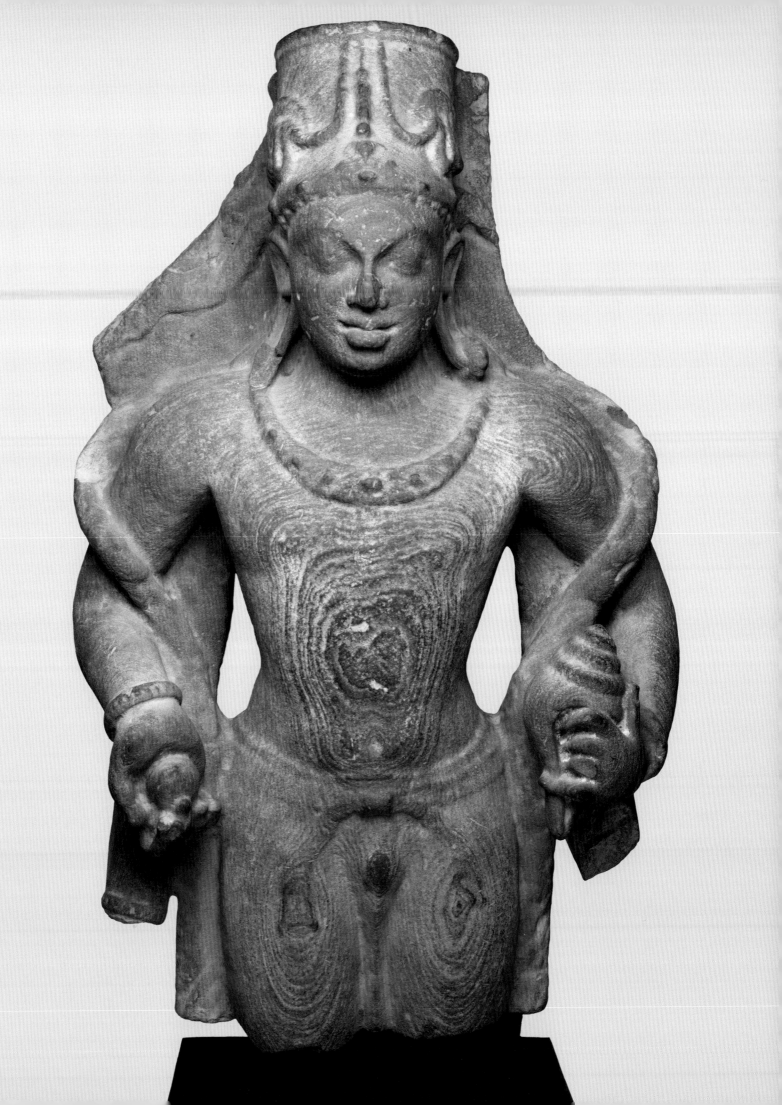

Figure 1–1 | Relief of Standing Vishnu, east wall, Cave 6, Udayagiri, Madhya Pradesh, 401 CE.
Photograph courtesy of Digital South Asian Library, American Institute of Indian Studies.

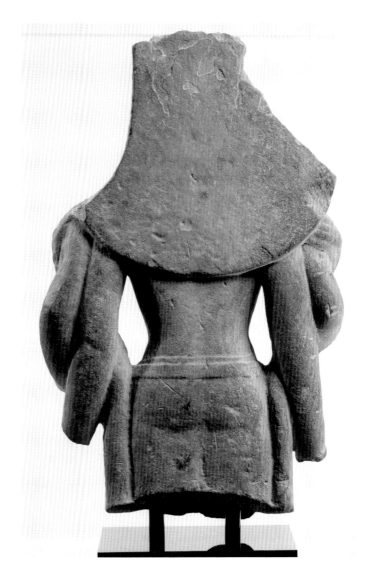

Boston figure). The fluttering streamers would have evoked a sense of motion and ethereality to the viewer, as if the god is swiftly descending from heaven to hear the prayers of his devotees; this feature would continue to appear on later icons made in the eastern regions under the influence of the Pala dynasty (750–1174).

Iconographically, the Boston, Brooklyn, and Uday-agiri Vishnus are also quite similar, with the front pair of hands holding small attributes. These are legible only on the Brooklyn image, which holds the conch shell in its left hand and a small object, possibly a lotus bud or seed, in its right; it is likely that the other two figures held similar objects in their front hands. The lower, rear hands of the Boston and Udayagiri figures rest on large attributes that stand on the ground. It is likely that the Brooklyn figure's lower hands did something similar, although they may have rested on figural attributes, as in the Vishnu of catalogue 12. Like the Udayagiri image, the Boston figure rests his very large rear left hand on a chakra (spoked wheel or discus). It is difficult to determine exactly what object stands beneath the Boston figure's rear right hand: it may be an extremely crude representation of Vishnu's clublike mace (*gada*), as appears in the Udayagiri example, or it may be some other type of object.[4]

A notable feature of the Brooklyn image is that it is carved in the round, with the back of the image delineated, although not finished to as high a degree as the front (see image above). Many early stone images have been found installed on freestanding altars or bases,[5] and circumambulation was an important element of worship in many early iconic traditions, so it is completely plausible that the rear of the image would have been visible in its original context.[6] A small, simply carved figure like the Boston piece was probably a less expensive commission, made for a provincial or domestic shrine. The strong resemblance between all three images—and several other known examples in Indian and western collections—indicates that as early as the late fourth century, sculptors had established relatively strict guidelines for the representation of Vishnu. ❀

3 | *Standing Vishnu*
Eastern India, West Bengal, or Bangladesh; Gupta period, 5th century
Terracotta; 40 x 16 x 9 in. (101.6 x 40.6 x 22.9 cm)
Private collection

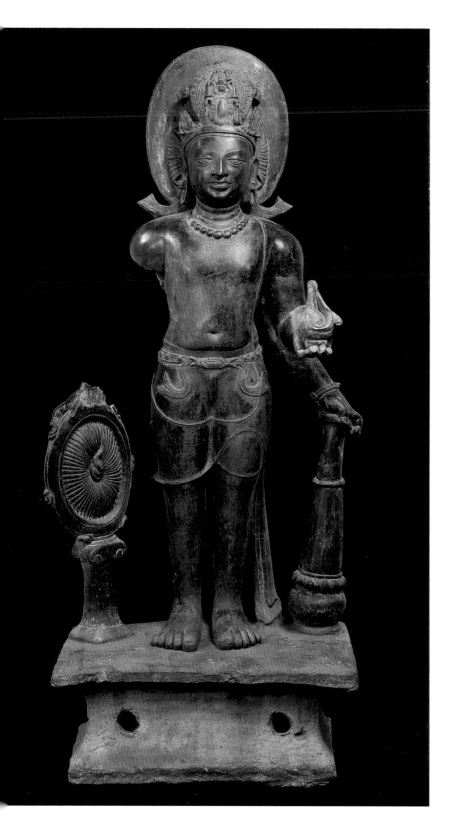

This handsome image of Vishnu in blackened clay is a close relative of catalogues 1 and 2, with hands still held low and large attributes resting on the ground at either side (although the positions of the chakra and mace have been switched). Like the earlier images, this one sports fluttering streamers on either side of his crown, here sculpted rather than incised into the halo, but unlike the others he does not wear the long, heavy garland.

The Gupta period (approximately 320 to 550 CE) saw a surge in the use of clay for temple sculpture, and elaborate brick temples with modeled terracotta ornaments were built all along the Ganges River, from northern central India to Bengal, in areas where good clay was in large supply. The vast majority of clay sculpture made in this era was in the form of reliefs that decorated the exterior walls of these temples (see cats. 23, 24, 136), and most of these reliefs illustrate the legends of Vishnu and his avatars. Freestanding figures modeled in the round are quite rare by comparison, but most represent Vishnu. It is likely that these figures were installed on altars, perhaps inside the brick temples, as focal points for devotion.

Of the freestanding Vishnu images in terracotta that are known, most were found in the Bogra district in western Bangladesh. Some of them share the polished black surface found on this example, a feature that distinguishes them from the majority of terracotta reliefs found elsewhere in Bengal and along the Ganges.[7] The patina is sufficiently uniform to suggest that it was intentionally added; it may be that the polished finish was reserved for shrine images.

This image was designed for use in temple processions: poles inserted through the holes in its substantial base would have allowed it to be carried like a litter. Such accommodations for portability are far more often found on images smaller than this one, especially bronzes. ✾

4 | Standing Vishnu
Southern India, Tamil Nadu, Thanjavur district; Pallava or early
Chola period, 8th century
Granite; 62 ³/₁₆ x 23 ½ in. (158 x 59.7 cm)
Seattle Art Museum. Eugene Fuller Memorial Collection, 69.13

5 | Seated Vishnu
Southern India, Tamil Nadu; Pallava or early Chola period,
8th–9th century
Granite; 55 x 30 x 15 in. (139.7 x 76.2 x 38.1 cm)
Brooklyn Museum. Gift of Alice Boney, 86.133

It is not surprising that the simplest images of Vishnu in the exhibition, the ones that are not complicated by the addition of numerous subsidiary figures, come either from the earlier periods, before the elaborations had been developed, or from India's southernmost region, Tamil Nadu, where a somewhat more minimal approach to sculpture prevailed. Ancient Tamil temple architecture often included stretches of unembellished wall punctuated by niches to which figural sculpture was mostly confined. These niches usually housed single, large figures. The stone sculpture of Tamil country is distinctive because it is in granite, a grainy, extremely hard material that was challenging to carve. While a preference for fewer, larger figures seems to have been mostly a matter of taste and tradition, the difficulty of working in granite may have also contributed to the Tamil temple-builder's tendency to eschew extra details.

On the basis of iconography and style, both figures of four-armed Vishnu (4, 5) appear to date to a transitional period, either shortly before the demise of the Pallava dynasty, which ruled southern India until the ninth century, or just after the victory of the great Chola dynasty, which conquered Pallava and other territories and continued to rule for another four hundred years. Both images hold the discus and conch shell, albeit in opposite hands, and both have their lower right hand in the hand gesture that means "do not fear" (abhaya mudra) while the lower left hand rests on a hip or knee, an indicator of casual ease. It is interesting to note that the discus on the Brooklyn piece is depicted in profile[8] and that the attributes on both images have small flames emanating from them. These flames, which indicate power and energy, are primarily a southern feature and appear on bronze images from the region as well.

The figures have small, spoked halos behind their heads and they wear a similar selection of jewelry and tall crowns, although in design these ornaments differ considerably. The variations may be a matter of regional tastes, quickly changing fashions, or simply artistic license. In bodily proportion, the figures are also dissimilar, with the Seattle figure appearing generally slimmer and more elongated, especially through the neck and torso. However, a survey of Vishnu images of the period and region indicates that these physical differences were dictated primarily by stance, with seated Vishnus typically appearing broader and standing versions looking leaner.

The difference in stance changes not only the bodily proportions, but also the perceived personalities of the deities represented: the standing figure appears far more formal and even distant despite his casually posed left hand and slight smile. By contrast, the seated figure appears to lean in toward the viewer, as if engaging him or her in conversation. Sitting with one leg pendant was known as lalitasana, or elegant pose; gods and kings were depicted in this posture when the artist wanted to show that they were at ease, in contrast to more authoritative postures with both feet planted on the ground, or meditative postures with both feet up. Lalitasana was the favored pose for seated deities in many Indian sculptural traditions because it was thought to signify a more approachable, compassionate demeanor. ✻

Southern India, Tamil Nadu; probably Vijayanagar period, c. 14th century
Bronze; 33 ⅓ x 13 ⅜ x 12 ⅞ in. (85.7 x 34 x 32.7 cm)
Kimbell Art Museum, Fort Worth, Texas. Gift of Ben Heller, AG 1970.01

The carvers of Tamil country decorated the exteriors of temples with powerful stone sculptures, as seen in the previous two examples, but the region's artisans truly excelled in the medium of bronze. Under the patronage of the Chola and later the Vijayanagar rulers, bronze casters in southern India created large numbers of graceful, lively, sensuous images of gods and goddesses that were installed on the altars of temples and paraded through the streets.

This unusually large image of Vishnu shows the god in his standard pose: holding the flaming chakra and conch in his upper hands (note that the chakra now faces forward, indicating that this image is later in date than cats. 4, 5) with his lower right hand making the gesture of reassurance. The lower left hand is posed slightly away from his hip, palm facing down. This gesture is often found on Chola bronze Vishnus. Although there is a Sanskrit term for it, *katyavalambita*, its meaning remains unclear: it appears to be a somewhat mannered variant of the hand resting on the hip (as in the stone image, cat. 4), but in some bronzes depicting standing Vishnu this hand rests in the same manner at the top of the mace, which stands at the figure's side. Some authors have suggested that the gesture should be read as beckoning.[9]

Vishnu stands on a double lotus pedestal: a cushion-shaped seed pod at the top with downward pointing petals below. The vertical tangs at either side of the base would have held a large, separately cast aureole. The loops at the bottom were used to fasten the image to a carrying device, perhaps a litter or cart, so the image could be transported in temple processions.

The date of this image has been a matter of debate. Because the face is somewhat sharply carved and because there is a great deal of ornament covering the body, it appears to be from the period when the Vijayanagar kingdom ruled southern India, after the fall of the Chola dynasty. There is a tendency for the bronze images of this later period to lack the grace or organic quality of earlier examples—and indeed this can be seen in the somewhat unconvincing way that the jewelry and garments drape over the body—but this figure has a remarkable physical presence, elegant curvature, and very lively hands, all of which keep it from feeling stiff or formulaic. ✳

Western India, Rajasthan or Gujarat; c. 12th–13th century
Stone; 42 x 35 x 4 ½ in. (106.7 x 88.9 x 11.4 cm)
The Trammell and Margaret Crow Collection of Asian Art, 1983.8

This exhibition includes many Vishnu images in which the god is surrounded by an extensive entourage of consorts, avatars, other deities, personified attributes, and members of a broader group of semidivine beings that might be called a "heavenly host." The subsidiary figures are always much smaller than the central god, and their positions and sizes within the larger composition speak to their roles within the Vaishnava mindset. In any arrangement, the surrounding figures can be understood as emanating from the central deity, like rays from the sun. Whereas these figures are usually carved on the same stone slab as the main icon, in western India after about the ninth century it became common to carve separate frames, known as *parikara*s, for icons; in some cases, these frames may have been commissioned for temples to use with previously existing icons.

This elaborate frame is interesting because, with the exception of the smallest attendants and women, all of the figures depicted are forms of Vishnu. The two standing Vishnus at the base, the six seated Vishnus that run up the sides, and the four smaller Vishnus that sit in either side of the arch all hold the same attributes—conch shell, lotus, mace, and chakra—but each figure holds these attributes in different hands. Vishnu is known by one thousand different names, all of them synonymous with the god but emphasizing a different trait. We know from iconographic texts that the arrangement of the objects on four-armed Vishnu images dictates which name of the god is being depicted in any given icon. Unfortunately, the various iconographic texts differ in the names they assign to each form, so it is not possible to identify precisely the twelve forms shown here.[10]

The figure at the top center of the arch differs from the others because he holds two lotuses in his upper hands and has his lower hands resting palms-up in the pose that is associated with meditation (see detail above). The two lotuses identify him as Surya-Narayana, the deity formed

from a merger of Vishnu with Surya, the god of the sun, since Surya is always shown holding two lotuses.[11] Worship of Surya-Narayana had emerged as an important branch of Vaishnavism in western India in the period when this frame was made. The identification of Vishnu with the sun dates back to the Vedic period, but the god became distanced from his solar origins over the course of centuries. The reunion of Vishnu and sun took place as the separate solar sect was absorbed into Vaishnavism. Surya-Narayana's prominence in western India may well be attributed to patronage by the royal families in that area who claimed Surya as their ancestor. ✳

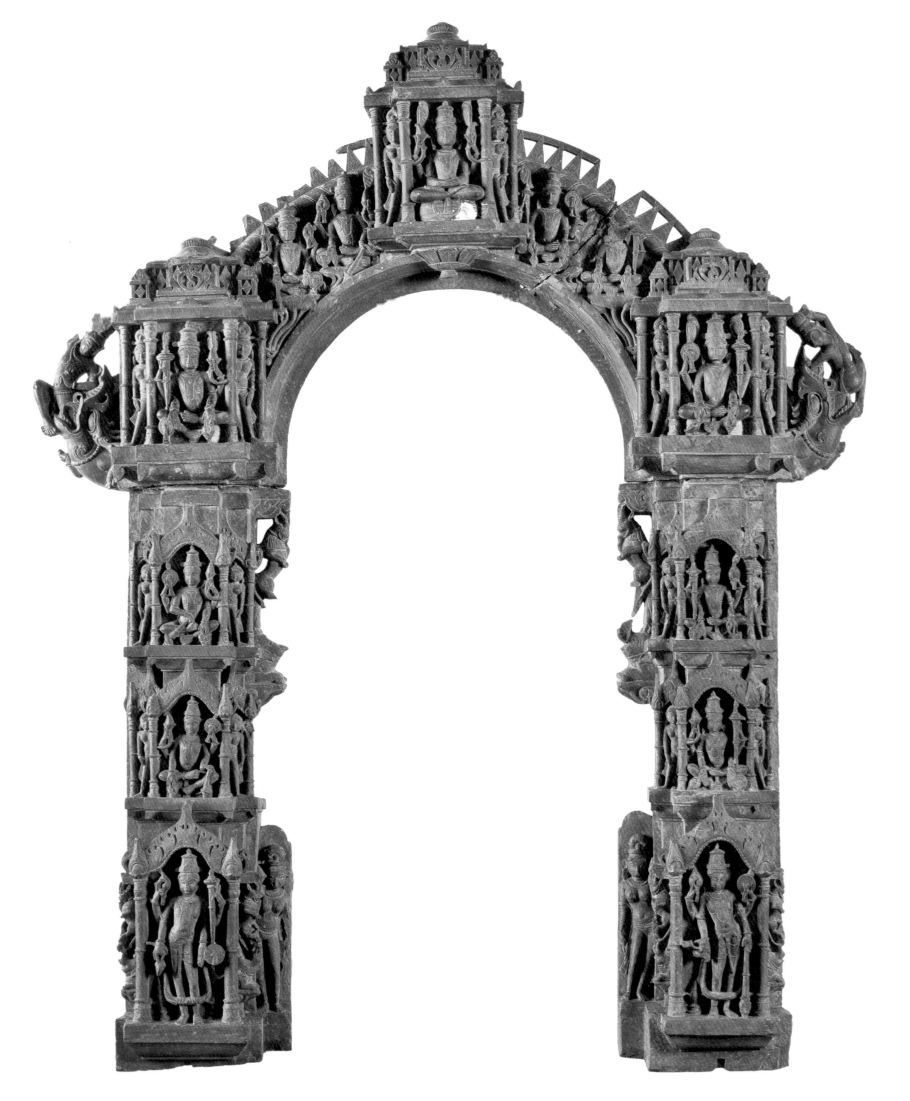

Attributes

The multiple arms of Hindu deities signify their superhuman strength and ability to perform numerous tasks simultaneously. Hindu gods and goddesses sometimes have ten arms or even more, each carrying emblems, including weapons, which may make them appear aggressive but more importantly signify their protective aspect. Chaturabhuja or Four-Armed Vishnu is distinguished by the particular attributes he carries in each of his hands: conch shell or *shankha*, discus or *chakra*, mace or *gada*, and lotus or *padma*. Together they display Vishnu's creative, protective and destructive functions.

Like Excalibur in the Arthurian legends, the weapons carried by Hindu gods and epic heroes are often given names to distinguish them from the ordinary weapons of mortals. Two of Vishnu's attributes, the mace and the discus, are celestial weapons of war, forged by the gods and possessing great powers. The mace Kaumodaki was given to Vishnu by Varuna, the god of the waters. According to the *Mahabharata* it is "capable of slaying every *daitya* [demon] and producing, when hurled, a roar like that of the thunder."[12] In one of his upper hands Vishnu holds the discus Sudarshana Chakra, "the foremost of all discoid weapons"[13] that can "irresistibly slay the enemy and again come back into thy [Vishnu's] hands."[14] In his other two hands Vishnu holds the conch-shell Panchajanya and the lotus Padma.

All of Vishnu's attributes may be depicted in anthropomorphic form as "weapon-men" (*ayudhapurusha*s). Sometimes the personified attributes may be depicted individually as separate deities and worshipped. Even though other gods in the Hindu pantheon also have powerful and potent weapons, Vishnu is the only one who is widely depicted with his attributes in their personified form. [NP]

8 | Sudarshana Purusha
Southern India, Tamil Nadu; c. 1300
Bronze; 4 ½ x 4 ⅜ x 1 in. (11.5 x 11 x 2.6 cm)
Museum für Asiatische Kunst, Berlin, I 5895

9 | Sudarshana Purusha (*following page*)
Southern India, Tamil Nadu; 11th century or later
Bronze; 7 ¼ x 5 ⅛ x 2 ⁵⁄₁₆ in. (18.5 x 13 x 6 cm)
Asia Society, New York. Gift from The Blanchette Hooker
Rockefeller Fund, 1994.003

According to the *Mahabharata*, the Sudarshana Chakra was given to Krishna by Agni, the god of fire. Another story in the epic says that Shiva was pleased with Vishnu's devotion and it was he who gave him the formidable discus. Often described as fiery and effulgent and compared to the sun, it recalls Vishnu's Vedic significance as a solar deity.

In these two bronze images (8, 9), Vishnu's discus is conceived as a separate deity, an autonomous conduit of Vishnu's creativity and destruction, who is worshipped in special Tantric rituals.[15] Sudarshana Purusha is depicted as a multi-armed figure standing within an upright flaming wheel, and carrying a number of attributes that include Vishnu's four. The flaming wheel surrounding the divinities

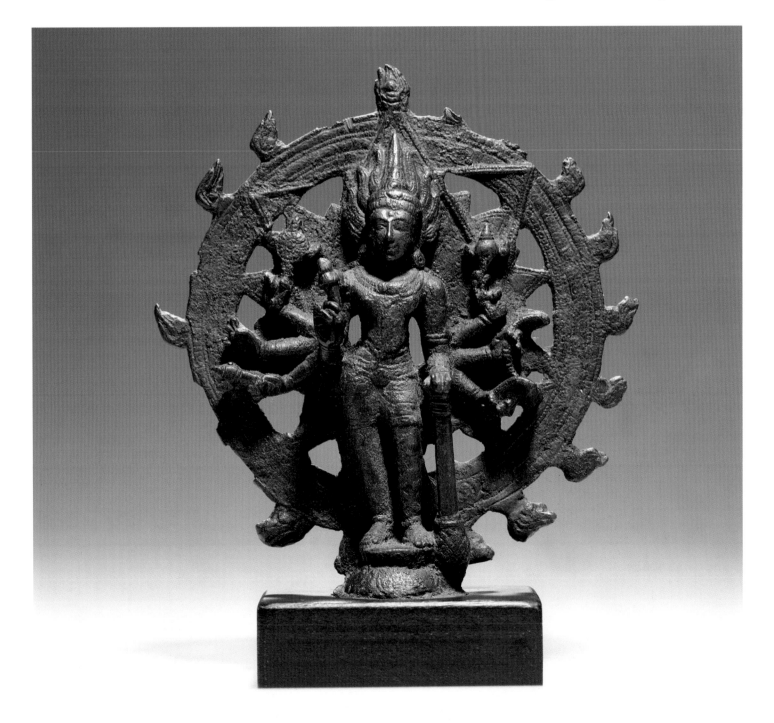

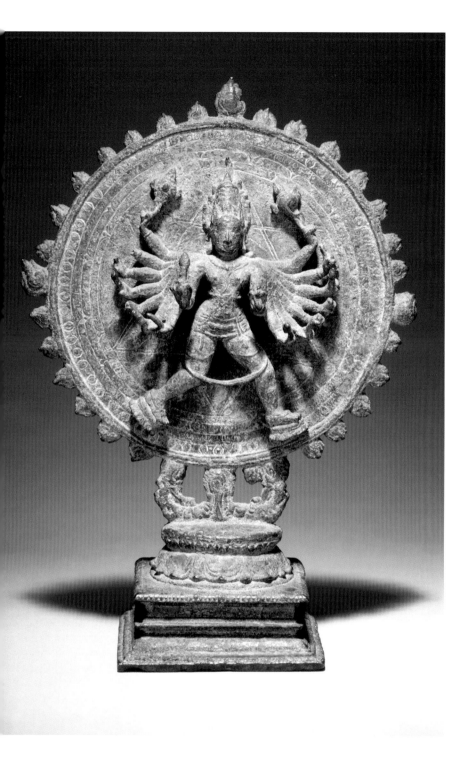

like a full body effulgent halo is a common motif in southern Indian bronzes.

The Berlin bronze (8) is considered the earliest example of southern Indian Sudarshana Purushas by some scholars[16] and is an eight-armed figure with a flaming crown. The deity stands in front of a Tantric *shat kona,* or star hexagram device composed of two interlaced triangles.[17] The upright equilateral triangle is associated with the male principle and fire, while the inverted triangle is associated with the female principle and water. Hence the *shat kona* "may symbolically represent the union of the two principles which create and coordinate the universe."[18] In addition to Vishnu's four attributes, he carries a pestle, a goad, a bow, and a noose. The fact that he carries Vishnu's four attributes suggests that he is capable of channeling the full potential of the god's powers.[19]

Images of Sudarshana with sixteen arms are depicted in one of two postures—either standing frontally with feet together (*samapadasthanaka*) or in a striding pose with the left leg forward (*pratyalidha*).[20] The Asia Society Sudarshana Purusha (9), previously identified as Vishnu, has sixteen arms and appears to be striding forward within a solid flaming disc. The discus and the conch shell are prominently displayed in his uppermost right and left hands respectively. Similar images usually have an incised *shat kona* behind the striding Sudarshana, and often an image of Narasimha, the half-man, half-lion incarnation of Vishnu on the back of the disc, though only the first feature is present in this image. In style the image appears to date to an early period, perhaps the eleventh century, which would make it the earliest Sudarshana Purusha from southern India. However, some scholars have argued that the sixteen-armed type did not appear until the seventeenth century.[21]

On account of their effectiveness in battle,[22] images of the sixteen-armed Sudarshana were meant to be worshipped in kingdoms under threat of being conquered by their foes and where the ruler's stability was at stake. Many Vishnu temples in southern India have separate shrines dedicated to Sudarshana Purusha within the temple precincts. [NP]

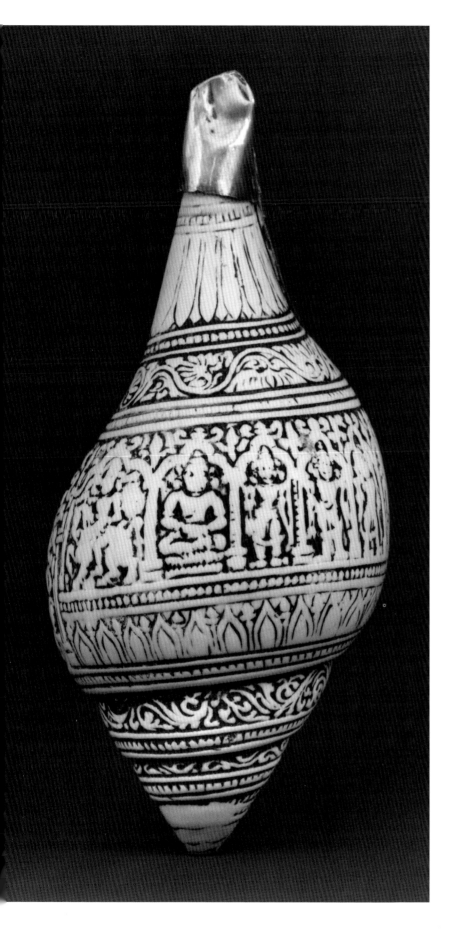

10 | Conch Shell Carved with Avatars of Vishnu

Eastern India (West Bengal) or Bangladesh; Pala period,
11th–12th century
Shell with silver; 9 x 3 ³/₄ x 3 ³/₄ in. (22.9 x 9.5 x 9.5 cm)
The Metropolitan Museum of Art. Gift of the Kronos
Collections, 1986.501.6

The story of how Krishna obtained his conch shell, or shankha, is told in the *Mahabharata*; as boys, Krishna and Balarama studied at the hermitage of Sandipani. After completing their education, they asked Sandipani what they should give him as teacher's fee (*guru dakshina*). He told them that his son Punardatta had been kidnapped by the demon Panchajana, and he asked the brothers to

11 | **Padmapurusha, the Personified Lotus of Vishnu**
Central India, Madhya Pradesh; c. 600
Sandstone; 20 x 9 x 5 in. (50.8 x 22.9 x 12.7 cm)
The Walters Art Museum, Baltimore, Maryland. Gift of John
and Berthe Ford, 25.258

rescue him. Some versions say that Panchajana used the conch as a war trumpet, while others say that he lived underwater in a conch shell. In both cases, Krishna killed Panchajana and acquired the conch (hence named Panchajanya) and returned Punardatta to his father. The Panchajanya was then used by Krishna as a war trumpet— he is often depicted blowing it during the famous *Mahabharata* battle.

While it is not clear that this conch shell was meant to represent the Panchajanya, the depiction on it of Vishnu's ten avatars intimately associates it with the god. It is decorated with intricately carved bands. Most of these bands are made up of undulating vines or geometrical motifs. However, one prominent band depicts the ten avatars, with a slightly larger carving of Lakshmi-Narayana appearing after Kalki, the last of the incarnations. The ten are depicted within framing archways and apart from a reversal of Matsya and Kurma, the first two, in order of their descent.[23] Lakshmi-Narayana is depicted within a more elaborate archway supported by Garuda, the celestial bird-mount of Vishnu, and flanked by a pair of adoring donors.

The sound of the conch shell is believed to be auspicious, akin to the sound of the sacred syllable Om. Hence the conch is blown at the beginning of rituals, festivals, celebrations, and ceremonies to drive out inauspiciousness and purify the environment. It may be blown in a celebratory vein at wedding ceremonies. In *puja* or worship rituals, a conch may be filled with water, which is poured on the images of the gods (lustration). It is also considered one of the nine treasures of Kubera, the god of wealth, capable of granting wealth and wishes.

A shankha is not a true conch but a *Turbinella pyrum*, or chank shell. It is common to the Indian Ocean and mostly spirals to the right. Originally dark brown on the outside, the white inner layer is revealed after carving. [NP]

12 | **Two-Sided Stele with Vishnu (Flanked by Personified Attributes) and Durga** (*following page*)
Northern or Eastern India, c. 7th century
Sandstone; 45 x 23 ½ x 17 in. (114.3 x 59.7 x 43.2cm)
Private collection

This sculpture is a personification (*purusha*) of the lotus (*padma*) attribute of Vishnu. The relaxed, pot-bellied figure carries a small lotus bloom in his right hand, which helps identify him. This figure was probably part of a larger group consisting of Vishnu and two personified attribute figures. Vishnu would be depicted much taller than the attributes. The sway of Padmapurusha's body suggests that he would have stood below Vishnu's left hand, and a counterpart figure would have been on the right, as seen in catalogues 12 and 13.

Vishnu's first creation was Brahma, who appeared seated on a lotus that sprang from Vishnu's navel. Hence Vishnu is also known as Padmanabha, or Lotus-Navel, and the lotus is regarded as a symbol of creation and fertility. The lotus is born in the mud but grows away from its base origins and is therefore considered a symbol of purity and transcendence. Vishnu's consort, the goddess of wealth and prosperity, Lakshmi, sits on a lotus and holds a lotus in one or both hands. Hence Vishnu's lotus also recalls his consort Lakshmi. The lotus is an important emblem in Buddhism as well, and although various Hindu and Buddhist deities are depicted sitting or standing on lotuses, or holding them in their hands, only Vishnu is shown accompanied by a lotus in personified form. [NP] ❀

On one side of this stele is a standing four-armed Vishnu with two hands resting on the heads of his personified attributes. All four arms are below waist level, a feature found in representations of the god until the eighth century or somewhat later. His upper left hand carries a conch shell while his lower left one is placed on Gadadevi—the female personified form of Vishnu's mace, who is depicted with a club behind her. Vishnu's upper right hand carries what appears to be a lotus bud while the lower right rests on Chakrapurusha—the male personification of Vishnu's discus with the same attribute depicted behind his head. Vishnu wears an elaborate flower garland and stands within an ornamental archway. On either side of the arch are depicted the three-headed Brahma and Shiva respectively. This Vishnu is similar to an image in the Norton Simon Museum (inv. no. F.1975.17.48.S), which has been attributed to Uttar Pradesh, c. 750–800, but it is perhaps even more similar to an image found at Khiarmahmudpur in the Dinajpur district of northwestern Bangladesh, which has also been attributed to the late eighth or early ninth century.[24]

On the other side of the stele is a four-armed Durga, a warrior goddess who is the fierce form of Shiva's wife Parvati, generally depicted with multiple arms and riding either a lion or a tiger. In southern India Durga is considered to be a Vaishnava deity, in which case she holds Vishnu's weapons (see cat. 20). However, the iconography here is different and she carries both Vaishnava and Shaiva attributes. In her lower right hand she carries the Vaishnava conch shell, while in her upper left hand she carries the Shaiva trident. The goddess holds a mirror in her upper right hand while the lower left hand is in boon-granting gesture, or *varada mudra*. She is accompanied by her lion mount and an attendant male figure. Durga also stands within an ornamental archway, flanked by flying celestials.

As it is carved on both sides, this stele was probably used for worship in a way that both Vishnu and Durga would be accessible, and possibly it was placed outdoors. The depiction of the two deities together in this form, however, is quite unusual, given that the goddess is not depicted only with Vaishnava iconography. [NP] ✺

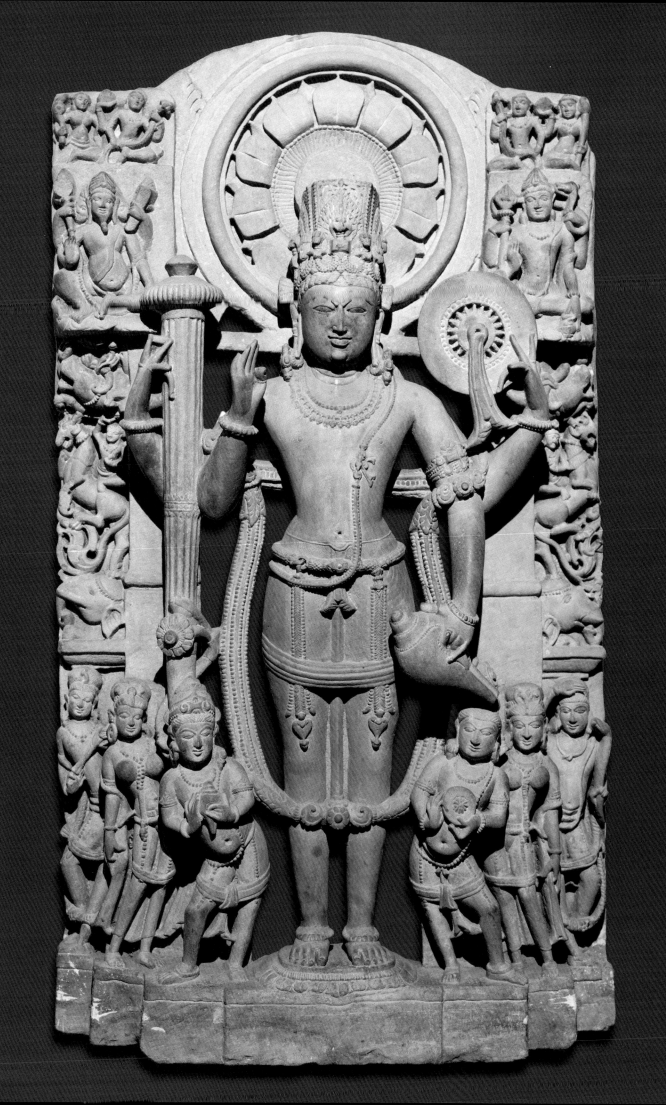

13 | **Vishnu Flanked by His Personified Attributes** (*previous page*)
Central India; 10th century
Sandstone; 40 ½ x 22 ⅝ x 8 in. (102.9 x 57.5 x 20.3 cm)
Krannert Art Museum and Kinkead Pavilion, University of Illinois,
Urbana-Champaign. Gift of Ellnora D. Krannert, 1969-10-1

This stele is dominated by the central figure of four-armed Vishnu, identified by his attributes the mace, the discus, and the conch shell. The lotus is absent and instead Vishnu holds his hand in the fearlessness gesture, *abhaya mudra*. Behind his head is a large lotus-bloom nimbus.

The reliefs on either side of Vishnu can be divided into three registers; the top one depicts the other two gods of the Hindu trinity, with Brahma on our left and Shiva on our right, accompanied by flying celestials. The middle register depicts animals and mythical creatures; and the bottom register depicts attendant figures, three on each side. The artist has created an approximate visual symmetry on either side of Vishnu.

In the lowest register, the front males on either side are personified attributes or *ayudhapurusha*s, weapon-men, each carrying a miniature attribute in his hands. On our left is the conch shell and to the right is the discus. These attributes are repeated in Vishnu's lower hands. The two females behind the *ayudhapurusha*s are the two wives of Vishnu, and the furthest two males are attendant figures.

This stele is very similar in subject matter and composition to one at the Metropolitan Museum, New York (inv. no. 68.46), which is attributed to the Punjab in the north of India. [NP] ✲

The Consorts of Vishnu and Female Forms of Vishnu

In Hinduism, every male deity has a female counterpart, usually portrayed as his wife or consort, who balances his male intellect and spiritual sophistication with female physicality and passion, qualities that some would argue are equally important. Although goddesses have been worshipped in India since prehistory, orthodox Hinduism did not make much of them until a later date. When goddesses gained prominence in Hindu scripture they were celebrated in two basic roles: as consorts to male gods, and as warriors who were celibate and sometimes ferocious. The many goddesses are often treated as manifestations of a single feminine force, known simply as Devi, Goddess; there is no comparable masculine entity.

Today, goddess-worship is the third most popular form of sectarian Hinduism, after worship of Vishnu and Shiva, but it also plays a role in the ritual practice and beliefs of the other two sects. It is common to worship the consort(s) of a god as part of the standard course of prayer; sometimes one finds a subsidiary shrine dedicated to the consort and sometimes the consort is enshrined on the same altar as the god.

Vishnu's consort and counterpart is Lakshmi. When shown together, they are called Lakshmi-Narayana. In many cases, Lakshmi appears as two separate goddesses, Shri Devi and Bhu Devi, who appear at either side of Vishnu. As goddess of good fortune and plenty, Lakshmi is one of Hinduism's most popular deities. She is worshipped primarily in a solo role: Lakshmi shrines appear in almost every Hindu-owned business, and most of them make little or no reference to Vishnu. Images of Lakshmi predate those of Vishnu by hundreds of years;[25] it is assumed that her origins are in popular traditions and that one way she was absorbed into the orthodoxy was by identifying her as Vishnu's wife. Lakshmi's role has since expanded to parallel that of her husband: she has incarnated herself repeatedly as consort to each of his avatars, most notably as Bhu Devi for the boar Varaha, as Rama's wife Sita, and as Krishna's lover Radha.

Vaishnava texts describe Lakshmi emerging for the first time as one of the elements created by the churning of the ocean (see the section on the Kurma avatar), but they also describe her as Vishnu's perpetual partner, present always on his heart—even at the moment of Creation—in the form of the *shrivatsa* mark. It is interesting to note that unlike Shiva and his consort Parvati, Vishnu and Lakshmi do not have children.[26]

14 | Lakshmi-Narayana

Northern India, Rajasthan; 10th century
Sandstone; 46 x 23 x 11 in. (116.8 x 58.4 x 27.9 cm)
Brooklyn Museum. Purchase Gift of the Charles Bloom
Foundation, Inc., 86.191

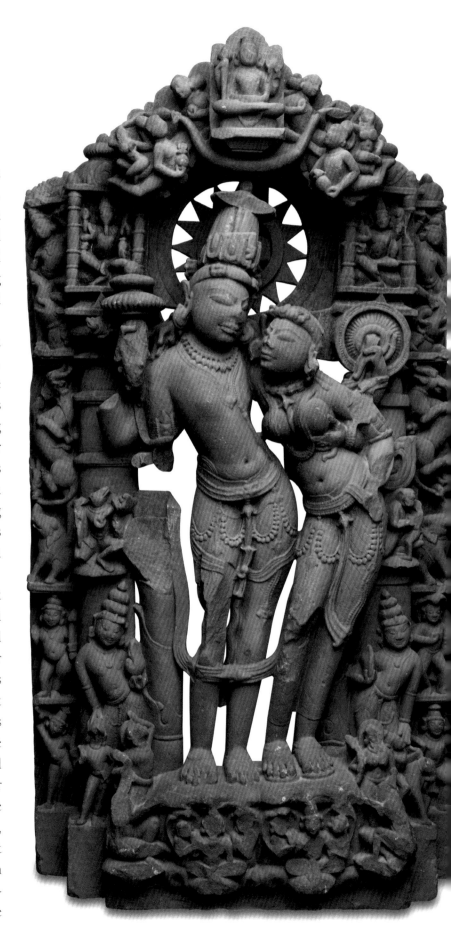

Images of the gods paired with their consorts often appear on the exterior walls of northern Indian temples. These divine couples are posed in very affectionate or even erotic embrace. Their delight in one another can be read both literally—showing us that the gods can be playful and lusty much like humans—or symbolically—representing the ideal balance and unity of various abstract concepts and qualities associated with male and female.

This image of Vishnu and Lakshmi is unusual in that the goddess is approximately the same size as the god. Where couples are so equally represented, they are to be worshipped together, as two halves of a whole. The image is also noteworthy because both god and goddess are standing in *tribhanga*, the swaying posture used frequently for other gods but only very rarely for Vishnu, who is almost always depicted standing straight. Vishnu's lower left arm has broken off, but we can see the remnants of his fingers touching the underside of Lakshmi's breast. The couple exchanges loving glances; this is also somewhat unusual because in most icons the gods return the gaze of the worshipper.

The iconography of this stele is complex but decipherable. At the apex is a small figure of Vishnu seated in meditation. At either side of the arch are unnamed flying figures, two of them preparing to lustrate (pour dedicatory water on) the couple below. In the small frames at left and right are bearded Brahma with his water pot and a figure that is probably Shiva, although his attributes are too eroded to read easily. Running down the sides are the ten avatars of Vishnu. At the very top, quite small and almost impossible to discern, are Matsya the fish on our left and Kurma the turtle on our right. Beneath them are two unnamed flywhisk bearers, two griffinlike creatures, and two elephants. Beneath these on our left are the squat figure of Vamana the dwarf and, beneath him, Rama, with bow and arrow. Across from them on our right are snake-hooded Balarama and Parashurama, his axe only visible

15 | **Vishnu with His Consorts** (*following page*)
Eastern India, West Bengal, or Bangladesh; Pala period,
11th century
Bronze; 16 ¼ x 6 ⅝ x 5 ⅛ in. (41.2 x 16.8 x 13 cm)
Private collection

from the side. Flanking the couple on the columns are Varaha the boar on our left and Narasimha the man-lion on our right. Beneath them are the larger figures of Vishnu's personified weapons, the conch on our left and the chakra on our right. In front of the weapons are more avatars on the outside—the Buddha with a manuscript at our right and Kalki on his horse on our left—while Vishnu's mount Garuda (damaged but identifiable because his legs are in the flying stance) salutes the couple from our left and Bhu Devi, the earth goddess, stands to our right. Bhu Devi often appears in images of Lakshmi-Narayana, and as we will see in catalogues 15 and 16, she frequently appears on equal footing with the other goddess. At the base of the sculpture were images of two kneeling devotees and two groups of *nagas* or snake deities. ✾

Most scriptural accounts of Vishnu mention only one consort, Lakshmi, but in the sculptural depictions of eastern and southern India, the god is often depicted flanked by two consorts, Shri Devi and Bhu Devi. Shri Devi is often used as an alternate name for Lakshmi, while Bhu Devi is the earth goddess. Both are considered manifestations of Lakshmi, with Shri representing the goddess' energy and Bhu representing her fertility or physicality. In southern Indian depictions, the two goddesses are identical except for the style of their breast coverings. In the east, they are more easily distinguished: Shri Devi plays a stringed instrument, usually identified as a *vina*, and Bhu Devi holds a lotus. The *vina* is more often associated with Sarasvati, goddess of learning, and indeed people often identify the Shri Devi figure as Sarasvati, but that goddess is the consort of Brahma and not often associated with Vishnu in texts, so it is probably more appropriate to call the *vina*-player Shri Devi. The pairs of consorts are almost always depicted much smaller than the central Vishnu.

Both of these images, one in bronze (15) and one in stone (16), come from the Bengali-speaking northeastern regions that were once under the domain of the Pala rulers. Both depict Vishnu with an arrangement of attributes that some iconographic texts identify as the Trivikrama form of the god: lotus bud in lower right hand, mace in upper right hand, conch in lower left, chakra in upper left. Trivikrama is the most common manifestation found among Pala-period sculptures; the name, "Taker of Three Steps," refers to the story of Vishnu's conquest of earth, sky, and heaven, which will be further explained in the section on the Vamana avatar, but the icons shown here make no reference to the act of stepping. The positions of the two goddesses are switched on the two images, and in the stone piece Bhu Devi holds a flywhisk instead of a lotus.

Each figure in the bronze group stands on a separate lotus rising from a stepped base and has an elaborate

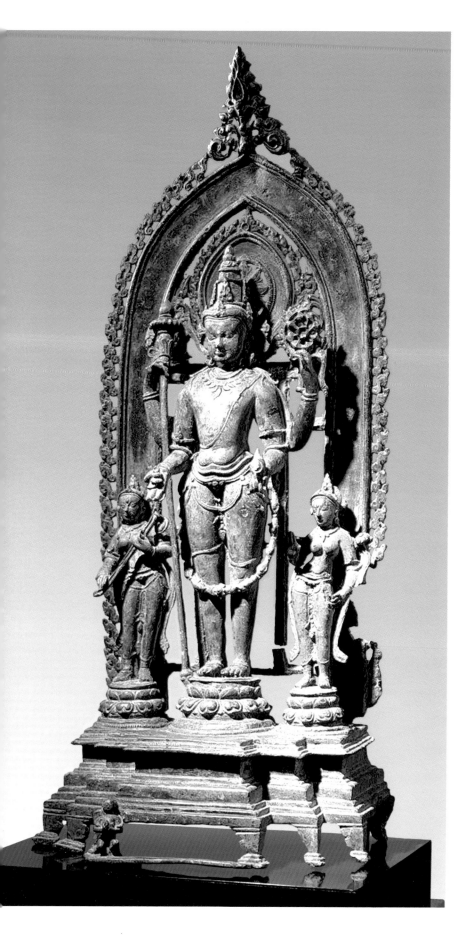

16 | **Vishnu with His Consorts** (*facing page*)
Probably Bangladesh, Dhaka district; Pala period, c. 12th century
Chlorite; 40 ½ x 20 ½ x 6 in. (102.9 x 52.1 x 15.2 cm)
Asian Art Museum. The Avery Brundage Collection, B60 S48+

flaming aureole (cast separately) standing behind them, and there is a smaller, round aureole surrounding the head of Vishnu. At the very foot of the base is a small kneeling figure, probably representing the donor of the piece, or the person whom the donor wished to honor; these kneeling figures are a common addition to Pala-period sculptures. Figures in Pala bronzes are sometimes slightly fleshier than in stone sculptures of the same period, and that is the case here: Vishnu has unusually wide hips and a soft chest, but these features give him an earthiness and approachability that are not often found in images of the god.

The stone stele is more elaborate than the bronze, in both iconography and decoration. Small male figures, apparently personified weapons (conch on Vishnu's right and chakra on his left), stand behind the goddesses, and two kneeling donors appear on the base. Above, mythical animals, heavenly musicians (*gandharvas*), and flying figures populate the sides of the stele. Every space not covered by a figure contains scrolling plants, swirling clouds, and flames of glory, creating an effect of churning energy that emanates from the god. The high degree of ornamentation on the stone image is associated with Pala sculptures of the twelfth century, whereas the more subdued treatment of the flames on the bronze aureole identifies that piece as the product of an earlier period, probably the eleventh century. ✻

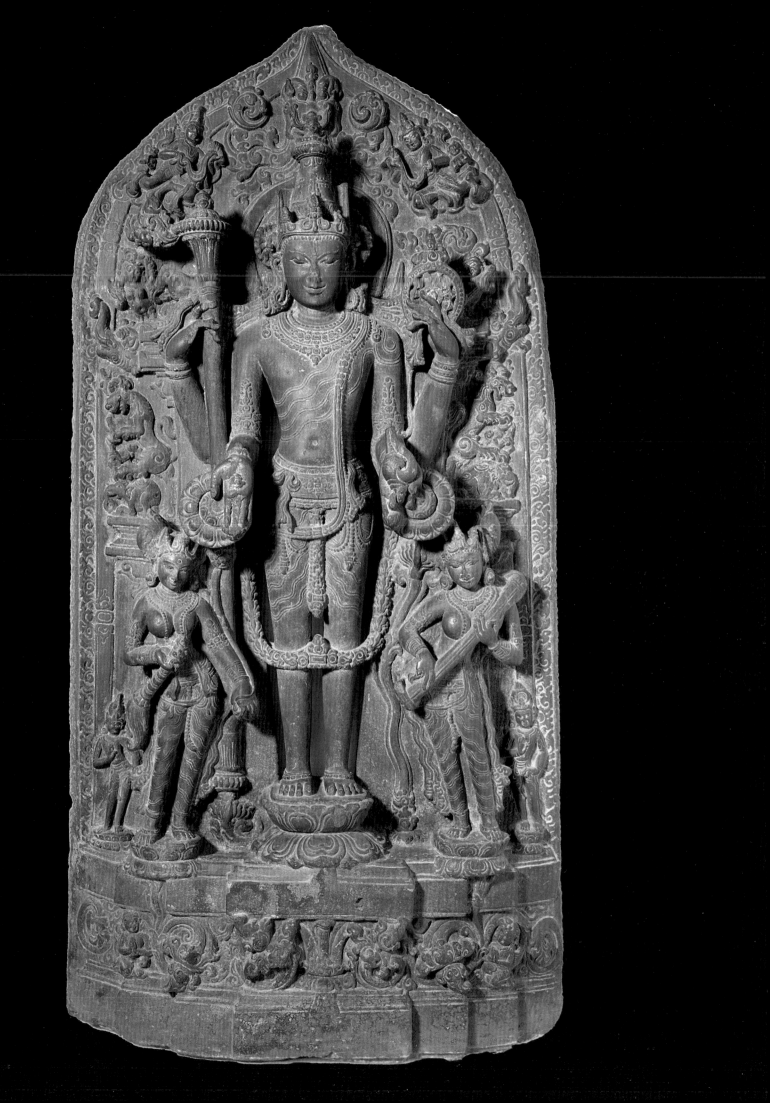

17 | A Vision of Vishnu (Vaikuntha Darshana)

Attributed to Murad and Lupha (both active late 17th–early
18th century)
Northern India, Rajasthan, Bikaner; c. 1710–15
Opaque watercolor, gold, and silver on paper
7 11/16 x 5 3/8 in. (10.5 x 13.7 cm)
Brooklyn Museum. Designated Purchase Funds, 1990.134

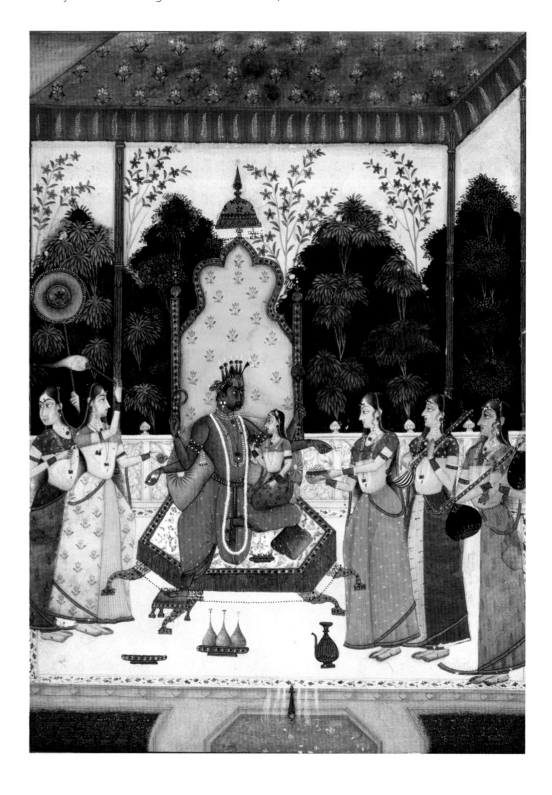

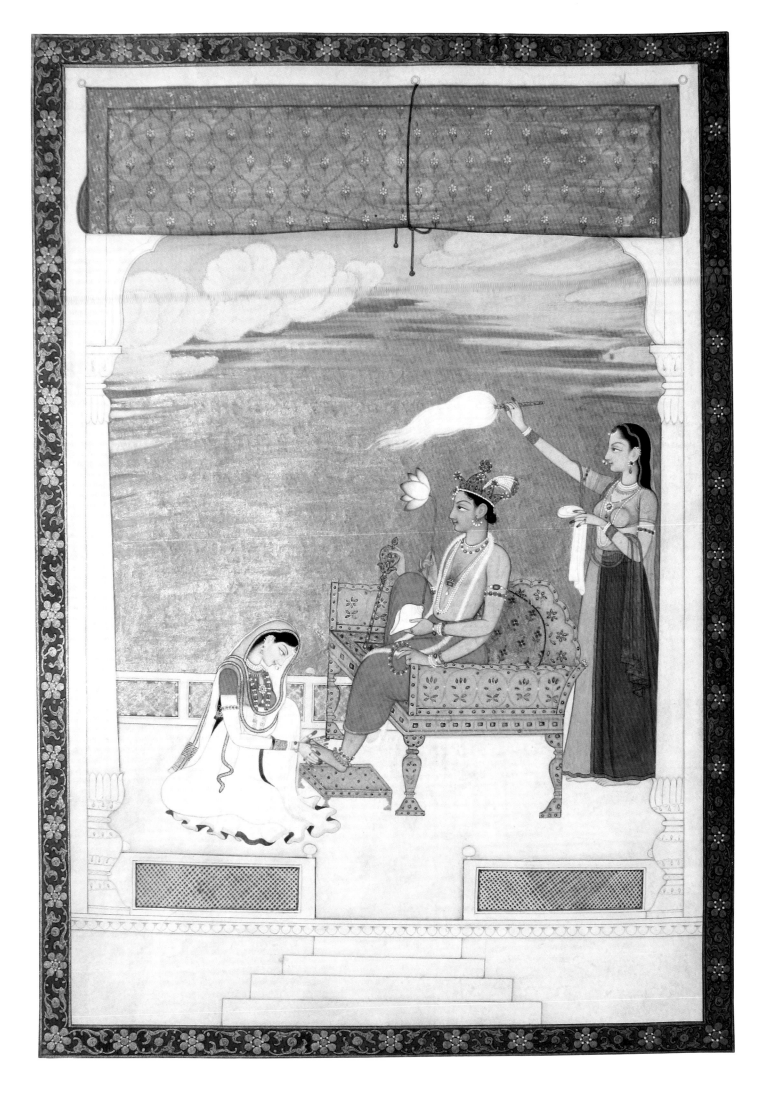

18 | Lakshmi Massaging the Foot of Vishnu (*previous page*)
Ascribed to Majnu (dates unknown) and Nainsukh
(c. 1710–c. 1775)
Northern India, Punjab Hills, possibly Basohli; c. 1765–70
Opaque watercolor, gold, and silver on paper
10 ¾ x 7 ⅜ in. (27.3 x 18.7 cm)
Catherine and Ralph Benkaim Collection

These two paintings (17, 18) display Vishnu and Lakshmi together in affectionate interaction, but with the goddess in a clearly subordinate position. In the Bikaner painting (17), in which Lakshmi appears on Vishnu's lap, the goddess is less than half the size of the god. She is significantly smaller than the female attendants, an iconographic anomaly as deities are almost always depicted as larger than the members of their entourage. In the Punjab Hills painting (18), Lakshmi serves Vishnu much the way an obedient wife was supposed to serve her husband, soothing his weary feet at the end of a long day. To touch a person's feet is a gesture of humility and respect in South Asian culture.

The Bikaner painting is one of several that depict a vision received by Karan Singh, the ruler of Bikaner state (reigned 1631–74). The king had a vivid dream about Lakshmi and Vishnu in their heavenly palace; when he awoke, he had his chief painter record the vision. Later, other painters portrayed it in additional paintings, including this one, which was made well after the king's death.[27] A comparison of this composition to those depicting rulers relaxing in their palaces reveals many similarities. Devotees, both royal and common, envisioned the gods as kings of the heavens, living much like earthly rulers in lovely garden pavilions with teams of servants and entertainers tending to their every whim.

The Punjab Hills painting is set in a similar pavilion, although instead of a garden background there is an intense golden sky. The furled blind at the top suggests that we are being allowed a peek into an otherwise closed world: the intimate domestic life of gods and their wives. This painting has a lengthy passage inscribed in gold ink on the reverse that quotes the *Mahanarayana Upanishad*, an ancient prayer praising Vishnu. Also on the reverse, in a different hand, is an inscription stating that the painting was made by the celebrated artist Nainsukh and another painter, presumably younger, named Majnu. The inscription is significant because although there are quite a few paintings attributed to Nainsukh, there are very few bearing inscriptions naming him, and even fewer indicating that he collaborated with others. Nainsukh developed a highly refined style with very thin lines and closely observed details that would influence later artists in the Punjab Hills profoundly. In style, this painting appears to represent a bridge between the moody naturalism found in many Nainsukh paintings and the supernatural lyricism that would characterize paintings made by later generations. As such, it makes sense that this would be a work made by the aging master with the assistance of a younger artist.[28]

19 | Lakshmi Lustrated by Elephants (Gaja-Lakshmi)

Page from an illustrated manuscript of the *Dashamahavidya*
Northern India, Punjab Hills, probably Guler; c. 1800–1825
Opaque watercolor and gold on paper
7 5/16 x 4 3/4 in. (18.5 x 12 cm)
Museum Rietberg, Zurich. Former collection of Alice Boner,
RVI 1384

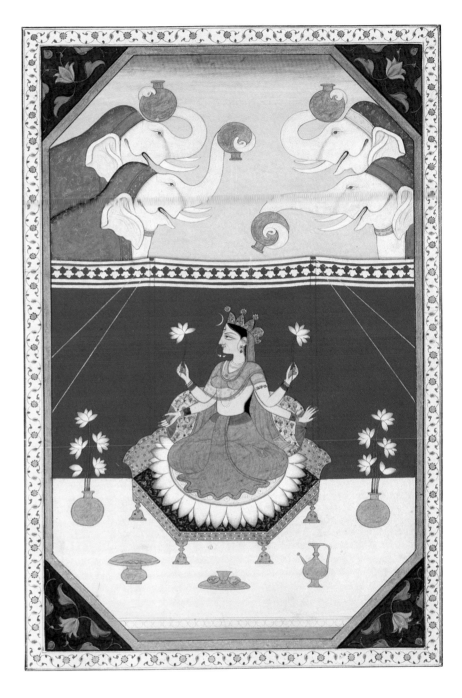

Lakshmi is worshipped on her own, in both Vaishnava and non-Vaishnava contexts, as the goddess of abundance and good fortune. She appears to have her origins in the fertility traditions that existed alongside Vedism in ancient India. To this day she is considered one of Hinduism's most approachable deities, along with the elephant-headed Ganesha.

The image of Lakshmi being bathed by elephants, or Gaja-Lakshmi, is of very ancient origin; it appeared in stone around 100 BCE[29] and in terracotta possibly even earlier. Water is a precious element in India, where rain does not fall for eight months straight, and it is intrinsically tied to fertility and well-being. Elephants are gray and heavy like rain clouds, a comparison found often in South Asian literature, so the image of elephants pouring water appears to be closely tied to the monsoon, the great season of rebirth in India. The pouring of water is also a ritual act in South Asian culture, a gesture of homage and accommodation, as seen in the Vamana avatar story.

This lively depiction of Gaja-Lakshmi shows the goddess seated on a low throne surrounded by golden vessels in an altar-like setting. She holds a blooming lotus in each of her upper hands; the lotus is a water plant, so while it typically represents transcendence it can also refer to the earthly blessings that come with plentiful moisture. Behind Lakshmi is a wall of cloth of the sort used in India for temporary encampments and special events, and behind that is a group of jolly elephants holding traditional brass water jars in their trunks. One of the most engaging aspects of this painting is the artist's placement of the group in a recognizable, earthly setting. Here the elephants have to reach over the wall to pour their water, a slightly transgressive act, whereas most depictions of Gaja-Lakshmi show the elephants floating in the air above the goddess or swimming in the great primordial ocean around her.

This painting comes from a series depicting the ten Tantric Mahavidya goddesses, of whom a golden-skinned form of Lakshmi, known as Kamala, is the tenth. She is shown with a crescent moon in her crown. The moon emerged from the churning of the ocean, just as Lakshmi did, therefore the moon is considered Lakshmi's brother. ✳

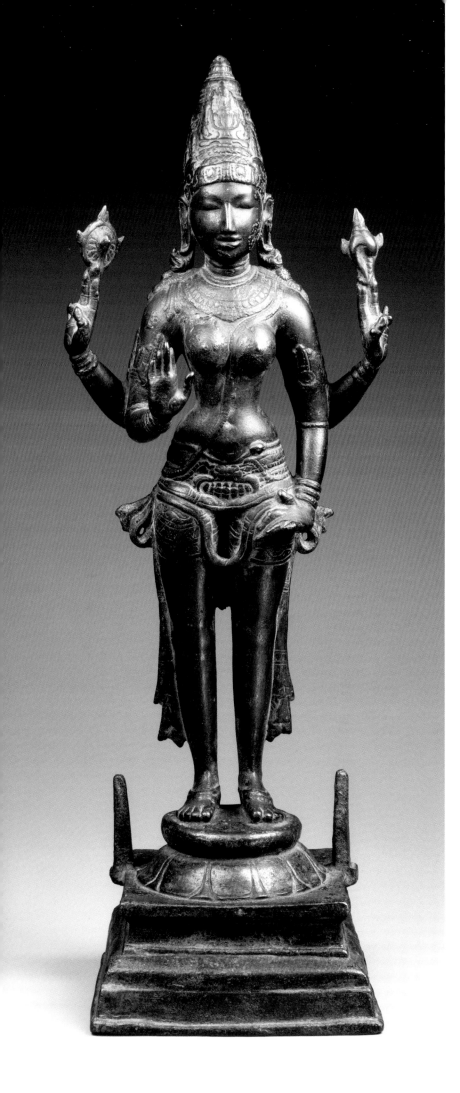

20 | Durga

Southern India, Tamil Nadu; Chola period, c. 970
Bronze; 22 ½ x 8 ½ x 6 ¾ in. (57.2 x 21.6 x 17.1 cm)
Brooklyn Museum. Gift of Georgia and Michael de Havenon, 1992.142

Durga is Hinduism's most powerful and most worshipped warrior goddess. Many texts celebrate her creation by a coalition of male gods, each of whom contributed his most distinctive power so she would be unmatched in battle. She is most often depicted with ten arms, each of them holding a weapon associated with one of the gods, a visual acknowledgement that she is the product of assembled forces.

Durga is also understood to be Vishnu's sister. The kinship is mentioned frequently in passing, but only rarely explained or analyzed in Hindu scripture.[30] The association of Durga with Vishnu appears to have been particularly prevalent in southern India, where she is sometimes depicted holding only Vishnu's weapons.[31] When she appears in this form, she is also called Vishnu-Durga or Narayani.

The Brooklyn Durga was made relatively early in the Chola period (ninth–twelfth century) when bronze casting reached unmatched heights. Deceptively simple in pose and impact, it reveals the careful balance of ornament and organic form found in tenth-century bronzes. Durga is shown holding the chakra between the index and middle finger of her upper right hand, and the conch between those fingers in her upper left hand. She makes the gesture of reassurance with her lower right hand and rests her lower left hand on her hip. Iconographically, she is identical to the Kimbell Museum Vishnu (cat. 6). In both northern and southern contexts, Durga is usually said to be a virgin, not interested in marriage. As such, she is worshipped alone, and she stands straight and tall, not bending or twisting toward a male consort the way the Bhu Devi and Shri Devi figures do in catalogues 15 and 16. This straight posture also recalls that of Vishnu, her brother. Wear to the front of her crown, face, and chest indicates that this image was touched often in worship. ✺

21 | A Goddess, Either Durga or Vaishnavi

Southern India, Tamil Nadu; Chola period, c. 11th century
Granite; 42 ¼ x 17 ¼ x 11 ¼ in. (107.3 x 43.8 x 28.6 cm)
Dayton Art Institute. Purchased with funds from the Junior League of Dayton, Ohio, Inc., 1964.12

22 | A Goddess, Probably Vaishnavi (*following page*)

Southern India, Karnataka; Hoysala period, c. 12th century
Chloritic schist
30 ½ x 18 ½ x 8 in. (77.5 x 47 x 20.3 cm)
Collection of Arnold Lieberman

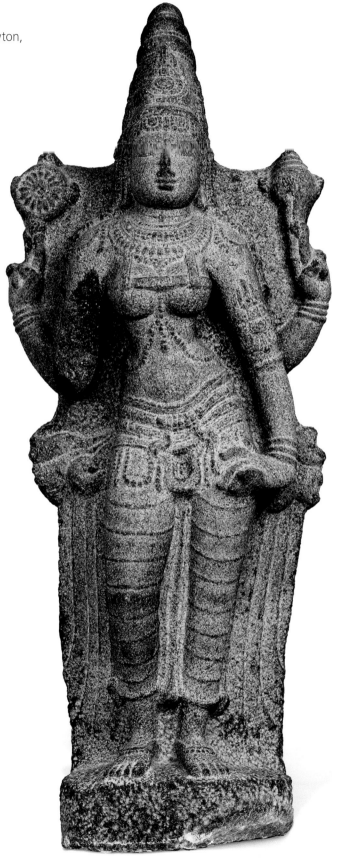

When they are depicted with their four-armed husband, the consorts of Vishnu almost always have two hands. This, along with size, serves to indicate their subsidiary status in a Vaishnava context. When we find a goddess with four hands she is probably a more powerful, stand-alone deity, as we see in the painting of Lakshmi (cat. 19) or the bronze Durga (cat. 20). The two goddesses depicted here (21, 22) have four hands. Both hold the conch and chakra in their upper hands (the seated figure holds them at the top of long, elaborate shafts and in the opposite hands from the standing figure); the seated figure holds the lotus in her lower right hand, and what appears to be a large fruit in her lower left hand.

The selection of attributes suggests that these female figures are associated with Vishnu, but finding a precise identification is not simple because they have been removed from their original context. The standing figure (21) may well represent Durga in her form as Vishnu's sister (since she has precisely the same attributes and gestures as the bronze Durga in the preceding entry and comes from the same region), but such images are rarely found in stone. The seated figure (22) is almost certainly a manifestation of Vishnu's female energy, or shakti, known as Vaishnavi, and the standing figure may depict Vaishnavi as well. Vaishnavi is mostly worshipped by devotees of the Goddess (Devi), who believe that the shakti of any god is the source of his greatest powers. The shaktis of the major gods are usually worshipped as a group, either as the seven Matrikas (Mothers) or as part of a larger group of Yoginis.[32] Both groups of goddesses are more often depicted seated so it is

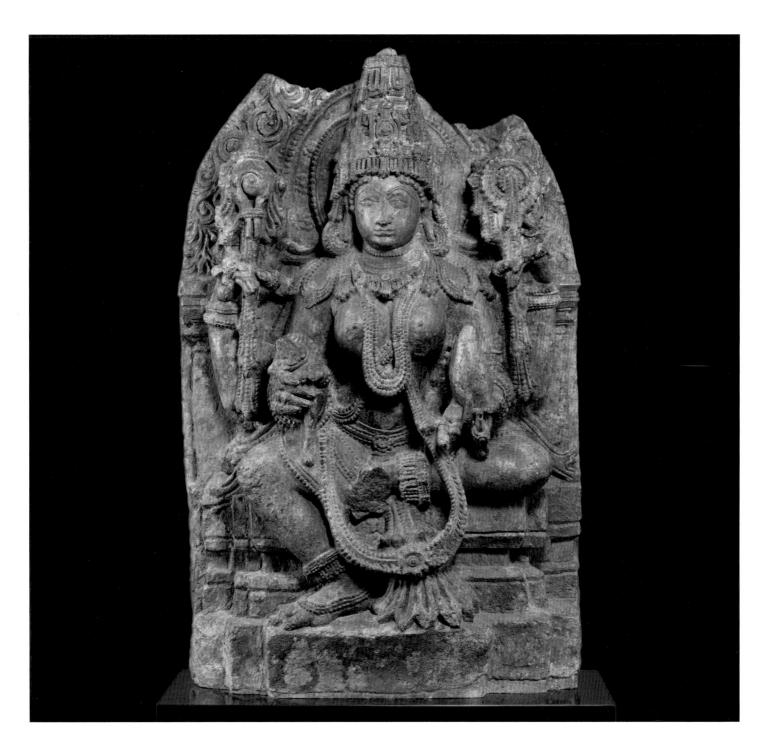

easier to imagine the seated image as a Matrika or Yogini. Large-scale, separately carved, standing figures of the Matrikas and Yoginis are almost unknown, so it is difficult to make a strong case for the standing goddess as a member of one of these groups.

Comparison of these two figures reveals the divergence of sculptural tastes prevalent at virtually the same time in the western and eastern regions of southern India. The standing goddess represents the eastern tradition, as supported by the Chola dynasty: carved in granite with an emphasis on the body, relatively minimal ornament, and no surrounding elements. The seated goddess represents the western tradition, as patronized by the Hoysala dynasty (1026–1343): carved in chlorite with the body serving primarily as a support for jewelry and attributes, and elaborate detailing of the backdrop. ✱

Garuda

In Hindu mythology, Garuda is the mythical half-man, half-eagle mount or *vahana* of Vishnu. He is known as the king of the birds and also appears in Buddhist mythology. The story of his birth is told in the *Mahabharata*: Kadru and Vinata were two sisters married to the sage Kashyapa. The sage offered them both the boon of children, and Kadru gave birth to a thousand powerful snakes as her sons while Vinata begat Garuda. Kadru and Vinata once made a bet where the loser would become the slave of the winner. Kadru and her snake sons used trickery to win the bet, Vinata became their slave, and Garuda vowed to obtain freedom for his mother.

The snakes told Garuda that the price of freedom was to bring the nectar of immortality, or *amrita,* to them. The amrita was in heaven guarded by a number of gods including Indra, but Garuda fought them all and managed to obtain the nectar, though he did not drink it himself. For his self-denial, he was granted immortality and freedom from disease by Vishnu, and was also given a place on his flagstaff. In return, Garuda was granted the boon that he would become the mount of Vishnu.

Indra was amazed by Garuda's strength and granted that snakes become his natural food, because it was their deception that had resulted in Vinata losing the bet. Garuda took the amrita to the snakes and thereby ensured his mother's freedom, but before the snakes could drink it, Indra took it away.

Garuda is usually depicted as a beak-nosed man with wings and talons. He is worshipped by both Hindus and Buddhists throughout South Asia and Southeast Asia and the Himalayas and he is still traditionally evoked to ward off snakes, snake-bites, and poisoning.[33] Today Garuda is the national symbol of Thailand and Indonesia as well as the symbol of the capital city of Mongolia. The national airline of Indonesia is called Garuda Indonesia. Garuda is also the name of a Special Forces unit of the Indian Air Force. [NP]

23 | Vishnu Riding Garuda

Bangladesh or Eastern India; Gupta period, 4th–5th century
Terracotta; 26 x 20 x 3 in. (66 x 50.8 x 7.6 cm)
Private collection

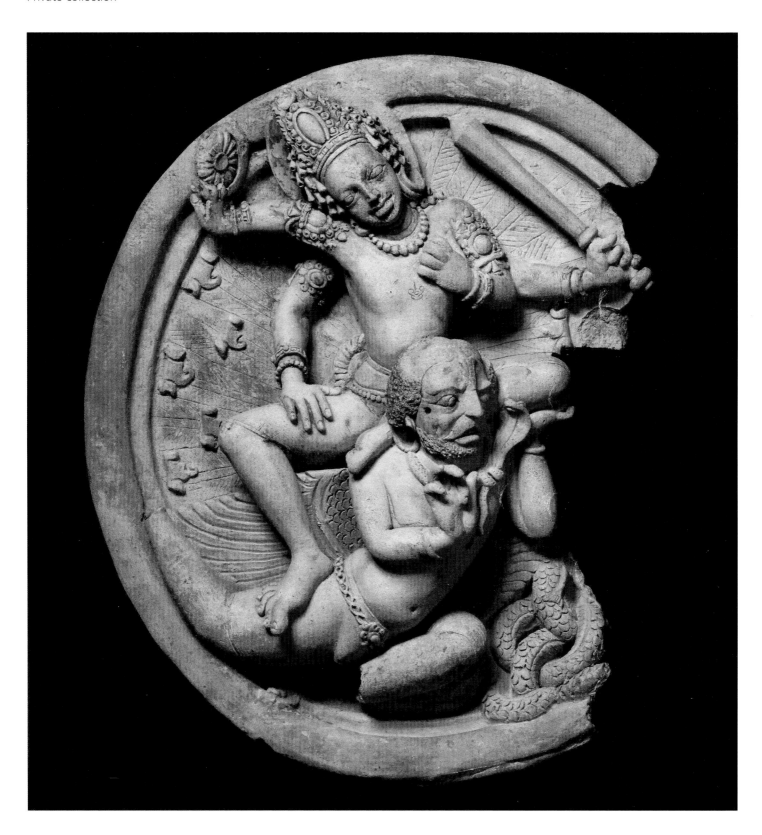

24 | Vishnu on Garuda
Northern India, Uttar Pradesh; Gupta period, 5th century
Terracotta; 12 ³/₁₆ x 14 ³/₄ x 4 ¹/₂ in. (31 x 37.5 x 11.4 cm)
Brooklyn Museum. Gift of Dr. Bertram H. Schaffner, 73.124

These two terracotta reliefs (23, 24) date from approximately the same period and yet they represent Vishnu and Garuda in remarkably different ways. The roundel (23) depicts a dynamic four-armed Vishnu riding a bearded and moustached Garuda. Vishnu's right leg rests on Garuda's thigh, while his other leg is supported by Garuda's hand, ensuring his stability during flight. Two arms hold up weapons in readiness for battle. Garuda carries a snake in his hand as they are his natural food. His wings and tail feathers fan out in all directions, creating a sort of halo that surrounds the two figures.

In Indian art gods are usually depicted as maintaining their equanimity even during battle and warfare, and here Vishnu appears to sport a slight smile. This contrasts with Garuda's almost pained expression of grim concentration. The representation of Garuda reflects influence from Greek sculptural traditions, in which faces were often individualized and highly expressive. Aesthetic influence from the Classical West, which was apparent primarily in the early Buddhist sculpture of Pakistan and Central Asia, continued to surface occasionally in the arts of South Asia well into the fifth century, although such expressive naturalism is usually confined to subsidiary figures while the gods are more often represented as iconic, idealized, and impassive.

The drama and refinement of the roundel can be contrasted with the other terracotta relief that also depicts Vishnu riding on Garuda, in this case accompanied by a third figure (24). This relief appears less carefully finished than the other, with rougher modeling and small punched circles used as a decorative element, yet it captures a sense of the god's swift descent from the heavens.[34] Vishnu rides Garuda and blows his conch shell while holding out a bow in another hand. The smaller accompanying figure is also an archer.

The panel has been identified as an illustration of Chapter Six of the *Ramayana* epic, in which Vishnu battles the demonic *rakshasas*, though the latter are not depicted.[35]

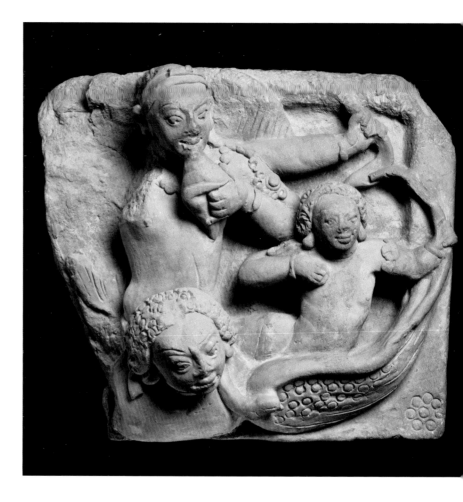

Another possible interpretation is that this is a scene from the *Mahabharata* and the second archer figure is Arjuna, the hero of the epic, who fought in the great battle of Kurukshetra with Krishna (an incarnation of Vishnu) as his charioteer.

The Brooklyn piece is one of many terracotta reliefs with Vaishnava subjects that served as architectural ornament for brick temples in northern and eastern India (see also cat. 136). The original context of the roundel is less clear, although large round reliefs sometimes appear high on the sides of a *shikhara*, or temple tower. [NP] ✺

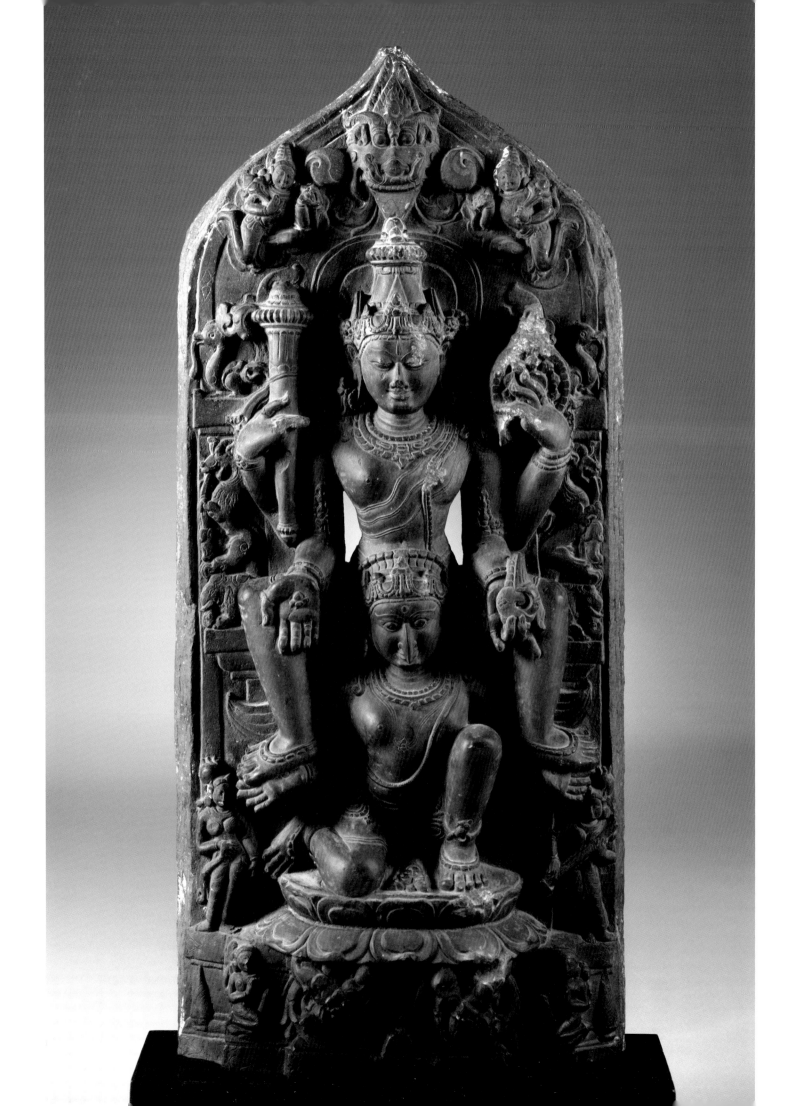

25 | **Vishnu Riding on Garuda** (*facing page*)
Eastern India; Pala period, 11th century
Schist; 25 9/16 x 11 x 3 in. (64.9 x 27.9 x 7.6 cm)
The Walters Art Museum, Baltimore, Maryland. Gift of John
and Berthe Ford, 25.242

26 | **Vishnu and Lakshmi on Garuda**
Northern India, Rajasthan; c. 1500–1700
Chlorite or serpentine; 31 ½ x 18 x 9 ½ in. (80 x 45.7 x 24.1 cm)
Asian Art Museum. The Avery Brundage Collection, B60S108

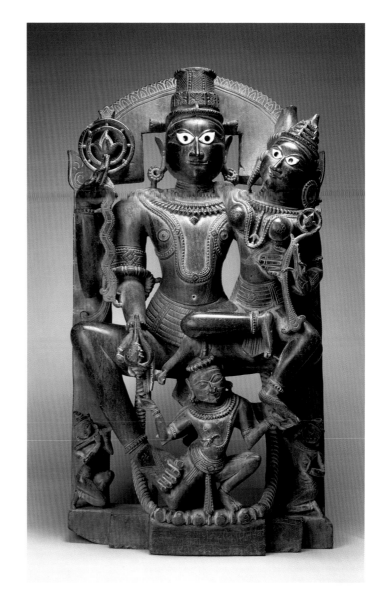

These two stone images (25, 26) represent four-armed Vishnu riding on Garuda, though in the one from Rajasthan (26) Vishnu is accompanied by his consort Lakshmi. They are from the opposite ends of northern India and they represent two very different sculptural aesthetics.

The Pala piece (25) is one of many similar depictions of Vishnu and Garuda carved in the typical black-gray schist of their region, with the figures placed inside a characteristic pointed arch (for related images, see cats. 16, 38, 39, 64). Garuda is seated on a lotus pedestal and supports Vishnu's feet in his hands. Vishnu carries the mace, the disc, and the conch shell, and his lower right hand is in *varada mudra*, the boon-granting gesture. At the top of the arch is a "face of glory," *kirtimukha*, and it is flanked by flying celestials. On either side of Garuda are Vishnu's two consorts, Bhu Devi and Shri Devi, while the kneeling figures on the base are a human couple representing the donors of the work.[36] Garuda's posture, with one knee bent behind him and one in front, is meant to suggest flight and can be seen repeated by the flying celestials that flank the *kirtimukha*.

Unlike the Pala sculpture in which Vishnu and Garuda are of proportionate size, Vishnu is much larger than Garuda in the image from Rajasthan. This use of hieratic scale emphasizes the greater importance of the deity. With one hand Vishnu holds Lakshmi close to the right side of his body, his two left hands carry the conch shell and a lotus, and the fourth hand is broken. Two small attendant figures sit at the lower corners.

The angularity and attenuation of the figures and the stylized depiction of elements such as the jewelry and Vishnu's lotus is typical of sculpture made in Rajasthan beginning around the fifteenth century. The eyes of the figures are designed to be inlaid with black and white marble or glass, which would have drawn particular attention to them. Rajasthani architects occasionally departed from the traditional sandstone to create temples in new materials such as white marble; the greenish stone is unusual, but its polished surface is in keeping with Rajasthani taste in the fifteenth century and later. On this sculpture there are two inscriptions in the Devanagari script in a western-Indian dialect that are not clearly legible, but possibly contain the name of the donor and the date of the sculpture.[37] [NP] ✳

27 | **Garuda** *(facing page)*
Eastern India or Bangladesh; Pala period, 11th century
Schist; 20 ¹⁄₂ x 9 ³⁄₄ x 2 ¹⁄₂ in. (52.1 x 24.8 x 6.4 cm)
Rubin Museum of Art, New York. Former Collection of Navin
Kumar, New York, C2005.33.1

Carved in the dark stone prevalent during the Pala dynasty in eastern India, this sculpture depicts Garuda kneeling on a lotus pedestal. His hands are folded in obeisance, suggesting that he is paying homage, possibly to Vishnu. But the small red flecks on his person suggest that this sculpture of a worshipper was itself worshipped. The red flecks are *roli*, a powdery substance that is used to adorn the foreheads of gods during *puja* (ritualized worship). Garuda's wings appear to be folded, perhaps indicating that he is at rest. His natural food of snakes serves as ornaments on his body.

Such images of kneeling Garuda were a common iconographic type in Bengal during the later Pala period and some would be installed atop a pillar in the courtyard outside a Vishnu temple.[38] The Garuda image was situated so it could face the Vishnu image inside the temple, its perpetual adoration celebrating Garuda's role as Vishnu's greatest devotee. A similar arrangement is found in Shiva temples where Shiva's mount, the bull Nandi, is usually placed outside the temple and facing the Shiva-*linga*. The Garuda column, or *stambha*, is one of the earliest documented Hindu icon types (for a later example, see fig. 27–1). A Garuda *stambha* was erected in 113 BCE at Besnagar in central India by Heliodorus, a Bactro-Greek envoy to an Indian court. Today its Garuda capital is missing, but the inscription on the column mentions it. [NP] ✳

Figure 27–1 | Garuda image atop a pillar,
Tirumala Venkateswara Temple, Tirupati, Andhra Pradesh.
© *Photos India / StockphotoPro.*

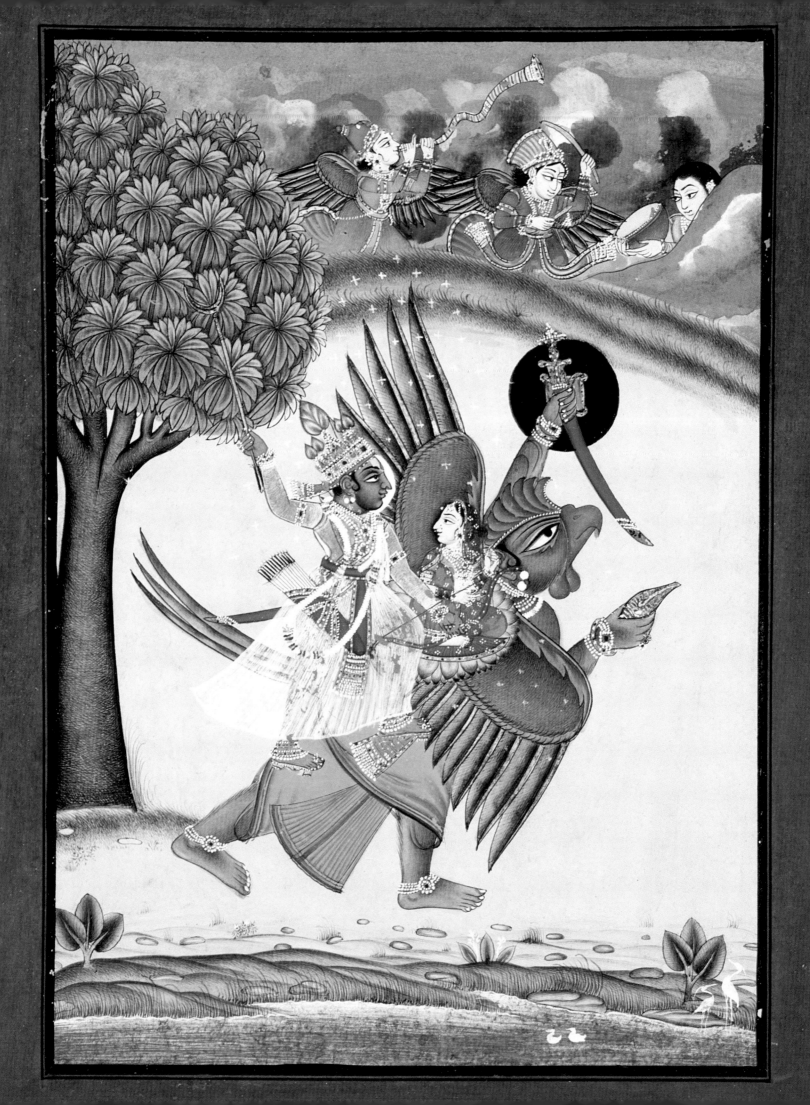

28 | **Krishna Mounting Garuda with Satyabhama**
(*facing page*)
Northern India, Rajasthan, Bundi; c. 1730
Opaque watercolor, gold, and silver on paper
10 ³⁄₈ x 8 in. (26.35 x 20.32 cm)
Los Angeles County Museum of Art. Gift of Jane Greenough
Green in memory of Edward Pelton Green, AC1999.127.32

29 | **Vishnu on Garuda**
Northern India, Rajasthan, Bundi; c. 1750–75
Ink and opaque watercolor on paper
8 ¹⁄₄ x 10 ³⁄₈ in. (20.95 x 26.35 cm)
Los Angeles County Museum of Art. Gift of Paul F. Walter,
M.77.154.12

These works from the Rajput state of Bundi depict Vishnu and Krishna and his consort riding Garuda (28, 29). The theme of Vishnu and Lakshmi riding Garuda was first introduced there around 1630 in the murals of Badal Mahal palace,[39] and became a popular subject with Bundi artists. The examples here represent different stages of the process of creation of such paintings: one is a finished work with the color filled in, while the other just has ink outlines with the underdrawing visible. Hence in the latter we get a glimpse of the experimentation that an artist went through before arriving at a finished product.

In the colored painting (28) we are presented with a landscape, and it is unclear if Garuda is flying or walking. He carries a sword and shield in one hand and Vishnu's conch shell in the other. Climbing aboard his back is a two-armed, blue-hued archer accompanied by a woman. The sky above has three winged figures who play musical instruments in a celebratory vein. The subject can be identified as an episode from the *Bhagavata Purana* in which the avatar Krishna kills the demon Naraka and seizes the wish-granting Parijata tree from his capital. He is accompanied on this mission by his wife Satyabhama and they ride Garuda. At the beginning of the relevant *Bhagavata Purana* chapter Krishna is called the wielder of the Sharanga bow, which fits the depiction here: Krishna as an archer accompanied by his wife riding on Garuda.[40]

Maharao Bhim Singh (r. 1707–20) introduced Garuda as the state symbol of the kingdom of Kota in 1719. Kota is immediately to the south of Bundi, where these paintings may have been made, and is often referred to as Bundi's sister kingdom because the rulers were blood relations and shared many interests and tastes. Two Garuda standards are worshipped as part of Kota's elaborate Dussehra celebrations today, although in the context of that festival Garuda is celebrated for his assistance in the defeat of Ravana, the demon king who is the arch enemy of the avatar Rama.[41] In the modern Kota festival, icons of Lakshmi and Narayana play the roles of Rama and his wife Sita and they mount Garuda so they can be transported to battle. Diwali, the festival of lights that comes nineteen or twenty days after Dussehra, celebrates Rama's return to his kingdom after fourteen years of exile. But in Vaishnava states like Kota, it also commemorates Krishna's defeat of Naraka. Hence in the Kota context, the pair of figures mounting Garuda would have multiple identities as Narayana and Lakshmi, Rama and Sita, and Krishna and Satyabhama.

In the ink image (29), Garuda is in flight and Vishnu seems ready for battle. He is depicted with eight arms rather than four and carries a host of weapons. [NP] ✳

The Legends of Vishnu

Vishnu is understood as a vast, formless, transcendent god who usually employs his avatars to conduct specific tasks. However, there are a few stories in which the god appears in nonavatar form, usually because the task at hand is greater than the more earthly heroics performed by avatars. In these manifestations he is known simply as Vishnu or Narayana.

Perhaps the most important and revered of the legends associated with Vishnu is the Creation story. There are two basic versions of Creation promoted by Hinduism: in both stories, the god Brahma brings the cosmos into being, but in the non-Vaishnava version, Brahma emerges from a golden egg, while in the Vaishnava version he emerges from Vishnu, who in this story is more often called Narayana. Narayana reclines on the giant serpent known as Ananta or Shesha, adrift on the primordial ocean. As he sleeps, a lotus grows from his navel and when it blooms, Brahma appears inside, ready to create. By having Brahma emerge from Vishnu, the Vaishnavas usurped Brahma's role as great Creator and reassigned it to Vishnu. The representation of reclining Vishnu is extremely popular and in some temples—most notably Srirangam in Tamil Nadu—this image is enshrined as the central object of worship.

Another, related story has Vishnu reclining amid the primordial ocean, but this time he lies on the leaf of a pipal or banyan tree, having assumed the form of a baby. This takes place not at Creation, but shortly before it, during the Destruction of the previous world. Vishnu reveals himself in this infant form to a great immortal sage, Markandeya, who is the only person ever to witness the transition from the end of one cycle to the beginning of the next. Markandeya calls to Vishnu to save him from the terrible fire and floods of the apocalypse, and the infant offers to let the sage enter his mouth. Inside, Markandeya finds all of creation, from the earth to the heavens.[42]

These two stories establish the immeasurable influence and pervasiveness of Vishnu promoted by Vaishnavas. The third important story associated with Vishnu in his primary form is much more reminiscent of the avatar legends because it involves a descent to earth in order to save a righteous devotee. In this story, known as *Gajendra Moksha,* or the Release of the King of Elephants, Vishnu flies down from the heavens when he hears the prayers of an elephant that is struggling with a sea monster (see fig. 36–1). Whereas the other two stories show Vishnu's participation in creation and destruction, this story illustrates the god's role as savior.

30 | Vishnu in His Cosmic Sleep
Central India, Madhya Pradesh; c. 12th century
Sandstone
14 9/16 x 27 9/16 in. (37 x 70 cm)
Private collection, Europe

31 | Vishnu in His Cosmic Sleep (*facing page*)
Northern India, Rajasthan, Ajmer; c. 1700
Opaque watercolor and gold on paper
7 x 6 ¾ in. (17.8 x 17.1 cm)
Catherine and Ralph Benkaim Collection

Complex in both iconography and meaning, the image of the Creation is perhaps the most difficult Vaishnava subject for non-Hindus to understand. A passage from the epic *Mahabharata* describes the scene:

> When there was but a single, dreadful ocean, and the moving and standing creation had perished, and all the creatures had come to an end … the blessed Vishnu, the everlasting source of all creatures, the eternal Person, slept solitarily on his ocean bed in the vast coil of the boundlessly puissant snake Shesha…. While the God was sleeping, a lotus of the luster of the sun sprouted from his navel; and there, in that sun-like and moon-like lotus, Grandfather himself was born, Brahma, the guru of the world.[43]

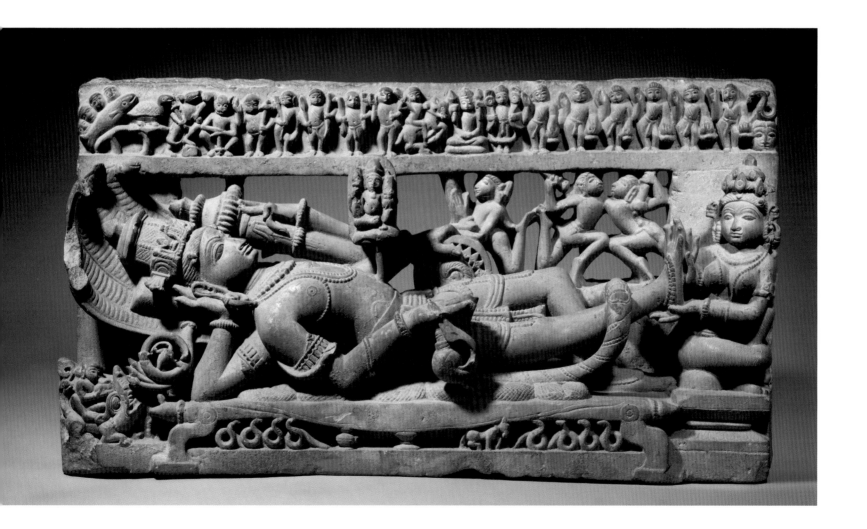

All Hindu accounts of Creation and Dissolution cite the ocean as the transitional state, chaotic and inhospitable but also amniotic. Mythic serpents, known as *nagas*, reside in the waters, and most of them are poorly behaved. Shesha, however, conducted religious penance in order to rise above his lot and was allowed to be of service by holding the earth steady on his coils.[44] Vishnu lies on Shesha for his cosmic sleep; the fact that Creation takes place while Vishnu is asleep suggests that everything we experience is merely Vishnu's dream. In Indian traditions, the navel is often cited as a locus of power, and a god's navel is said to be the central point around which the universe revolves. Lotuses are usually emblems of transcendence, rising up from the murk to bloom in pure colors; here the lotus stalk is more like an umbilical cord, albeit attached to the source's stomach rather than to the offspring's. In most artistic representations of the episode, Vishnu is attended by the

earth goddess Bhu Devi, who massages his foot as he sleeps. The goddess is rarely mentioned in Vaishnava accounts, but in the *Devi Bhagavata Purana*, a scripture dedicated to goddess-worship, it is argued that there must be something supporting the ocean on which Vishnu floats, so Bhu Devi, the earth, would have to be present at Creation as well.[45]

The two representations of the legend illustrated here (30, 31) contain the same basic elements—Vishnu lies on Shesha with a goddess assisting him—but they offer very different effects and lessons for the viewer. The painting (31), much smaller and simpler in composition, emphasizes the emptiness of the chocolate-colored ocean around them. Paintings from Ajmer tend to be somewhat minimal in their approach, and here that style is particularly effective. The painter offers an elevated viewpoint so there is nothing to see except the divine group and the lotus-filled waters surrounding them, just as it was at the moment of Creation.

By contrast, the sculpture from central India (30) includes a large cast of characters. Shesha uses his multiple cobra hoods as a canopy to shield Vishnu, who has one hand supporting his head and the other three holding his usual weapons. The goddess rubs his feet. The figure of Brahma (very small, lest we forget who the real Creator is) appears atop a short stem at the center. Flying figures appear in the pierced background panel: two of them appear to carry weapons, so they might be identified as the demons Madhu and Kaitabha, who threatened Brahma and had to be killed by Vishnu. Below are the serpent denizens of the deep.[46] Above and to our left are the ten avatars: Matsya the fish (with the four Vedas behind him), Kurma the turtle, Varaha the boar, Narasimha the lion-man, Vamana the dwarf, Parashurama with his axe, Rama with his bow and arrow, Balarama with his plow, the Buddha, and Kalki on his horse. At the center is Surya-Narayana, the solar form of Vishnu, seated holding two lotus buds.[47] To the right are the nine planetary deities (*navagrahas*), starting with Surya the sun holding two lotuses and ending with Ketu in the form of a snake above Rahu in the form of a giant head. The presence of the planets celebrates the scope of Vishnu's influence, while the avatars celebrate his role as Preserver as well as Creator. ❋

32 | Markandeya's Vision
Possibly by Manaku (c. 1700–c. 1760)
Northern India, Punjab Hills, possibly Guler; c. 1750
Opaque watercolor and gold on paper
11 ⁷⁄₁₆ x 7 ½ in. (29 x 19 cm)
Museum Rietberg, Zurich. Former collection of Alice Boner,
RVI 1372

33 | Markandeya's Vision
Northern India, Punjab Hills; c. 1775–1800
Opaque watercolor and gold on paper
11 ½ x 9 ¼ in. (29.2 x 23.5 cm)
Philadelphia Museum of Art. Purchased with the
John T. Morris Fund, 1955-11-1

Several texts tell the story of Markandeya, the immortal sage who actually survived the end of one cycle of existence so that he could describe the Destruction and subsequent Creation in the next cycle. In the *Mahabharata*, Markandeya tells his own story, which begins after fire has raged through the world, followed by deluge:

> As I roam on this desolate total ocean, without seeing a single creature, I become terribly afraid. I go to all lengths and swim, and despite my fatigue find nowhere a resting place as I keep going. Then one day I see in the flood of the waters a tall, wide banyan tree. I see a child sitting on a spreading branch of that tree ... a child with a face like the full moon and eyes as wide as a blooming lotus ... his skin the color of cornflowers ...
>
> The lotus-eyed and radiant child ... says to me these words, which gladden my ears: "I know that you are very tired, friend, and desirous of rest: sit here, Markandeya Bhargara, for as long as you wish. Enter my body, good hermit, and rest here, sir, I shall make room for you as a favor."... On a sudden the child opens its mouth wide, and powerlessly I am translated into it by an act of fate. And when I so suddenly enter the hollow of his mouth, O king, I behold all of earth overspread with kingdoms and cities.... I see the heavens illumined by sun and moon and blazing with lights.... I see all the hosts of the Gods.... Whatever creature, either moving or standing, which I had seen before in the world I see again in the belly of the Large Spirit. Living off fruits I explore this entire universe inside his body for more than a hundred years, and nowhere do I see an end to his body.[48]

Markandeya is finally delivered out of the infant's belly once it is safe for him.

The revelation offered to the sage is made all the more miraculous by the fact that the cosmos is contained within the body of what appears to be a baby. Other accounts make even more of Vishnu's infant form, describing the throbbing folds of his belly and the way that he sucks his own toes.[49] The significance of the infant form has of course been the topic of much discussion, but among other things, it can be understood as an emblem of hope and the object of unmatched adoration, simultaneously gentle and powerful.

These two very similar paintings of Markandeya's vision (32, 33) were probably made by members of the same artist family, one or two generations apart. Manaku, possibly the painter of the earlier image, created figures that exhibit an illusion of volume not previously found in paintings made in that region. Subsequent generations in Manaku's family took his nascent naturalism further, rendering lively figures in minute detail. In their images of Markandeya approaching the infant, both artists have reduced the banyan (or pipal, a type of fig tree) to a five-leafed branch, appropriately detailed, with new leaves budding in orange and small purple figs growing along the stem.[50] The later painting is more expressive of the chaotic situation, with water swirling in the background and the exhausted sage more clearly desperate for shelter.

In both cases the artist invites us to conflate the infant manifestation of Vishnu with that of Krishna (see the Krishna section for similar figures), and indeed in some texts the cosmic infant is identified as Krishna, who offers a similar vision of the cosmos within his body when his adoptive mother Yashoda looks into his mouth. Neither artist has attempted to depict what lies within the infant. ✺

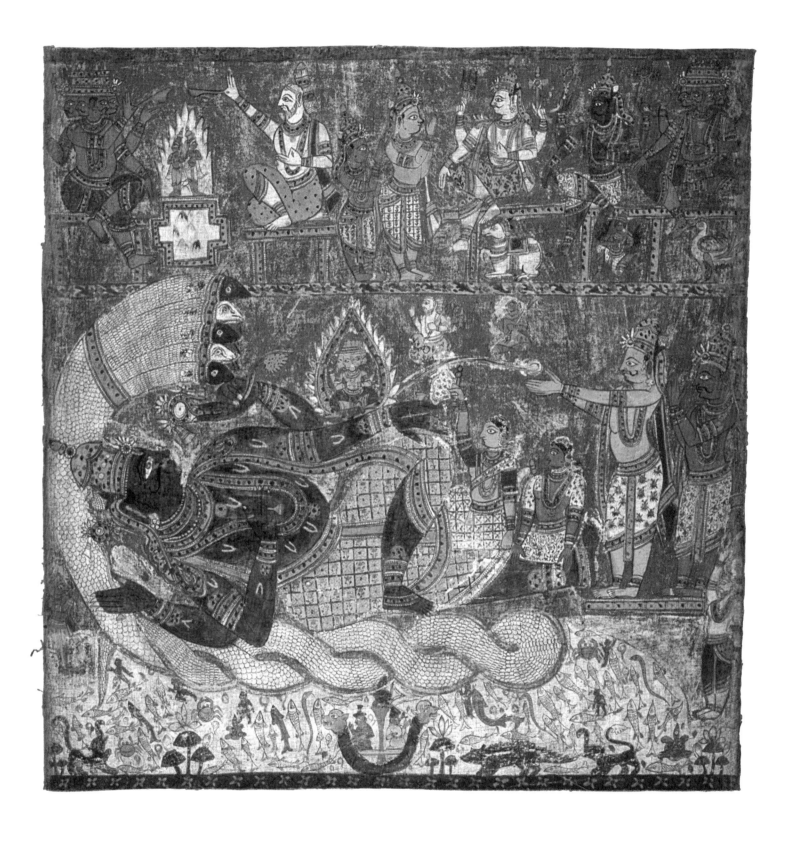

34 | Vishnu in His Cosmic Sleep (*facing page*)
Fragment from a scroll depicting the lives of Markandeya
and Bhavana
Southern India, Andhra Pradesh, Telangana region;
late 18th century
Opaque watercolor and gold on cloth
34 ⅝ x 34 1/16 in. (88 x 86.5 cm)
University of Michigan Museum of Art. Gift of Dr. and Mrs.
Leo S. Figiel and Dr. and Mrs. Steven J. Figiel, 1980/2.305

35 | Vishnu Reclining on a Pipal Leaf
Fragment from a scroll depicting the lives of Markandeya
and Bhavana
Southern India, Andhra Pradesh, Telangana region;
late 18th century
Opaque watercolor and gold on cloth
34 x 34 in. (86.4 x 86.4 cm)
University of Michigan Museum of Art. Gift of Dr. and Mrs.
Leo S. Figiel and Dr. and Mrs. Steven J. Figiel, 1980/2.306

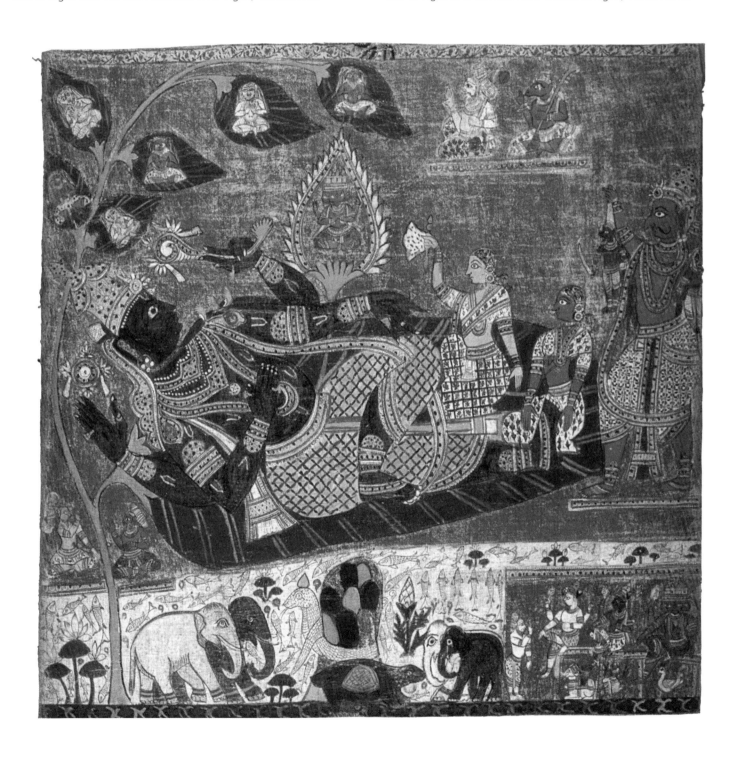

These two large paintings on cloth (34, 35) were cut from a long, vertical scroll that was used in performances by itinerant storytellers. Each scene is boldly painted for optimal viewing from a distance, but also elaborately detailed so the narrator would not lack for material. Performances of this scroll were reserved for members of the Padmasali caste, who were traditionally employed as weavers (other scroll subjects were performed for other castes).

The scroll depicts episodes from the life of the sage Bhavana, who invented weaving and is considered the progenitor of the Padmasalis. Bhavana emerged from a ritual fire kindled by the sage Markandeya, who conducted the fire sacrifice when he wanted to create clothing for the gods. Bhavana spun thread from the fibers of the lotus that had risen from Vishnu's navel, and he used it to make divine finery, making him the first weaver. Because Markandeya was responsible for Bhavana's creation, he figures prominently in the scroll as well.

The image of Creation (34) with Vishnu lying on Shesha, is pertinent to the scroll because of the lotus and because Markandeya is often said to have been present to witness it. Here Vishnu is accompanied by two consorts at his feet. The two standing male figures are difficult to identify with certainty; they are worshipping Vishnu by pouring an offering of water and appear again at the center of the top register.[51] To their left Brahma assists Markandeya with the fire sacrifice, in which a small figure—presumably Bhavana—appears. To the right are white-skinned Shiva with his bull, blue-skinned Vishnu with Garuda, and multiheaded Brahma with his goose. Beneath Shesha is a wonderful depiction of ocean life, with several types of fish, a crocodile, and sea monsters called makaras.

The image of Vishnu on the banyan leaf (35) is quite different from the two paintings examined previously; Vishnu is apparently not in infant form. Instead, he has Brahma rising from his navel and the company of two consorts. It is not surprising that the banyan tree and Creation stories would be conflated, since they both involve the god reclining on the primordial ocean. Additional deities appear on other leaves of the tree. Again, the identity of the large standing figure at the right is unclear. Below Vishnu appears a vignette with Kurma the tortoise avatar supporting Mount Mandara and the serpent Vasuki wrapped around it, ready to serve as the churning rope: this is a slightly later episode in the watery Creation myth. Markandeya is shown at the lower right, worshipping Shiva, Vishnu, and Brahma. ❁

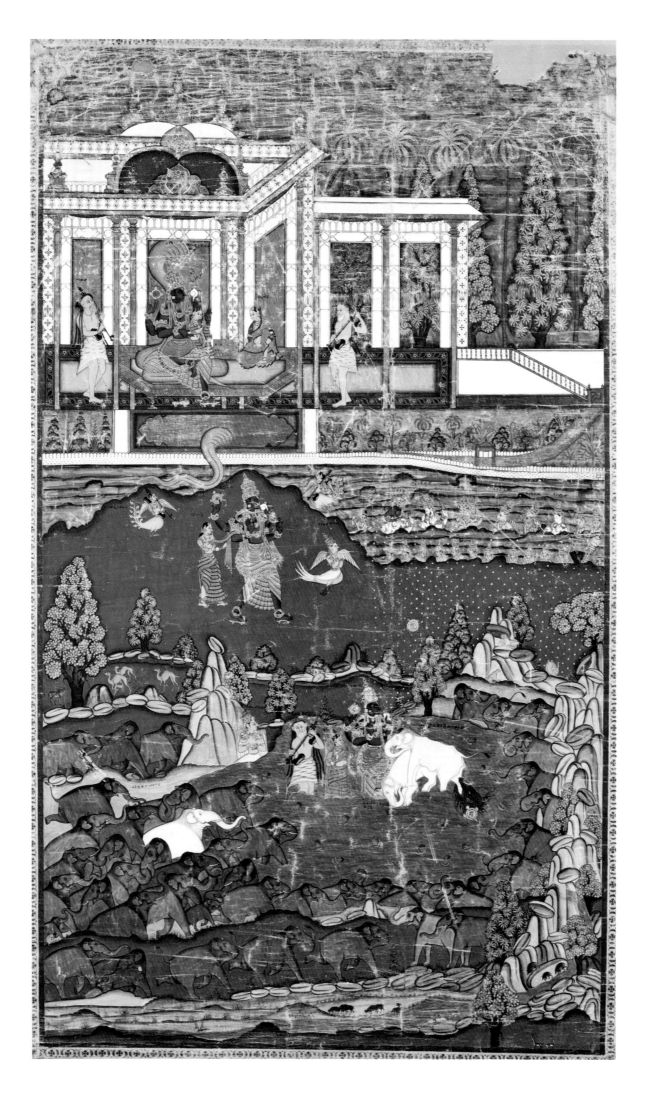

36 | Vishnu Saving the Elephant (Gajendra Moksha)
(*previous page*)
Attributed to the Jaipur Painter
Southern India, Deccan, Hyderabad; early 18th century
Opaque watercolor on cloth; 55 ½ x 33 ¼ in. (141 x 85.5 cm)
Catherine and Ralph Benkaim Collection

37 | Vishnu Saving the Elephant (Gajendra Moksha)
(*facing page, far right*)
Northern India, Rajasthan, Kota; mid 18th century
Opaque watercolor and gold on paper
8 ¹⁄₁₆ x 5 ⁹⁄₁₆ in. (20.5 x 14.1 cm)
Collection of Kenneth and Joyce Robbins

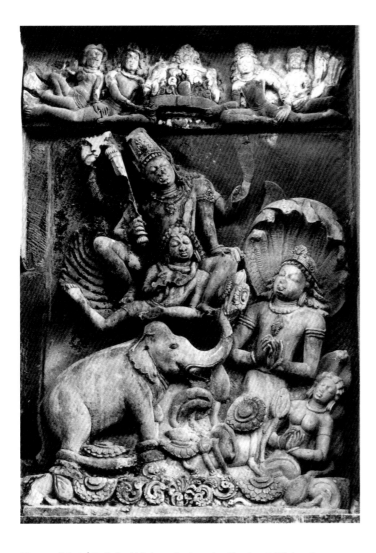

Figure 36–1 | Relief of Vishnu Saving the Elephant (*Gajendra Moksha*), Dashavatara Temple, Deogarh, Uttar Pradesh, 6th century.
Photograph courtesy Digital South Asian Library, American Institute of Indian Studies

The most popular story in which Vishnu descends to earth in his own form (rather than as an avatar) is the tale of the elephant seized by a sea creature. Known in Sanskrit as *Gajendra Moksha*, the Release of the King of Elephants, this tale has been illustrated by artists since at least the sixth century, when it appeared in a large relief on the side of the Deogarh Dashavatara temple (fig. 36–1).

Several scriptures recount the incident, which usually begins with an extensive description of the beautiful natural setting, a verdant garden surrounded by mountains with a lake "resplendent with golden lotuses."[52] The king of the elephants, in full rut, is mating with his females in this garden when the group decides to bathe in the lake. There, a powerful sea creature, probably best understood as a gharial or Ganges crocodile, clamps down on the elephant-king's leg and attempts to pull him into the depths. The two struggle at length (in most accounts their battle lasts one thousand years) until the elephant is nearly dead from exhaustion. He finally thinks to turn to Vishnu for help. In some versions, he recites a long hymn to the god; in others he has only enough strength to lift a lotus skyward and speak the god's name. Vishnu's response is swift:

> Seeing the elephant greatly afflicted, Lord
> Hari ... (feeling the speed of Garuda as
> too slow) at once alighted (from Garuda),
> and immediately dragging the elephant
> out of the lake along with the alligator,
> out of compassion rescued the lord of the
> elephants from its jaws by rending them
> open with the discus, while gods stood
> simply looking on.[53]

The two paintings (36, 37) illustrate the incident in radically different ways, but both emphasize the notion of descent. The first (36), hailing from the Deccani kingdom of Hyderabad, shows Vishnu three times: at the top in a palatial setting seated on the serpent with Lakshmi and attendants, then below at the center where he is apparently assessing the situation, and then in the lake, where he helps to pull the emaciated elephant from the clutches of the monster. The elephant appears twice, in overlapping

bodies, the second bowing to Vishnu while a barely visible human head emerges below, presumably illustrating the release of the individual who had been trapped within the elephant's body by a curse (see detail above).[54]

This large-scale composition, painted on cloth and probably used for storytelling performances much like catalogues 34 and 35, offers a simple map of the cosmos, with Vishnu's paradise, known as Vaikuntha, at the top, a narrow strip of sky at the center (the other gods appear on this level, as small onlookers floating in the clouds as if they were water), and the watery, rocky domain of animals below. The heavenly realm is cultured and sophisticated, with orderly trees and a rectangular pool, while the animal realm is untamed, with forbidding mountains ringing the irregularly shaped lake. The three-tier composition recalls Vishnu's conquest of the three realms of the cosmos, a story that will be discussed in the section on the Vamana avatar.

By contrast, the Kota painting (37) captures the story in a single vignette, with Vishnu swooping down to save the elephant, who raises the lotus to him. This composition closely follows the *Bhagavata Purana* account, in which Vishnu left Garuda behind in his rush to reach the elephant. The god appears in an active stance, leaping downward with chakra poised for throwing.[55] Although much smaller and less complex than the Hyderabad painting, the Kota image includes several evocative details such as the panicked scramble of the female elephants, whose dark bodies serve to highlight the white skin of their king, an effect echoed in the stormy clouds above. ✿

Notes: The Image of Vishnu

1 It remains unclear whether all stone and clay sculptures were painted in the ancient Indian world. Certainly some modern and renovated temples boast colorful sculpted imagery, and iconographic texts indicate the appropriate colors for sculpted icons. However, surprisingly few traces of old pigment remain on most Hindu temple carving. The scarcity of remaining pigment suggests that at least some temple sculpture was left unpainted.

2 Upon its arrival at the Museum of Fine Arts, Ananda K. Coomaraswamy suggested that the piece dated to c. first–second century CE.

3 A stone inscription at the Udayagiri site states that the carving of the caves took place during the reign of Chandragupta II (382–401 CE), so this sculpture is likely to date to the last decades of the fourth century. The date of the Boston piece might be even later, as suggested by comparison to a similarly sized, similarly rudimentary Vishnu image carved into one side of a pillar found at Rajghat in Varanasi (now in the Bharat Kala Bhavan, Varanasi) that bears a date to 478 CE, during the reign of Budhagupta. See James C. Harle, *Gupta Sculpture: Indian Sculpture of the Fourth to the Sixth Centuries A.D.* (London: Oxford University Press, 1974), pls. 56, 57.

4 Ananda K. Coomaraswamy identified it as a fire altar, which wouldn't be inappropriate for Vishnu, as he is closely associated with Vedic-style sacrifice in early literature.

5 We do not know if these altars were originally installed within shrine structures or if they were open to the elements. If there were shrines, then these buildings must have been constructed from nondurable materials because little survives to indicate their presence.

6 Similar examples in the collections of the Asian Art Museum of San Francisco and the Cleveland Museum of Art (both published by Pratapaditya Pal in *The Ideal Image: The Gupta Sculptural Tradition and its Influence* [New York: Asia Society, 1978], cat. nos. 3, 24) and another example in the Government Museum, Mathura (no. 59.4838) are carved in the round, suggesting that this was a common practice.

7 Related images can be found in the exhibition catalogue *Chefs-d'oeuvre du Delta du Gange: Collections des Musées du Bangladesh* (Paris: Musée Guimet, 2007), cat. nos. 8, 19.

8 The representation of the chakra in profile appears to be an indication of an early date, usually to the Pallava period (sixth–ninth century). Later representations of Vishnu from Tamil regions show him with the chakra facing the viewer, as seen in cat. 6 herein. It is perhaps a little too tidy to speculate that with its discus in three-quarter view, the Seattle figure can be attributed to a transitional period, when Pallava tastes were giving way to Chola.

9 J.E. van Lohuizen-de Leeuw, *Indian Sculptures in the von der Heydt Collection* (Zurich: Museum Rietberg, 1964), 202.

10 See T.A. Gopinatha Rao, *Elements of Hindu Iconography* (1914; reprint Delhi: Motilal Banarsidass, 1993), vol. 1, part 1, 227–44, for various lists of the twenty-four most prominent forms of four-armed Vishnu.

11 A similar arrangement of seated, four-armed Vishnus with Surya-Narayana at the top appears on the separately carved *parikara*

surrounding the icon of Vaikuntha Vishnu in the Lakshmana temple at Khajuraho (see Fig 145–1). The complex iconography of that temple and its enshrined image has been the topic of considerable discussion by scholars, and the presence of Surya-Narayana on the shrine image frame only adds to the confusion. See Hiram W. Woodward Jr., "Lakshmana Temple, Khajuraho and its Meanings," *Ars Orientalis* 19 (1989), 27–48; and Devangana Desai, *Religious Imagery of Khajuraho* (Delhi: Franco-Indian Research, 1996), 99–148.

12 From the *Mahabharata*, translated by Kisari Mohan Ganguli, in http://www.sacred-texts.com/hin/m01/m01228.htm.

13 From the *Mahabharata*, translated in W.E. Begley, *Visnu's Flaming Wheel: The Iconography of the* Sudarsana-Cakra (New York: New York University Press, 1973), 11.

14 Ibid., 14.

15 Ibid., 65.

16 Ibid., 66.

17 Ibid.

18 Ibid., 85.

19 Ibid., 67.

20 Ibid., 71.

21 Ibid., and to Joan Cummins in conversation.

22 Ibid., 73.

23 Martin Lerner, *The Flame and the Lotus* (New York: Metropolitan Museum of Art and Harry N. Abrams, 1984), 84.

24 The Dinajpur image is now in the Bangladesh National Museum, Dhaka. It is reproduced and discussed in Frederick M. Asher, *The Art of Eastern India, 300–800* (Minneapolis: University of Minnesota Press, 1980), 96 and pl. 234.

25 There have been several studies of the origins of Lakshmi worship and imagery. The most recent, which casts a broader net than others, is Doris Meth Srinivasan's "Sri-Laksmi in Early Art: Incorporating the North-western Evidence," *South Asian Studies* 26, no. 1 (March 2010) 77–95.

26 Ganesha and Karttikeya, usually understood to be the sons of Shiva and Parvati, were both born in unusual circumstances; neither is the offspring of both god and goddess in the traditional sense.

27 Amy G. Poster et al., *Realms of Heroism: Indian Paintings at the Brooklyn Museum* (New York: Brooklyn Museum and Hudson Hills Press, 1994), 157. The colophon recording the dream that inspired the image is on the reverse of the original painting, published by Karl Khandalavala, Moti Chandra, and Pramod Chandra in *Miniature Paintings from the Sri Motichand Khanjanchi Collection* (New Delhi: Lalit Kala Akademi, 1960), 49, pl. E.

28 A figure similar to the Benkaim Vishnu appears in a painting showing an enthroned Krishna and Radha receiving homage from the poet Bihari, also attributed to Nainsukh but not inscribed. That painting, in the collection of the late Alvin O. Bellak, and now in the Philadelphia Museum of Art was attributed by B.N. Goswamy to 1763 or later, when Nainsukh was in the later phase of his career. See B.N. Goswamy and

Eberhard Fischer, *Pahari Masters: Court Painters of Northern India* (Zurich: Artibus Asiae, 1992), 302.

29 The relief appears in a roundel on the *vedika* or stone fence that surrounded the Buddhist *stupa* (reliquary mound) at Bharhut in central India. The *vedika* is now in the Kolkata Museum (Calcutta).

30 The kinship is mentioned briefly in several texts, but rarely explained or analyzed. Durga is often associated with Shiva's consort, Parvati, and Parvati is said to be Vishnu's sister as well. Probably the most prevalent explanation for Durga's kinship to Vishnu is that as Yogamaya, she is born to Krishna's mother. The goddess takes the form of an unborn child and is born immediately before Krishna, in order to protect the infant god from his evil uncle. When the uncle kills the infant/goddess, Yogamaya rises up from the body to reveal his mistake. Yogamaya/Durga is thus worshipped by devotees of Krishna as his elder sister, although other traditions consider Durga to be Vishnu's younger sister. See *Bhagavata Purana,* Book 10, Chapter 4, line 9 (hereinafter 10.4.9).

31 There are many non-Vaishnava Durga images in the South as well. For further discussion of Durga's role in southern Indian tradition, see Vidya Dehejia, *The Sensuous and the Sacred: Chola Bronzes from South India* (New York: American Federation of Arts, 2002), 134–37.

32 In texts, Vaishnavi almost always acts as a member of one of these groups of goddesses. In the *Varaha Purana* (chapter 90), she is part of a trio of goddesses, emanating from the combined forces of Brahma, Vishnu, and Shiva.

33 Robert Beer, *The Handbook of Tibetan Buddhist Symbols* (Boston: Shambhala, 2003), 76.

34 The panel is crafted in the regional style of Mathura during the Gupta period (fourth–sixth century CE) as indicated by its modeling of figures and the use of the circular punch marks. From Amy Poster, *Journey through Asia: Masterpieces in the Brooklyn Museum of Art* (Brooklyn: Brooklyn Museum of Art; London: Philip Wilson, 2003), 168.

35 Poster, *Journey through Asia*, 168.

36 Pratapaditya Pal, *Desire and Devotion: Art from India, Nepal and Tibet in the John and Berthe Ford Collection* (Baltimore: Walters Art Museum; London: Philip Wilson, 2001), 78.

37 The inscriptions were studied in 1999 by Dr. Gouriswar Bhattacharya and the information was obtained from Dr. Qamar Adamjee at the Asian Art Museum, San Francisco.

38 Susan Huntington, *The "Pala-Sena" Schools of Sculpture* (Leiden: E.J. Brill, 1984), 184.

39 Joachim K. Bautze, catalogue entry in Stuart Cary Welch, editor, *Gods, Kings, and Tigers: The Art of Kotah* (New York: Asia Society Galleries; Cambridge, MA: Harvard University Art Museums; Munich: Prestel, 1997) cat. no. 42, 158–59.

40 *Bhagavata Purana*, 10.59.

41 Bautze, in *Gods, Kings, and Tigers,* 158–59.

42 This story is reminiscent of several other Vaishnava accounts in which Vishnu or one of his avatars opens his mouth and an onlooker witnesses all of creation inside. See the Varaha section.

Unlike the similarly vast Vishvarupa manifestation (see the section on Krishna), the revelation given to Markandeya is not entirely frightening and it offers the sage shelter from the perils of cosmic annihilation.

43 *Mahabharata, Aranyaka Parvan,* chapter 194, verse 10, translated by J.A.B. van Buitenen (Chicago: University of Chicago Press, 1975), 2:611.

44 *Mahabharata, Adi Parvan,* chapters 31–32, van Buitenen translation, 1:91–93.

45 *Devi Bhagavata Purana,* Book 1, Chapter 2, lines 6–10. A serviceable translation is available online at www.astrojyoti.com/devibhagavatam1.htm

46 The significance of the small horse is unclear. A relief with almost identical iconography, but somewhat earlier in date, is in the Los Angeles County Museum of Art, no. M.79.111. It also has the horse in the bottom register. See Pratapaditya Pal, *The Divine Presence: Asian Sculptures from the Collection of Mr. and Mrs. Harry Lenart* (Los Angeles: Los Angeles County Museum of Art, 1978), 14.

47 Another small image of Surya-Narayana appears at the top of the *parikara* in cat. 7 herein.

48 *Mahabharata, Aranyaka Parvan,* chapter 186, verses 75–110, van Buitenen translation, 2:589–90.

49 *Bhagavata Purana*, 12.9.24–25.

50 *Ficus religiosa;* it is the same species under which the Buddha gained enlightenment.

51 They might represent Madhu and Kaitabha, the demons who were slain by Vishnu soon after Brahma emerged from the lotus. In their arrogance, Madhu and Kaitabha questioned the power of the gods and offered Vishnu a boon. Pouring of water is sometimes an indication that one has agreed to grant a boon, as seen in the story of Vamana.

52 *Bhagavata Purana,* book 8, chapter 2, line 14, translated by Ganesh Vasudeo Tagare, in Ancient Indian Tradition and Mythology Series, vols. 7–11 (Delhi: Motilal Banarsidass, 1999), 1003.

53 *Bhagavata Purana*, 8.3.33, Tagare translation, 1013.

54 Most versions include an account of the previous life of the elephant, and sometimes of the crocodile. In the *Bhagavata Purana*, the elephant was a Vishnu-worshipping South Indian king who had been cursed to elephant rebirth by the sage Agastya when the king was so rapt in meditation that he failed to greet the sage properly. The elephant remembers the hymn to Vishnu from his previous, more pious life. In the *Vishnudharmottara Purana*, the elephant and crocodile were rivals in their earlier existence, when they were both *gandharvas,* or heavenly musicians. The *gandharvas,* with the wonderful names Haha and Hoohoo, were cursed to animal rebirth by the sage Devala after they insulted his taste in music (*Vishhnudharmottara Purana*, book 1, chapter 193).

55 The crocodile is shown already bleeding at the base of his jaws, forecasting the wound he will receive once the chakra is released.

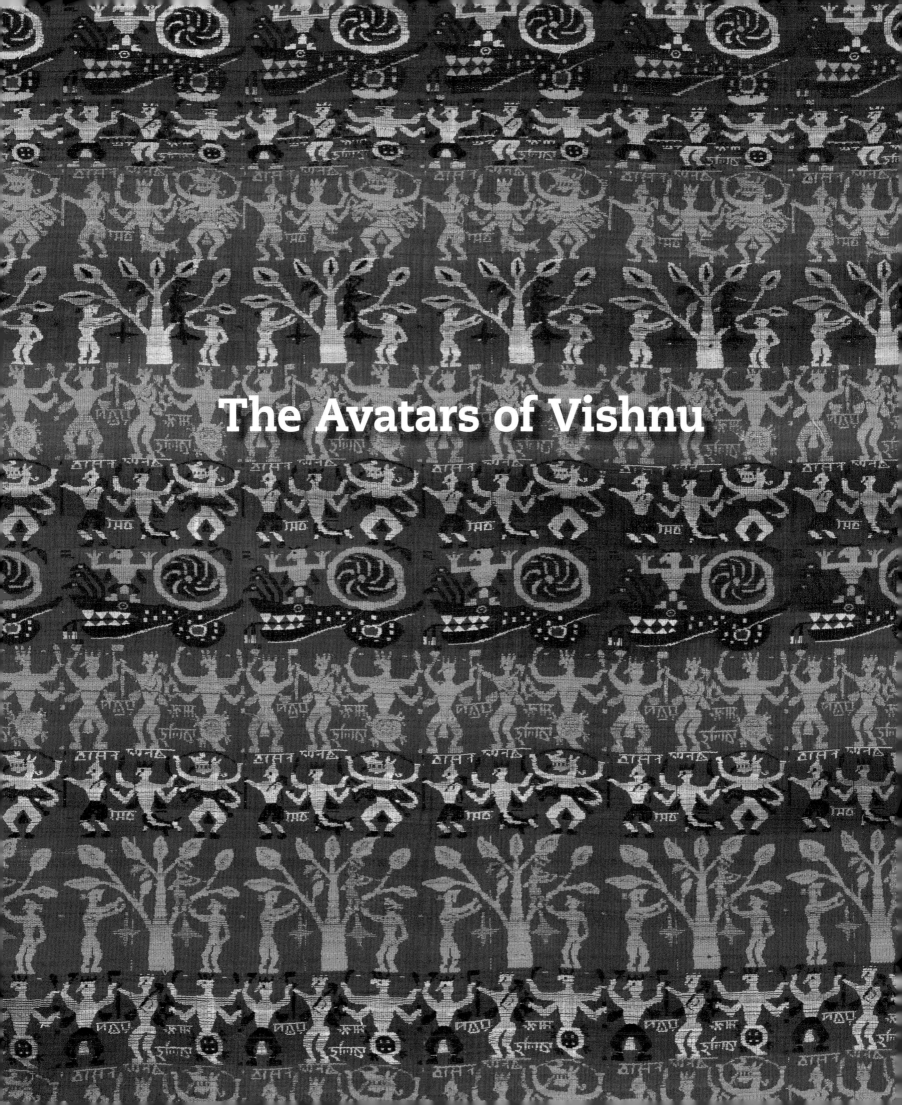

The Avatars of Vishnu

Introduction

The gods and goddesses of Hinduism interact with humanity on a relatively frequent basis, or they did in the past. Vishnu comes to earth more frequently than other gods, and he develops a signature method for the descent: he narrows his vast self down to more limited, more specific forms that are suited to the tasks at hand. These forms are known as avatars. The avatars are corporeal, often mortal, and sometimes even subject to human weaknesses, but physically, morally, and intellectually they are very definitely superior to any earthly being.

The avatars usually descend in order to defeat demons. In almost every case, the demon is a previously righteous individual who was corrupted by excessive power after being granted a boon by another god. Demons, known as *rakshasa*s, are treated as a separate species in Hindu mythology. They are not inherently evil but they can cause serious trouble because they are both more powerful and less disciplined than humans. They are not to be killed without cause, but when they threaten the fragile balance of power in the universe they must be stopped.

The avatars of Vishnu are often celebrated as a group, usually of ten (the *Dashavataras*, "ten avatars"). Many of these figures were discussed in early texts, but they were not identified as avatars or associated with one another until the *Matsya Purana* listed a group of six, probably around the fourth or fifth century CE. The *Vishnu Purana,* of about the sixth to eighth century, offers a standard list of ten: Matsya the fish, Kurma the tortoise, Varaha the boar, Narasimha the man-lion, Vamana the dwarf, Parashurama the Brahmin, Rama the prince, Krishna the cowherd-prince, the Buddha, and Kalki the avatar of the future. In other texts, the list varies because Krishna is often left off (being treated as Supreme God, more than an avatar) and is replaced by his brother Balarama, or Balarama replaces the Buddha. The *Bhagavata Purana* lists twenty-two avatars, all of them envisioned as manifestations of Krishna.

When the avatars are discussed as a group, it serves as a celebration of Vishnu's (or Krishna's) great power and compassion, a wonder-filled account of the god's multiplicity. The most popular text celebrating the ten avatars is a series of brief verses that appear at the beginning of the romantic-devotional poem *Gita Govinda (Song of the Cowherd)* by the twelfth-century author Jayadeva. Repetition of these verses is prescribed for many Krishna-worshipping sects, and the *Gita Govinda*'s accounts of the ten avatars form the basis for series of paintings—examples from many appear in the subsequent sections—in which each page depicts a single avatar at a key moment.

For the first five avatars, the order of descent illustrates an early Hindu hierarchy of biological and intellectual sophistication, with the fish at the lowest level, succeeded by a reptile, a mammal, a half-human, and finally a human. Such hierarchies were prevalent in Hinduism in concepts of reincarnation—rebirth in the form of a boar was preferable to rebirth as a tortoise—and it extended into the human realm in the form of the caste system. When we look at the human avatars, however, we see that the order ceases to match the caste system hierarchy, with two Brahmins (Vamana and Parashurama), who should have been the most sophisticated, appearing before the avatars of the warrior caste (Rama, Krishna, Balarama, and the Buddha), who should have been somewhat inferior.

38 | Stele with Vishnu, His Consorts, His Avatars, and Other Deities

Eastern India, West Bengal, or Bangladesh;
Pala period, 11th century
Schist; 48 x 20 ¾ x 5 in. (121.9 x 52.7 x 12.7 cm)
Brooklyn Museum. Gift of Dr. David R. Nalin, 1991.244

39 | Stele with Vishnu, His Consorts, the Ten Avatars, and Garuda

Bangladesh; Pala period, 11th–12th century
Schist; 48 x 22 x 8 in. (121.92 x 55.88 x 20.32 cm)
Minneapolis Institute of Arts. The John R. Van Derlip Fund, 90.67

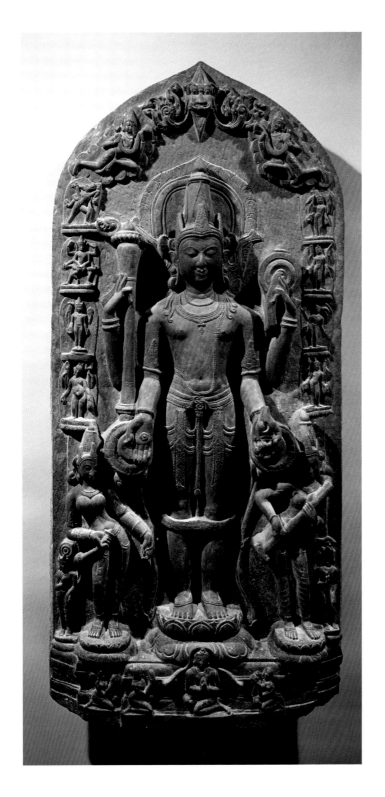

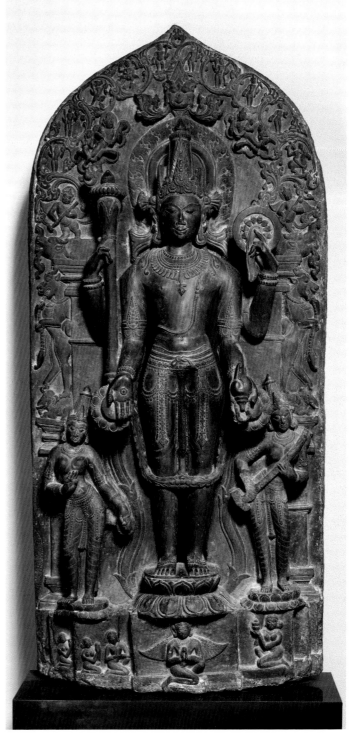

Among the many, many schist steles of Vishnu made during the reign of the Pala dynasty in eastern India and Bangladesh, most are in the form of catalogue 16, with the god flanked by his consorts and by auspicious animals and foliage. The two examples shown here (38, 39) are more complex in their iconography: Vishnu is accompanied by small figures of his avatars, and in the case of the stele now in Brooklyn (38) by other deities as well.

All ten avatars are depicted in the Minneapolis image (39), framed by coiling vines at the top of the panel. They read from our left to right in the order in which they descended. Matsya and Kurma at the far left are depicted in an unusual hybrid form, with the heads of a fish and a tortoise rising from human bodies (they are far more often depicted as purely fish or tortoise, or with the upper body of Vishnu rising up from a fish tail or a tortoise shell). They are followed by the boar-headed Varaha in his usual striding stance and the lion-headed Narasimha with his victim lying on his lap. Immediately below the peak are the dwarf Vamana and the axe-bearing Parashurama. Then along the right slope are Rama with his bow, Balarama with his plow, and a somewhat indistinct figure, apparently wearing a turban, who appears to be the Buddha because he carries no weapons. The final avatar, who has yet to arrive, is the equestrian Kalki. It is interesting to note that all of the avatars are depicted with only two hands, whereas the central figure of Vishnu has four.

The subsidiary figures on the Brooklyn stele appear in columns at either side of the central Vishnu. They at first appear to be four-armed representations of the avatars, but there are only eight of them and not all are in fact identifiable as avatars. On the left side, we can identify Varaha the boar and Narasimha the man-lion at the top, in the same standardized poses as in the Minneapolis piece. But beneath these easily identified figures we find a four-armed Vishnu, holding the same attributes in the same order as the large central Vishnu, and beneath him, the corpulent figure of the god Brahma, whose additional faces are just barely discernable on either side, and who carries the sacrificial spoon and water pot among other attributes. The role played by either of these gods in the overall program is unclear.

The right side also begins with a straightforward string of avatars: Balarama with his plow, Rama with his bow, and Parashurama with a shield and his weapon lifted above his head (this is less clear: there is a chance that this is Kalki, who is more often shown carrying a shield but who is almost never shown without his horse). Beneath these is another figure who appears to be Vishnu, carrying a lotus, mace, and maybe a conch.

Pala-period steles with this mix of gods and select avatars are not unknown, but their ritual function or interpretation is unclear.[1] In any such arrangement of a central god surrounded by smaller figures, the subsidiary deities are understood to be emanations or aspects of the larger icon (see the later section on multiheaded Vishnu images). It is relatively unusual to see the god Brahma in this role, as one of several forms of Vishnu, but as we have seen, according to the Vaishnava creation myth, Brahma is really just another emanation from Vishnu, having risen from the god's navel. ✣

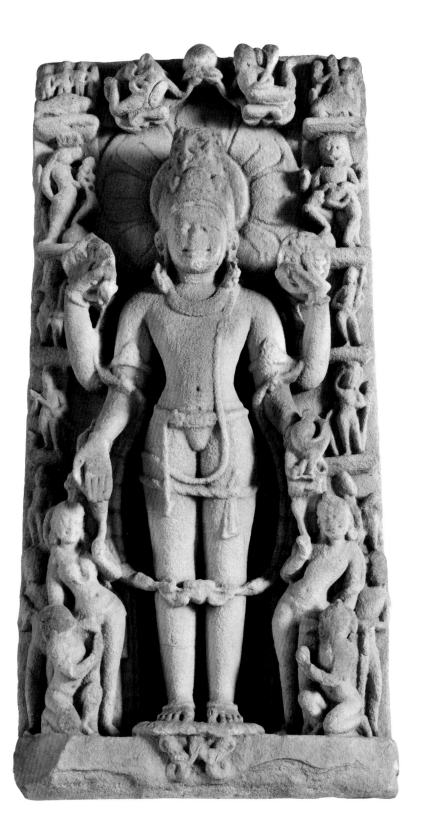

40 | **Vishnu Flanked by the Ten Avatars**
Northern central India; c. 9th–10th century
Sandstone; 38 ¾ x 17 ¾ x 6 in. (98.4 x 37.5 x 15.2 cm)
The Trammell and Margaret Crow Collection of Asian Art,
1982.53

Vishnu appears standing at the center of this stele, holding the chakra (discus) and conch in his left hands and what might have been the head of the mace (with foliage emerging from its top) in his upper right hand.[2] He is flanked by a male and a female figure, apparently unnamed attendants (they have no iconographically distinguishing features). Small depictions of his ten avatars appear on either side. The avatars appear in chronological order, running back and forth from top to bottom, with Matsya the fish at the top left and Kurma the tortoise at the top right, then Varaha the boar and Narasimha the man-lion, the dwarf Vamana and Parashurama with his axe, a human figure at the left holding something long, probably Rama with his bow, another human figure at the right apparently with his arm raised, probably Krishna lifting Mount Govardhana, another human figure with few if any distinguishing features, probably the Buddha, on the left and Kalki on his horse on the right.

The sculpture has received considerable wear, but it remains legible if one knows what imagery is likely to appear, and the original beauty of the smiling central figure is still apparent. The wear makes it more difficult to attribute, since quantity and sharpness of surface details are important indicators of region and period, however the lively grace of the attendant figures suggests a relatively early medieval-period date. An image with such complex and inclusive iconography would have appeared in a prominent position on a temple, either in a major niche on an exterior wall, or possibly enshrined on an altar in the sanctum. ✺

41 | Frame (*Parikara*) for an Image of Vishnu

Northern India, Rajasthan; mid 9th century
Sandstone; 12 3/16 x 82 9/16 x 4 1/2 in. (31 x 209.9 x 11.4 cm)
Smithsonian American Art Museum, Gift of John Gellatly.
Courtesy of the Arthur M. Sackler Gallery, Smithsonian
Institution, LTS 1985.1.592

This arch-shaped relief once formed the upper element of an image frame (*parikara*), similar in form to catalogue 7. It is carved in considerable depth with a complex array of flying figures, couples on elephants, and three small *parikaras* in which three of Vishnu's avatars are enshrined. They are the dwarf Vamana at our left, standing with his parasol, Parashurama at center, seated and with his battle axe over one shoulder, and Rama at the right, seated holding a bow and arrow. Rama is accompanied by a small female figure making *anjali mudra*, the palms-together gesture of greeting and respect; she is probably Sita, his wife. In the standard lists of avatars, these are the middle three, so we can probably assume that the vertical supports of the arch illustrated the others, with the first four on the left (Matsya and Kurma together, followed by Varaha and Narasimha enshrined separately) and the last three on the right (maybe Krishna, maybe Balarama, maybe the Buddha, and Kalki).[3] What's interesting about this approach is that Parashurama, who is one of the least venerated avatars, is by default situated in the most prominent location, at the top center of the arch.

The heavenly host populating the areas between the avatar figures is a standard element of later North Indian sculpture. Their stance, with both knees bent and one foot pointing upward, indicates that they are flying. Most of these attendants carry flowers with which to shower the figure of the icon that would be below, or garlands with which to drape it, but two at the center carry stringed instruments to provide entertainment.

One of the most striking features of this *parikara* is the three monster faces—one at the center and two in profile at the ends. The central face is a hungry demon, a *kirtimukha*. The outer faces are sea monsters, known as *makaras*, who are like crocodiles with elephant snouts. These frightening creatures are actually auspicious emblems, fierce protectors of the temple and icon, representing the fact that even monsters can be inspired to serve the gods. ❀

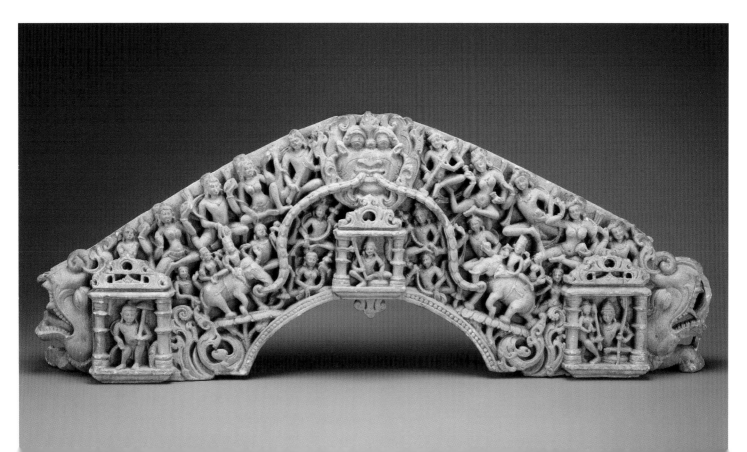

42 | **Two-Sided Plaque with Vishnu and the Ten Avatars**
(*Vishnupatta*)
Eastern India, West Bengal, or Bangladesh; Pala period,
c. 11th century
Phyllite; 5 ⅞ x 6 x ¾ in. (14.9 x 15.2 x 1.9 cm)
Philadelphia Museum of Art. Stella Kramrisch Collection,
1994-148-30

This two-sided stone plaque is a *Vishnupatta*, or tablet dedicated to Vishnu, probably designed as a portable focus for worship. These plaques have been found throughout the Bengal region, which straddles the border between modern-day Bangladesh and the Indian state of West Bengal, and all appear to date to the Pala period (eighth to twelfth centuries) or slightly later. The same form appears in copper and bronze as well. Although the precise ritual purpose of these objects is unclear, scholars have suggested that they were made at major temple sites to be sold to pilgrims, who installed them on their home shrines.[4] There is also a chance that they were made for people to donate to temples, as votive offerings, although one would then expect to find large numbers at temple sites, which has not been the case.

This is an unusually fine example; most are more crudely carved. On one side, it depicts an enthroned Vishnu, flanked by female attendants, with Lakshmi above, being showered by elephants, and Garuda kneeling below. The Vishnu image is framed by an elaborate altarpiece. On the other side, a lotus medallion reveals images of the avatars on its ten petals. The avatars appear in the usual order—from fish to Kalki—progressing clockwise. This arrangement of Vishnu on one side and avatars on the other appears to have been standard for these objects, although the selection of avatars varies from piece to piece. ✻

43 | Standing Vishnu with Consorts and Avatars

Southern India, Karnataka; Western Chalukyan period,
11th century
Bronze; 8 x 4 ½ in. (20.3 x 11.5 cm)
Collection of Eberhard Rist

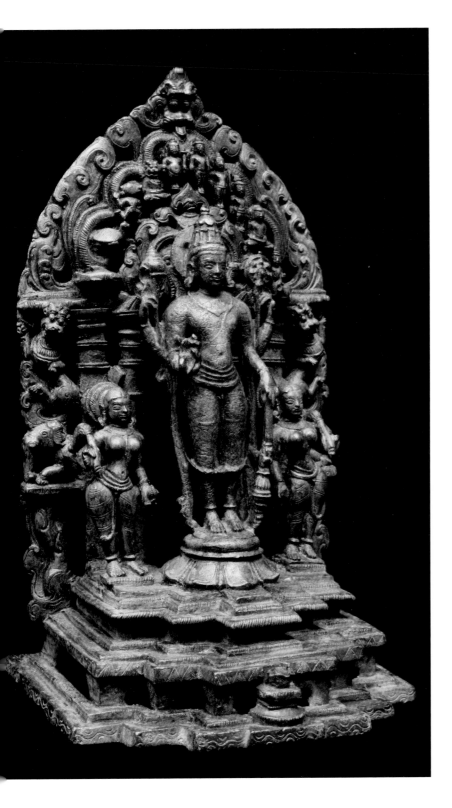

This bronze altarpiece contains an extensive array of information in miniature. Vishnu appears at the center, four armed and holding the usual attributes.[5] He is flanked, in typical South Indian fashion, by the consort goddesses Shri Devi and Bhu Devi, each holding small lotus buds and the yak-tail flywhisks (*chauris*) often carried by heavenly attendants. They stand on a multitiered altar with a small pedestal at the front. This probably supported an image of Garuda, now broken off.

What truly stands out in this image is the elaborate altar frame that serves as a backdrop for the standing figures. Supported by rearing *yali*s, griffinlike beasts, standing on the backs of elephants and with billowing clouds or flames around the edge and a *kirtimukha*, hungry demon face, at the top, the aureole also contains figures of the ten avatars, starting with Matsya the fish at the lower left, with Kurma, Varaha, Narasimha, Vamana, Parashurama, Rama, Balarama, the Buddha, and Kalki appearing in arched formation from left to right. That the figures are so readily identifiable despite their small size is remarkable. The degree of detail is typical of bronze and stone sculpture made for the Western Chalukyan rulers of the western Deccan from the tenth to twelfth century.[6] ✺

44 | Pendant Depicting the Avatars of Vishnu

Northern India, Rajasthan, probably Jaipur; early 18th century
Gold with champlevé enamel, citrine quartz, emeralds, rubies,
and diamonds; 1 15/16 x 1 7/8 in. (4.9 x 4.8 cm)
Museum of Fine Arts, Boston. Otis Norcross Fund, 39.764

With its jeweled front (below right) and elaborately enameled reverse, this small pendant is typical of northern Indian jewelry made for the elite in the seventeenth, eighteenth, and nineteenth centuries. The enameled decoration is created by carving trenches into the surface of the gold, then filling the incised areas with clear and opaque colored glass paste, which is fused to the surface during firing. Unlike most enamel-backed jewelry, which incorporates floral motifs, this pendant features an elaborate miniature tribute to Vishnu's avatars. It was probably made to be worn by a devotee of Krishna, for whom the piece would have served as an amulet (bringing good luck and warding off evil) and a means of keeping the god close to his or her heart at all times.

The pendant features an image of Krishna at the center, delivering the teachings of the *Bhagavad Gita* to Arjuna on his chariot. They are surrounded by the avatars,

who are arranged by size and importance: Narasimha propitiated by Prahalada appears in the upper left corner, followed by Rama, his wife Sita, and standing brother Lakshmana addressed by the monkey Hanuman, then the Jagannatha trio (see cat. 162 for further explanation) in the upper right corner. Matsya the fish and Kurma the tortoise appear on the right edge. Vamana receiving the pledge from Bali and his wife, and Kalki with his horse are along the bottom. Parashurama with his axe and Varaha standing on the body of a demon are on the left side. If we count Krishna and Balarama in the Jagannatha trio as avatars, then all ten are present here. ✸

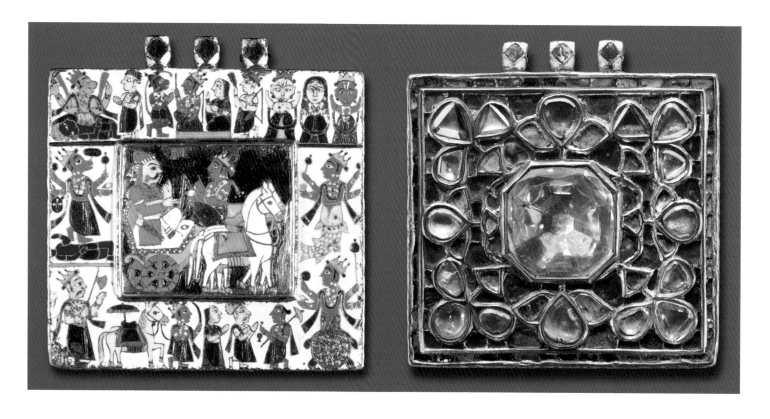

45 | Fragment of a Lampas-Weave Textile Depicting Avatars of Vishnu

Eastern India, Assam; 17th century
Dyed and undyed silk; 49 7/8 x 33 1/2 in. (126 x 85 cm)
Virginia Museum of Fine Arts, Richmond. The Arthur and
Margaret Glasgow Fund, 89.4

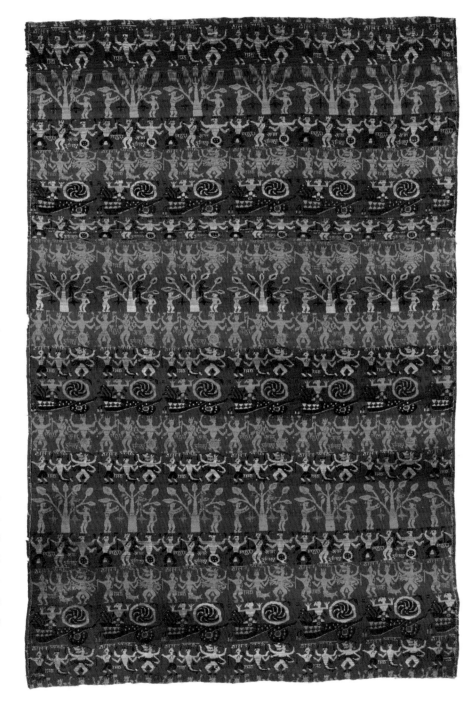

Lampas weaving is a complex technique that involves using two sets of weft threads: one for the background and a supplementary set for creation of a pattern against that ground. The eastern region of Assam specialized in weaving luxurious lampas textiles in rich colors of silk that were exported throughout southern Asia; some of their most complex and compelling products featured figural imagery of Vaishnava subjects.

This impressive piece features horizontal bands of repeating motifs, each depicting an avatar of Vishnu, complete with inscriptions in Assamese identifying the subjects. At the top, bottom, and center, in black and white, we see Matsya with the fish tail, flanked by Vamana and the man-lion Narasimha. Beneath this in yellow is a depiction of a tiny Krishna in a tree, flanked by the gopis as they beg for the return of their clothes (see cats. 115–18). Another black-and-white band depicts Kurma rising from the round tortoise shell, flanked by what appear to be Parashurama and Balarama. Beneath this in yellow is a repeat of the Matsya motif, then in black and white an image of Krishna dancing on the head of the giant serpent Kaliya (see cats. 102, 103).

Scholarship relating to these textiles has uncovered a story relating to their origin in a sixteenth-century royal commission. It appears that their original function was as wrapping cloths for sacred manuscripts of the *Bhagavata Purana* which were enshrined (in the place of icons) in the temples of a Vaishnava sect that did not condone the worship of icons.[7]

�֎

46 | Vishnu on Ananta, Flanked by his Kurma and Matsya Avatars
Kapoori Devi (active c. 1970–1995)
Eastern India, Bihar, Mithila region, Ranti village; c. 1975
Ink and opaque watercolor on paper; 22 x 30 in. (55.8 x 76.2 cm)
Los Angeles County Museum of Art. Gift of Doris E. Bryant,
AC1998.255.3

47 | The Ten Avatars of Vishnu with Their Yantras
(*facing page*)
Batohi Jha (active c. 1975–2000)
Eastern India, Bihar, Mithila region, Madhubani area; c. 1975–82
Ink and opaque watercolor on paper
20 x 59 ¾ in. (50.8 x 151.8 cm)
Asian Art Museum. Museum Purchase, 1999.39.45

These paintings (46, 47) represent a relatively recent manifestation of an art form that is thought to be ancient in origin. In the 1930s, a British art historian offered the first documentation of the intricate, sometimes colorful murals made by women in the villages around the town of Madhubani. These villages lie in an area known since ancient times as Mithila, in the northern part of Bihar state between the Ganges and the border with Nepal. The wall paintings were made primarily as decoration for the inner chambers of upper-caste homes where the household deities were enshrined, where newlywed couples spent their first nights together, and where babies were born. The painting tradition appeared to be well established, with techniques and motifs passed from mother to daughter over many generations.

In 1966–68, the Mithila region experienced a terrible drought that decimated the local economy. In an attempt to bring an alternative form of income to the area, the All-India Handicrafts Board sent social workers with paper and paints, and the women who had once painted walls for special occasions now tried their hands at creating works on paper for sale. The images they made were both traditional and innovative in form, and with their modernist appeal they became quite fashionable and profitable in the last quarter of the twentieth century, both in India's cities and in the West.[8]

The painting by the female artist Kapoori Devi (46) is in the distinctive linear style practiced by members of the high-ranking Kayastha caste. It features a highly stylized Vishnu lying on the serpent Shesha (also known as Ananta), which is unusual in being seen from above. The central figure is flanked by the tortoise Kurma on the left and the fish Matsya on the right—both of these avatars depicted with Vishnu emerging from the necks of the animals—and all three are shown partially submerged in water, emphasizing the aquatic aspect of Vishnu.

The artist Batohi Jha's painting (47) is in a far more colorful, less intricate style, also practiced in the area of Madhubani but more typically by artists of the Brahmin caste. Batohi Jha was one of the few male artists associated with Mithila painting (he is no longer active), and as a practicing Tantric priest, he often included esoteric elements in his work. In this complex image, each of the ten avatars is accompanied by a diagram of circles within squares, known as a *yantra*. In the esoteric practices of both Hinduism and Buddhism, yantras are thought to be powerful evocations of a deity's power and presence, but like all things Tantric, the power of these diagrams can be accessed only by the initiated. It is interesting to note that in this painting, the avatars do not appear in their usual order. Reading from left to right, they are: Krishna fluting, Rama with his bow, Kalki with his horse, the boar-faced Varaha, Narasimha with his tongue hanging out, Parashurama with his axe, the dwarf Vamana with his parasol, Kurma rising from his turtle, the Buddha meditating, and Matsya rising from the fish. ✳

The Matsya Avatar

Vishnu's first incarnation is as a great fish or Matsya. The Matsya incarnation is usually depicted as half-man, half-fish, with Vishnu's four-armed torso emerging from the head of a fish. Occasionally, Matsya is depicted as a gigantic fish, and in rare instances, as having the body of a man and the head of a fish.

There are two stories associated with Matsya: in one, Vishnu incarnates as Matsya to save the Vedas (the oldest sacred texts of Hinduism), and in the other, he rescues man and other creatures from a great deluge and ensures the survival of life on earth. In some versions, the two stories are conflated into one.

The first story from the *Bhagavata Purana* begins with an account of the demon Hayagriva who steals the Vedas from Brahma's mouth while the god is sleeping and hides them in the ocean. Brahma turns to Vishnu for help, and the latter assumes the form of an enormous fish and plunges into the depths, ultimately killing Hayagriva and restoring the Vedas to Brahma.

The second story of Vishnu's Matsya incarnation closely parallels the tale of Noah's Ark from the Book of Genesis. As the righteous king Manu performs rituals on the banks of a river, he is approached by a tiny fish begging for his protection. Manu initially keeps the fish in a pot, which he outgrows overnight. Then Manu uses a well with the same result. Thereafter the fish grows larger than a tank, and a river, and is finally taken to the ocean—which he occupies from shore to shore. Manu realizes that this is no ordinary fish, and Matsya reveals his divine nature. He tells Manu to build a boat and place one of each animal and plant species on it. The Seven Sages (*Saptarshi*), regarded by the Vedas as patriarchs of the Vedic religion, would also accompany him. The boat and its inhabitants would be protected from the destruction that was about to engulf all creation. When the great deluge occurs and the earth is flooded, Matsya keeps the boat afloat for a hundred years. After the waters recede, Manu and the creatures on the boat are entrusted with the task of repopulating the earth. [NP]

48 | Matsya

Northern India, Eastern Himachal Pradesh; 11th century or later
Schist; 14 ⅝ x 12 ⅛ x 3 ¾ in. (37.1 x 30.8 x 9.5 cm)
Philadelphia Museum of Art. Purchased with funds contributed
by Miss Anna Warren Ingersoll, Nelson Rockefeller, R. Sturgis
Ingersoll, Mrs. Rodolphe Meyer de Schauensee, Dr. I. S. Ravdin,
Mrs. Stella Elkins Tyler, Louis E. Stern, Mr. and Mrs. Lionel
Levy, Mrs. Flagler Harris, and with funds from the bequest
of Sophia Cadwalader, funds from the proceeds of the sale
of deaccessioned works of art, the George W.B. Taylor Fund,
the John T. Morris Fund, the John H. McFadden, Jr., Fund, the
Popular Subscription Fund, and the Lisa Norris Elkins Fund from
the Stella Kramrisch Collection, 1956-75-39

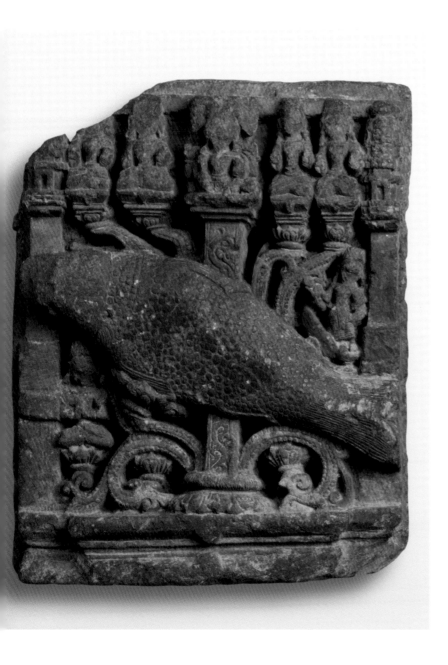

This work portrays Matsya as a gigantic fish. He is resting on one flower of an elaborate lotus plant, the coiling stems, curling leaves and tendrils of which travel all across the work's surface, imitating the waves of Matsya's watery world. Matsya is accompanied by Vishnu's consorts Shri Devi, who sits cross-legged on a lotus near his head, and Bhu Devi, who stands near his tail.[9] Above are a row of five seated figures with Brahma at the center (identifiable in part by the oversized area that would have backed his multiple heads, now damaged). The seated figures on either side of Brahma probably represent the Vedas. Miniature versions of temples of a northern Indian type (*nagara*) decorate the tops of the side pilasters of the image; this relief probably came from a similar temple.[10] [NP] ❈

49 | Matsya Kills Hayagriva

Mahesh (active c. 1730–1770)
Northern India, Punjab Hills, Chamba; c. 1745
Opaque watercolor on paper; 7 5/8 x 11 11/32 in. (19.4 x 28.8 cm)
San Diego Museum of Art. Edwin Binney 3rd Collection,
1990:1187

This painting illustrates a moment near the conclusion of the episode of Matsya recovering the Vedas. Matsya is portrayed as a fish from whose open mouth emerges the four-armed and yellow-robed Vishnu. The demon, with horns and a shell, has been defeated, and Vishnu places a victorious foot on his chest while tearing open his stomach. Three miniature figures signifying the Vedas appear out of the demon's stomach, their hands folded in obeisance to Vishnu.

The depiction of the water here is more pattern-like than a representation of something as seen in the natural world. This is because the artists were not restricted by the dictates of realism, and their intention was to successfully convey the idea of what they were depicting rather than the appearance. [NP]

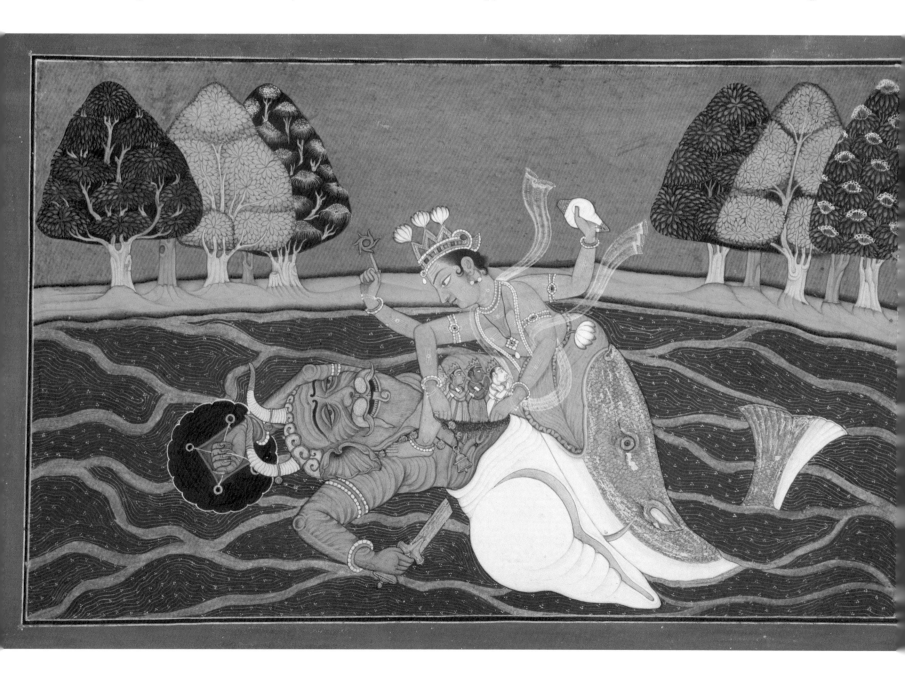

50 | Matsya Saves Manu and the Sages

Page from a *Bhagavata Purana* manuscript
Northern India, Rajasthan, Jaipur or Bikaner; c. 1775
Opaque watercolor on paper; 5 ⅛ x 7 ⅝ in. (13 x 19.5 cm)
Museum Rietberg, Zurich. Former collection Horst Metzger,
RVI 1978

In this painting the artist has depicted together different chronological moments from the *Bhagavata Purana* account of the Matsya avatar that conflates the two stories associated with this incarnation. In the narrow band of sky, the four-headed Brahma sleeps on a bed, exhausted after the task of Creation. The demon who stole the Vedas from him while he was sleeping is shown lying at the bottom of the ocean, already defeated by Matsya. He is portrayed with a horse-head in accordance with his name Hayagriva, which means "horse-necked one." The gigantic, almost reptilian Matsya occupies a large portion of the visual field. The names of the four Vedas he has rescued are written on his neck. To his horn is tied the snake Vasuki, with which he pulls Manu's boat and keeps it afloat during the flood that engulfed all creation. The eight figures on the boat are Manu and the Seven Sages he saved. [NP]

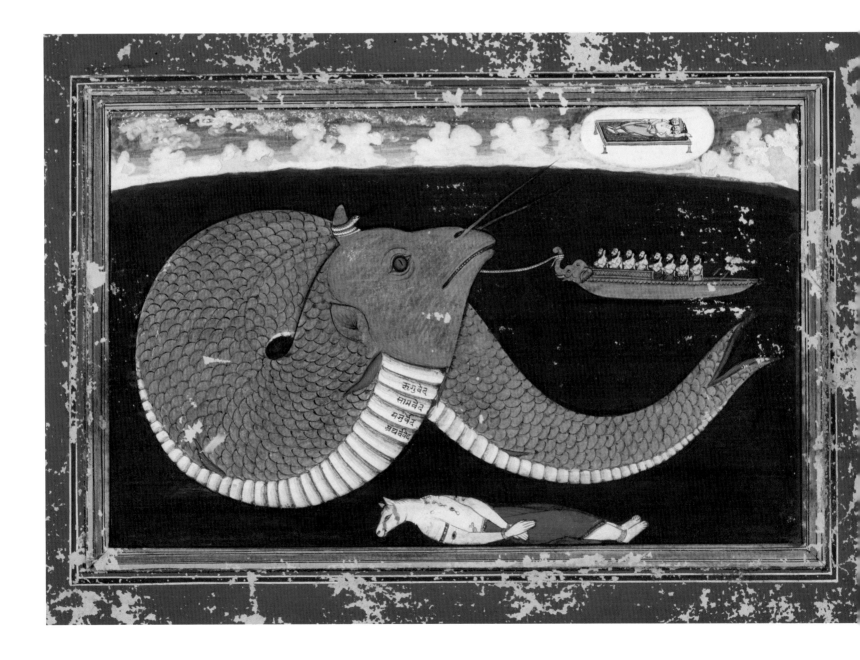

51 | Pot Lid with Painting of Matsya Slaying the Demon

Eastern India, Orissa; late 19th–early 20th century
Opaque watercolor and lacquer on wood; Diameter 7 ½ in. (19 cm)
Philadelphia Museum of Art. Gift of Mr. and Mrs. Stanley F. Myers,
1995-151-6

It might surprise us to see elaborate painting on such a mundane object as a water vessel lid. However this is not an unusual occurrence in the Indian context, where utensils and other quotidian articles can be beautifully decorated with depictions of popular myths and legends. Depicted on this pot lid is the story of the Matsya incarnation rendered in a style similar to that of Orissan *pata* paintings on cloth.

Often regarded as a folk style, the Orissan *pata* is characterized by bright colors, including the distinctive orange-yellow used as a skin tone. The paintings emphasize linearity, and the delineation of the profile with its downward pointed nose is instantly recognizable. The background may be covered all over with decorative motifs. See catalogue 163 for an example of Orissan *pata* painting.

Depicted on the lid is four-armed Vishnu in his Matsya avatar emerging from the mouth of a fish. In three hands he carries his attributes of the discus, the conch shell, and the mace, and with the fourth he pulls the pigtail of the demon, identifiable by his shell and green complexion. The encounter takes place in water. The reverse of the pot lid is also decorated, but with a simple pattern. [NP]

The Kurma Avatar

Vishnu's second incarnation is Kurma or the tortoise.[11] The Kurma incarnation is represented either as a tortoise or as half-man, half-tortoise. In the latter form he usually has four arms and carries Vishnu's conch shell (*shankha*) and discus (*chakra*).

Vishnu incarnates as Kurma to help the gods against the demons after the former are cursed by the sage Durvasa. Indra, the king of the gods, insults the great sage, who then curses all the gods with loss of strength and power. Fearing destruction at the hands of demons owing to their diminished strength, the gods approach Vishnu. Vishnu assures the gods that they would regain their powers if they churn the ocean of milk along with the demons, using Mount Mandara as a churning stick and the divine snake Vasuki as a rope. "In the form of the divine Tortoise, He [Vishnu] supported the mountain (called Mandara) on His back when the ocean was being churned for nectar."[12] The churning yields fourteen magical objects, including the nectar of immortality, which the gods and demons are supposed to share.

In order to deceive the demons, Vishnu takes the form of a beautiful, seductive woman, Mohini. In this guise, he convinces the demons to entrust the nectar to him, promising them their share. But when it is their turn to be served the nectar, he disappears.

The "churning of the milk ocean" episode was very popular in Southeast Asia, and inscriptional evidence suggests that it was often reenacted at the coronation of Khmer kings. It is also depicted at many temples in Indonesia and Cambodia. One of the grandest representations is found in the eastern gallery at Angkor Vat, where the wall is carved with approximately 200 figures of gods and demons stirring up the waters below them (see fig. 52–1). [NP]

Figure 52–1 | Relief depicting the Churning of the Ocean of
Milk, eastern gallery, Angkor Vat, Cambodia, mid 12th century.
© *Michael Freeman / StockphotoPro*

Northern India, Punjab Hills, Mankot; c. 1700
Opaque watercolor on paper; 8 1/16 x 10 7/16 in. (20.5 x 26.5 cm)
Museum Rietberg, Zurich. Former collection Alice Boner,
RVI 1249

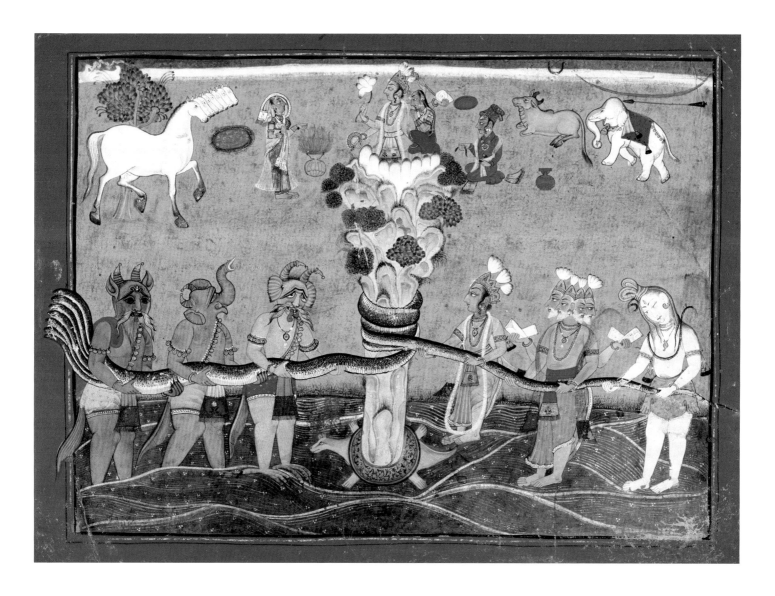

These two paintings (52, 53), from different workshops in the Punjab Hills, depict the churning of the milk ocean made possible through Vishnu's assistance. The central vertical axis in each painting is the inverted Mount Mandara, with Vishnu in two forms at either end. In his four-armed human form, Vishnu sits on a lotus at the top, and in his tortoise incarnation, he supports the mountain underwater. In the later image (53), the tortoise is nearly invisible within the roiling ocean. Almost

symmetrically arranged on either side of the central axis, grasping the multihooded snake Vasuki and standing in the water, are the gods and demons. At the tail end are the gods Brahma, Krishna, and Shiva, and at the head end are the demons. The base nature of the demons is underscored by their grotesque, animal-like faces and their horns and fangs.

On either side of Vishnu are the fourteen magical objects produced by churning the ocean. These include the

Northern India, Punjab Hills, Basohli or Chamba; c. 1760–65
Opaque watercolor and gold on paper; 8 x 11 in. (20.3 x 27.9 cm)
Philadelphia Museum of Art. Gift of Stella Kramrisch,
1984-139-1

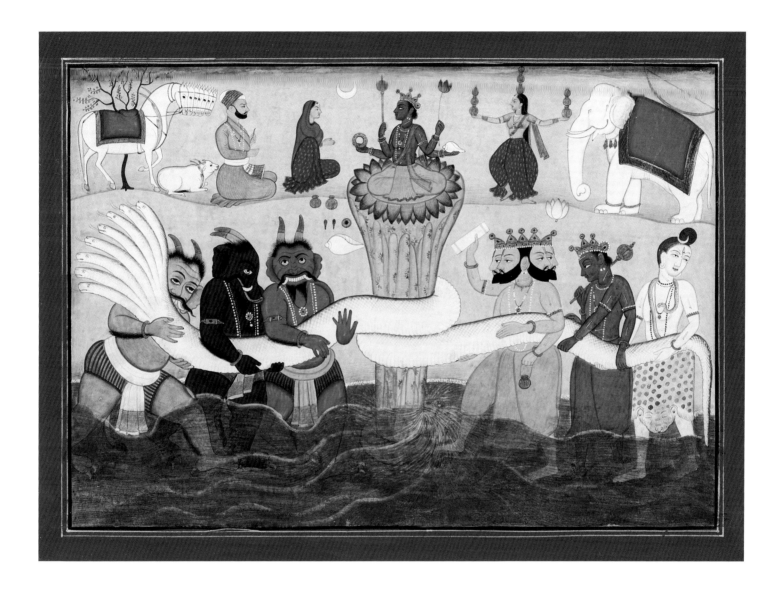

wonderfully fragrant Parijata tree, the elephant Airavata that becomes Indra's mount, the multiheaded horse Ucchaishravvas, the wish-granting cow Kamadhenu, Varuni the goddess of wine, weapons, poison, the nectar of immortality, and the goddess Lakshmi, who is Vishnu's consort and is depicted seated next to him on the lotus in the Mankot painting (52).

The compositional parallels between these and other paintings depicting the churning of the milk ocean suggest that there was an established scheme for depicting this episode. However, each painting will have an individualized style recognizable as the product of a different atelier. [NP]

54 | Shiva Chasing Mohini

Northern India, Punjab Hills, Garhwal; c. 1790
Opaque watercolor and gold on paper; 6 ¾ x 9 ⅝ in. (17 x 24.4 cm)
Collection of Dr. and Mrs. Frederick Baekeland

When Shiva heard about Vishnu's assumption of the female form of Mohini in order to deceive the demons and regain the nectar of immortality for the gods, he became desirous of seeing this enchanting embodiment. To this end, he visited Vishnu in his heavenly abode Vaikuntha with his consort and retinue. Vishnu acceded to his request and transformed himself into "a most beautiful damsel with a girdle lying about her hips, that were wrapped with a brilliant piece of linen, delightfully sporting with the movements of a ball."[13]

This painting from the Garhwal region in the Punjab Hills depicts the completely bewitched Shiva chasing Mohini, having forgotten that she is none other than Vishnu. Shiva is recognizable by the crescent moon on his head, the matted locks, the animal skin, and the trident. He pursues Mohini, "as the ruttish leader of a herd of elephants would run after a she-elephant desiring copulation"[14] while she tries to escape into a cave. Ultimately Shiva realizes his error and Vishnu re-assumes his masculine form, congratulating Shiva for having conquered his delusion.

A painting in a private collection in India depicts the same scene with an almost identical composition, though with slight differences in the use of color and shading. One painting is a copy of the other, though probably made by different artists in separate workshops. Such copies provide evidence for the exchange of information between artists working in different areas; in most cases the exchange took place when paintings were given by one patron to another. The recipient would then request copies of the gift from his own artists. [NP]

The Varaha Avatar

Vishnu descends as Varaha at the request of the first ancestor of men. The earth goddess, known as Bhu Devi or Prithvi, has sunk deep into the primordial ocean and as a result there is no solid ground where humans can establish a home. Vishnu appears as an enormous boar and immediately dives down to recover the earth. Descriptions of the avatar make much of his porcine form:

> He moved through the sky with his tail held aloft. With his shaking
> mane and kicking hoofs he dispersed the clouds. His body was hard with
> tough hide bristled with sharp, erect hair. The Lord, the savior of the earth,
> appeared brilliant with his white tusk and shining eyes.[15]

Boars were much admired by hunters in India for their speed, strength, and stubborn bravery. Being a boar, Varaha is able to track the scent of the goddess and then burrow into the ocean to retrieve her. He pulls her up with his tusks and places her gently on top of the waters, where she remains.

As Varaha pulls up the earth goddess, he encounters a demon named Hiranyaksha, who attempts to obstruct him. In some versions of the story, Hiranyaksha was responsible for the earth's submersion. Varaha dispatches him after a battle. Hiranyaksha is the twin brother of Hiranyakashipu, the demon who will be killed by the Narasimha avatar. These twin demons were once the gate keepers of Vishnu's paradise, but they were cursed to be born on earth three times, each rebirth in the form of a demon, each destined to be killed by an avatar of Vishnu. The subsequent incarnations of Hiranyaksha and Hiranyakashipu are Ravana and his brother Kumbhakarna (defeated by the Rama avatar) and Shishupala and Dantavaktra (slain by Krishna).

Whereas Matsya and Kurma do not receive a great deal of worship except within the group of avatars, Varaha enjoys a large following. He is often represented prominently on Vaishnava temples, and there are even a few temples dedicated specifically to him (fig. 55–1).[16] The Varaha legend is of considerable antiquity, with mention of a boar lifting the earth appearing in Vedic-period texts,[17] and images of Varaha begin to appear around the same time as images of Vishnu.

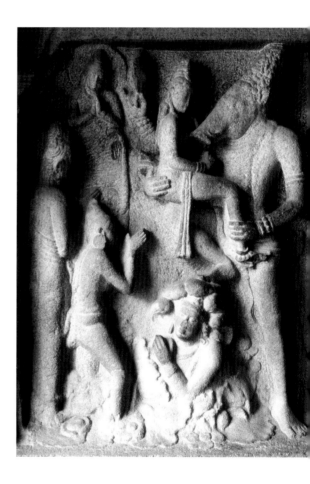

Figure 55–1 | Relief depicting Varaha rescuing Bhu Devi, Varaha cave, Mamallapuram, Tamil Nadu, 7th century.
© Dinodia/Photos India

55 | Varaha Rescuing Bhu Devi

Northern India, Rajasthan; c. 1000
Schist; 33 x 17 ¼ x 6 in. (83.8 x 43.8 x 15.2 cm)
Asian Art Museum. The Avery Brundage Collection, B62S15+

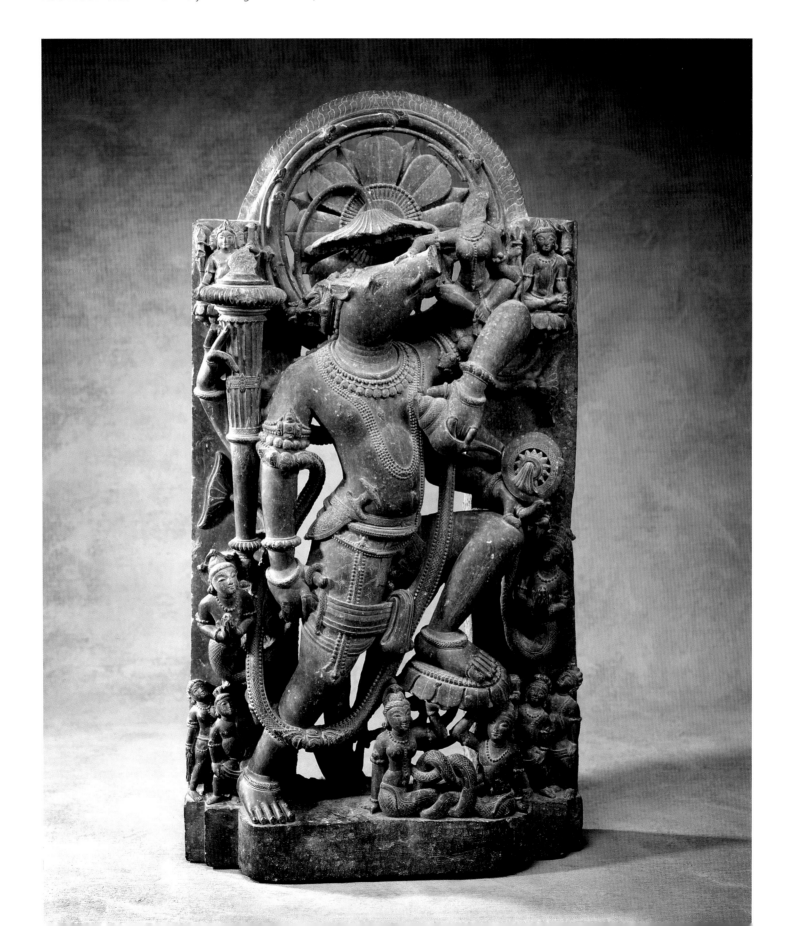

Southern India, Kerala; c. 14th–15th century
Bronze; 13 x 7 ¾ x 5 ⅛ in. (33 x 19.7 x 13 cm)
Brooklyn Museum. Gift of Paul E. Manheim, 78.259.1

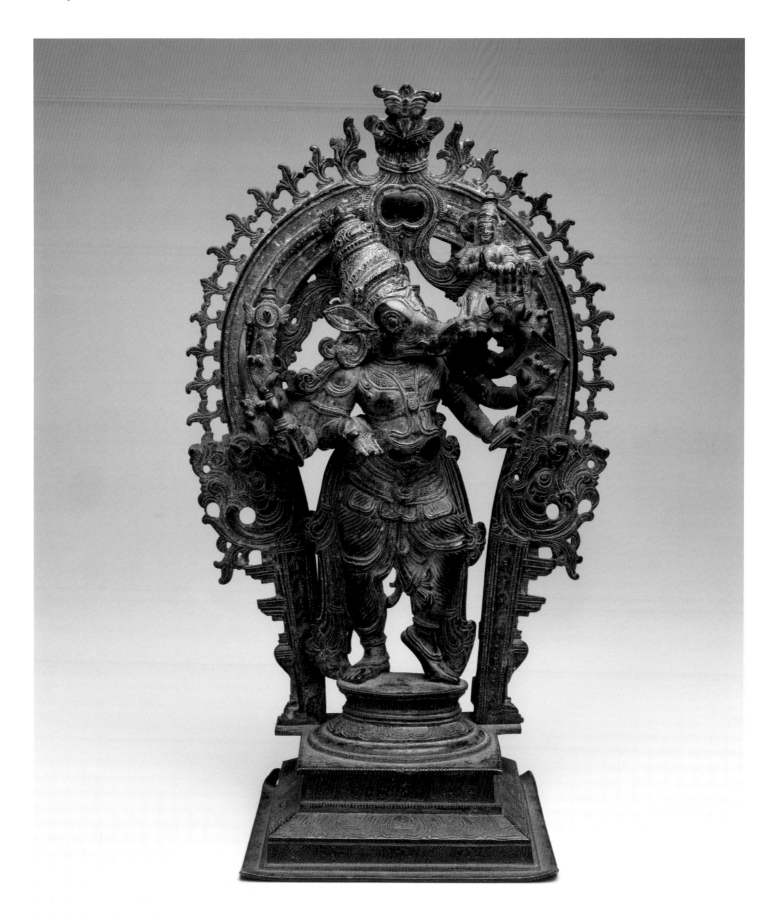

These sculptures, one from the north and one from the south (55, 56), depict Varaha with a human body and boar's head. This form of the avatar is far more common in the art of both northern and southern India than the form with a boar's body (see cat. 57), probably because it lends itself to the vertically oriented niches of temples and also because it allows easier expression of the heroic and personable character of the god. Anthropomorphic representations of Varaha also allowed closer identification with Vishnu: these images have multiple arms holding the standard weapons of the god.

Although textual descriptions have Varaha lifting the earth goddess with his tusks, in these images she is perched on his shoulder or just slightly above. This allows for something like a face-to-face encounter between Bhu and the boar. In the bronze piece now in Brooklyn (56), the goddess kneels with her hands in the gesture of homage, *anjali mudra*. She is giving thanks to Varaha for saving her, but she has also become his disciple. The *Varaha Purana*, a major Hindu text, takes the form of a dialogue between Bhu Devi and Varaha, in which she asks questions and he offers teachings. In the stone image in San Francisco (55), Bhu Devi reaches out to pat the boar on the snout; Bhu Devi is often called Varaha's consort, and this affectionate gesture makes reference to the more romantic aspect of their relationship.

In the stone image, the central figure has a parasol in the form of a lotus leaf, a charming detail specific to images of Varaha, although the parasol was a common emblem of authority in ancient India. The lotus motif continues below, where his elevated foot steps on a lotus flower that is supported by *nagas*, snake deities who are closely associated with water. The lotuses and *nagas* remind us of the watery setting. Varaha's striding stance here speaks to his energy and heroism. The bronze figure, with one heel raised, offers a similar sense of action

The southwestern state of Kerala boasts very few stone temples or sculptures, but it is home to sophisticated metal-casting and wood-carving traditions. Kerala bronzes are distant cousins to the Chola bronzes of neighboring Tamil Nadu, using similar formats (here, the stepped base with separately cast aureole) and iconography. However, Kerala bronzes tend to feature squatter figures and they are usually far more elaborate, featuring extensive detailing of jewelry and costumes. This taste for ornamentation relates the sculpture of Kerala with its neighbors to the north in Karnataka (see the Hoysala-period stone sculpture of Vaishnavi, cat. 22). ✹

57 | Cosmic Varaha
Central India, Madhya Pradesh or Eastern India, Bihar
c. 10th century
Basalt; 22 ¹⁄₁₆ x 31 ⁵⁄₁₆ x 11 ¹¹⁄₁₆ in. (56 x 79.5 x 29.7 cm)
The James W. and Marilynn Alsdorf Collection

When Varaha is depicted in theriomorphic or animal form, the depiction often emphasizes the avatar's role as a cosmic deity. These figures are relatively rare and appear to have been objects of worship (rather than subsidiary figures on the exterior of a temple), installed as icons on their own altars. Large, freestanding representations can be found in at Apsadh in Bihar (dating to the seventh century), and at Eran (fifth century) and Khajuraho (tenth century), both in Madhya Pradesh.

Varaha is here accompanied by Bhu Devi, who is much closer to his size than the Bhu figures depicted in images of an anthropomorphic Varaha. With them appear smaller figures of a *naga* (snake deity) and another figure who might also relate to the watery setting. The mace that Varaha uses in his battle with Hiranyaksha lies on the ground between his feet.

None of these features are terribly different from those found on anthropomorphic images of Varaha, but on the boar's animal body are carved multiple small figures of deities, sages, and heavenly beings, a feature not found on two-legged representations. With this pantheon on his back, Varaha becomes something similar to Krishna as Vishvarupa (see cats. 131–33, 173), a manifestation of the true, vast, all-encompassing nature of the divine: he is all things, even including all gods. Indeed, at one point in the *Varaha Purana*, Bhu Devi asks a question of the avatar and he laughs in response. When she looks in his mouth she sees all of creation inside and is terrified by the magnitude of it.[18]

In this form, Varaha is often called Yajna-Varaha, or Varaha of the Sacrifice. Several texts celebrate the boar avatar as an embodiment of the highly structured, highly orthodox sacrificial rites of the Vedic tradition. ✾

58 | Varaha Appears before Brahma and Sages

Attributed to Manaku (c. 1700–c. 1760)
Page from an illustrated manuscript of the *Bhagavata Purana*
Northern India, Punjab Hills, possibly Guler; c. 1735–40
Opaque watercolor, gold, and silver on paper
8 ½ x 12 ½ in. (21 x 31.7 cm)
Collection of Eberhard Rist

This painting comes from a dispersed *Bhagavata Purana* manuscript that was never finished, probably because it was too ambitious in its attempt to illustrate every episode of the multivolume text. Most *Bhagavata Purana* manuscripts focus almost entirely on Book Ten, which narrates the life of Krishna, but this series devotes many pages to the previous books, including representations of stories rarely if ever illustrated elsewhere.

This image of Varaha comes from Book Three, which tells the story of Creation. After Brahma rises from the navel of Vishnu, he creates various gods and divine sages; then he creates Manu, the progenitor of all men. Manu asks Brahma to pull the earth from the ocean so that he, his wife, and his future family will have some place to live. Brahma invokes his own creator, Vishnu, and almost immediately a tiny boar falls from his nose. The text recounts:

While he (Brahma) was looking on, a great miracle took place: the small boar in the sky shot up to the size of an elephant in a moment. Along with Brahmanas with Marici as their chief with Kumaras and with Manu, he saw the boar form and began to think in various ways. "Is it the transcendental Being appearing in the form of a boar? What a miracle that it should come out of my nose! It appeared like the tip of a thumb and in a moment it became as big as a great boulder. Can this be the Divine Sacrifice (i.e. Lord Vishnu) himself who is trying my mind to exhaustion (by concealing his real form)?"[19]

It appears that this illustration depicts this moment, when Brahma (depicted here with a crown and his usual beard) and two sages (one of whom is probably Manu) look at the newly arrived boar, who is "as big as a great boulder," and wonder who or what it is. The fact that Varaha has not yet revealed himself as an avatar of Vishnu could account for the fact that he appears here in purely animal form without any attributes, a true rarity among painted representations of the Varaha legend. ✳

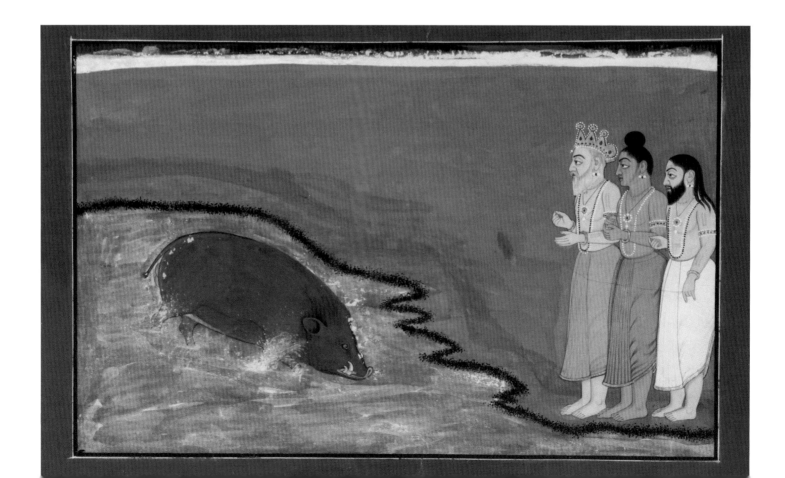

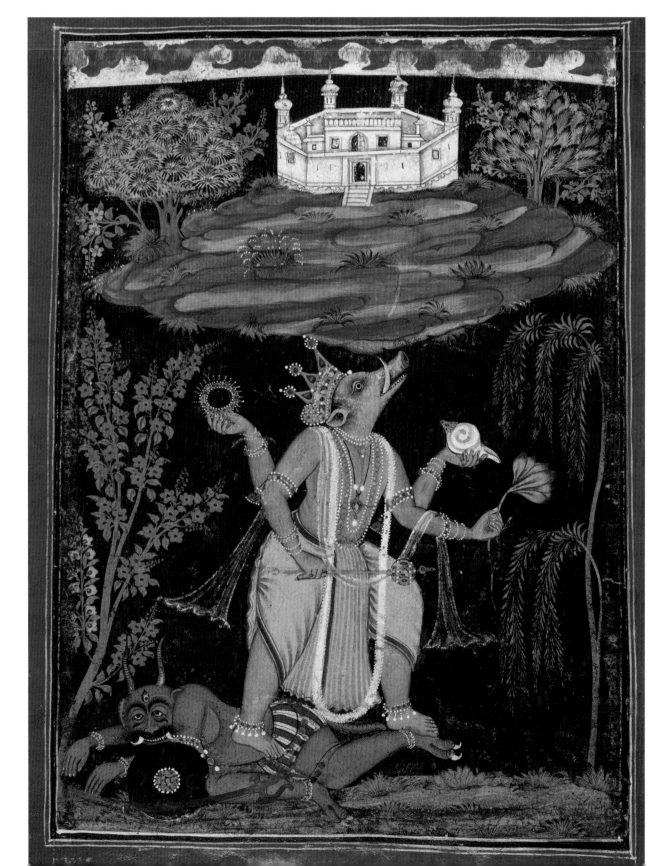

60 | Varaha Rescuing the Earth
Page from an illustrated *Dashavatara* series
Attributed to Mahesh of Chamba (active c. 1730–1770)
Northern India, Punjab Hills, Chamba; c. 1750–75
Opaque watercolor, gold, and silver on paper
8 1/16 x 11 in. (20.5 x 28 cm)
Museum Rietberg, Zurich. Gift of Balthasar and Nanni Reinhart,
RVI 1514

61 | Varaha Rescuing the Earth (*facing page*)
Page from an illustrated manuscript of the *Gita Govinda*
Northern India, Punjab Hills, Guler or Kangra style; c. 1775–80
Opaque watercolor, gold, and silver on paper
6 3/4 x 10 9/16 in. (17.1 x 26.8 cm)
The Kronos Collections

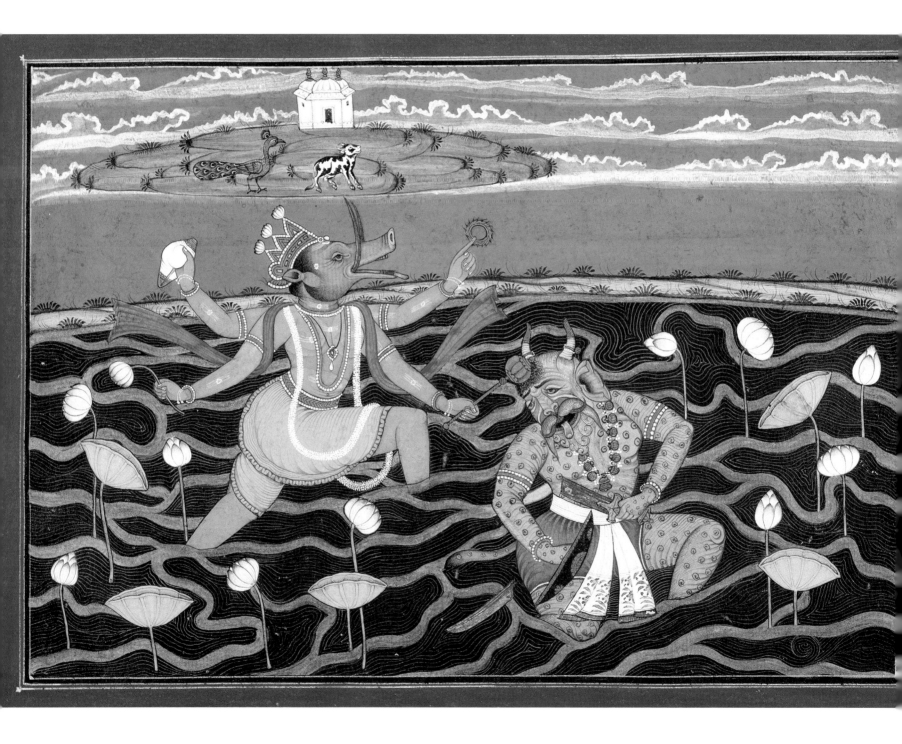

These three images of the Varaha avatar (59, 60, 61), all from the Punjab Hills, reflect the broad range of styles practiced in that area, as well as the relatively small amount of leeway allowed to artists as they illustrated iconic legends. All three depict Varaha in quasi-anthropomorphic form, with boar head and four arms, and all represent the earth as a land mass rather than as a goddess. They also include the demon Hiranyaksha, who rarely appears in sculptural depictions of the story. In all three, the demon has already lost the battle, although the paintings express this defeat in various ways.

The Bilaspur painting (59) reads more as an icon than the others, with Varaha standing on his enemy's corpse, a trope used often in sculptural icons of other deities to indicate victory over an enemy. Hiranyaksha is here depicted with a third eye, a feature that identifies him with the god Shiva, although the texts offer no hint of this association. It is interesting that this painting completely disregards the aquatic setting of the story, and that the earth as depicted here (and in the Chamba painting) includes a palace, even at this early juncture. Perhaps this is the future home of Manu.

The Chamba painting (60) is also from an avatar series and has been attributed to the same artist as catalogue 50, although the Matsya illustration appears to be from a different series. The emphasis here is far more on the demon Hiranyaksha, with broken sword and a true expression of suffering, and on the ocean, with swells rendered as a network of cells. All of these features are very similar to the artist's earlier rendering of Matsya, but here the effect is bolder and more decorative, with lotuses added for further visual interest.

The stylization of the water is softened considerably in the Kangra-style image (61), which emphasizes the submersion of boar and demon, with the cloudy paint used to obscure the figures even hinting at the primordial ocean's milky quality (as mentioned in the story of the Kurma avatar). Here, the salvaged earth sits atop the water, as described in the texts. This page comes from a celebrated manuscript of the *Gita Govinda (Song of the Cowherd)*, a devotional text dedicated to Krishna that begins with an invocation of the avatars, whom it treats as manifestations of Krishna. The *Gita Govinda* verse about Varaha reads:

> The earth clings to the tip of your tusk
> Like a speck of dust caught on the crescent moon.
> You take form as the Boar, Krishna.
> Triumph Hari, Lord of the World![20]

The Narasimha Avatar

After the death of his brother Hiranyaksha at the hands of Vishnu in his boar incarnation, Hiranyakashipu is filled with anger and grief. He vows to avenge the death by severing Vishnu's head with his spear.[21] He orders his demonic hordes to exterminate all the Brahmins engaged in austerities and sacrifices and wreak havoc on earth, while he performs severe penance (for 36,000 years). Brahma goes to the hermitage of Hiranyakashipu and tells him to ask for any boon. The demon asks that his death not be caused by any creature created by Brahma, or at the hands of animate or inanimate beings, gods, demons, or serpents, that he not die indoors or outdoors, during day or night, on earth or in the air, from human or animals, or through weapons. Having obtained the boon, Hiranyakashipu takes over control of the universe and establishes himself in Indra's palace. The gods and inhabitants of the earth go to Vishnu for deliverance from the demon's oppression, and Vishnu assures them that Hiranyakashipu's demise is near.

Hiranyakashipu's son Prahalada is a great devotee of Vishnu, even though he was born into the demon race. When his father asks what he has learned from his preceptor, Prahalada sings the praises of Vishnu. This enrages Hiranyakashipu, who decides to kill this treacherous offspring. But all his attempts to end Prahalada's life are in vain: spears, trampling elephants, poisonous snakes, destructive spells, starvation, fire, exposure to the elements, throwing him from a high cliff onto rocks, all fail. Through these trials, Prahalada continues to exalt Vishnu.

Hiranyakashipu challenges Prahalada about Vishnu's omnipresence: "Where is that lord of the universe other than me, that has (just) been mentioned by you, O wretched one? If it is urged that he is (present) everywhere, wherefore is he not seen in the pillar (over there)?"[22] In order to validate Prahalada's faith, Vishnu appears out of this pillar in the form of a gigantic man-lion Narasimha. Narasimha and Hiranyakashipu engage in armed combat, till ultimately, at sunset, which is neither day nor night, Vishnu in his man-lion form, which is neither human nor animal, places the demon on his thigh, which is neither earth nor air, at a threshold, which is neither inside nor outside, and tears him with his claws and kills Hiranyakashipu, and then he wears his entrails like a garland. Thus Brahma's boon is not nullified, yet the oppressor of the earth is killed. Narasimha is then celebrated by all the gods, semidivines, and humans.

Narasimha may be depicted in his wrathful or *raudra* form, where he tears open the demon's flesh to pull out the entrails (fig. 62–1) or in a calm meditative posture. In his raudra depictions, Narasimha is one of the most violent and bloodthirsty of Vishnu's incarnations. [NP]

Figure 62–1 | Relief depicting Narasimha killing Hiranyakashipu, Keshava Temple, Belur, Karnataka, c. 1117.

© Dinodia / Photos India

62 | Narasimha

Northern India, Mathura area; c. 4th century
Sandstone; 14 ¼ x 8 ½ x 3 ⅞ in. (36.2 x 21.6 x 9.8 cm)
Philadelphia Museum of Art. Purchased with the John D.
McIlhenny Fund and the Thomas Skelton Harrison Fund,
1987-18-1

This sculpture depicts Narasimha in the process of disemboweling the demon Hiranyakashipu. Narasimha is depicted as a two-armed figure without any attributes. His right foot rests firmly on the ground while his left leg is bent with the knee placed on the ground. The pattern below the ground suggests a pillared platform.[23] The *Bhagavata Purana* describes Vishnu's Narasimha avatar: "It had fierce eyes shining as molten gold and a face swollen with its dazzling hair and manes. It had fearful teeth and a tongue waving like a sword and sharp as the blade of a razor, and looked (all the more) frightful because of its frowning aspect."[24]

The static and pliable body of Hiranyakashipu rests on Narasimha's thighs as he plunges his hands into the demon's stomach. Hiranyakashipu's horizontal body bisects the sculpture, and its comparatively smaller size draws attention to Narasimha's great bulk, height, and powerful body and limbs.

This Narasimha has a furrowed brow, fangs, and lolling tongue that are similar to those in later sculptures, but its robe, simplicity, and stance set it apart.[25] The drapery that covers both shoulders is similar to that in images of the Buddha from the late fourth century.[26] The image is carved in the flecked red sandstone of the Mathura region; Hindu, Buddhist, as well as Jain sculptures from this region and period all make use of this distinctive stone.

This sculpture is not a cult image but rather a narrative relief. Other small narrative reliefs depicting Narasimha slaying Hiranyakashipu survive from fifth- and sixth-century Gupta period temples, but the simple plasticity of this image suggests an earlier date.[27] [NP] ✳

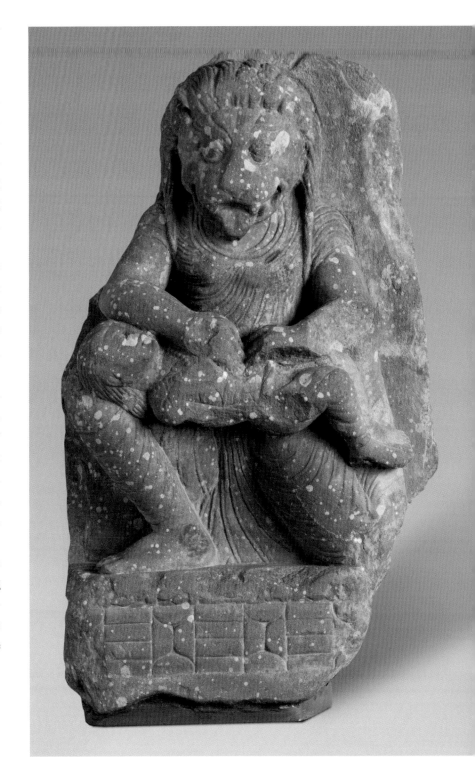

63 | Narasimha

Northern India, Mathura area; c. mid 6th century
Sandstone; 33 ¼ x 18 ½ x 7 ½ in. (84.46 x 46.99 x 19.05 cm)
Los Angeles County Museum of Art. From the Nasli and Alice
Heeramaneck Collection, purchased with funds provided by the
Jane and Justin Dart Foundation, M.81.90.20

This sculpture depicting the standing Narasimha is damaged, missing a hand, feet and its nimbus. However, the "fierce shining eyes" are clearly visible, and the image successfully conveys an impression of great physical strength through its powerful chest and muscular thighs.

Narasimha stands in a hieratic frontal pose, has four arms, and is depicted carrying Vishnu's attributes. Two arms are bent at the elbow and rest near the waist, and the undamaged left one carries the conch shell. The two other arms extend downward and are placed on the heads of personified weapons (*ayudhapurushas*). The left hand rests on the male discus figure Chakrapurusha while the right is placed on the female mace figure Gadadevi.

This image of Narasimha is similar in its style, pose, and arrangement of attributes to standing images of Vishnu from the Gupta period (see cats. 1, 2, 12). It was probably a cult icon used as a principal side figure in a Vaishnava temple, or as the main focus of worship in a Narasimha temple.[28]

There has been debate about the dating and authenticity of this sculpture, and some scholars have disagreed with its sixth-century Gupta attribution.[29] An investigation was carried out by the Conservation Center at the Los Angeles County Museum, where wear and tear, weathering, tool marks, and surface accretions were examined under a stereomicroscope. This led to the conclusion that the sixth century date was correct, the sculpture was authentic, and there was no scientific evidence to suggest that it was manufactured more recently.[30] [NP] ✳

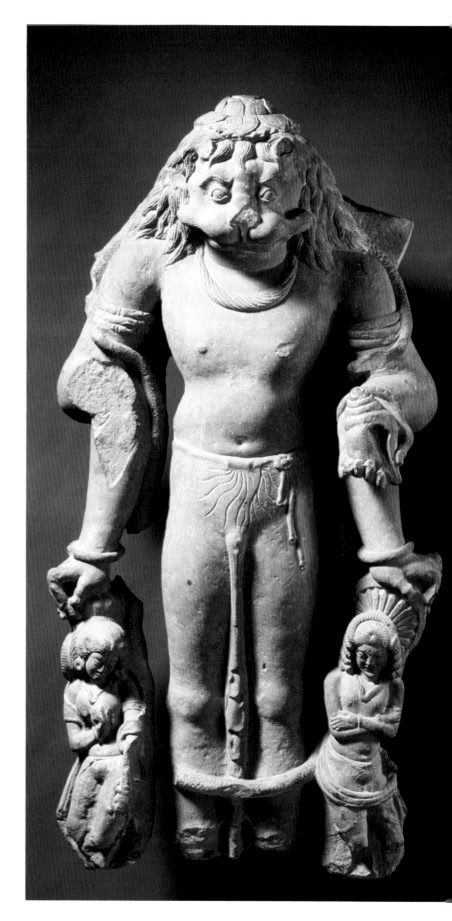

64 | Narasimha Kills Hiranyakashipu, with an Earlier Episode Below

Bangladesh; c. 1100–1200
Carbonaceous chloritic phyllite
29 x 16 x 6 ½ in. (73.7 x 40.6 x 16.5 cm)
Asian Art Museum. Gift of the Connoisseurs' Council, 1997.4

This sculpture of Narasimha eviscerating Hiranya-kashipu depicts more than one episode from the story. The main image depicts six-armed Narasimha with his claws inside the demon's stomach. With two other hands he holds Hiranyakashipu's head and right leg, apparently stretching out the body. Narasimha carries no attributes, and his head is surrounded by a lotus-bloom nimbus. The relief has a face of glory (*kirtimukha*) flanked by flying celestials on top of the arch, similar to other Pala images (cat. 38). Interestingly, Narasimha's bent left leg tramples on a figure, which is a second depiction of the defeated Hiranyakashipu.

At the center of the sculpture's base, flanked by adoring figures, is an earlier episode from the story (see detail). In this central panel, Hiranyakashipu on the right sticks out a leg to kick a pillar while challenging his son Prahalada's belief in Vishnu's omnipresence. We can perceive the figure of Narasimha beginning to emerge from the pillar, the prelude to the scene depicted above. [NP] ✳

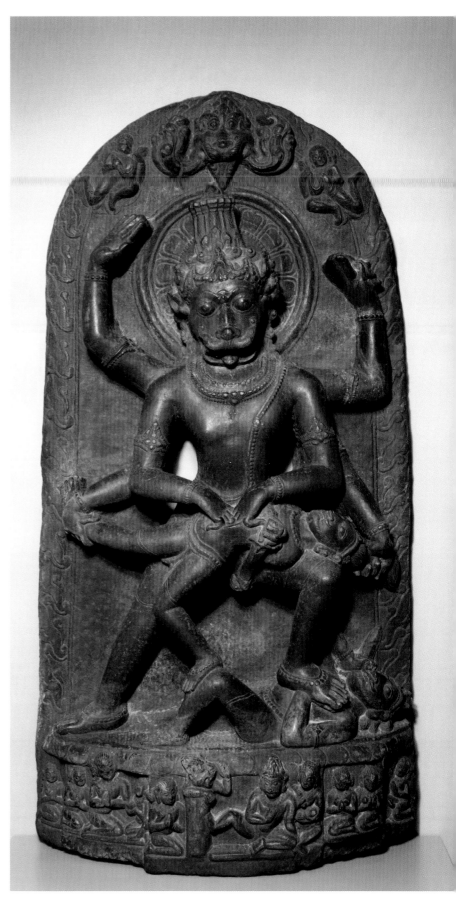

65 | Lakshmi-Narasimha
Eastern India, Orissa; c. 1250
Sandstone; 35 ⅜ x 20 ⅛ x 11 ¼ in. (89.9 x 51.1 x 28.6 cm)
Toledo Museum of Art. Purchased with funds from the Libbey
Endowment, Gift of Edward Drummond Libbey, 1987.176

66 | Yoga-Narasimha
Southern India, Tamil Nadu, Thanjavur region; Chola period,
12th century
Bronze; 18 ¾ x 13 x 9 ½ in. (47.6 x 33 x 24.1 cm)
The Metropolitan Museum of Art. Samuel Eilenberg Collection,
Bequest of Samuel Eilenberg, 1998 (2000.284.4)

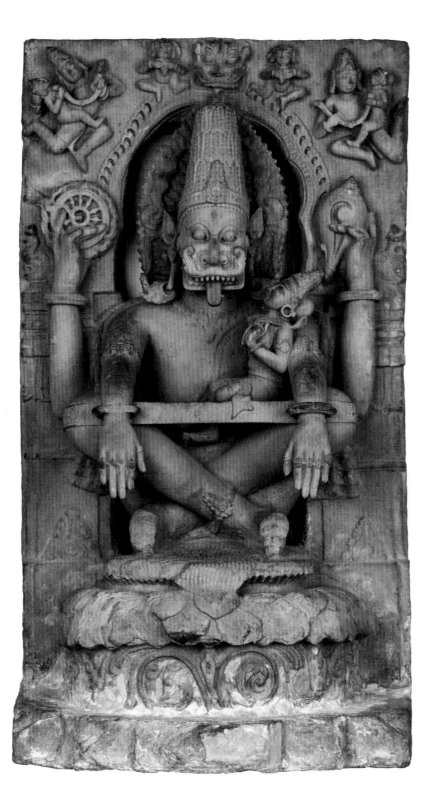

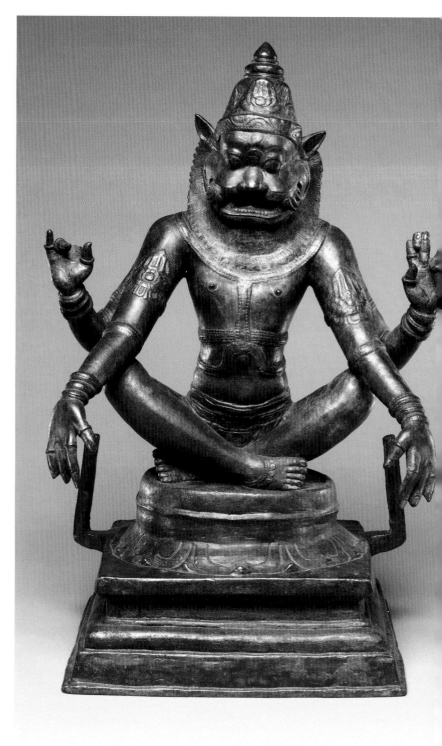

Images of Narasimha in the act of killing Hiranyakashipu must be worshipped very carefully so not to anger the deity further, and in some places only those priests who are life-long celibates are allowed to perform the *puja*. The two sculptures here (65, 66), one in stone and one in bronze, depict the man-lion incarnation of Vishnu in a less violent mien, not gruesomely disemboweling Hiranyakashipu but sitting in a calm and meditative posture. The four-armed figure sits cross-legged with two arms extended over his knees in a typical posture of meditation and two arms held up to carry Vishnu's conch shell on his left and discus on his right. A *yoga-patta*, or band that assists in holding together yoga poses, is wrapped around the stone Narasimha's knees. This helps to convey that Narasimha is not merely sitting, but practicing meditation.

The majority of seated Narasimha images from Orissa have a small image of Lakshmi sitting on the avatar's left leg. Various Orissan literary works contain elaborate descriptions of the marriage of Lakshmi and Narasimha. Typically, Lakshmi-Narasimha images depict the meditative man-lion sitting on a tall lotus throne, which will be decorated with two or three rows of lotus petals. Often an image of Garuda is carved on the lower register along with devotees and lotus rhizomes. Garuda does not appear to be present in this Lakshmi-Narasimha image (65), although he may have been depicted where the base is now damaged. Narasimha's mane flares out to create a nimbus behind his head. Lakshmi is depicted carrying a lotus in her left hand.[31]

The overwhelming majority of Lakshmi-Narasimha images date from the Eastern Ganga dynasty of Orissa (eleventh–fifteenth centuries), a time when it was especially popular for kings to be compared with Narasimha. Because many Ganga rulers took the deity's name, images of Narasimha simultaneously represented both the god and the dynasty.[32]

The bronze image (66) also depicts Narasimha seated on a lotus that is placed on a pedestal. The relaxed attitude of Narasimha in a meditative pose is emphasized in the drape of the figure's long front arms and in the slight forward roll of his shoulders. His upper hands would have held now-missing attributes, probably the chakra and conch. [NP]

67 | **Narasimha Kills Hiranyakashipu**
Page from an illustrated *Dashavatara* series
Northern India, Punjab Hills, Nurpur or Chamba; c. 1700–1725
Opaque watercolor and gold on paper
8 7/16 x 5 7/8 in. (21.5 x 15 cm)
Museum Rietberg, Zurich. Gift of Balthasar and Nanni Reinhart, MRZ 2005.46

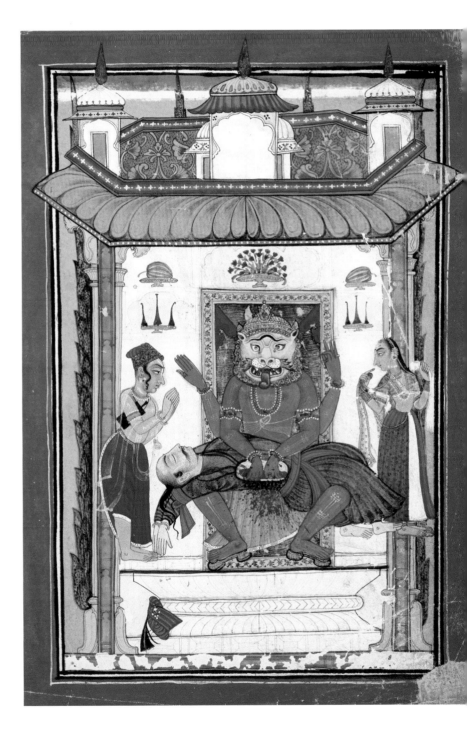

68 | Narasimha Kills Hiranyakashipu

Northern India, Punjab Hills, Mankot; c. 1700–1723
Opaque watercolor on paper; 8 ¼ x 11 ⁷⁄₁₆ in. (21 x 29 cm)
Museum Rietberg, Zurich. Former collection Alice Boner,
RVI 1210

These paintings (67, 68) produced at two different courts in northern India depict Narasimha in the process of disemboweling Hiranyakashipu while he is worshipped by Prahalada and other figures.

The vertical orientation of the painting from Chamba (67) is unusual: mythological paintings were most commonly executed on a horizontal page so that the paper would emulate the shape of the original palm-leaf manuscripts, but a vertical image mimics an icon. Here, a four-armed Narasimha sits in a doorway at the threshold, which is neither indoors nor outdoors; Hiranyakashipu's boon would not allow him to be killed either inside or outside. Narasimha uses no weapons but his claws to kill the demon, and in this image a gaping hole is shown in Hiranyakashipu's body with blood dripping from it. Behind Narasimha's head we can see the split pillar kicked by Hiranyakashipu from which Narasimha emerged, and he is flanked by a worshipping Prahalada on our left and a female figure on our right.

In the Mankot image (68), the scene is also set within a pavilion, but the major difference here is in the depiction of Narasimha, who is shown as being half tiger, rather than half lion. Hiranyakashipu's body is limp but he still holds a shield, reminding viewers of the terrible combat between him and Narasimha. Behind Narasimha is the split pillar, and he is flanked by Prahalada and a throne. The crown with three lotus flowers worn by Prahalada is characteristic of Mankot (as seen in the image of Vamana, cat. 71); another crown of this type appears on the floor, where it has fallen from the demon's head. [NP] ✺

The Vamana Avatar

Vishnu's first fully human avatar is Vamana, who assumes the form of a dwarf. He descends to earth at the request of the goddess Aditi, who is mother to many of the gods. She asks for Vishnu's assistance in regaining the heavenly capital from a demon named Bali. Bali is actually the grandson of Prahalada, the great devotee of Vishnu whose father was killed by Narasimha. After being humiliated by Indra (the king of the gods), Bali has turned to a group of Brahmin priests for assistance. The priests grant him unusual strength and a group of important weapons, and he leads a demon army in a siege on Indra's city. Bali defeats the gods and installs himself on Indra's throne. Worried about the future of her sons, the gods, Aditi performs sacred vows to attract the attention of Vishnu, who then promises to be born from her womb. He is born in his usual four-armed, refulgent form, but immediately transforms himself, "like a wonderfully active actor," into the body of a dwarf born into the Brahmin caste.[33] He is then reared and initiated as a Brahmin youth.[34]

Hearing that Bali is conducting an elaborate sacrificial rite with the assistance of the same Brahmins who gave him his special powers, the dwarf Vamana proceeds to the site of the sacrifice with the accoutrements of a holy mendicant: grass skirt, deerskin shawl, matted hair, parasol, sacred staff, and water jar. He is immediately noticed by the participants because of his superhuman brilliance, although no one is sure of his true identity. Bali offers Vamana a seat, and he washes the dwarf's feet and then puts some of the wash water on his own head, a gesture of humility and homage. He offers the splendid Brahmin anything he might want. After praising Bali's ancestry in a somewhat tongue-in-cheek manner, the dwarf asks for as much land as he can cover in three steps. Bali snickers at the apparently puny request and is about to grant it when his chief preceptor, Shukra, warns him of the dwarf's true identity. Bali ignores the advice. He grants the request with the ceremonial gesture of pouring water from a jar and all of a sudden the dwarf Brahmin transforms himself.

> That dwarf form of that infinite Hari [Vishnu] ... miraculously expanded to such an extent as to include that earth, the heaven, the cardinal points, the oceans, the sub-human beings, human beings, gods and sages and everything else.[35]

Oh King! He covered the earth of Bali with one foot; He occupied the sky with his body and the quarters with his arms. As he covered the celestial region with another second step there was not the slightest space left for the third as the second step of the Lord of wide strides extended higher and higher ... up to Satyaloka—the region of god Brahma.[36]

Vishnu reclaims the realms of earth, sky, and heavens with three enormous steps. The demons are furious at the deceit and attempt to attack the god, but they are easily dispelled by Vishnu's attendants. Vishnu captures Bali but then forgives him his transgressions and allows him to serve as king of another, smaller domain.

Vamana is only rarely worshipped by himself.[37] More often he appears among the avatars on a Vishnu temple or in a *Dashavatara* (ten avatars) manuscript. Some very compelling images of the Vamana story appear in the reliefs of rock-cut temple caves dating from the sixth and seventh centuries (see page 14), in which the avatar is shown taking his second or third step in the form known as Trivikrama. Despite the antiquity and majesty of the image, Vishnu's three-step-taking form was only occasionally depicted in sculpture or painting after the end of the first millennium CE.

69 | Vamana

Northern India, Kashmir; c. 800
Bronze; 7 ¼ x 3 ⅞ x 2 in. (18.4 x 9.8 x 5 cm)
Museum für Asiatische Kunst, Berlin. I 10125

70 | Vamana

Eastern India; Pala period, 13th century
Schist; Height 23 ½ in. (59.7 cm)
Collection Peggy Scott and David Treplitzky

Vamana's most striking physical feature is his dwarfism, which is usually depicted through short legs and arms and a corpulent torso. In some images, such as the small bronze from Kashmir (69), it can be difficult to distinguish him from various child deities such as Krishna, except that he carries unusual attributes, including the parasol (here broken, although its shaft may still be present in his upper left hand) and the water jug (in his lower left hand).[38] He is usually depicted wearing the simple clothes of a Brahmin, which are not so discernable in this Kashmiri image although he does have the long matted locks of an ascetic that drape over his shoulders. The figure is flanked by personified attributes: the female mace at his left and

a male form, possibly the chakra, at his right. A donor/ devotee appears at one side.

The stone Vamana (70), yet another product of the avid patronage for Vaishnava sculpture in the Pala period, holds Vishnu's lotus seed, mace, chakra, and conch instead of the dwarf Brahmin's parasol and water pot. Unlike the Kashmiri representation, which is treated as an ascetic with long hair, the stone figure is identifiable as a young *Brahmacharin* (Brahmin-in-training) through his closely cropped hair and topknot. The curls of hair and bump at the top of his head are reminiscent of depictions of the Buddha, who was, like this young Brahmin, a renunciant.[39] The figure is flanked at the top of its stele by the god Brahma— bearded and holding a rectangular manuscript of the Vedas in his left hand—on our left, and the god Shiva—holding a trident and snake—on our right.

Vishnu assumes the form of a dwarf so his request for three steps of land will seem like a pittance to the demon Bali. However, the dwarf disguise may also have made Bali look more favorably upon him, as dwarves seem to have enjoyed special status in traditional Indic culture. Dwarves appear frequently in ancient Indian art, usually as the impish spirits, called *ganas*, who serve the god Shiva and are ruled by Shiva's son Ganesha (Lord of *Ganas*). But dwarves appear in non-Shaiva contexts as well, usually mixed in with auspicious emblems such as water jars overflowing with gemstones and abundantly flowering vines. It appears that dwarves, at least the more corpulent ones, were associated with plenty and fertility. ❀

71 | **Vamana Receiving Water**
Northern India, Punjab Hills, Mankot; c. 1700–1725
Opaque watercolor, gold, and silver-colored paint on paper
11 5/16 x 8 13/16 in. (28.7 x 22.4 cm)
Philadelphia Museum of Art. Alvin O. Bellak Collection, 2004-149-32

72 | **Vamana Having His Feet Washed**
Attributed to Nikka (c. 1745–c. 1833)
Northern India, Punjab Hills, Guler style at Chamba; c. 1775–80
Opaque watercolor and gold on paper
15 x 12 in. (38.1 x 30.5 cm)
Collection of Eberhard Rist

These paintings capture the story of Vamana through the interaction between Bali and the dwarf Brahmin. The later painting, in the Guler style (72), is more complex, depicting the group of Brahmins who gave Bali his powers and who are now conducting the sacrifice for him. They are an interesting assortment of holy men, some of them wearing the horizontal *tilak*s (sectarian forehead marks) of Shiva. They hold the long, rectangular pages of traditional *sutras* (religious scriptures, which were originally written on palm leaves), and they throw or ladle offerings into the sacrificial fire. The sacred space of the ritual has been fenced off temporarily with a canopy erected over the proceedings. Bali's demon servants bring additional offerings and fuel for the fire. Bali and his wife, Vindhyavali, greet and pay homage to the dwarf Vamana by washing his feet in a large brass basin while he makes a gesture of blessing on them.

The painting from the Punjab Hill state of Mankot (71) shows Bali pouring water into the dwarf avatar's hands, a traditional ceremony that makes official the granting of a request. In both representations, Vamana is depicted as a mature, bearded Brahmin (in the Guler painting his beard is white), not the young *Brahmacharin* that many texts say he appeared to be. It is interesting that both painters added the detail of a parasol made of leaves (in the Mankot painting it appears to be a single, large leaf held up by a branch), the appropriate accoutrement for a forest-dwelling ascetic (see cats. 78, 79 for the leaf outfits worn by Rama and his companions when they live in the wilderness). The earlier painting shows him wearing a deer skin. In both, Bali's preceptor, Shukra, raises a finger in admonition or astonishment (he is just visible behind the front encampment wall in the Guler-style painting). Shukra is depicted as a Vaishnava in the earlier painting, wearing the vertical tilak, or sectarian mark, on his forehead and arms (see cat. 156 for further discussion of tilaks) but as a Shaiva with horizontal tilaks in the later image.

It is interesting that although Shukra wears a crown in the Mankot painting, his ruler, Bali, has a bare head and wears the tonsure of a renunciant. This is in keeping with the fact that he is embarking on a major Vedic-style sacrifice; he too wears Vaishnava tilaks. Bali is depicted in both works as fully and properly deferential and not as a demon. If we did not know the story, we would not guess that he is the adversary. Bali makes for an interesting villain because he is essentially very devout and respectful of Brahmins; his fault is in accumulating an inappropriate degree of power, a matter of hubris rather than malice. ✳

73 | Trivikrama
Central India, Madhya Pradesh; 10th century
Sandstone; 8 ⁷⁄₈ x 9 x 3 ⅛ in. (22.5 x 23 x 8 cm)
Museum für Asiatische Kunst, Berlin. I 9989

74 | Trivikrama
Eastern India, Orissa; 12th century
Gneissic rock; 37 x 19 ⅝ x 12 in. (93.9 x 49.8 x 30.5 cm)
Art Institute of Chicago. Gift of Nathan Rubin and the Ida Ladd
Family Foundation, 2001.428

Trivikrama, the Taker of Three Steps, is one of Vishnu's most awe-inspiring and triumphant manifestations (73, 74), made all the more fantastic by the fact that this gigantic form emerges from the body of a dwarf. Given its vast scope and the fact that it consists of three sequential acts (stepping across the earth, then across the sky, then into the heavens), the subject defies full sculptural representation, especially in a single image. However, the image of Vishnu with one foot high in the air came to stand in for the story in full.

The small sandstone relief from central India (73) may not do justice to the god's unfathomable size, but its lively stance seems to capture the god in mid stride. It probably originally appeared in a program of small vignettes celebrating the deeds of Vishnu and/or his avatars, running around the side of a temple or on the edges of an image frame. Vishnu holds his chakra and conch, and his raised foot seems to kick or be bitten by a large floating head. The head often appears in depictions of Trivikrama and it is usually identified as that of the celestial deity Rahu, the immortal disembodied head who causes eclipses when he swallows the sun or moon, only to have them emerge shortly thereafter from his open throat.[40] Rahu is not mentioned in either the *Vishnu Purana* or the *Bhagavata Purana* versions of the Vamana–Trivikrama story. Vishnu does vanquish Rahu in the story of the Kurma avatar: Rahu sips the immortal elixir produced when the gods and demons churn the ocean, but Vishnu beheads him before the elixir can spread to the rest of his body, so he is left as a disembodied head for all eternity. There is no particular reason to include Rahu in images of Trivikrama except perhaps as a signifier of outer space. Another possible explanation for the head is that it belongs to Bali, who is sometimes said to have offered his head as the final resting place of Vishnu's foot at the end of the third step into the heavens. This humble offer turns Bali into a devotee who is then blessed by the touch of the god's foot.

The larger relief (74), which was carved in the very grainy stone that distinguishes sculpture from the eastern state of Orissa, offers an interesting solution to the problem of depicting three steps in a single relief. The god has one leg lifted in the typical manner; the foot is not present and may never have been included in the image (it ends in a very clean, rounded edge that suggests that it was never broken). If the foot was originally absent, then it might have been understood as having disappeared into the unfathomable distances of heaven. What is truly unusual is the presence of a foot at the level of the god's groin, apparently emerging from his stomach. This represents the second step across the sky, higher than the earth-bound foot but not nearly as high as the one that reached the divine realm. With his head thrown back to look upward at his final step, the lively figure of the god appears to be dancing across all existence. Beneath the giant figure of Trivikrama are the parasol-carrying Vamana holding out his hand and the larger figure (now headless) of Bali, pouring the offering water into it. ❈

The Parashurama Avatar

Parashurama is the sixth avatar of Vishnu, incarnated to end the dominance of the Kshatriyas, the warrior caste, who had "taken to unrighteous ways"[41] and have become a burden on the earth. He is the fifth son of sage Jamadagni and Renuka. Though born into the priestly caste (his mother was a Kshatriya), Parashurama becomes a supreme warrior, wielding the great axe Parashu given to him by Shiva. With this axe he beheads his mother at his father's instructions, as Renuka's pure mind had been defiled by lustful thoughts. Pleased with Parashurama, Jamadagni confers boons on him. Parashurama asks that his mother be restored to life without any memory of her death and that he enjoy a long life and be undefeatable in single combat.

Once, when Renuka is alone at the hermitage, it is visited by the powerful, thousand-armed, Kshatriya king Kartavirya. Renuka looks after him as was customary for an honored guest, but he repays her by stealing her celestial cow of plenty. Parashurama returns to the hermitage and, hearing the story from his mother, decides to teach the arrogant Kartavirya a lesson. In the battle that follows, Parashurama cuts off all one thousand arms of Kartavirya and kills him. Then, in order to avenge their father's death, the "vile and extremely heartless"[42] sons of Kartavirya go to the hermitage and kill Parashurama's old and defenseless father. The furious Parashurama takes a vow to wipe out all the Kshatriyas from the earth. "He found that the kings had become inimical to the Brahmans; enraged at this He rid the earth of the *kshatriya* race as many as twenty one times."[43] The *Bhagavata Purana* says that Renuka beat her breast twenty-one times in agony after her husband's brutal murder, which is why Parashurama wipes out the Kshatriyas that many times.

Parashurama's story continues in the *Ramayana*, where he is finally humbled by Rama, a Kshatriya, but also an incarnation of Vishnu. Rama breaks the bow of Shiva in order to win Sita's hand in marriage. When he returns to his kingdom with his bride, he is challenged by Parashurama, who is a great devotee of Shiva. Rama defeats Parashurama, after which the latter retired to the Himalayas. This overlap between incarnations may seem a bit strange, but it happens again when Parashurama becomes the teacher of Vishnu's tenth incarnation, Kalki.

Parashurama's irascible temper and violent behavior have made him one of the less popular of Vishnu's avatars, although he does attract some devotion. The southwest coast of India is known as Parashurama region (*kshetra*), because it is believed to have been retrieved from the sea by him when he shot an arrow to drive the sea back. He is said to have brought Brahmins from the north to this region and is credited with the construction of thousands of temples.

A temple built for Parashurama in Maharashtra has an interesting story attached to it: a wealthy Muslim lady of the Adil Shahi dynasty (1490–1686) dispatched her ships filled with merchandise for Arabia, when a terrible storm rose over the Arabian Sea. The lady prayed to Parashurama and the storm ceased, saving her ships and her merchandise. In gratitude, she built a temple in his honor at Phede, which became a major pilgrimage site for Hindus and Muslims.[44] [NP]

75 | **Parashurama**

Mola Ram (1743–1833)
Northern India, Punjab Hills, Garhwal; c. 1780
Opaque watercolor and gold on paper
8 9/32 x 10 23/32 in. (21 x 27.2 cm)
The San Diego Museum of Art. Edwin Binney 3rd Collection, 1990:1314

76 | Parashurama

Northern India, Punjab Hills, Bilaspur; c. 1700–1720
Opaque watercolor and gold on paper
6 ⅛ x 8 ½ in. (15.6 x 21.6 cm)
Collection of Subhash Kapoor

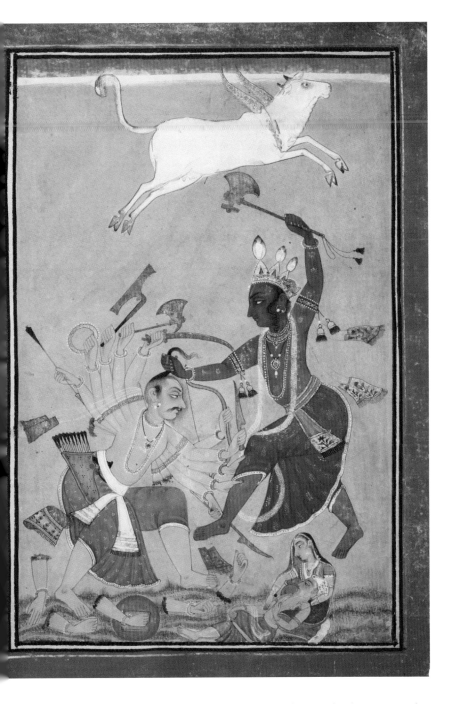

Though these paintings (75, 76) depict similar episodes, their style and overall effect is completely different. The focus of the images is the blue-hued, axe-wielding Parashurama who hacks away at the limbs of Kartavirya.

Now with his (one thousand) arms the celebrated Arjuna [another name for Parashurama's foe, not to be confused with the Pandava] synchronously fitted arrows to his five hundred bows in order to pierce Rama [Parashurama]. Rama (however), who was by far the foremost of those that (ever) wielded missiles and who had (only) one bow, simultaneously cut them down with his arrows. Again, with his hard-edge axe Rama, for his part, violently lopped off, like the hoods of a serpent, (all the thousand) arms of Arjuna, who came rushing forward in battle with (terrible) speed.[45]

Parashurama's blue coloring identifies him as an incarnation of Vishnu, and his face remains serene despite the bloodshed. It is a common trope in Indian painting that the deity's face is calm during battle and destruction of foes. Parashurama wears a crown and jewels like a warrior in the Bilaspur painting but in the Garhwal image he is identifiable as belonging to the priestly class by the small, white, parallel caste marks on his arms and legs. Kartavirya carries a multitude of weapons in his surviving arms, while the ones that have been chopped off lie bleeding on the ground. Kartavirya was supposed to have one thousand arms, but all of them are not depicted in the paintings. The viewer must imagine that he had that many and that all were ultimately cut off.

The prostrate figure and the woman in whose lap his head rests are Parashurama's parents, shown after his father had been killed by Kartavirya's sons—an event that takes place later in the story. In the Garhwal painting (75) they sit outside a tent-like hut. The winged celestial cow is flying away, escaping from her captor, Kartavirya.

In the Bilaspur painting (76), the crown worn by Parashurama is similar to the crowns worn by incarnations of Vishnu in other paintings from the region in the eighteenth century. Also, his transparent scarf with floral borders is in keeping with the fashion of the eighteenth century, particularly as worn at the imperial Mughal court. [NP]

The Rama Avatar

In striking contrast to the warrior-hating Parashurama, the next two avatars of Vishnu are born into the warrior, or Kshatriya, caste. The first of these, Rama, is in fact held up as the greatest Kshatriya of all time, a model for all Hindu rulers.

Rama's life story is told in the *Ramayana*, an epic tale that was first recorded in Sanskrit by the poet Valmiki sometime between the seventh and fourth centuries BCE.[46] The story has been retold countless times by other poets, often in vernacular languages,[47] and it continues to resonate outside of the Hindu world, in places like Buddhist Thailand and Muslim Java, in part because it is an entertaining adventure story and in part because royal patrons admire the ideal of divine kingship embodied in Rama.

The primary purpose of the Rama avatar is to put down the demon Ravana, who like so many of Vishnu's adversaries was granted a wish that gave him excessive power, in this case a wish that he would be invincible to god or demon. It never occurred to Ravana to include mere mortals in his list of potential rivals, so the descent of Vishnu in the form of a man takes advantage of a loophole, much like the ones exploited by the Narasimha avatar. Like the other human avatars, Rama lives a long life and brings many other benefits to humanity beyond the defeat of Ravana.

Born a prince, Rama promises to be a great successor to his father's throne. He uses his particular skill in archery to win the hand of his beautiful wife, Sita. Rama's seemingly flawless character is tested when his father, under the sway of a young wife, disinherits him and exiles him to the wilderness. Ever the loyal son, Rama departs with his wife and his favorite brother, Lakshmana.

The three make the best of their time in the forest, but the idyll is interrupted when Ravana, the multiarmed, multiheaded king of the demons, abducts Sita and takes her back to his palace on the island of Lanka. Rama and Lakshmana seek Sita with the help of new allies, a clan of monkeys. The monkey general, Hanuman, locates Sita and then aids the brothers in a great battle against the demons. After violent fighting, Rama slays Ravana and retrieves Sita. The victory is tainted by rumors of Sita's impurity, and although she is clearly beyond reproof, the couple finds it necessary to live apart, even after the birth of their twin sons. The term of his exile ends and Rama assumes his father's throne, from which he rules wisely for the rest of his life.

Although the *Ramayana* story was familiar to every child in India for centuries, the Rama avatar did not attract a sectarian following (or temples dedicated solely to him) until around the twelfth century.[48] Worshippers of Rama assert his transcendent perfection as the great god Vishnu, but others find Rama's most interesting qualities in his human frailties: his doubts, his regrets, even an apparent lack of awareness of his own avatar status.[49]

77 | Rama

Southern India, Tamil Nadu, probably Kaveri River Delta; Chola period, c. 11th century
Bronze; 30 x 13 ½ x 9 ¾ in. (76.2 x 34.3 x 24.8 cm)
Philadelphia Museum of Art. Purchased with the W.P. Wilstach Fund, the John D. McIlhenny Fund, and with funds contributed by the Women's Committee of the Philadelphia Museum of Art in honor of their 100th anniversary, W1982-106-1

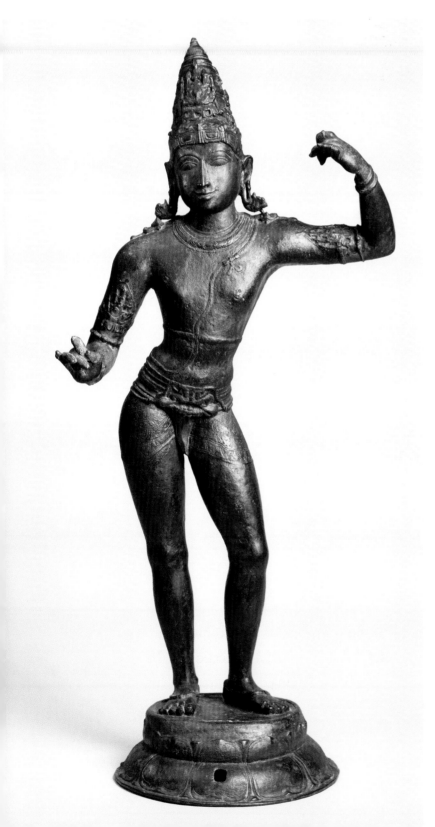

The temples of India and Southeast Asia are covered with narrative reliefs and murals depicting the many episodes of the *Ramayana*, but because Rama did not attract a sectarian following until the twelfth century or later, freestanding or large-scale icons of the avatar are relatively rare. The one region in which one finds Rama icons in an earlier period is Tamil country, in southeastern India, where worship of Rama and his family was apparently included in the complex schedule of rituals conducted at Vishnu temples, at least for a brief time in the tenth and eleventh centuries.[50] A small number of *Ramayana* groups were cast in bronze in that period, consisting of a figure of Rama, a similar but smaller image of his brother, Lakshmana, a lovely figure of Sita, and a standing Hanuman. This graceful image of Rama almost certainly belonged to such a four-figure group, although the other members of the set have not been located.

This icon originally depicted Rama leaning on a tall archer's bow with his raised left hand while his right hand held an arrow.[51] Rama is a great archer, and archery plays an important role at key moments throughout his life: he wins the hand of his wife Sita by stringing and then snapping in two the giant bow of Shiva; he loses her because he is off trying to shoot a golden stag; he shoots the monkey king Vali with an arrow; and he finally defeats Ravana with a special arrow that was created by the god Brahma. Shortly after Rama snaps Shiva's bow, his predecessor avatar, Parashurama, gives him another bow that had belonged to Vishnu (and with which Vishnu had bested Shiva in an earlier contest). The bow, known as Kodanda, is one of the only possessions that Rama takes with him to the wilderness. Images of Rama leaning on his bow are called "Kodanda Rama." Because of its history, the presence of the bow celebrates more than Rama's prowess at archery; it also represents Vishnu's superiority over Shiva, and the passing of at least some form of divine authority from the Brahmins (as manifested in Parashurama) to the warriors/Kshatriyas (as manifested in both Rama and Krishna). ✦

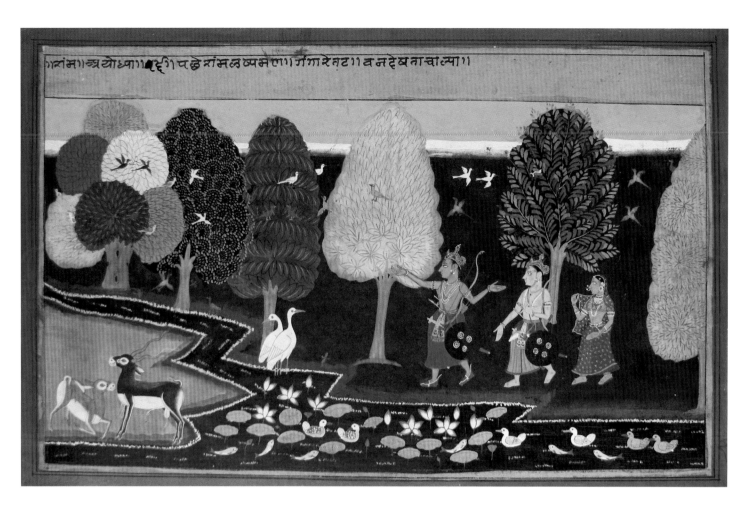

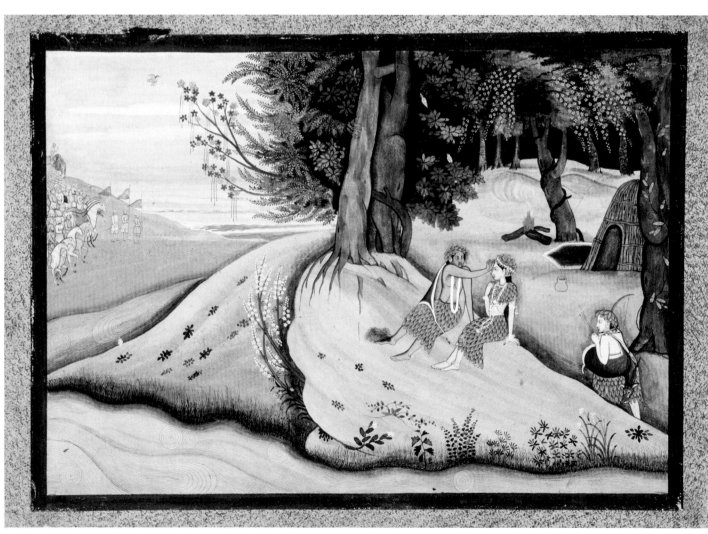

78 | Rama, Sita, and Lakshmana Walking to Chitrakuta
(*facing page, above*)
Page from an illustrated manuscript of the *Ramayana*
Northern India, Rajasthan, Mewar; c. 1680–90
Opaque watercolor on paper; 10 x 16 in. (25.4 x 40.5 cm)
Collection of Catherine and Ralph Benkaim

79 | Rama, Sita, and Lakshmana in Exile
(*facing page, below*)
Page from an illustrated manuscript of the *Ramayana*
Northern India, Punjab Hills, possibly Kangra; c. 1775
Opaque watercolor and gold on paper
9 ¾ x 14 ¹⁄₁₆ in. (24.8 x 35.7 cm)
Collection of Ramesh and Urmil Kapoor

The *Ramayana* begins with an account of Rama's birth, childhood, and wedding to Sita. These early passages establish the hero's supremacy, but the narrative does not become dramatic—or often illustrated—until Rama is sent away by his own father. The exile of Rama from his kingdom of Ayodhya to the wilderness of Chitrakuta (and then further, by choice, into Dandaka) is acknowledged by all to be a great injustice, primarily because Rama is so clearly meant to lead the kingdom. Rama, in his great wisdom, chooses to treat his years in the woods as an opportunity for spiritual growth.

As seen in these depictions (78, 79), the wilderness to which Rama is exiled is actually quite fertile and attractive. In the Valmiki *Ramayana*, Lakshmana describes the site of their new home to Rama: "Look, there is a pond close by that shines like the sun and is filled with fragrant lotuses! And there is the river Godavari ... lined with trees, visited by swans and all kinds of song birds."[52] The Tulsidas *Ramayana* suggests that the woods are beautified by the presence of Rama: "From the time that Rama made his home there, the hermits lived happily and without fear. The mountains, woods, rivers, and lakes were suffused with beauty and day by day grew more exceedingly lovely. The many birds and deer were full of joy, and the bees added

a charm by their sweet buzzing."[53] The descriptions of the fertile woods, teeming with life, are reminiscent of so-called *Krishna Lila* literature, which describes the rural idylls of Krishna's youth, but the Valmiki text predates the *Krishna Lila* tradition by a millennium.

The depictions reproduced here indicate that the subject of Rama's exile offered a rare opportunity for Indian artists to turn their attentions away from the figure, if only momentarily, and toward the landscape. The Mewar painting (78), the earlier of the two, is in the classic graphic, legible style practiced over the course of the seventeenth century in that state.[54] The pairs of animals underscore the fertility of the setting.[55] Although the abundant trees appear to be more stylized than documentary, most are in fact recognizable species common to South Asia.

The Kangra-style painting (79) dates about one hundred years later and reflects the painter's interest in depicting deep, spacious settings that resemble the known world, with muted colors and modeled surfaces. In the distance, we see the troops of Rama's younger brother, Bharata, who attempts to follow Rama into exile. The pomp and formality of this tiny army contrasts dramatically with the ruggedness of the campsite and the casual affection of Rama's interaction with Sita.

The primary preparation made by Rama, Sita, and Lakshmana before they leave civilization is a change of clothing, from their royal finery to the rough garb of religious ascetics. Illustrators of the *Ramayana* (including this artist) often fashion fanciful costumes out of green leaves for the trio, even though Valmiki's text does not specify that this is what they wore, and the later version by Tulsidas (more often the textual source for later North Indian depictions) makes only brief mention of bark cloth. The fact that there is prescribed attire for forest dwelling underscores that Rama's departure follows the ancient Hindu practice of religious retreat, in which one forsakes the comforts and distractions of everyday life in pursuit of insight and emotional strength. �֎

80 | Surpanika Complains to Ravana

Page from an illustrated manuscript of the *Ramayana* (the "Shangri" *Ramayana*)
Northern India, Punjab Hills, Bahu; c. 1690–1710
Opaque watercolor on paper; 8 ½ x 12 ½ in. (21.6 x 31.8 cm)
Collection of Catherine and Ralph Benkaim

The exile of Rama, Lakshmana, and Sita to the wilderness would have been uneventful were it not for a lustful demoness named Surpanika. Having become infatuated with Rama after a glimpse of him in the woods, she took on the form of a lovely woman and approached him, offering herself as a superior alternative to Sita. Rama and Lakshmana spoke to her gently with but a heavy dose of sarcasm that she did not understand, and she lunged at Sita, perceiving her as a rival. Rama protected Sita, and Lakshmana punished Surpanika by cutting off her nose and ears.

The furious demoness first sent her brother, Khara to slay Rama; even though Khara brought an enormous army of demons, Rama killed all of them single-handedly. Then Surpanika went to Lanka to see her other brother, Ravana, the great, multiheaded king of the demons. Through a combination of admonishments, in which she told her brother to stop being so complacent; warnings, in which she described the threat to all demons posed by Rama; and promises, in which she expounded on the unequalled beauty of Sita, Surpanika roused her equally vengeful and lustful brother to action. He departed in search of the great prince and his desirable wife, intent on slaying the one and abducting the other.

This painting is from an extensive *Ramayana* series that is usually known by the name of the principality where it was found: Shangri.[56] The pages of the series reflect at least four different painting styles, but most compositions are quite simple, with figures posed in a line against a flat, single-color background as seen in catalogue 82. This composition is unusually complex, with an elaborate architectural setting to evoke the grandeur of the demon capital, and water in the foreground to indicate the capital's location on the island of Lanka. Surpanika appears at the gate, doubly hideous for her mutilated face, calling her multiheaded brother to action. Ravana, who has multiple arms as well as heads, appears in a boat, ready to cross over to the mainland. He is joined by a wide variety of demons. Indian artists have long enjoyed developing new demon physiognomies; the attributes of a typical demon are bestial: horns, snouts, hair, and fangs. ✸

81 | The Abduction of Sita

Page from an illustrated manuscript of the *Ramayana*
Northern India, Punjab Hills, Kangra style; c. 1775
Opaque watercolor and gold on paper
9 ³⁄₄ x 14 in. (24.8 x 35.7 cm)
Brooklyn Museum. Anonymous Gift, 78.256.3

When Ravana sees Sita, she appears as beautiful as his sister had promised, and in keeping with his passionate demon nature, he becomes completely smitten. He manages to gain access to her by sending another demon in disguise as a golden deer. Rama pursues the deer at Sita's request, and Lakshmana follows him when he hears what he perceives as a cry of pain. Ravana initially approaches the solitary wife in the form of a religious ascetic, but then reveals himself and tries to convince her to join him on Lanka. When she refuses, he wrestles her onto his chariot. A vulture named Jatayu hears her cries and attempts to free her. Jatayu manages to destroy Ravana's chariot, but the demon king eventually cuts off the vulture's wings and feet and leaves him to die while he

grabs Sita and flies away. As they fly over the woods, a group of monkeys look up, and Sita throws her scarf and jewelry to them, hoping that they will tell Rama what happened.

This painting comes from the same series as catalogue 79. Unlike that illustration, which captures a mood as much as a specific episode, this composition captures a dramatic series of events in explicit detail. Rama and Sita appear twice: such depictions of multiple moments in a single setting through repetition of figures is known as continuous narration and is common in Indian painting. The violence of the battle between Ravana and the vulture Jatayu is summed up in the mutilated body of the bird and the wreckage of the demon's chariot, while the sky is tinged with blood-red clouds, as if injured by the horror of the situation. The trio of trees immediately above the battle echo the figure of Ravana overpowering Sita: unattractive but larger trees flank a beautiful, healthy specimen. In an ironic detail, a bird returns to its perch to find its mate waiting; Rama will not enjoy the same experience. Sita is flying away, getting smaller as she disappears into the distance. ✻

82 | **Rama Kicks the Body of Dundubhi** (*facing page, above*)
Page from an illustrated manuscript of the *Ramayana* (the
"*Shangri*" *Ramayana*)
Northern India, Punjab Hills, Bahu; c. 1700–1710
Opaque watercolor, silver, and gold on paper
8 ⅝ x 13 ⅞ in. (21.95 x 35.3 cm)
Brooklyn Museum. Ella C. Woodward Memorial Fund, 70.145.2

83 | **Rama and Lakshmana Confer with Sugriva about the
Search for Sita** (*facing page, below*)
Page from an illustrated manuscript of the *Ramayana*
Northern India, Punjab Hills, Mankot or Nurpur; c. 1700–1710
Opaque watercolor and gold on paper; 7 ⅞ x 12 in. (20 x 30.5 cm)
Brooklyn Museum. Gift of Mr. and Mrs. Robert L. Poster, 85.220.1

These two paintings (82, 83) belong to the intermediate section of the *Ramayana*, after Sita has been abducted but before she has been located. They narrate the important episodes in which Rama develops his strong alliance with the monkeys, or Vanars, by helping their leader, Sugriva, to usurp the throne from his brother Vali. As an exiled prince, Rama has no human troops he can call on, but his forest partnerships—which will expand to include bears—prove to be invaluable when he must fight Ravana and his demon army later in the story. The monkeys and bears live much like humans, with political machinations and petty rivalries, but they are more subject to bestial impulses and as such make a good foil for the perpetually steady Rama.

In the painting from the "Shangri *Ramayana*" (82), the same series as the Surpanika illustration (cat. 80), Rama is shown kicking the emaciated body of a demon. The body belongs to Dundubhi, a terrible, giant, buffalo-horned fiend who had attacked the city of the monkeys seeking vengeance over the death of his son. Vali, then king of the monkeys, had killed Dundubhi by picking him up and flinging him to the ground. Later, Rama comes across the body of the demon in the company of Vali's brother Sugriva (the crowned monkey pictured here). At the time, Rama is strategizing with Sugriva about seizing the kingdom from Vali. Sugriva points to the giant corpse as an example of his brother's great strength and the challenge that awaits anyone who would confront him. In response Rama kicks the body with his toe, sending it flying a great distance. Sugriva is impressed by Rama's power, but he notes that the corpse is all skin and bones, desiccated and therefore much lighter than it was when alive.[57] The incident prefigures the much larger, future encounter with demons, but in the future the demons will not be so easily dispatched.

The second image (83) is from an extensive, somewhat quirky *Ramayana* series that has traditionally been attributed to the hill state of Mankot but is just as likely to hail from Nurpur or another atelier. In this image, Sugriva has taken the monkey throne with the help of Rama and Lakshmana. After what seems to the brothers to be an interminable rainy season, during which Sugriva spends all his time celebrating his victory, drunk and making love to his wives, the monkey king is finally ready to repay Rama by assisting with the search for Sita. He summons vast numbers of monkeys from every region. He sends teams to the four directions (depicted here as the four corners of the painting), describing in detail the varied terrains and landmarks of India.[58] Sugriva notes, and Rama agrees, that his most loyal and talented general, Hanuman (here depicted as one of the crowned monkeys in the upper right corner, the other being Angada), is most likely to succeed in the task of finding Rama's wife. Rama gives Hanuman his ring to present to Sita when he locates her. ✳

84 | **Ravana Challenges Rama's Army**
Northern India, Punjab Hills, Mandi, c. 1750
Opaque watercolor on paper
6 ⅛ x 7 ¾ in. (15.5 x 19.5 cm)
Brooklyn Museum. Gift of Dr. Bertram H. Schaffner, 1994.11.1

85 | **Rama's Armies Battle Against Demons** (*facing page*)
Page from an illustrated manuscript of the *Ramayana*
Northern India, Punjab Hills, Mandi; early 19th century
Opaque watercolor and gold on paper
9 ¹⁵/₁₆ x 13 ⅞ in. (25.3 x 35.5 cm)
Museum für Asiatische Kunst, Berlin. I 5417

The battle between the armies of Rama and Ravana is long and exceedingly bloody. It is however one of the most visually compelling wars ever fought, given that the opposing armies are made up of monkeys and bears on one side and a diverse body of demons on the other. Ravana's troops are well armed, with handsome horses and sophisticated weaponry; Rama's army, in contrast, wields nothing but tree trunks and rocks. Both sides make use of magic, but in the end the demons—who are more courageous in battle than one might expect—prove incapable of outfighting the steady and clever monkeys and bears, who are, after all, led by a manifestation of God.

This group of paintings (84, 85, 86) includes two from the same hill state, Mandi, which was a center for painting for three centuries, although the styles of painting practiced there changed radically with each century. The later Mandi painting (85) is in keeping with the refined, spatially deep style practiced throughout the Punjab Hills in the later eighteenth and early nineteenth century. It offers a brilliant sense of the contrast between the two armies: the demons

are strange in appearance but orderly and well armed, while the monkeys and bears—drastically outnumbered—must clearly rely on brute force. The image depicts the moment when Ravana arrives on the battlefield for the first time; his appearance is so brilliant and intimidating that legions of monkeys and bears flee in despair (seen at the upper left). The composition of the painting, with Rama's troops bearing down on the demons, hints at the victory to come.

In the small eighteenth-century painting from Mandi (84), Rama is shown finally coming face-to-face with Ravana. Lakshmana, ever rash, shoots the first arrow at the demon king, with no success. Severed hands fall from Ravana's body, but the texts tell us that he is capable of regenerating lost limbs. This painting is not part of any known *Ramayana* series, and it is unusual because it was made for a royal

patron who was staunchly Shaiva (a worshipper of Shiva). Shamsher Sen of Mandi (reigned 1727–81) and his father commissioned a small body of extremely eccentric paintings in the mid eighteenth century, most of them propitiating Shiva in one way or another. Given the sectarian affiliation of the patron, it might be best to read this painting as a celebration of Ravana, even though he eventually loses the battle, because he is one of Shiva's greatest devotees. Ravana becomes Shiva's worshipper inadvertently, when he expends enormous effort trying to lift the peak of Mount Kailasha, Shiva's home, so he can hurl the mountain at Rama. Despite the fact that he is opposed to Shiva during the struggle, the intensity of his concentration amounts to devotion. Ravana's sectarian affiliation is apparent here in the Shaiva tilak marks running horizontally across his many foreheads. ✳

Eastern India, Western Bengal, probably Kolkata; c. 1860
Opaque watercolor on blue-tinted European paper
6 ⅝ x 11 ¾ in. (16.8 x 29.8 cm)
Collection of Kenneth and Joyce Robbins

A later painting, made probably in Bengal (86), depicts the battle as a giant melee, with Rama (here green) and Ravana shooting at each other from enormous chariots the size of houses while their teeming armies engage in hand-to-hand combat and monkeys fly above. The use of green for Rama's skin can be found in many Bengali paintings, and the practice carries further east into Southeast Asia, especially Thailand, where a version of the *Ramayana*, called the *Ramakien*, serves as the national epic, and royal temples boast many images of the green-skinned hero.

This painting includes many western pictorial conventions, including the use of atmospheric perspective: the use of lighter colors and blurrier outlines on the smaller figures toward the horizon enhances the sense that they are further away than the more vividly rendered figures of the foreground. Many paintings of this sort were made in the mid nineteenth century for European patrons, who were interested in acquiring images that captured the exotic legends and culture of India. This particular image was rendered on European-made paper, which was used almost exclusively for paintings intended for sale to Westerners.

Ravana proves to be a difficult opponent for Rama because of his ability to regrow heads and arms as they are cut off. He also creates an illusion in which he multiplies himself infinitely, causing considerable fear among his opponents. Rama finally manages to slay him with an arrow to the chest or stomach, the site of a deposit of immortal elixir that Ravana had swallowed but never completely absorbed.[59] Rama is able to kill Ravana by piercing the source of his rejuvenating power.

Hanuman

Rama's victory over Ravana would not have been possible without the assistance of the great monkey general Hanuman. The son of Vayu the wind god, Hanuman is blessed with supernatural strength and near invincibility.[60] He is one of the greatest heroes of mythic literature, combining the physical ability and playfulness of a monkey with the loyalty and fortitude of a warrior. Some of his most miraculous feats in the *Ramayana* include jumping across the ocean to Lanka to find Sita and delivering a Himalayan mountaintop to Lanka so that the herbs that grow there could be used to heal an injured Rama. Whereas most monkeys—including Hanuman's king, Sugriva—tend to be driven by base desires, Hanuman is a consummate diplomat.

In the *Ramayana*, Hanuman is praised for his valor and devotion to Rama, but the text does not hint at the following that Hanuman would eventually attract. One cannot travel far in any part of India without encountering a shrine to the monkey god; his temples are often small and unassuming, but they far outnumber those dedicated to Rama. The Hanuman cult is of relatively late date, emerging around the ninth or tenth century but not flourishing until much later.[61] Over time the worship of Hanuman has developed into a tradition that is largely separate from the worship of Vishnu or Rama.[62] There are sophisticated texts dedicated to the promotion of Hanuman worship, but for the most part the practice has grown among the masses, who celebrate the monkey god as a protector with magical powers. His followers sometimes admit that he is not a transcendent deity like Vishnu or Shiva, capable of granting great spiritual insight, but they also point out that the worldly benefits that one can gain by worshipping Hanuman are perhaps all we can expect in this decadent age of *Kali Yuga*. Because of Hanuman and his colleagues, monkeys—especially the black-faced Hanuman langurs—enjoy special status in India and they are often fed at temples.

87 | Mask of Hanuman

Southwestern India, Northern Karnataka or Southern
Maharashtra; 18th century
Brass; 13 x 11 ¼ x 3 in. (33 x 28.6 x 7.6 cm)
Peabody Essex Museum. Gift of Leo S. Figiel, M.D. and Family,
2006, E303506

Hanuman is unusual among Hindu deities for the way that he is often portrayed in shrine images. Most icons (as opposed to narrative images, not meant for worship) depict the gods frontally, facing the worshipper to offer the sense that one enjoys the deity's undivided attention. But many icons of Hanuman show the monkey god in profile, leaping across the sky with a giant boulder in one hand (see fig. 87–1 for a variant of this type and see the next entry for a full discussion of this subject). He does not face or engage the worshipper. A thorough analysis of this distinctive iconographic feature has yet to be made, but it is likely that the more narrative representation of Hanuman can be traced to the fact that he was originally celebrated as a hero, rather than worshipped as a god.

This elegant brass mask was probably made as an ornament for a Hanuman icon. Brass sheaths and masks are more often used on lingams (the phallic emblems of Shiva, the objects of worship in Shiva temples), but they can also occasionally be found on figural icons, in disparate areas of India such as Chamba and Karnataka. These coverings probably serve a dual role, beautifying the icon while also protecting it from wear caused by the frequent touching of devotees. The brass-casters active in northern Karnataka and southern Maharashtra in the eighteenth and nineteenth centuries developed a sophisticated metallurgy that allowed for smooth, subtle forms and a warm golden color. Hanuman appears to have enjoyed a particularly avid following in this area, as it produced many small bronze icons of the god as well. ✳

Figure 87–1 | Relief of Hanuman with modern paint, Hanuman Temple, Hemakuta Hill, Hampi, Karnataka.
© espixx/StockphotoPro

88 | Hanuman Carries a Mountaintop

Northern India, Punjab Hills, Chamba; 18th century
Cotton plain-weave embroidered with silk and flat wire
29 ½ x 39 in. (74 x 99 cm)
Museum of Fine Arts, Boston. Helen and Alice Colburn Fund, 1983.320

In the great battle between the demons and Rama's army of monkeys and bears, both sides draw frequently on their superhuman abilities. One of the weapons of choice, especially for monkeys who do not use arrows, is large rocks, which they tear from mountains and hurl at their opponents.[63]

Hanuman is shown here lifting one of these enormous rocks, striding from one mountain peak to another, his mighty mace raised in his other hand. This pose is the most popular for icons of Hanuman, enshrined in temples all over India, although in temple icons he is often shown flying through the air. It is likely that this image celebrates a specific episode in which Hanuman retrieves a mountaintop, not to hurl it at an opponent, but to bring rare medicinal herbs to Rama and Lakshmana and their injured troops. Hanuman is sent to the Himalayas by the wise old bear Jambavan, who tells him to collect four herbs that grow on a specific peak. When the monkey arrives at the mountain, the herbs disappear as he

tries to pick them, so, frustrated, he "grabbed the mountain by its peaks and uprooted it along with its trees, elephants, minerals and plateaux."[64] He takes the whole mountaintop to Lanka, where the scent of the herbs revives the troops. Although the *Ramayana* treats this story as an example of Hanuman's strength—and of his somewhat impulsive monkey nature—the incident has led to Hanuman's more modern reputation as a healer.

This embroidered cotton panel is a *rumal*, a cloth used to drape over gifts that were presented on trays on special occasions. Made in the areas around the principality of Chamba, in the hilly northern state of Himachal Pradesh, these embroideries are often compared to the miniature paintings made in this region in the same period. Designs for rumals, line drawings on paper, have been found in the collections of painter families,[65] suggesting that painters provided the compositions for the embroideries, which were then carried out by professional embroiderers or sometimes by upper-caste women. Rumals made in the Chamba area are almost always Vaishnava in subject if they are not strictly floral. The rulers of Chamba claimed descent from Rama, so it is not surprising that they would have been interested in celebrating Hanuman.[66] Another rumal from the Chamba area is illustrated in catalogue 114. ✳

89 | Hanuman Revealing Rama and Sita in His Heart
Eastern India, West Bengal, Kolkata; mid 19th to
early 20th century
Watercolor and silver on mill-made paper
18 x 11 in. (45.7 x 27.9 cm)
Peabody Essex Museum. Museum Purchase, 2003, E302104

90 | Hanuman Revealing Rama and Sita in His Heart
Eastern India, West Bengal, Kolkata; mid 19th to
early 20th century
Watercolor and silver on mill-made paper
18 x 11 in. (45.7 x 27.9 cm)
Peabody Essex Museum. Museum Purchase, 2003, E302226

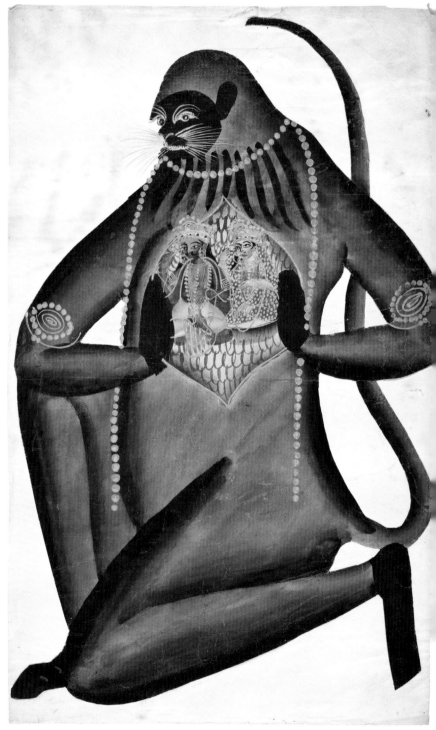

These two very similar paintings (89, 90) belong to a short-lived tradition of image-making that flourished in the bazaars of Kolkata (Calcutta), particularly in the market around the Kalighat temple, from the mid nineteenth century through the first decades of the twentieth century. Kalighat paintings (as they came to be known) were mass produced by low-caste artisans who sold them at low prices to casual consumers. Because the paintings had to be made quickly and cheaply, the artists employed an economy of brushstrokes and minimal detail to create images that look surprisingly modern in their spontaneity and abstraction. One of the signature features of Kalighat paintings is the use of darker contour strokes to endow forms with a sense of volume, a feature that some scholars have attributed to European influence, but which can also be found on clay figures made by the ancestors of the Kalighat artists.[67]

A comparison of these two Hanuman images shows that the artists had a set notion of how the subject should be depicted (blue-skinned, kneeling, his hands flanking the hole in his chest), but that they could employ subtle variations, as in the curvature of the tail or the style of the jewelry. These two paintings are clearly by different hands, although we will never know the identity of the artists.

The subject is Hanuman ripping open his chest to show that Rama and Sita are forever present in his heart. The miniature royal couple sits and waves, surrounded by stylized entrails. The story is a favorite among devotees of Hanuman and Rama, but it does not appear in the *Ramayana*s of Valmiki or Tulsidas. In later variants of the epic, the episode takes place after Ravana has been killed and all are celebrating. Rama thanks Hanuman for his help with the gift of Sita's necklace. Hanuman immediately starts to break apart the beads of the necklace, and when asked why he is destroying his precious gift, he says that he is looking to make sure that Rama and Sita are present in every bead. In acknowledgment of this early incident, both paintings show Hanuman wearing a broken string of beads. Even after hearing this explanation, some onlookers question the depth of Hanuman's devotion to Rama and Sita, and in response he opens up his chest to show their presence there.[68]

This story emphasizes Hanuman's role as Rama's greatest devotee. As such he serves as a model for all other followers of Rama, and because extremes of devotion can raise the devotee to divine status, the monkey becomes an object of worship. ✺

Krishna as Avatar and God

The prince-cowherd Krishna is included among Vishnu's avatars in early lists and representations. Over the course of time, Krishna rose in importance; although he came to earth and lived and died among humans, he came to be considered something more than an avatar. Some texts have differentiated between the other avatars, who are but partial embodiments of Vishnu, and Krishna, who is Vishnu in full. For his followers, Krishna is the Supreme God. Krishna's origins can be traced to a clan called the Vrishni, who worshipped Vasudeva, an earthly hero from the Mathura area who later gained divine status (see Doris Meth Srinivasan's essay in this volume). The story of Vasudeva-Krishna expanded, and beginning around the epic period, Vasudeva came to be associated with Vishnu.

Whether avatar or not, Krishna's earthly story remains the same. He descends in order to kill his own uncle, Kamsa, who, like all the foes of Vishnu, has gained excessive power through a boon. Kamsa receives a warning that his nephew will kill him, so he destroys all of his sister's babies as they are born. Krishna's father manages to save Krishna, who is raised by an adoptive family in a pastoral community, away from his uncle's capital at Mathura. From the start, Krishna is a remarkable infant and child, beautiful and alternately mischievous and heroic, with superhuman strength that allows him to defeat one demon after another (some of them sent by Kamsa). As he grows into a young man, he enjoys the supposedly easy life of a cowherd, playing with his male friends (gopas) in the fields and then luring the women of the community (gopis) out of their homes at night for more illicit pastimes. The youth of Krishna has become the source for a very rich body of scripture, devotional poetry, and performing and visual arts, all celebrating the wonder experienced by the cowherds and milkmaids who lived in the presence of the divine.

Krishna's biography continues after he leaves his rural idyll, but it becomes less lyrical and more practical: he finally goes to Mathura, where he kills his uncle and sets up a new court, then he retreats to the western shore of India, to Dwarka, where he rules for many years and marries many wives. The most important contribution of Krishna's later life appears in the epic *Mahabharata*, in which he delivers the sermon of the *Bhagavad Gita* to Arjuna on the battlefield and reveals himself as Vishvarupa.

Krishna is the primary inspiration and focus for bhakti, or religious devotion, in India. Because the god has an extensive earthly biography in which his personality emerges quite clearly, he is a more approachable, engaging form of the divine than most other Hindu deities. Krishna's followers envision strong, emotional relationships with the god, in the form of either

an infant or a charismatic young man. Love—maternal or romantic—is used as a potent analogy for devotion to God, who is magnetic and delightful but also sometimes careless or naughty in his behavior. Many bhakti groups emphasize that Krishna's most blessed followers, the gopas and gopis of his youth, were uneducated people who recognized Krishna intuitively and as a result they tend to favor personalized forms of worship over strict ritual procedure, and the vernacular languages over Sanskrit. The various bhakti sects that developed around worship of Krishna and his sculptural manifestations are discussed in detail in the essay by Cynthia Packert in this volume.

Krishna is recognizable in imagery not simply because of his blue skin but also because he wears a saffron-colored *dhoti*, or long loin cloth, and a crown with peacock feathers in it. Krishna is the only avatar of Vishnu who carries a flute, and he is often depicted with cows and female attendant/admirers.

91 | Shrine for the Worship of Krishna as an Infant (Balakrishna)

Southern India, Tamil Nadu, Thanjavur region; 18th century
Opaque watercolor, gesso, gold, and jewels on cloth and wood
24 ½ x 27 ¾ x 3 ¼ in. (62.2 x 70.5 x 8.3 cm) when closed
Peabody Essex Museum. Gift of Marilyn Walter Grounds,
E302035

Although we have brief stories of Rama's childhood, and presumably other avatars were once young as well, Krishna is unusual in the degree of attention he attracts in infancy. Even before he is weaned, Krishna develops a lengthy roster of celebrated deeds, both heroic and impish, that are recounted repeatedly, and at a relatively late date Krishna began to be worshipped in the form of an infant.

Infants wield remarkable power: gentle but demanding, charismatic and influential. Practitioners of bhakti (devotion) project their own memories of parenting onto the religious experience, imagining themselves nurturing, anointing, and otherwise doting upon an absolutely charming child. Although we shall see that Krishna's behavior can be vexing, it is easily forgiven.

Although infant Krishna is worshipped throughout India, images of the child god are found most frequently in southern India. We shall see sculptural depictions of the toddler in the following catalogue entries, but we find his most infantile manifestation in the elaborately decorated paintings of Thanjavur. Thanjavur (Tanjore) was the capital

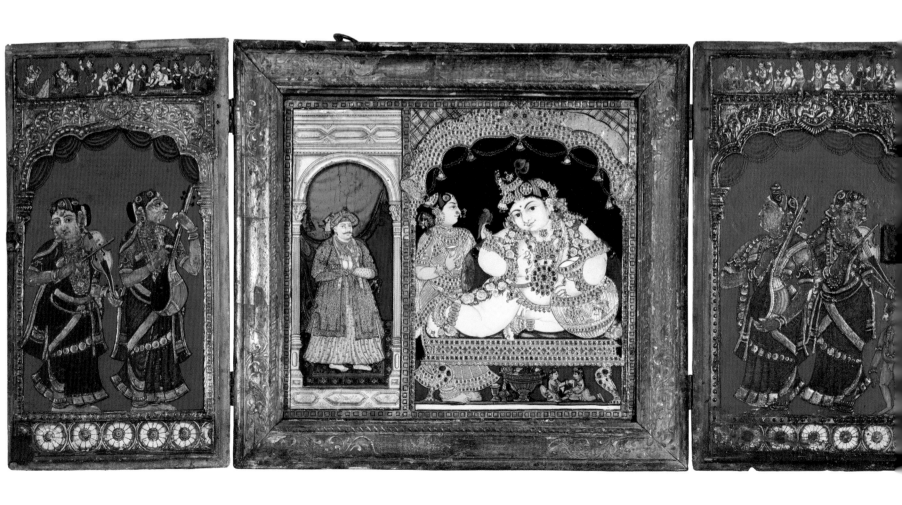

city of Tamil rulers off and on for several centuries, and it is home to a large temple dedicated to Shiva. Under the Nayaka rulers (sixteenth to nineteenth centuries), a distinctive painting style emerged in the area, painted on coated cloth that has been stretched over wood panels. After painting the image, the artist applied relief decoration in thick plaster to select areas then covered that with gold paint and inlaid gemstones. Unlike the many manuscript paintings made by contemporaneous courts, Thanjavur paintings were religious icons, made for display and worship on the domestic shrines of the southern elite. Their raised golden elements would have sparkled in the lamplight of the altar.

The most popular imagery in the Thanjavur tradition relates to baby Krishna—showing him with his mother, or floating on the banyan leaf, or eating butter balls, as seen here. The god is usually shown very fat and jolly, with light skin, but with the expressive face of a somewhat older person. Here, the giant pink infant lounges on a throne, attended by a woman with a parrot. He is honored, in the adjacent panel, by a standing aristocrat, probably the Thanjavur ruler for whom this particularly fine painting was made. Unlike most Thanjavur images, this one has small wood doors, painted on both sides with the images of female musicians (see below). It would have been closed when not in use to protect the image inside. ✺

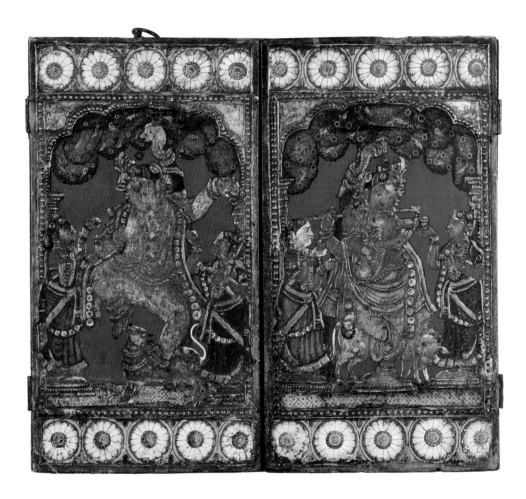

92 | Infant Krishna Dancing
Southern India, Tamil Nadu; Nayak period,
probably 16th century
Bronze; 5 ½ x 2 ¼ x 2 in. (14 x 5.7 x 5 cm)
Nancy Wiener Gallery, Inc

93 | Infant Krishna Dancing
Southern India, Tamil Nadu; Nayak period, 16th century or later
Silver and gold; 2 x 1 ¼ x 1 in. (5 x 3.2 x 2.5 cm)
Collection of Nancy Wiener

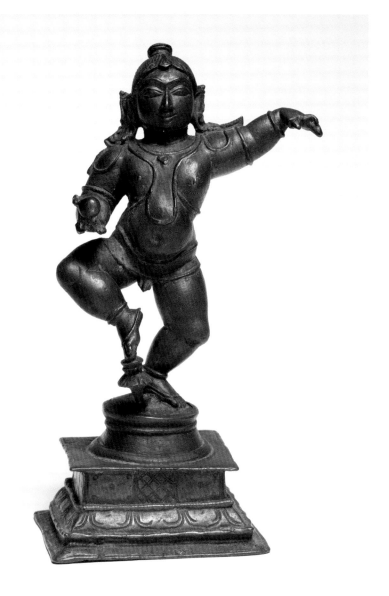

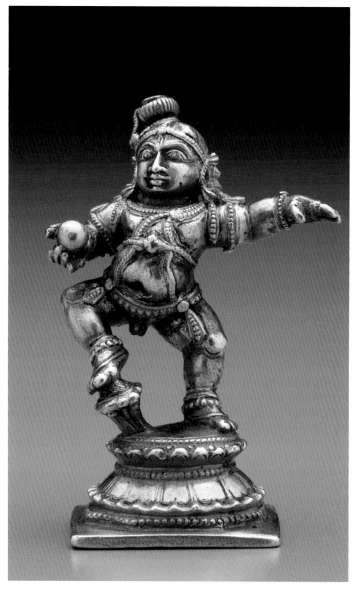

As both a child and a young man, Krishna lives much of his life in pursuit of fun. His exuberant nature is used as an explanation of the relationship between mortal and god. The gods are understood to spend much of their time engaged in *lila*, a Sanskrit term meaning "play," and mankind is their toy or playmate. The gods enjoy us enormously, but in their lightheartedness they can be heedless. The whimsy of the gods leads to highs and lows of religious experience for the devotee, who feels alternately adored and rejected. But the charm of the gods—and the memory of what it was like to be their favorite, if only for a moment—keeps devotees in their thrall.

94 | Infant Krishna Dancing

Eastern India, Orissa; 17th century
Brass with traces of pigment
8 ⅝ x 6 ½ x 4 ½ in. (21.91 x 16.51 x 11.43 cm)
Los Angeles County Museum of Art. Purchased with funds provided by Mrs. Burton M. Fletcher, M.87.124

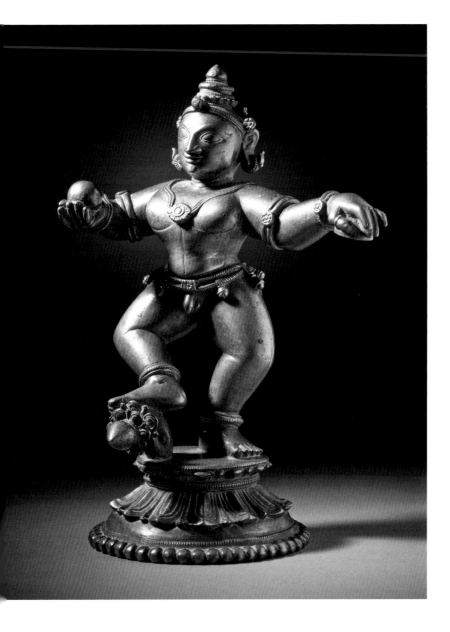

Dancing baby Krishna (92, 93, 94) is the very embodiment of *lila*. He is naughty, holding a stolen butter ball in one hand, but he brings smiles to the faces of all who witness him. There are only a few key moments in Sanskrit accounts of the Krishna story when the god is specifically described as dancing: the most celebrated are after his victory over the serpent Kaliya (see cats. 102, 103) and in his night-time trysts with the milkmaids (see cats. 106–114). However, later vernacular accounts tell of his ability to dance as a small child.

In the Chola period, southern sculptors developed an icon of the child Krishna in the midst of a dance but without a specific narrative. The image was made primarily in bronze and it was later emulated further north. The three images shown here—two from the South and one from the eastern state of Orissa—show the chubby child Krishna in the same pose, with one knee raised and toes pointing down (supported by a lotus in all three examples), standing on a bent leg. He holds the butter ball forward in the palm of his right hand while he extends his left arm elegantly outward with palm facing down to help him balance. All three figures are naked except for jewelry; the Orissan figure wears a belt with jingle bells on it, presumably placed on the wayward child by his mother so she could keep track of his whereabouts. The challenge in creating such images is to capture both the playfulness of the child and the complete self control of the god incarnate.

The southern bronze image (92) is perhaps the most masterful in its sculpting, capturing both the shifting weight of the child's stomach and the poise of a talented dancer. This piece and the smaller silver image (93) probably date from after the Cholas, from the period of the Nayaka rulers, when more and more images of Krishna depicted him as an infant rather than a youth, a trend that would continue into the Thanjavur painting tradition (seen in the previous catalogue entry). Both small pieces were probably used on private altars. Antique silver images are extremely rare, presumably because they were expensive and the precious material was melted down in times of need or when images became damaged. The silver image is so small that it might have been carried on the person of a devotee. The Orissan image (94) clearly derives its form from the southern model, although it has the longer, more tubular limbs and large, flat eyes that are typical of Orissan metal sculpture. The smooth stylization of this eastern image will be taken several steps further in the image of Krishna fluting in catalogue 108, made in a neighboring state three hundred years later. ✺

95 | Krishna and Balarama as Naughty Children

Northern India, Punjab Hills; c. 1780
Opaque watercolor and gold on paper; 7 ⅛ x 11 in. (18 x 28 cm)
The Kronos Collections

Because Krishna's father wishes to save him from the evil Kamsa, he secretly delivers the infant god to the village of Vrindavan, a pastoral community in Braj, the rural area outside of Mathura. There he is raised by a cowherd, Nanda, and his wife, the milkmaid Yashoda. Krishna grows up with his older brother, Balarama, who was brought to Braj previously. The two begin to get into trouble almost immediately, some of it brought on by demons and some of it of their own devising. In this painting, we see the two working together in pursuit of their favorite treat: freshly churned butter. White-skinned Balarama creates a distraction, pulling on Yashoda's veil, while blue-skinned Krishna reaches into the churning jar. Krishna's adoptive

father Nanda on one side, and some gopis (milkmaids) on the other, witness the misdeeds, and another child gestures toward the action.

This precise tactic for stealing butter is not described in the *Bhagavata Purana*, but others, including piling up household furnishings so he can climb up to pots that are beyond his reach and using his own radiance to light his way in dark rooms, are recounted by the milkmaids when they complain to his mother.[69] The painting offers an interesting illustration of a simple churning mechanism, one probably used by many households in rural India: the churning staff is rotated by pulling a string wrapped around it, while it is held upright by additional strings holding it to a post set in the ground next to the butter jar. The setting, with its finely carved columns, walls set with niches, wood screen door, and decorative frieze, is remarkably palatial for a cowherd's home. ❈

96 | Baby Krishna Tied to a Mortar

Page from an illustrated manuscript of the *Bhagavata Purana*
Northern India; c. 1525–40
Opaque watercolor on paper; 7 ⅛ x 9 ¼ in. (18.1 x 23.5 cm)
Collection of Subhash Kapoor

This painting is from an extensive early series depicting the *Bhagavata Purana*. In the previous painting we saw baby Krishna stealing butter; here we see him being punished for such a theft. After Krishna denies any wrongdoing, Yashoda ties him to a heavy grinding stone so he cannot get into any further trouble.

The sixteenth-century saint Surdas, who wrote a large body of devotional poetry about Krishna's childhood, describes what happened next:

> And then Syam [Krishna] conceived the plan.
> The women had all returned to their homes;
> His mother had set about her work;
> So, unseen, he dragged the great stone
> between the Twin Trees,
> and the leaves began to tremble at his touch.
> He felled both trunks
> and they crashed to the earth,
> where the sons of Kubera emerged;[70]

The superhuman infant drags the stone between two trees and pulls until he causes them to uproot. The sons of Kubera (the god of wealth) who emerge from the trees had been cursed and turned into trees by the sage Narada. The story teaches that even when he is being naughty, Krishna cannot help but be a savior.

In this painting we see two women in the pavilion on the left: they are probably Yashoda and another gopi. On the right is the blue-hued child Krishna, dragging the drum-like mortar stone between two crossed trees. These same trees are shown uprooted and upside down in the air above. The next page in the set would have probably depicted the sons of Kubera offering obeisance to Krishna for setting them free.

Some of the characteristic features of this manuscript are its flat primary colors, the preponderance of red, linearity, faces with eyes that extend almost from nose to ear, and the transparent scarves of the women. These qualities identify the series as the product of a relatively early period, but its region of origin remains a matter of debate. [NP]

97 | Krishna Slaying Putana (*above*)
Page from an illustrated manuscript of the *Bhagavata Purana*
Northern India, Rajasthan, Bikaner; c. 1600–1610
Ink and opaque watercolor on paper
9 ⅝ x 11 ⅞ in. (24.4 x 30.2 cm)
The Metropolitan Museum of Art. Cynthia Hazen Polsky and
Leon B. Polsky Fund, 2002 (2002.176)

98 | Krishna Slaying Putana (*below*)
Northern India, Punjab Hills, Kangra; c. 1780
Ink and light color on paper; 8 ¼ x 12 ¼ in. (21 x 31.1 cm)
Collection of Kenneth and Joyce Robbins

These two images (97, 98), in very distinct styles, depict the child Krishna slaying the demoness Putana, who was sent to kill him by his maternal uncle Kamsa. In the words of Surdas:

So deceitfully, Putana came to Braj
At the King's command;
Her form so lovely, her nipples painted with
poison.[71]

Putana had conducted this caper before: disguising herself as a beautiful woman and asking to suckle infants, who would die from the poison on her nipples. But when she brings Krishna to her breast, he sucks out the poison and her life, causing her to revert to her demonic form before falling down dead.

In the Bikaner painting (97) we are presented with the climactic moment from the narrative when Putana has reverted to her monstrous form with an animal-like face, fangs, and pockmarked skin. Krishna stands on top of her still grabbing her nipple, while Yashoda, Balarama, and Rohini (Balarama's mother) reach out for him.

The Kangra drawing (98) depicts three episodes from the story: at the top left we see Putana in disguise approaching a pavilion where Krishna is lying on a bed surrounded by women. Putana is drawn in a similar fashion and so is hardly distinguishable from the other women. The next episode takes place in the pavilion on the right, where Krishna is sucking the life out of a disheveled Putana while other women turn away in agitation. To the left of this scene is a gigantic Putana in her demonic form, dying, while the diminutive Krishna is being picked up by a group of women. The visual contrast between their sizes further emphasizes Krishna's divine powers.

The Kangra drawing is probably a preliminary sketch that would have been painted over later. This might come as a surprise since it is highly finished and rendered in considerable detail. In painting workshops, the drawing was usually completed by a high-ranking master, who passed the composition to lesser artists for coloring. Even when left unfinished, these master drawings were treasured by later generations of artists. [NP] ✼

99 | Krishna Slaying the Crane Demon Bakasura

Page from an illustrated manuscript of the *Bhagavata Purana*
Northern India, Rajasthan, Bikaner; c. 1600–1610
Opaque watercolor and gold on paper
9 ³⁄₈ x 11 ¹⁄₈ in. (23.8 x 28.3 cm)
Collection of Subhash Kapoor

Once Krishna and Balarama are out with other cowherds and some cattle, and they stop by a pond to give the cows a drink. Standing in this pond is a gigantic crane—a demon who took this disguise to kill Krishna—that attacks and swallows Krishna. But Krishna burns its palate and the bird-demon has to disgorge him. The crane again attacks Krishna, who grabs half of its beak with each hand and tears the demon in two. Balarama, identified by his plow, looks on.

Indian artists used color to evoke an emotional response in the viewer, and this painting is divided into two distinct color zones, with the demon occupying the black space and Krishna and his entourage occupying the red. A red background often denoted the important players or important episodes on the page. Alternatively, the black might represent the water of the pond. [NP] ✼

100 | **Krishna Killing Aghasura**
Page from an illustrated manuscript of the *Bhagavata Purana*
Central India, Malwa; 1675–1700
Opaque watercolor on paper; 9 3/16 x 14 1/8 in. (23.3 x 35.9 cm)
The Walters Art Museum, Baltimore, Maryland. Gift of John
and Berthe Ford, W.890

101 | **Krishna Killing Aghasura** (*facing page*)
Northern India, Punjab Hills, Kangra; 19th century
Opaque watercolor on paper; 9 1/4 x 13 5/8 in. (23.5 x 34 cm)
Asian Art Museum. Gift of George Hopper Fitch, B84D9

These two paintings (100, 101) depict Krishna slaying the serpent demon Aghasura, the younger brother of the demons Putana and Bakasura. Aghasura assumes the form of a boa constrictor eight miles long and lies down on a path taken by Krishna and the cowherds with their cattle.

His lower lip rested on the earth, while the upper lip touched the clouds; the corners of the mouth looked like caverns, his fangs resembled mountain- peaks, the interior of his mouth was full of darkness; his tongue was like a broad road, his breath was like a tempestuous blast and he was burning hot (with rage), his eyes resembling a wild fire.[72]

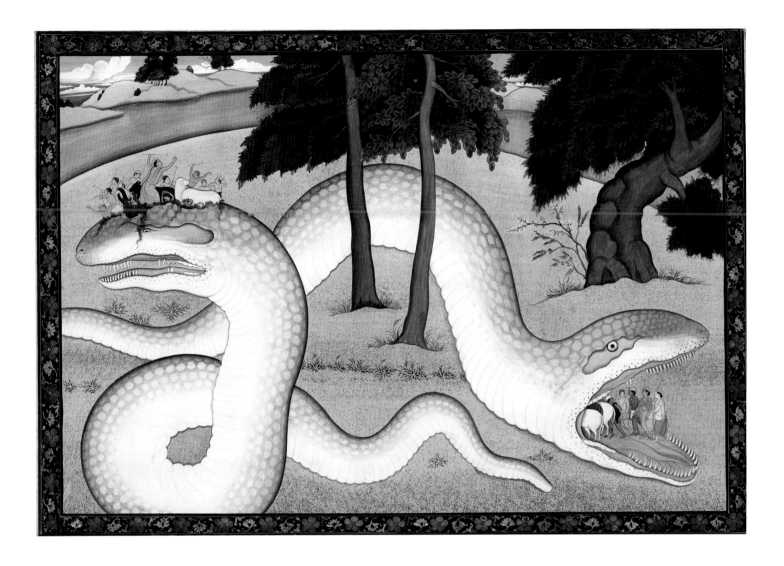

The cowherds mistake the serpent's mouth for the entrance to a cave and go in with their cattle, followed by Krishna. When he reaches the throat of the monster, Krishna increases his size and chokes the serpent, causing the top of its skull to burst open.

Both paintings depict two episodes from the story: Krishna and his entourage entering the serpent's mouth and the bursting through the crown of its head, though in the Malwa painting (100) the demon is depicted only once. The Malwa artist has divided the page into horizontal registers; the upper register depicts Brahma, Shiva, and other divine and semi-divine figures who celebrate Krishna's victory in the heavens. In the Kangra painting (101), the serpent demon appears twice and dominates the visual field owing to its size and color. The figures of the cowherds are minute in comparison, and one must look very carefully to spot the darker, yellow-robed Krishna when the group enters the serpent's mouth. In the scene where they burst through the head, Krishna is more easily located due to his central position in the group. [NP]

102 | Krishna Subduing Kaliya, with Naginis Begging for Mercy

Page from a *Bhagavata Purana* manuscript
Northern India, Punjab Hills, Garhwal; c. 1785
Ink and opaque watercolor on paper
8 x 10 ½ in. (20.3 x 26.7 cm)
The Metropolitan Museum of Art. Rogers Fund, 1927 (27.37)

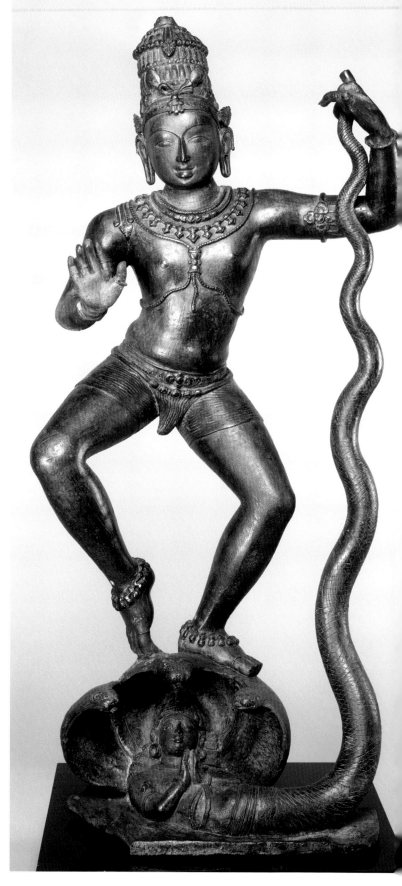

103 | **Krishna Dancing on Kaliya** (*facing page*)
Southern India, Tamil Nadu; Chola period,
late 10th–11th century
Bronze; 34 ½ x 13 ¾ x 10 ¼ in. (87.6 x 35 x 26 cm)
Asia Society, New York. Mr. and Mrs. John D. Rockefeller 3rd
Collection, 1979.022

Another one of Krishna's heroic deeds involves the defeat of the giant serpent Kaliya. The story begins when Krishna and his companions bring the herds to a river for a drink. The water has been poisoned by the presence of the serpent. All of the cows and cowherds fall ill and have to be revived by the god, after which he dives into the toxic depths to battle the snake. At first it seems as though he cannot win, as Kaliya coils around his body, but then Krishna expands himself, causing enormous pressure on the snake, who eventually releases the god. Krishna jumps up on the multiple hoods of the great cobra,

> then, the original teacher of all art forms
> danced, his lotus feet made red by contact
> with the heaps of jewels on the serpent's
> head ... Krishna, chastiser of the wicked,
> crushed whichever head of that one-
> hundred-and-one-headed snake would
> not bend with blows of his feet, O king....
> Whichever head he raised up, Krishna
> forced him to bow low, striking at it with his
> feet as he danced.[73]

The description of simultaneous dancing and fighting shows us that even battling demons is a matter of *lila* for the young god.

The painting (102) shows the struggle between Krishna and Kaliya, before it is clear who the victor will be (although the serpent is shown head-down, surely indication that he is suffering). Krishna is in the water, wrestling with the snake, while the many serpent wives, known as *naginis*, beg the god for mercy. On shore, Krishna's companions express concern while Balarama makes a gesture of encouragement. The *Bhagavata Purana* says that Balarama is the only onlooker who does not worry because he is the only one who knows that his brother is divine.[74]

The bronze image (103) shows Krishna frolicking with the tail of the serpent in his raised hand while he makes a gesture of reassurance to the viewer. The snake is not shown in distress, as the text describes, but in a posture of adulation, looking up at the god and making the gesture of homage. Demons usually receive salvation when they are killed by gods: despite their enmity, the proximity to God during battle brings blessings, and the demon's intense concentration on the divine adversary amounts to devotion. The story of Krishna dancing on the heads of the snake demon Kaliya was probably the inspiration for later depictions of Krishna simply dancing (see cats. 92–94), however the story of Kaliya takes place somewhat later in Krishna's youth, when he is no longer a butter-addicted toddler. This masterful bronze captures the god as an older child or young teenager, with longer, slimmer limbs but a somewhat larger head than would be found in adult figures, and still a touch of baby fat. ❋

104 | Krishna Swallowing the Forest Fire

Page from an illustrated manuscript of the *Bhagavata Purana*
Northern India, Punjab Hills, Bilaspur; mid 18th century
Opaque watercolor and gold on paper
8 ³⁄₈ x 12 ½ in. (21.4 x 31.8 cm)
Museum für Asiatische Kunst, Berlin. I 50257

According to the *Bhagavata Purana*, the cowherds of Braj experienced two different forest fires, and both times they were rescued by Krishna, who swallowed the fire. The devotee-poet Surdas explains the cowherds' surprise at the quick ignition and subsequent extinguishing of the fire:

Amazed at the sight, the people exclaim:
Earth and sky alike were aflame,
fire spreading in great, bounding strides;
There was no rain; no one brought water;

what made it stop?
It burst so fiercely upon the forest!
Why did it go out?[75]

In this painting we see Krishna, the cowherds, and cattle all surrounded by the forest fire. While the cowherds cover their eyes in fear, Krishna seems to drink up the fire. Other animals seem to flee in the opposite direction, from the fire. [NP]

105 | Krishna Lifting Mount Govardhana

Page from an illustrated manuscript of the *Bhagavata Purana*
Northern India, Punjab Hills; c. 1780–85
Opaque watercolor and gold on paper
8 3/16 x 11 1/4 in. (20.8 x 28.7 cm)
Museum Rietberg, Zurich. Gift of Lucy Rudolph, RVI 1772

In this story Krishna humbles the pride of Indra. Indra, the god of rain and thunder, was one of the supreme deities in the Vedas, but his importance was greatly reduced in the Puranas, even though he remained the leader of the gods. The pastoral people of Braj would worship Indra because rain was an important resource, and they would make offerings to him of the substances produced as a result of rain. These included cooked rice, boiled pulses, buns, cakes, and milk. Krishna instructs the inhabitants of Braj, in the words of Surdas:

> Believe what I say!
> If you care for the Land of Braj,
> then worship Govardhana [the mountain]!
>
> ...

What did *Indra* ever do for you?
He's a crutch; give him up![76]

The people then give their offerings to Mount Govardhana, and this brings the wrath of Indra down on the inhabitants of Braj. He sends torrential rain to punish them and everyone turns to Krishna for protection. Krishna effortlessly uproots Mount Govardhana, and with one hand lifts it up above his head, providing shelter from the rain for all the people and animals.

In some versions of the story, he needs just one finger to hold the mountain, a detail captured here in an exquisite image by an unnamed artist who most likely trained under Nainsukh, the innovative painter of catalogues 18 and 142. Here, Krishna appears at the center, surrounded by cattle and townspeople of all ages (some of whom attempt to assist the god by using their herder's sticks to prop up the mountain). The crowd parts to reveal the god standing on a golden dais, which lends an iconic quality to an otherwise narrative image. Krishna rests his hand on the head of a small child, an affectionate gesture that reflects his role as protector. In the sky above, we see Indra on his elephant emerging from dark rain-clouds. [NP]

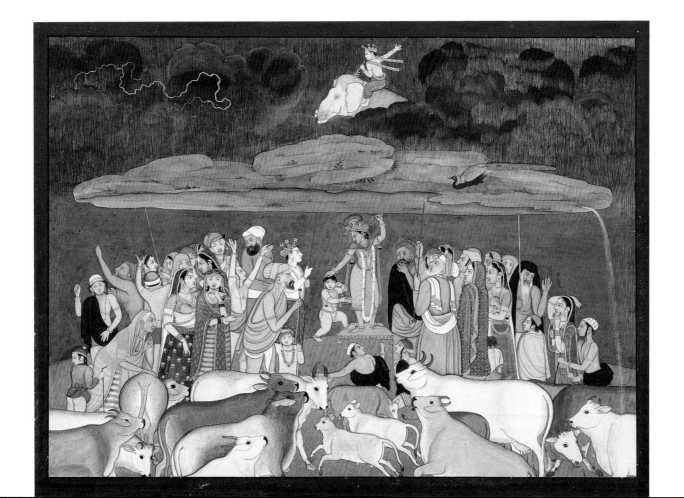

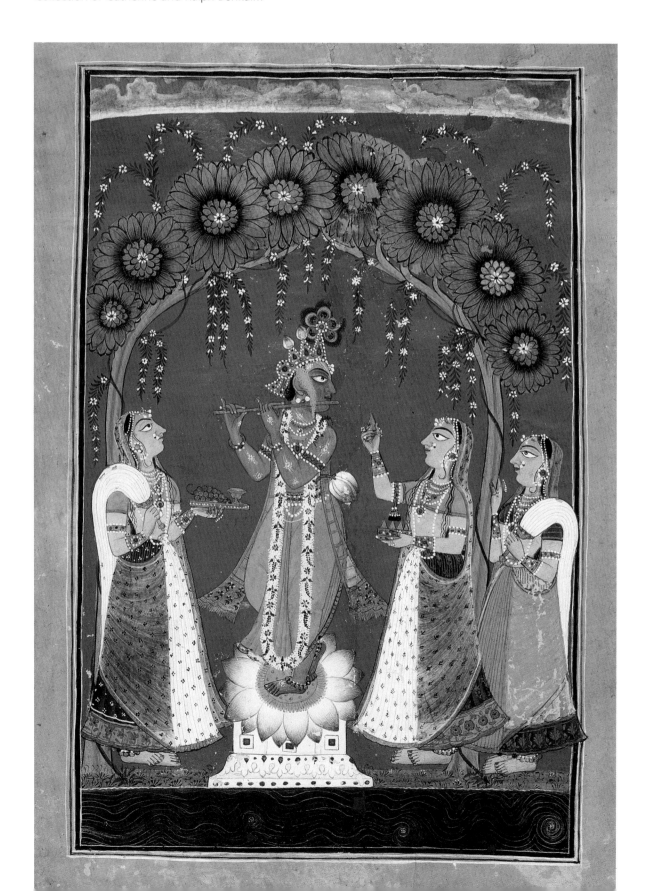

Page from an illustrated manuscript of the *Gita Govinda*
Northern India, Punjab Hills, Guler or Kangra; c. 1775–80
Opaque watercolor and gold on paper
7 x 10 ¾ in. (17.8 x 27.3 cm)
Collection of Ramesh and Urmil Kapoor

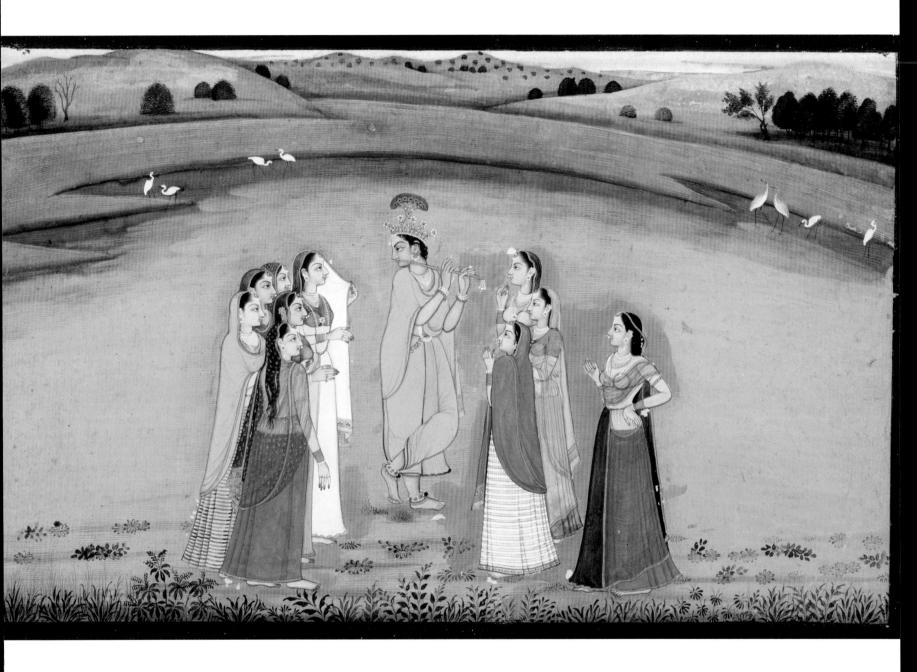

108 | Krishna Fluting
Eastern India, West Bengal, Kolkata; c. 1920
Phyllite with paint; 20 x 9 x 9 in. (50.8 x 22.9 x 22.9 cm)
Philadelphia Museum of Art. Purchased with Museum Funds,
1966-122-1

109 | Braid Ornament with Krishna Fluting on a Cobra
Southern India; 18th century
Gold with rubies, emeralds, diamonds, and pearls
1 ¹⁵⁄₁₆ x 1 ¹⁵⁄₁₆ in. (5 x 5 cm)
Collection of Susan L. Beningson

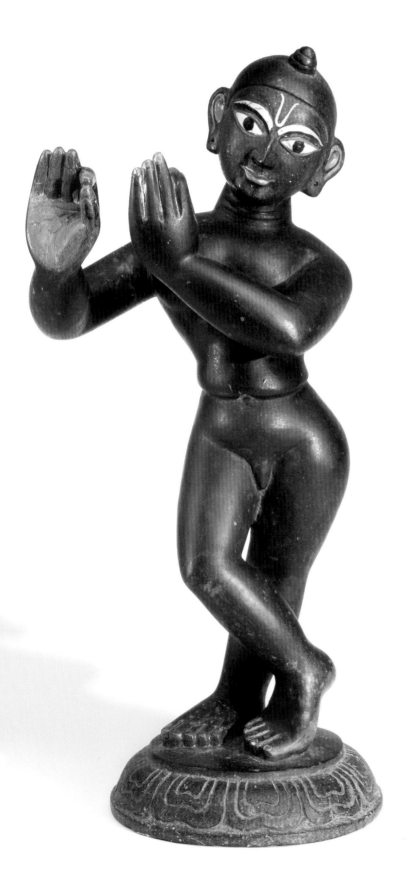

With this cluster of flute-playing images (106–109), we make the transition from Krishna's adventuresome childhood to his more romantic youth, and the type of love he inspires changes from parental to erotic. Even when he is a child, Krishna's beauty is much admired by the women of the community, but as he grows into a young man, he becomes so sexually attractive that he is impossible to resist.

From his childhood, Krishna counted flute playing among the carefree pastimes of his pastoral existence. Easily carried, the flute has long been the preferred instrument of nomads and herders. But in Krishna's hands, it takes on a mesmerizing role, as described by the sixteenth-century princess-poet Mirabai:

> Sister, the sound of the flute
> Has driven me crazy.
> Without Hari [Krishna], nothing avails.
> On hearing the sounds
> I lose body-consciousness,
> My heart well caught
> In the meshes of the net.[78]

A passage in the *Bhagavata Purana* describes the effects of Krishna's flute playing on women, animals, even rivers and clouds: all must stop what they are doing to listen. The women are then drawn to the musician; they leave their homes with makeup applied to only one eye, pots boiling over on the fire.[79] The music of the flute becomes an emblem for Krishna's powers of attraction, for the intoxication of love and desire.

When playing the flute, in a form known as Venugopala, Cowherder with a Flute, the god almost always stands on one foot with the other poised in front, an elegant pose that suggests he could begin dancing shortly. In the earlier of the two paintings (106), the god stands on a lotus pedestal under a bower dripping with flowers: he is enshrined by nature. He is attended by gopis who act like worshippers at an icon, offering food and whisking away the flies. The iconic quality of this image is in keeping with its original context: it is from a *Dashavatara,* or *Ten Avatar,* series, in which each avatar is presented in a single image,

designed to assist the viewer in prayer. We see a more narrative, personal approach in the later painting (107), which comes from a series illustrating the *Gita Govinda* of Jayadeva, one of the most popular poems of Krishna bhakti. Here, the women draw near, their hands reaching out to the god. One draws her veil around her—perhaps shyly, perhaps coyly—as she makes steady eye contact with Krishna.

The stone image (108) comes from the very prevalent Bengali tradition of Krishna bhakti. The god's hands are poised to hold a flute, which is now missing; it originally stood with a smaller image of Radha, Krishna's favorite gopi. Its body is highly stylized and simplified, from the smooth cap of hair with a tiny topknot, to the folds of the neck, to the deeply cut waist. The application of paint is quite common in recently used icons, especially on the eyes, which should look back at the worshipper, and the figure wears a typical Vaishnava U-shaped tilak mark on his forehead (see cat. 155). When displayed, this image almost certainly wore a skirtlike *dhoti* of yellow cloth, a miniature peacock-crested crown (see cat. 166), and earrings in his drilled lobes.

The jeweled ornament (109) combines two Krishna stories into one, showing him fluting while standing on a multihooded serpent, which at first glance seems to be Kaliya but might not be. Here, the cobra hoods serve as a canopy for the god, recalling the images of the great serpent Shesha, on whom Vishnu reclines during the Creation. Because Krishna's followers consider him to be one and the same as Vishnu, it is not uncommon to find representations that equate the two, showing Krishna holding the discus and conch or floating on the banyan leaf (see cats. 32, 33). Shesha assumed earthly form as Balarama, Krishna's older brother and constant companion, so this image of Krishna on serpent could also be read as a celebration of the two brothers. In any case, the jewel, which was meant to adorn the top of a woman's braid at the back of her head, contains some beautiful stones, including a delicately carved emerald for the dark-skinned god's face. ✳

110 | Krishna Dancing with the Gopis

Page from an illustrated manuscript of the *Balagopalastuti*
(detail)
Western India; c. 1450–75
Opaque watercolor, gold, silver, and ink on paper
4 ⅛ x 9 ⅛ in. (10.48 x 23.18 cm)
Los Angeles County Museum of Art. Purchased with funds
provided by Lizabeth Scott, M.88.49

111 | Vasanta Raginī (*below*)

Page from an illustrated *Ragamala* series
Northern India, Rajasthan, Bundi; c. 1675–1700
Opaque watercolor and gold on paper
11 ¹³⁄₁₆ x 9 ⅜ in. (30 x 23.8 cm)
Museum für Asiatische Kunst, Berlin. I 5696

112 | Fragment of a Textile Depicting Krishna and the Gopis (*facing page*)

Eastern India, probably Assam; 19th century
Dyed and undyed silk; 27 ⅜ x 22 ⅞ in. (71.5 x 58.5 cm)
Virginia Museum of Fine Arts, Richmond. The Robert A. and
Ruth W. Fisher Fund, 94.4

After Krishna plays his flute, luring the gopis away from their homes, he frolics with them in the moonlight, usually on the verdant banks of the river Yamuna. Their pastimes are definitely sexual, but they are described most often as a dance. The many poetic, pictorial, and performance depictions of the nighttime meetings became a genre unto themselves, known as *rasalila*, or, literally, "delightful play." These three objects (110, 111, 112) capture the fun, excitement, and grace of *rasalila*.

The first piece (110) is from one of the earliest surviving illustrated manuscripts dedicated to Krishna, a copy of the *Balagopalastuti* (*Hymn to the Young Cowherd*), a series of verses praising Krishna in earthy and heavenly forms, written in Sanskrit by the South Indian poet Bilvamangala, probably in the early fourteenth century. The manuscript was painted in the fifteenth century; its early date is reflected in its format, with small, horizontal pages, of which a relatively large part is given over to text. To this day, traditional Hindu books are printed in a horizontal format, which recalls the long palm-leaf pages used in India prior to the introduction of paper. This format is found more often in contemporaneous illustrated manuscripts dedicated to the Jain religion; the same artists probably made this Hindu subject. The small illustration shows Krishna, carrying a herder's staff and a small horn instead of a flute, dancing energetically with *gopis* at either side in a wooded setting with cows below. A related verse in the *Balagopalastuti* reads:

> While the sound "dhunga, dhunga" is softly
> tapped out on the drum, and the women of
> Vraja [Braj] follow him,
> Madhava [Krishna], the son of Devaki,
> dances on the charming courtyard stage and
> plays his flute.[80]

The other painting (111) is an illustration from a series of musically inspired imagery, known as a *Ragamala* (*Garland of Ragas*). This image depicts the sentiment heard in *Vasanta Ragini*, the classical music theme named after spring. In India, spring is celebrated in January and February, when plants have had a chance to sprout and grow after the monsoons of summer. It is a time of rebirth and fertility, and poems about Krishna's dalliance with the gopis often describe the fruitful abundance of the natural setting in great detail. Indian classical music does not have set lyrics, but a verse often sung to the tune of *Vasanta Ragini* comes from the great bhakti poem, the *Gita Govinda* by twelfth-century author Jayadeva:

> Budding mango trees tremble from the
> embrace of rising vines.
> Vrindavan forest is washed by meandering
> Yamuna river waters.
> When spring's mood is rich, Hari roams here
> To dance with young women, friend—
> A cruel time for deserted lovers.[81]

The verse is particularly appropriate to this painting because the trees at either side, with the clusters of dark green leaves and feathery flowers, are budding mangoes. Krishna here dances with female musicians, and he carries a stringed instrument instead of his usual flute, but he is identifiable by his blue skin and saffron skirt.

The textile (112) is a rare piece, made in the far northeastern corner of India, in the modern state of Assam. It is woven in silk in a complex technique known as lampas in which there are two sets of weft threads: those forming the background and those forming the pattern. These lampas weaves were a particular specialty of Assam and were exported widely; many of them include Vaishnava imagery, such as these charming vignettes of Krishna accompanied by gopis with the usual backdrop of flowering trees. In this example, Krishna plays his flute at either end of each register while at the center he is shown carrying a woman. This probably refers to the sole mention of a favorite gopi that appears in the *Bhagavata Purana* (the theme of the favorite would gain popularity later in bhakti literature): one unnamed woman, who is allowed to stay with Krishna after he has abandoned the others, grows bold and asks him to carry her because she is tired. He offers to lift her, but then punishes her excessive confidence by disappearing.[82]

❀

113 | Rasamandala
Southern India, probably Tamil Nadu; c. 1700–1900
Bronze; 7 ¾ x 6 ¼ x 2 ⅜ in. (19.7 x 15.9 x 6 cm)
Asian Art Museum. The Avery Brundage Collection, B77B5

114 | Rasamandala
Northern India, Punjab Hills, Chamba area; late 19th century
Cotton embroidered with silk threads; Diameter: 27 in. (68.6 cm)
Philadelphia Museum of Art. Purchased with funds contributed by Ann McPhail and Marion Boulton Stroud, 1991-48-1

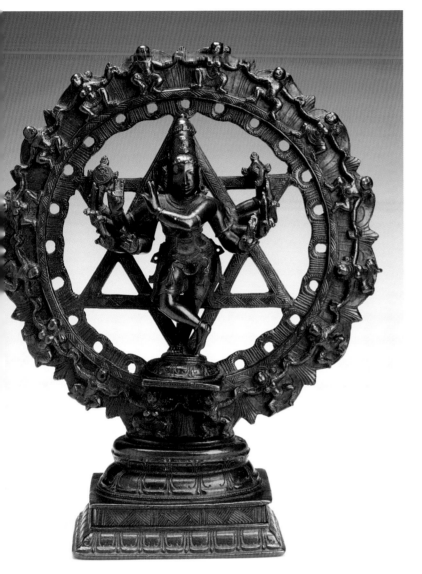

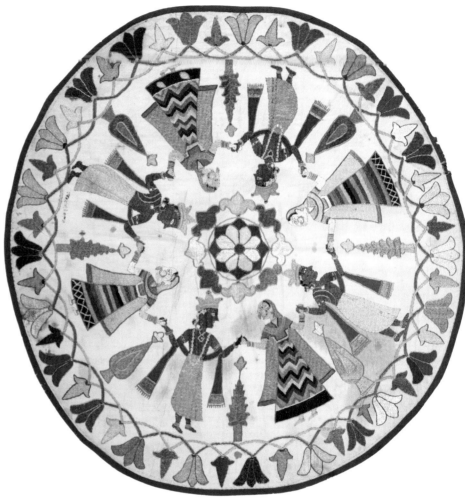

Krishna's moonlight trysts with the gopis are sometimes fraught with jealousy; the young god alleviates this by multiplying himself so that each gopi is alone with him. This miracle is depicted in various ways, but the most potent manifestation comes in the *Rasamandala*, or Circle of Delight (113, 114). The circle of the *Rasamandala* suggests the perfect balance of devotee and divine.

The embroidery (114) offers the more typical representation, with *gopis* dancing in a circle, and Krishna repeatedly appearing between them. A verse from the *Balagopalastuti* (see cat. 110) indicates that in some des-

criptions of the *Rasamandala* Krishna (Madhava) supplies the music as well:

> Between each young woman was Madhava;
> between each Madhava was a young woman.
> In the middle of a circle so arranged,
> the son of Devaki played his flute.[83]

In an unusual example of a round *rumal*, or covering wrap, Krishna and the gopis dance with each Krishna exchanging meaningful glances with a single milkmaid. As in most pictorial representations of the evening trysts, this embroidery makes reference to the forest setting, with tiny trees placed between each figure and blossoms running around the edge. The gopis wear the large nose rings often associated with rural women in northern India. This piece is carefully embroidered to be the same on both sides, abundant use of metallic thread probably suggests a later date of manufacture than seen in the other rumal in this catalogue (see cat. 88).

The round form of the bronze piece (113) recalls images of Sudarshana Chakra, Vishnu's personified discus. On closer examination, we see that it shows Krishna fluting at the center (the flute is now gone), surrounded with a ring of miniature dancing gopis and Krishnas. The sculptor cleverly flipped the orientation of the dancers half-way through so that none are upside down. The central Krishna has multiple arms, indicating that he is not merely the earthly manifestation who enjoyed the company of milkmaids, but a pervasive, eternal, cosmic force. He stands in front of a six-pointed star composed of two overlapping triangles. The superimposed shapes represent the perfect balance of opposite forces—mortal and divine, male and female—that is also found in the *Rasamandala*. Practitioners of Krishna bhakti believe that one can and should mingle with the divine, and that the divine is capable of offering us its undivided attention, just like Krishna does for his many girlfriends. ✤

115 | **Krishna Steals the Gopis' Clothes** (*facing page, above*)
Page from an illustrated manuscript of the *Bhagavata Purana*
Northern India, Rajasthan, Bikaner; c. 1600–1610
Ink and opaque watercolor and gold on paper
7 15/$_{16}$ x 11 1/$_{16}$ in. (20.2 x 28.1 cm)
The Metropolitan Museum of Art. Cynthia Hazen Polsky and Leon B. Polsky Fund, 2001 (2001.437)

116 | **Krishna Steals the Gopis' Clothes** (*facing page, below*)
Page from an illustrated manuscript of the *Bhagavata Purana*
Northern India, Rajasthan, Bikaner; c. 1690–1700
Opaque watercolor and gold on paper; 11 ¾ x 15 in. (30 x 38 cm)
Collection of Catherine and Ralph Benkaim

One of the favorite episodes of Krishna's *rasalila* is the theft of the gopis' clothes. The gopis go for a swim in the river after they perform a ritual in honor of a goddess. Krishna sneaks over to the riverbank and takes their clothes, dragging them up a tree. Soon thereafter, the naked milkmaids realize what he has done. Andal, the ninth-century female saint/poet of the Tamil region, envisioned herself as one of the gopis, begging Krishna to return their clothes:

> We are tired of standing in the waters.
> Your game is unfair
> The village is too far off.
> We are bound to you alone,
> But if our mothers see us now
> They would indeed be cross.
> Lord who alone exists at the deluge,
> Do not keep climbing
> The flowering wild lime,
> Throw down our clothes.[84]

Krishna has them approach in a position of supplication, with their palms together up by their heads. This pose of course offers him a perfect view of their beautiful bodies. He eventually returns the clothes. The *Bhagavata Purana*, in a rare instance of editorializing, remarks on the situation:

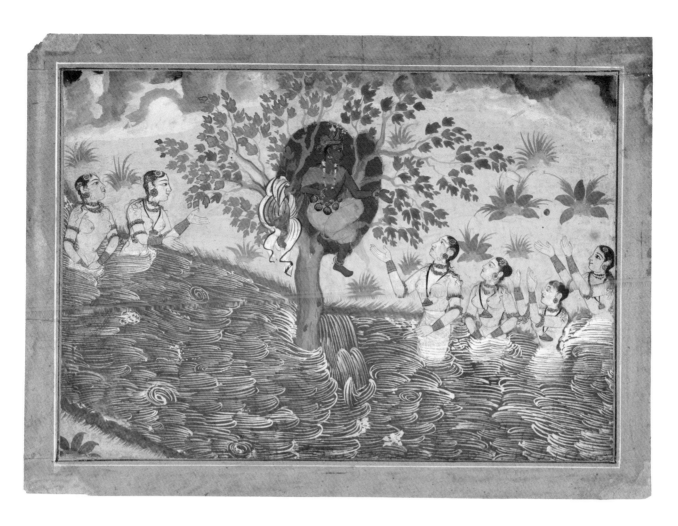

117 | Krishna Steals the Gopis' Clothes

Northern India, Punjab Hills, probably Garhwal; c. 1775–1800
Opaque watercolor and gold on paper
9 13/16 x 7 5/16 in. (24.9 x 18.8 cm)
The Walters Art Museum, Baltimore, Maryland. Gift of John
and Berthe Ford, 2001, W.863

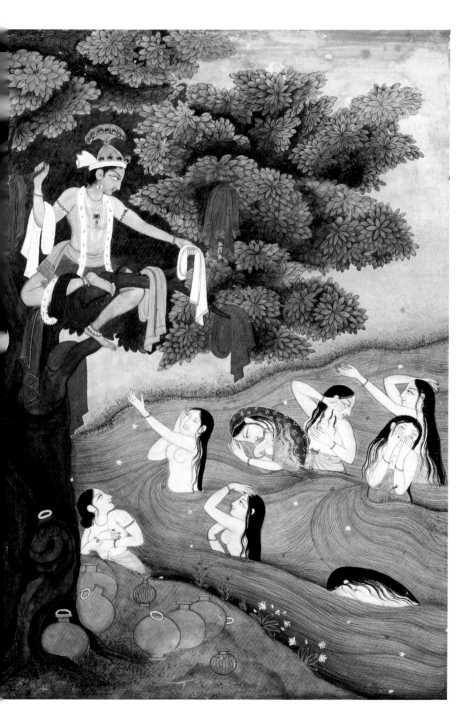

The girls were cheated, deprived of their modesty, derided and made to perform like puppets. Moreover, their clothes were stolen. Yet, they were not really upset with Krishna. They were delighted to be in the company of their darling.[85]

The incident offers the most painful—and delightful—illustration of humanity's helplessness in the face of divine whimsy. The gopis must surrender, exposing themselves completely to God, but they do not mind what would have been a humiliating experience in a non-devotional setting.

The three paintings (115, 116, 117) and one relief (118) here treat the incident in somewhat similar ways: Krishna is raised well above the gopis in the tree, and they must plead upward for mercy. In the relief and in the two earlier paintings, Krishna is centrally located, like an icon with the gopis appearing below as attendant or donor figures. The earliest image, now in the Metropolitan Museum (115), shows Krishna surrounded by a red halo. The next painting (116), which was probably made in the same region but about eighty years later, places an unusual emphasis on the blessed landscape of Braj, and here the gopis are shown twice, hiding behind some bushes as well as in the water. Apparently the vision of their lovely bodies is reserved for Krishna. The latest painting (117), probably from the Punjab Hills state of Garhwal, offers an innovative, more purely narrative format, with Krishna at one side and a network of diagonals formed by shoreline, water, branches, and arms. Nudity is relatively rare in Indian art, and indeed in most of these representations the gopis are at least partially covered by water or by their own hands. It is interesting to compare the various approaches to the representation of water and its potential transparency, a perpetual challenge to painters, as seen in many avatar paintings in this exhibition as well.

The terracotta relief (118), which consists of three square blocks, would have appeared on one of the distinctive brick temples of Bengal, many of which were dedicated to Krishna. The use of terracotta for temple sculpture has ancient origins, as seen in the Gupta-period (fourth–fifth century) terracottas in catalogues 23, 24, and 136, but only

Eastern India, West Bengal, possibly Birbhum district;
c. 1700–1900
Terracotta; 18 ¾ x 18 ½ x 2 ¾ in. (47.6 x 47 x 7 cm)
Asian Art Museum. The Avery Brundage Collection, B60S171+

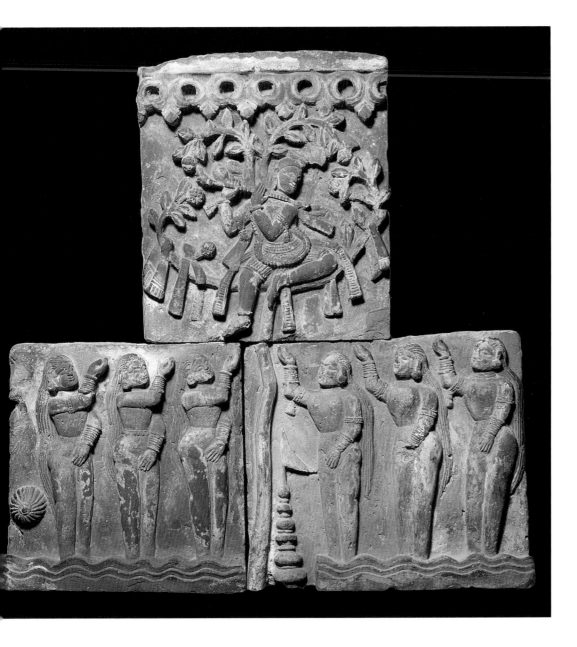

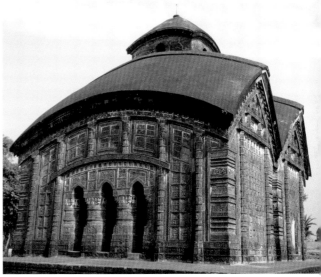

Figure 118–1 | Shyam Rai Temple,
Bishnupur, West Bengal, 1643.
Photograph by Benoy K. Behl

in Bengal did clay remain a prominent medium for large-scale, elaborate temple (and mosque) architecture (fig. 118–1). We can see that this later relief is modeled in a somewhat more shallow manner than its ancient predecessors. The bead-shaped border at the top of the relief probably formed a molding that continued in multiple blocks above various other images of Krishna's biography that would have appeared around the temple exterior. The icon enshrined in this temple may well have resembled the fluting image in catalogue 108.

119 | Krishna and Radha in a Grove

Attributed to the Kota Master (active early 18th century)
Northern India, Rajasthan, Kota; c. 1720
Ink, opaque watercolor, and gold on paper
7 ½ x 4 ⅜ in. (19.1 x 11.1 cm)
The Metropolitan Museum of Art. Cynthia Hazen Polsky and
Leon B. Polsky Fund, 2003 (2003.178a)

Although the *Bhagavata Purana* makes only brief mention of a favorite gopi and it does not mention her name, later devotional literature developed long and elaborate accounts about a favorite, named Radha. The romance between Krishna and Radha begins when they are children, and the two admire each other as they reach maturity. Radha is usually said to be married to another cowherd, but her love for Krishna is all-consuming. Radha's infidelity is rarely problematized because no mundane marriage can (or should) compete with a devotional relationship. Nevertheless, the interaction between Krishna and Radha is often described in unabashedly sexual terms.

Much like *Rasamandala* imagery, depictions of Krishna with Radha illustrate the perfect bliss to be experienced in a merger of mortal and divine (119, 120, 121). Much like Lakshmi-Narayana imagery (see cat. 14), these depictions also celebrate the balance of male and female attributes, and indeed Radha is often described as an earthly manifestation of the goddess Lakshmi. As in much of the imagery of Krishna's dalliances with the gopis as a group, the forest seems to burst into bloom as a response to the joy and sexual energy of the pairing. This is certainly the case in the beautiful Kota image (119), in which the couple embrace, each holding a flower garland with which they will decorate their beloved. The couple is here shown walking, probably on their way to a private spot, so the image captures an atmosphere of eager optimism and intense longing.

Despite their divine status, the couple must meet in secret in the woods. However, we know from centuries of Indian romantic literature that clandestine trysts are more passionate and exciting. The painting from Kangra (121) shows Krishna and Radha stealing a moment together in a grove of trees while their friends and neighbors work and play nearby. The painting falls into two genres: those that capture the lyrical tranquility of the cowherding community of Krishna's youth, and those that capture the passion of Krishna and Radha. Here, Krishna reaches to pluck away the veil that Radha has demurely pulled across her breasts. They sit on a bed of leaves and flower petals, the standard furnishings for a woodland tryst.

The painting from Bengal (120) depicts a different, more public meeting of the couple, in which Krishna and

120 | Krishna and Radha Meet in the Forest during a Storm

Eastern India, Bengal; Mughal style, c. 1770
Opaque watercolor and gold on paper
10 ¼ x 14 ¾ in. (21 x 37.5 cm)
Collection of Catherine and Ralph Benkaim

121 | Krishna and Radha Meeting in the Forest
(*following page*)

Northern India, Punjab Hills, probably Kangra; c. 1810–20
Opaque watercolor and gold on paper
11 ¾ x 16 ¾ in. (29.8 x 42.5 cm)
Collection of Eberhard Rist

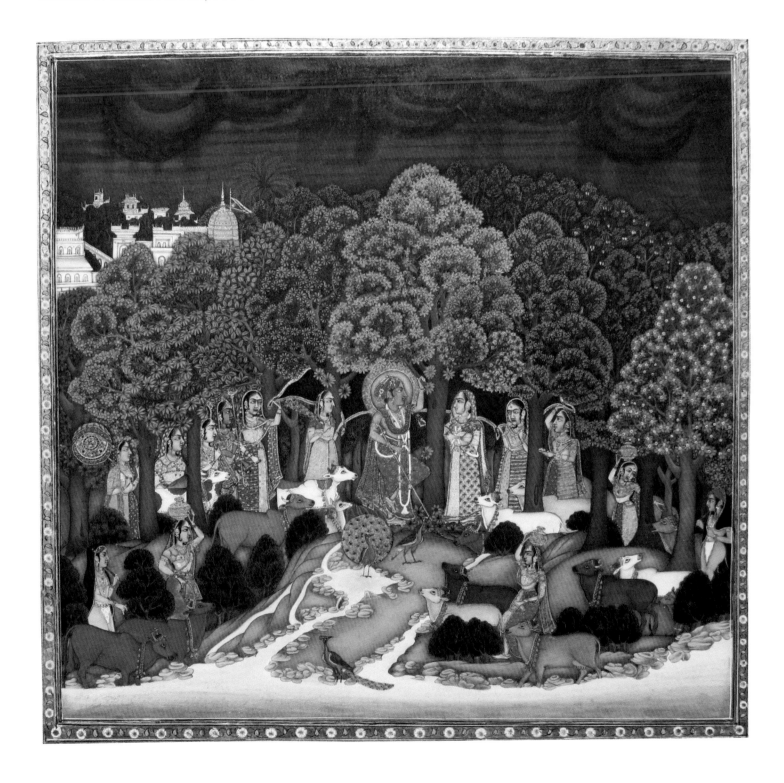

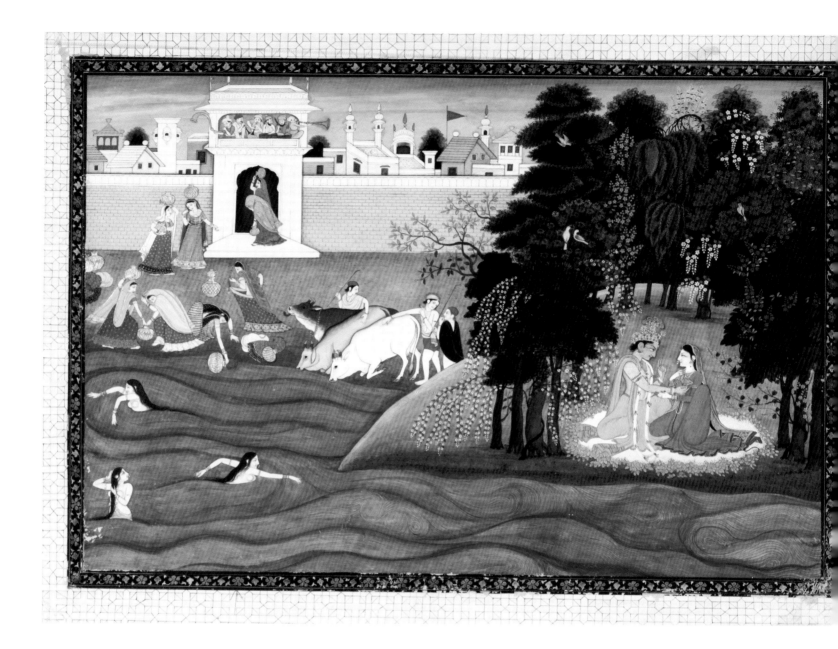

Radha seek shelter together from a gathering storm. The monsoon season is considered extremely erotic, with its burgeoning clouds and unsettled atmosphere. Seeking shelter from the rain is a good excuse for coming into close quarters with one's beloved. Here, Krishna and Radha stand under a tree, surrounded on either side by other gopis and cattle. Krishna raises his hand, reminding us of the time when he raised Mount Govardhana in order to protect the community when Indra sent down a far more dangerous storm (see cat. 105). Radha gives him a flower, an offering of both devotional and romantic love. In its delicate details and sensitive rendering of animals, this painting exhibits influence from the imperial Mughal atelier, and was most likely painted for a Hindu patron in Bengal in the period after many Mughal-trained artists dispersed to provincial courts. ✾

122 | Radha, Krishna, and Their Messenger

Page from an illustrated manuscript of the *Gita Govinda*
Northern India, Rajasthan, Mewar; c. 1720
Opaque watercolor and gold on paper
10 x 16 ⅞ in. (45 x 25.4 cm)
Asian Art Museum. Gift of the collection of Gursharan and
Elvira Sidhu, 1990.217

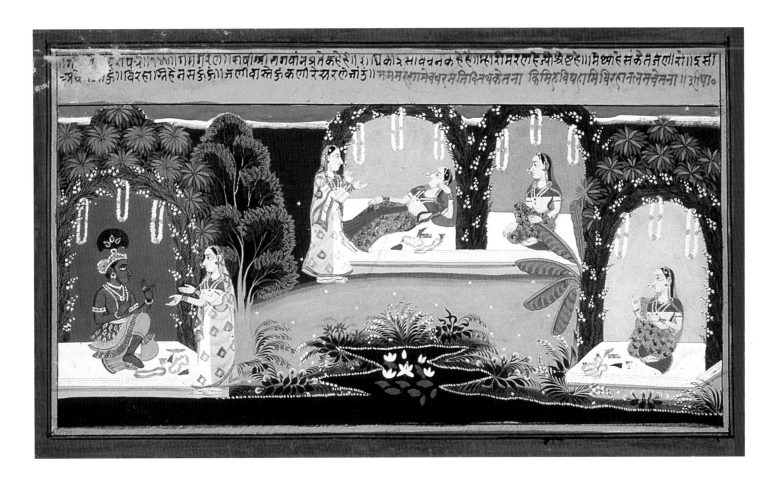

Although the love between Krishna and Radha brings great excitement and joy to both lovers, it is also plagued by misunderstandings and long, painful periods of separation. Mostly it is Krishna's fault, as he is certainly a philanderer; however Radha is to blame for prolonging the separation with her stubbornness. Several poetic texts written by practitioners of bhakti describe the agony felt by the couple when they are apart. Illustrated here are images (122, 123, 124) from two of the most celebrated romantic-bhakti poem series, the *Gita Govinda* (*Song of the Cowherd*) by the twelfth-century East Indian poet Jayadeva, and the *Sat Sai* (*Seven Hundred Verses*) by the seventeenth-century central

Indian poet Bihari. Both of these poems offer multiple vantage points, including those of onlookers, to explore the complex emotions of romantic and devotional love.

All three of these paintings illustrate the important role played by the *sakhi*, or female confidante, who acts as a messenger between the lovers, ever working toward reconciliation. The painting from Mewar (122) particularly emphasizes the *sakhi*'s role as go-between, showing her twice: once speaking to Krishna on the left, and once speaking to Radha at the center. Radha is shown twice more, sitting alone with her thoughts. The vignettes are framed by a flowering bower draped with garlands; in

123 | Radha Suffering from Malaise (*following page*)
Page from an illustrated manuscript of the *Sat Sai*
Northern India, Punjab Hills, Kangra; c. 1780–90
8 ¼ x 5 ¹⁵/₁₆ in. (21 x 15.1 cm)
Museum Rietberg, Zurich. Former collection Horst Metzger,
RVI 2113

124 | Krishna Gazes Longingly at Radha (*facing page*)
Page from an illustrated manuscript of the *Gita Govinda*
Northern India, Punjab Hills, Kangra; c. 1820–25
Opaque watercolor and gold on paper
11 ⅛ x 14 ⅜ in. (28.25 x 36.5 cm)
Brooklyn Museum. Designated Purchase Fund, 72.43

three of them one of the lovers sits with additional garlands and small metal dishes and cups before him or her. These objects can be read two ways: either as the accoutrements of a romantic evening, holding small snacks and fragrant blossoms designed to enhance the mood but left unused because the lovers are quarreling, or as devotional offerings, which would be deposited by worshippers before the icon of Krishna or Radha in a temple.

The illustration from the *Sat Sai* (123) shows Radha slouched on a low seat while her *sakhi* pleads Krishna's case. There are several verses in the *Sat Sai* that this painting could depict; all of them involve the confidante trying to convince Radha to take Krishna back:

> Don't be taken in
> by the harsh words
> of thoughtless men.
> He loves you alone
> not another.
> Foolish girl,
> how can one who has tasted grape juice
> ever long for the bitter fruit
> of the neem tree?[86]

> Just a glimpse of Krishna
> has won you over;
> but still
> you're keeping up the pretence
> of being annoyed.
> I'm sure, dear girl,
> it's just to hide
> the embarrassment
> of your surrender![87]

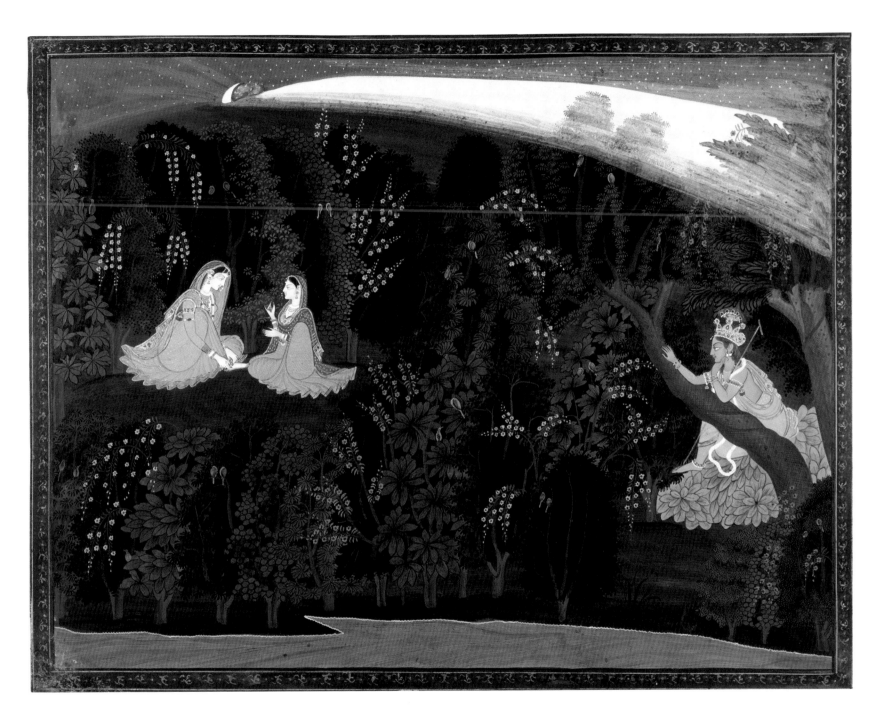

The partially opened door behind Radha might indicate the gradual opening of her heart and arms to her wayward lover.

The third painting, probably from the same region or painter family as the *Sat Sai* page but maybe one generation later (124), comes from a celebrated manuscript of the *Gita Govinda*, often named after the state, Lumbagraon, where it was located for many years. Here, with bodies that glow against the gloom of the evening, Radha converses with the *sakhi* while Krishna eavesdrops. The *sakhi* seems to be making a convincing point, as Radha appears with a slight smile on her face. Krishna likewise is smiling. The interlacing of flowering creepers and leafy trees foreshadows the reunion to come, as do the pairs of birds that appear throughout the painting. The swath of moonlight is perhaps the most dramatic feature of the painting, maybe signifying a ray of hope. ❀

125 | **Krishna Massaging Radha's Feet**
Northern India, Punjab Hills, Mankot; c. 1730
Opaque watercolor, gold, and beetle-wing casings on paper
10 ½ x 8 in. (26.7 x 20.3 cm)
University of Michigan Museum of Art. Museum purchase
made possible by the Margaret Watson Parker Art Collection
Fund, 1979/1.160

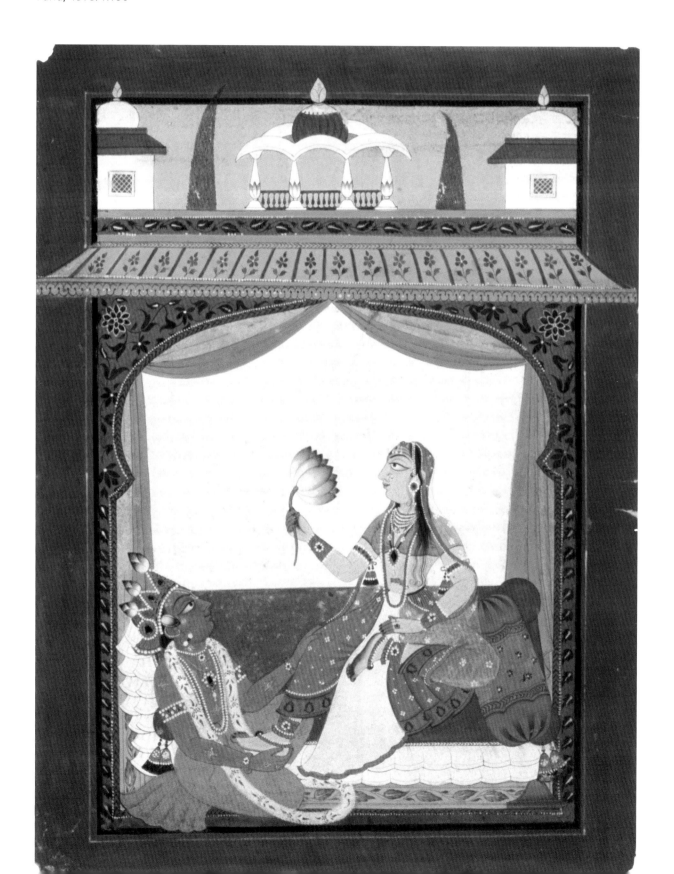

126 | **Khandita Nayika**

Northern India, Punjab Hills, Garhwal; c. 1800–1820
Opaque watercolor and gold on paper
10 ⅜ x 7 ½ in. (26.4 x 19 cm)
Brooklyn Museum. A. Augustus Healy and Frank L. Babbott
Funds, 36.251

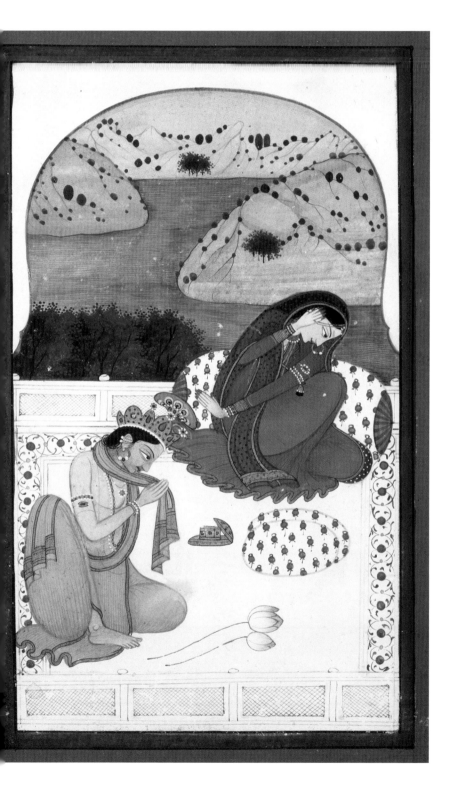

In order to win back Radha after an indiscretion or argument, Krishna must debase himself, even though he is a god. In the earlier of these two paintings (125), Krishna massages Radha's feet while she sits on a bed. He looks up at her in adoration. The scenario represents a dramatic shift from that illustrated in the Nainsukh painting of Vishnu and Lakshmi (cat. 18), in which the goddess is in the servile position. In the bhakti tradition, God is understood to love his devotees much as they love him, and at times he must debase himself in order to regain their trust. The artist makes an overt comparison between Radha and Lakshmi here, with the mortal lover shown holding a lotus, the goddess's emblem. This painting is unusual in its inclusion of an additional material adhered to the surface: the tiny, glistening, iridescent shapes that appear on the figures' jewelry are in fact cut from the outer wing casings of beetles. Artists in the Punjab Hills used beetle-wing casings for a limited period beginning in the mid seventeenth century; the practice was mostly out of fashion by the time this painting was made.

In another image of Krishna supplicating before Radha (126), we see the god kneeling with hands folded in the gesture of homage. Radha sits above him (but on the same carpet) with one hand shooing him away and the other covering her ear so as not to hear his pleas. The god has brought two lotuses, possibly as gifts for his lover. Krishna bends his head in shame, but he looks up at Radha to gauge her response. The painting has been associated with a series depicting *nayika*s or generic romantic heroines, each of whom represents a type of woman and the way she might be expected to react in different circumstances. Khandita Nayika is the woman "whose lord has spent the night away from home; when he returns in the morning, she reproaches him bitterly."[88] Although the types described in *nayika* literature are meant to describe women's reactions to their mortal husbands, this scenario lends itself well to conflation with the Radha-Krishna relationship because Krishna is so often unfaithful to Radha. ❀

127 | Krishna, Dressed as a Woman, Approaches Radha

Northern India, Rajasthan, Bundi; c. 1750–1800
Opaque watercolor, gold, and silver on paper
12 ⅝ x 8 ⁹⁄₁₆ in. (32 x 21.7 cm)
Museum für Asiatische Kunst, Berlin. I 5913

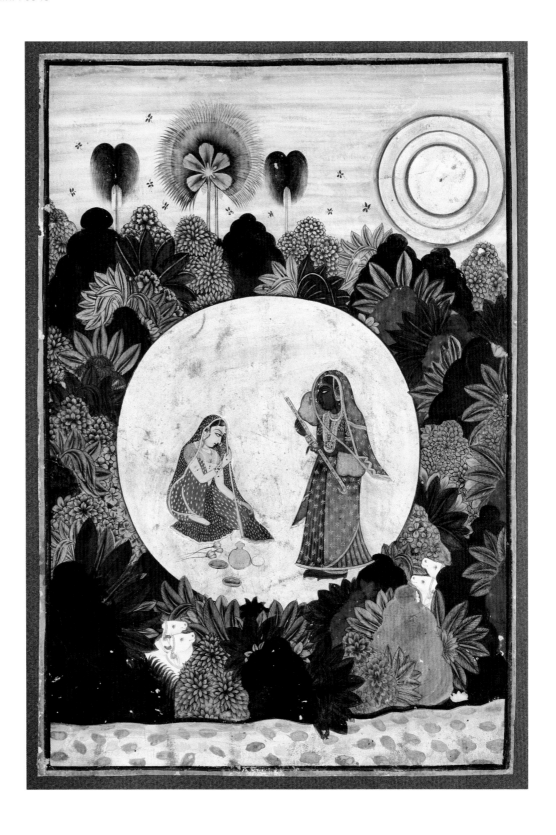

128 | Krishna and Radha Exchange Clothes

Northern India, Punjab Hills, Kangra; c. 1775–90
Opaque watercolor and gold on paper
Image, 7 ⅝ x 5 ⅜ in. (19.5 x 13.5 cm)
Collection of Susan L. Beningson

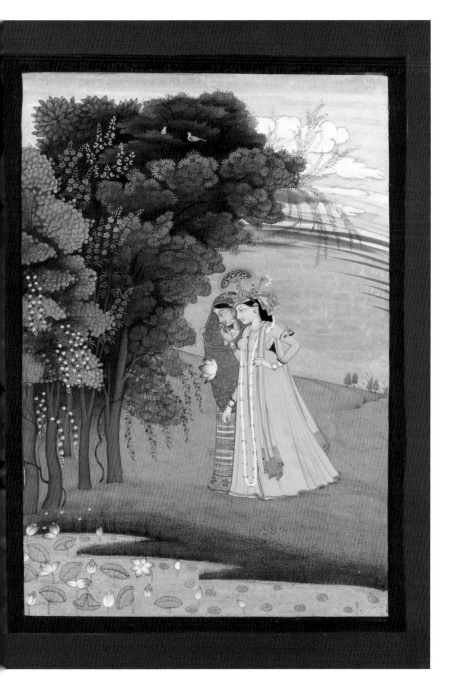

There are two separate moments in the relationship between Radha and Krishna when the god dresses in woman's clothing. The first, illustrated in the painting from Bundi (127), takes place when Radha is too furious with Krishna to allow him into her sight. He disguises himself as a female musician, a heavenly being known as a *kinnari*. He approaches Radha and her friends and offers to play her a tune. When asked her identity the mysterious musician says she is Shyam Sakhi (Dark-Skinned Confidante). Just as Radha is about to offer the musician a token of thanks, one of her friends helps her realize that the woman is Krishna; Radha is so amused by the sight of him in woman's clothing that she cannot be angry.

Like several other paintings from the Bundi-Kota area, this image situates Radha and Krishna in a halo of light that echoes the disc of the sun and full moon. The friends are not present in this illustration, and Krishna is barely recognizable except for his dark blue skin. Like the images of Krishna kneeling before Radha, the Shyam Sakhi incident reveals the god's willingness to sacrifice his own pride in order to win back his beloved.

In a separate episode, when Radha and Krishna are at their happiest, the couple exchange clothes as part of their love play. In this painting (128), Radha has donned Krishna's saffron dhoti (here represented as a full coat for modesty's sake) and his crown with its distinctive crest of peacock feathers, and the god has put on Radha's sari, which he pulls over his head like a sweet young thing. The exchange, known as *Lila Hava*, Playing at Gestures or Coquettish Play, involves imitating each others' mannerisms as well as attire. When the lovers exchange clothes, they reveal that there is actually little to distinguish them, that in their intimacy they have effectively merged into a single being. God and devotee have become one and the same. Devotion has elevated the devotee to divine status. ✺

129 | Krishna and Radha with Scenes from Krishna's Life in the Background

Northern India, Rajasthan, Jaipur; c. 1880
Opaque watercolor and gold on paper
14 x 10 ¼ in. (35.6 x 26 cm)
Asian Art Museum. Gift of Elton L. Puffer, 2004.47

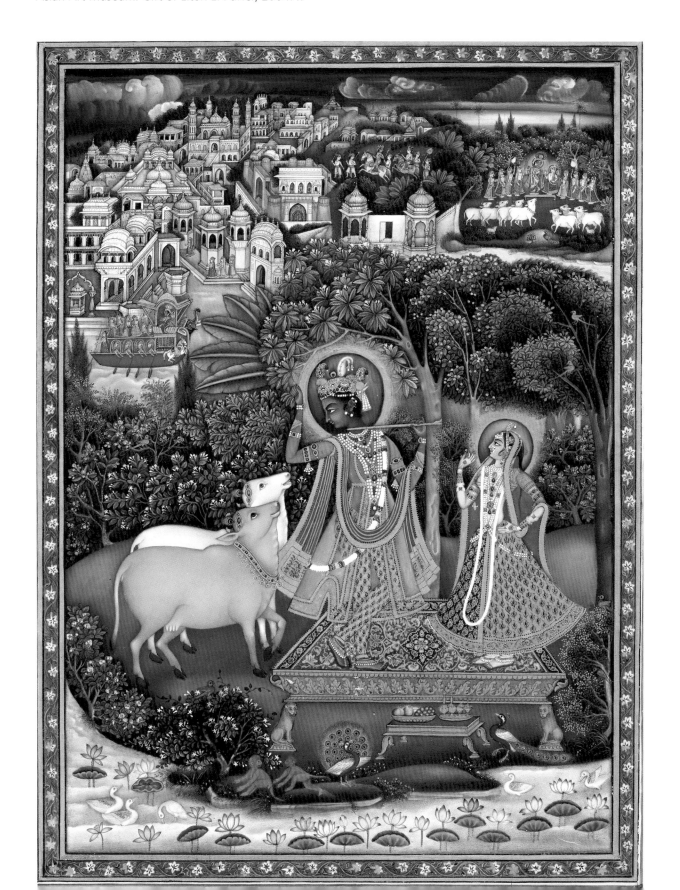

130 | Worship of Krishna and Radha

Harinarayan (dates unknown)
Northern India, Rajasthan, Jaipur; c. 1900
Opaque watercolor and gold on paper
16 ¼ x 12 ¼ in. (41.3 x 31.1 cm)
Norton Simon Museum. Gift of Ramesh and Urmil Kapoor,
P.2002.2

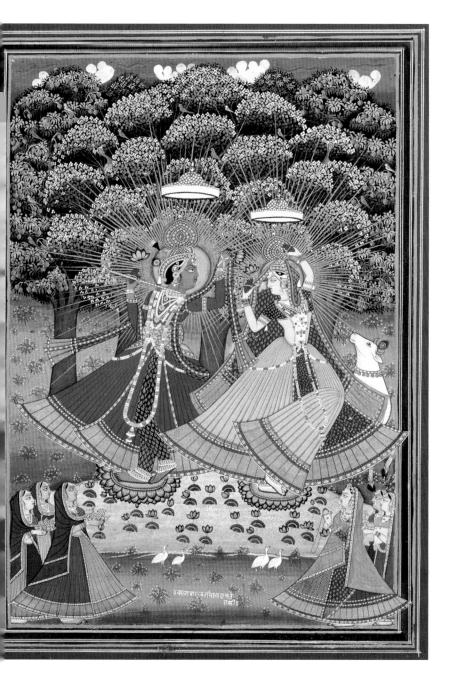

These two paintings of Radha and Krishna (129, 130) depict the couple as a divine pairing of male and female much like Lakshmi-Narayana icons. In both images, Krishna and Radha are depicted substantially larger than those around them, and in both they are elevated above the ground with offerings before them (in the Norton-Simon painting [129], the offerings are held by female worshippers), all suggesting that these paintings were designed to serve as icons rather than illustrations of narratives.

Both were probably made in the city-state of Jaipur, in Rajasthan, where a vivid but slightly stiff painting style was in fashion at the end of the nineteenth century. The two paintings reveal two very different solutions to the task of depicting Radha and Krishna in iconic form. The Norton-Simon image, signed by a little-known artist named Harinarayan, displays the figures in angular dancing poses that recall sculptures, with highly stylized pleated garments arrayed to either side much the way the garments placed on temple sculptures are often arranged. However, in a departure from iconic sculpture conventions, the lovers look at each other instead of at the viewer. The dramatic golden rays emerging from both figures overlap each other and the foliage of the trees to create a complex pattern.

The San Francisco painting (130) shows the couple in more natural postures and clothing, but with Radha substantially smaller than Krishna. Krishna looks down at a pair of adoring cows. Peacocks, waterbirds, and monkeys in the foreground entertain the couple, while in the background Krishna appears three more times in tiny vignettes depicting episodes from his biography. The evening *rasalila* with the gopis appears at the right; Krishna and Balarama riding horses, possibly on their way to Mathura to conquer the evil Hamsa, appear at center; and at the left we see a large, sophisticated city, possibly the re-enthroned Krishna's capital at Mathura or later Dwarka. Here, Krishna rides on a pleasure boat with a group of women. The center and left scenes identify Krishna more fully as a warrior and king, roles the god plays later in life, after leaving Braj. ❀

131 | **Vishvarupa**
Northern India, Punjab Hills, Bilaspur; c. 1740
Opaque watercolor and gold on paper
7 3/4 x 4 5/8 in. (19.8 x 11.7 cm)
Collection of Catherine and Ralph Benkaim

132 | **Vishvarupa** (*facing page*)
Northern India, Punjab Hills, Kangra; c. 1810–20
Opaque watercolor, gold, and silver on paper
11 5/16 x 8 5/8 in. (28.73 x 21.9 cm)
Collection of Eberhard Rist

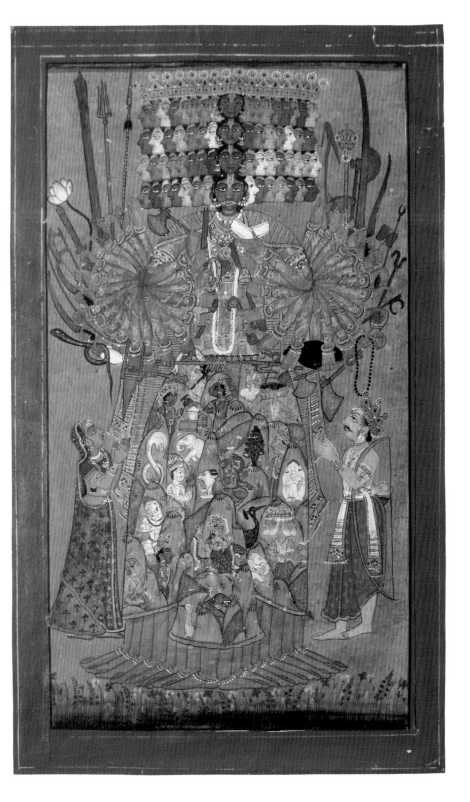

The *Bhagavad Gita* is one of the most influential scriptures in Hinduism, as it spells out many key concepts, including the importance of developing a strong, personal relationship with God. It takes the form of a conversation between the hero Arjuna and the god Krishna, who are standing in Arjuna's chariot before a very bloody battle, in Krishna's more serious adulthood, after he leaves Braj. Like the epic *Mahabharata* in which it appears, the *Bhagavad Gita* is rarely illustrated by painters or sculptors. Its impact and appeal is primarily conceptual and verbal, rather than narrative and visual. However, there is one part of the *Bhagavad Gita* that offers a very compelling challenge to artists; this is the moment, about halfway through their discussion, when Arjuna asks Krishna to reveal his true form. Krishna says that he must give Arjuna special sight in order for this to be possible, then,

> O King, saying this, Krishna,
> the great lord of discipline,
> revealed to Arjuna
> the true majesty of his form.
>
> It was a multiform, wondrous vision,
> with countless mouths and eyes
> and celestial ornaments,
> brandishing many divine weapons.
>
> Everywhere was boundless divinity
> containing all astonishing things,
> wearing divine garlands and garments,
> anointed with divine perfume.
>
> If the light of a thousand suns
> were to rise in the sky at once,
> it would be like the light
> of that great spirit.

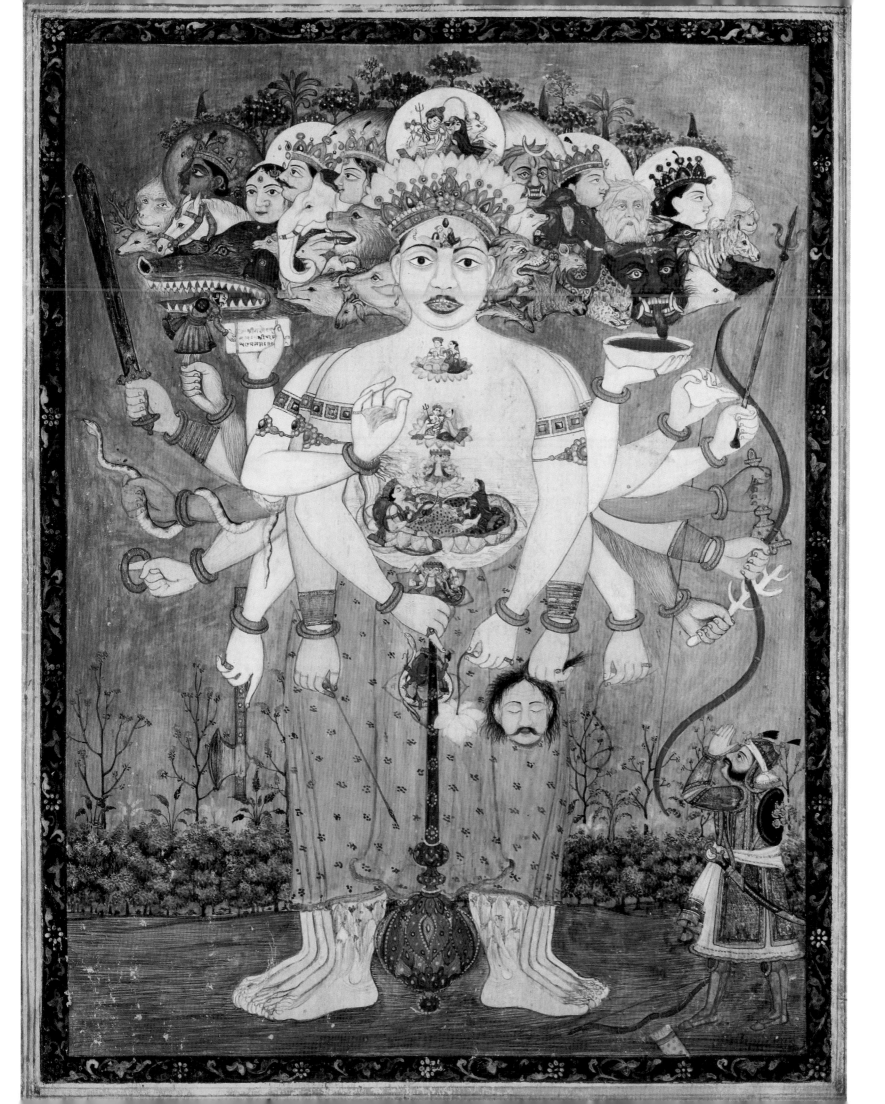

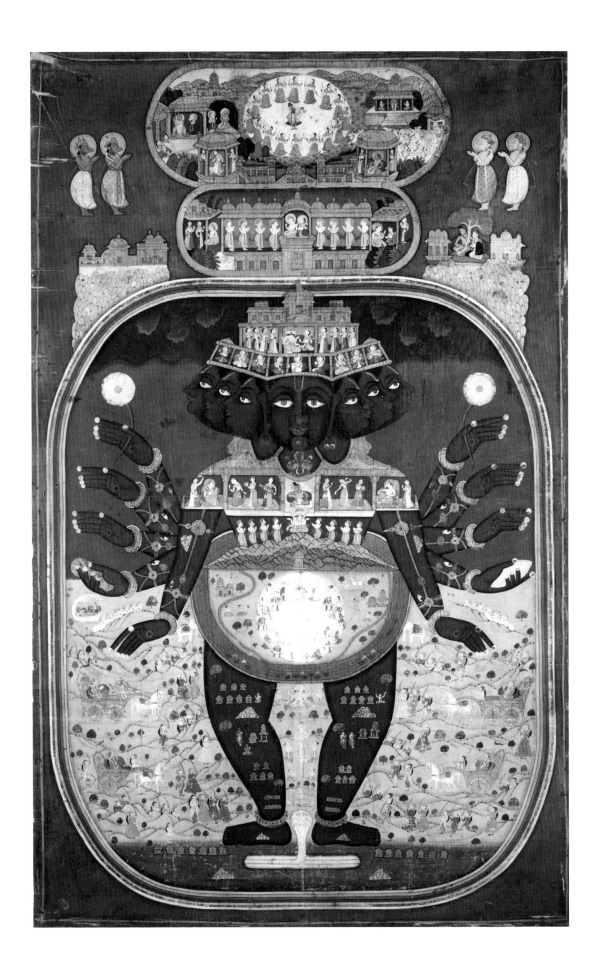

133 | **Vishvarupa** (*facing page*)
Northern India, Rajasthan, possibly Kota; 19th century
Opaque watercolor on cloth; 56 x 36 in. (142.2 x 91.4 cm)
Nancy Wiener Gallery, Inc.

Arjuna saw all the universe
in its many ways and parts,
standing as one in the body
of the god of gods.[89]

Frightened by what he sees, Arjuna begs Krishna to return to his familiar, more approachable form, and the compassionate god does so.

The giant body revealed by Krishna to Arjuna is usually known as Vishvarupa, or Having All Shapes. It is inherently beyond the comprehension of mere mortals, and yet artists have long attempted to capture some sense of it through the most complex, most multiple figures imaginable. The three paintings shown here (131, 132, 133) represent very different approaches to the challenge.

The earliest image, from the Punjab Hills state of Bilaspur (131), is surprisingly small for such a giant subject. It shows the god with sixty-four faces of various colors (but blue at the center) and a flurry of blue arms holding every imaginable weapon. On his dhoti, above his multiple feet, are the shapes of mountains, each one with the image of a god superimposed upon it: the monkey Hanuman, the elephant-headed Ganesha seated on the bull Nandi, and the Goddess seated on her tiger appear down the center, and there are other deities on either side. A woman and a king worship the god; they might be Krishna's adoptive mother Yashoda and the hero Arjuna, since both were granted visions of the god in this overwhelming form.

The painting from Kangra (132), which dates to about seventy years later, replaces the tidy row of matching heads for a cluster of many different faces, some belonging to animals, topped by trees to suggest that Vishvarupa is the support for the world. The number of arms and legs has been reduced, but they too are differentiated (some arms are blue, others are hairy, and the legs are covered with mountains); the dhoti is now plain, but on his stomach and chest the god sports tiny images of Vishnu lying on the serpent Shesha and some divine couples. A warrior in chain mail, almost certainly Arjuna, worships the god from below.

A large painting on cloth made in Rajasthan (133) provides still more information while sacrificing some complexity in the central figure. Here, the faces are all the same, with other gods appearing in the architecture of the crown and shoulders. On the god's belly we see the *Rasamandala*, the circle dance in which Krishna duplicated himself to be with all the gopis. That dance is virtually replicated above, in an ovoid space at the top of the painting that appears to represent Vishnu's paradise, Vaikuntha; here, the gopis dance around a single figure of Krishna, who is in the form of Shrinathaji (see cats. 157–60).[90] Whereas the other paintings depicted the many gods as components of Vishvarupa, here the emphasis is quite clearly on Krishna. In the landscape at either side of the figure we can spot figures in chariots, presumably the Kaurava and Pandava families preparing for battle, including the blue-skinned Krishna in the chariot with Arjuna at our left.

These images depict Vishvarupa as relatively placid (in the first painting, the central face has fangs), but in the text the destructive aspect of the god is very much apparent. For a more ferocious image of Vishvarupa, see catalogue 174, a twentieth-century popular print that draws on these earlier models but also departs from them in significant ways. ❈

134 | Krishna and Radha Worshipped in the Dwarka Shrine

Northern India, Rajasthan, Amber; c. 1680
Opaque watercolor on paper
13 x 9 ¾ in. (33 x 24.8 cm)
Collection of Catherine and Ralph Benkaim

We have seen that Krishna spent the early part of his life with his foster parents among the cowherds in the idyllic rural setting of Braj. Once he reached adulthood he returned to his birthplace Mathura to kill his evil maternal uncle Kamsa and stayed on there, assisting his grandfather, the king Ugrasena, in the protection, governance, and administration of the region. Krishna would never visit Braj or revel in its bucolic pleasures again.

When Mathura was under attack from two different foes, Krishna decided to leave and build a new citadel for the protection of the capital's citizens. The architect of the gods, Vishvakarma, constructed the superbly planned, richly decorated, and well-fortified city of Dwarka along the western ocean in the Saurashtra region of Gujarat. After Krishna departed the earth, the people of Dwarka were warned to leave the city; without the god's protection, it was submerged in the ocean. Archaeological studies indicate that around 1500 BCE, the western coast of India was indeed inundated. Modern-day Dwarka is a rebuilt version of the ancient city. Today it is an important Vaishnava pilgrimage site (fig. 134–1).

Paintings from Amber evince two trends: one is strongly influenced by the naturalism and muted colors of Mughal painting, while the other maintains a more Rajput style of execution, with flat primary colors and shallow picture space. This painting belongs to the latter group. The inscription at the top of the page indicates that it depicts Radha and Krishna sitting in a flower pavilion after going to Dwarka, surrounded by devotees, musicians, and dancers.[91] One should note, however, that according to

135 | **Krishna Battles Banasura** (*following page*)
Page from an illustrated manuscript of the *Harivamsha*
Northern India, Mughal school; late 16th century
Opaque watercolor on paper; 11 ¾ x 7 ½ in. (29.9. x 19.1 cm)
Seattle Art Museum. Eugene Fuller Memorial Collection, 63.37

Figure 134–1 | Dwarkadhish Temple, Dwarka, Gujarat, 16th century.

Photograph by Benoy K. Behl

the texts, Radha never accompanies Krishna to Dwarka; his time there is spent with his numerous (over 16,000) wives. Hence, we must ask if this was intended to be a depiction of temple icons in worship, or of the enthroned Radha and Krishna themselves. If it is an icon, then it is worth noting that the attendants on either side are women rather than the usual male priests.

Radha and Krishna are seated within an elaborate version of a typical metal shrine from western India.[92] At the apex is Brahma, below him Ganesha, and in the niches all around are depictions of female attendant figures. [NP] ❋

Although texts such as the *Mahabharata* and *Bhagavata Purana* provide extensive information about Krishna's biography after he moves to Dwarka, this period of his life is relatively little celebrated in either art or poetry, in large part because much of Krishna's adult activity is roughly similar to that of any king and therefore neither terribly magical nor romantic.

This page from an illustrated manuscript of the *Harivamsha*, or *Lineage of Hari* (another name for Krishna), depicts an episode from relatively late in his life. The episode is primarily about Krishna's grown grandson, Aniruddha, who is admired and then kidnapped by Usha, the daughter of a powerful demon king named Banasura. Banasura does not approve of the romance between Usha and Aniruddha, so he mistreats Aniruddha even while keeping him in the demon kingdom. Krishna must fight Banasura in order to win back his grandson.

The image shows the battle between the blue-skinned Krishna and Banasura, who is bleeding from the shoulders. Beneath their chariots we see scores of dismembered arms; all of these have been cut from the demon, who was blessed by the god Shiva with super powers, including the many arms. Despite his divinely granted strength, Banasura is no match for Krishna, who ultimately defeats him.

This *Harivamsha* series was made by painters of the imperial Mughal atelier, who had trained in the hybrid Indian-Persian-European painting style developed under the patronage of the emperor Akbar (reigned 1556–1605). The fingerlike rock formations and the astonished soldiers watching from behind the hill are both Persian conventions imported by the Mughals, while the miniature citadel and naturalistic tree are both evidence of the Mughal interest in European tropes. The text and subject matter are entirely Indian, illustrating the Muslim Mughals' quest to inform themselves of the traditions and culture of the country they had conquered approximately fifty years earlier. ❋

The Balarama Avatar

Balarama is often listed as the seventh avatar of Vishnu.[93] He is best known as the brother of Krishna, but is also said to be the human manifestation of the serpent Shesha (or Ananta), on whom Vishnu reclines while creating the universe. Unlike some other avatars, Balarama has no single deed for which he is celebrated. As Krishna's life long associate, his character is revealed only in brief and occasional accounts, but what emerges is multifaceted and sometimes contradictory: heroic and yet irresponsible, a hedonistic savior. His complexity appears to be due, at least in part, to changes over time in his perceived role.

All accounts agree that Balarama is Krishna's older brother. Like Krishna, he has his origins in the ancient hero-worshipping traditions of the area around Mathura, and his early role as a great warrior carries into the later literature, in which he is celebrated primarily for his superhuman physical strength (Balarama means "Rama the Strong"). Some of the very earliest depictions of the two gods show them in a triad with a sister, Ekanamsha, who faded into obscurity after about the third century.[94] In this early period, Balarama—as elder brother—may have been considered Krishna's superior,[95] but he soon stepped into Krishna's shadow as the younger brother was elevated even beyond avatar status.

Balarama and Krishna have the same biological parents, Vasudeva and Devaki, but the gods transplanted the embryo of Balarama from Devaki to the womb of Rohini. This transfer, undertaken to protect Balarama from his evil uncle Kamsa, is the source of Balarama's most common alternate name, Samkarshana, which derives from a Sanskrit verb that means both to extract and to draw together.[96] The two divine boys grew up together in the pastoral communities of Braj, the white-skinned Balarama, dressed in dark blue garments, offering a striking visual contrast to his blue-skinned brother. Early hints of Balarama's impetuousness become more problematic after the brothers kill their uncle; Balarama spends most of his adulthood inebriated, occasionally causing very serious trouble.

Balarama's most recognizable attribute is his plow, in the form of a wedge- or hook-shaped blade on the end of a long handle. It appears in the most ancient images of the god and suggests an early role as agricultural deity, perhaps initially as a counterpart to Krishna's cowherd. Although Balarama's plow is mentioned often in Hindu scripture, there is only one prevalent story in which he uses it, to divert the course of the Yamuna River, for purely selfish purposes but with positive results.

136 | Balarama Abducted by the Demon Pralamba

Northern India, probably Uttar Pradesh; Gupta period,
5th century
Terracotta; 21 ½ x 14 x 6 in. (55.8 x 38 x 15.2 cm)
Brooklyn Museum. Promised gift of Gwenn Miller in memory of
Barbara Stoler Miller, L1998.2.1

In the stories of Krishna and Balarama's idyllic childhood among the cowherds of Vrindavan, it is usually Krishna's job to dispatch demons. In a few instances, however, Balarama reveals his great strength and heroic nature. This relief depicts Balarama's victory over the demon Pralamba, who sneaks into the pastoral community disguised as a cowherd (gopa). The young gods and their friends are playing games in which the victors celebrate their wins by being carried on the shoulders of the losers. Pralamba arranges to lose to Balarama's team and picks the god up (the *Bhagavata Purana* suggests that he targeted Balarama because he knew that Krishna was invincible[97]). He then reveals his true, demonic form: "like a black cloud in the rainy season ... his eyes as large as cart wheels."[98] He attempts to fly off, abducting Balarama, but the powerful god squeezes him with his knees and pummels his head with his fists, causing Pralamba to fall to the ground and die. The demon's enormous, shattered form is compared to a mountain hit by a bolt of lightning.[99]

Sculptural representations of this episode are relatively rare, although another terracotta panel from approximately the same period and region can be found in the Allahabad Museum.[100] Despite its fragmentary condition, the Brooklyn relief captures the relaxed strength of Balarama's body (still chubby in its youth) as well as the pain experienced by the demon during his defeat. Pralamba has the snail-shell curls and pot belly often associated with demons in Indian and Southeast Asian imagery, and his knee is bent (and his scarf fluttering) to indicate that he is in mid flight. His eyes are large, as described in texts, but without pupils, perhaps illustrating the gory detail, included in some accounts, that Balarama gouged them out during the beating.[101] ✸

137 | Balarama
Central India; 8th–9th century
Sandstone; 17 ½ x 10 ¾ x 4 in. (44.5 x 27.3 x 10.2 cm)
Brooklyn Museum. Gift of the Ernest Erickson Foundation, Inc.,
86.227.158

138 | Balarama
Bangladesh or Eastern India, West Bengal; c. 1000
Bronze; 13 ⅞ x 6 x 3 ⅜ in. (35.3 x 15.5 x 8.4 cm)
Museum für Asiatische Kunst, Berlin. I 5880

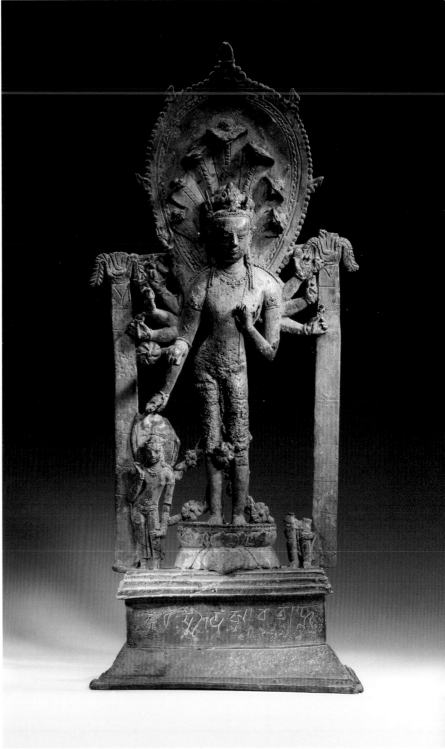

Many icons of Balarama indicate that he is a manifestation of the serpent Shesha by depicting him with multiple cobra hoods. Shesha (or Ananta) is the serpent on which Vishnu reclines when he creates the cosmos. Balarama's identification with the serpent underscores his role as a support for Krishna, who, like Vishnu, enjoys Balarama/Shesha as a constant companion. One might think that later rosters of avatars, which included Balarama instead of his brother, would downplay his role as a manifestation of the great snake (because he is instead supposed to be a manifestation of Vishnu), but iconographers did not seem to find his dual affiliation a problem, presumably because Shesha is, like all beings, an extension of Vishnu as well. Balarama is Vishnu, but as filtered through his serpent aspect.

Balarama's association with snakes is one of the primary features that separates him from his brother. Divine serpents, called *naga*s, were widely worshipped in ancient India for their association with water and the world beneath our feet. Early Balarama images are easily mistaken for images of *nagaraja*s, or snake kings. The identification of Balarama with Shesha may represent an attempt to absorb popular *naga* worship into more orthodox Vaishnava practice. Like his *naga* brethren, Balarama is associated with water and the earth through his plowing of the Yamuna. Upon Balarama's death, it is said that a large snake, presumably Shesha, came out of his mouth and made its way toward the ocean.[102]

In the relatively small stone image (137), Balarama is shown standing in a graceful *tribangha*, or three-bend pose, holding a rosary and a hooked plow. A third hand (the fourth is no longer present) rests on the multiple cobra hoods. Balarama is presented here not as a participant in a narrative but as a subject of adoration. The hand holding the rosary is raised with the palm facing forward, a gesture made by deities to reassure their worshippers (*abhaya mudra*). This is not Balarama the capricious brother but Balarama the gracious protector. The size of the sculpture might suggest that it served as one of the secondary figures in a temple's iconographic program, perhaps appearing as part of a group of avatars in a frieze. However, it is unusual that the serpent hood on this image appears to one side and in addition to a halo: usually icons of Balarama sport

multiple serpent hoods, centrally located behind the head in the place of a halo, as seen in the bronze illustrated here. This feature could indicate that this sculpture was originally a subsidiary or attendant figure, flanking a larger central figure of Vishnu or Krishna, in which case the serpent hood would have served as a framing device at the far right side of a complex icon.

The identification of the bronze (138) has been the matter of considerable debate. It is stylistically in keeping with the bronzes of the early-to-mid Pala period, a moment of fervent Vaishnavism in Bengal. The iconography has, however, proven problematic. It seems clear that the standing figure, with its snake hoods, represents some form of Balarama. Like the stone example, he has one hand—his top right, out of synch with the others because it rises from his shoulder—raised to touch the hoods. Unlike the stone figure, this bronze figure had many arms, at least eleven of them.[103] His lowest right hand touches a personified weapon and presumably the lowest left hand would have rested on one too (it is now gone); it is the other weapons and attributes held by the figure that have proven puzzling: a round object, a staff with an animal at the top, a sea monster (*makara*), and a crescent moon on one side; and a flag, a small object, and a solar disc on the other. His raised central hand makes the gesture of reassurance. No single deity mentioned by iconographic texts holds all the attributes found on this image. As a result, one scholar has suggested that this icon represents all of the four *vyuha*s, or emanations of Vishnu, in a single body (see the introduction to the section on multiheaded Vishnus for further discussion of the vyuha concept and the deities it includes).[104] Other explanations have included an obscure Tantric variant of Balarama, whose meaning was known to only a few initiates and has not survived to the present. The inscription on the base gives the name of the donor.　❈

139 | Balarama Diverting the Course of the Yamuna with His Plow

From an illustrated manuscript of the *Dashavatara*
Northern India, Punjab Hills, Nurpur or Chamba; c. 1700–1725
Opaque watercolor and gold on paper
8 7/16 x 6 1/8 in. (21.5 x 15.5 cm)
Museum Rietberg, Zurich. Gift of Balthasar and Nanni Reinhart, 2005.47

140 | Balarama Diverting the Course of the Yamuna with His Plow (*following page*)

Probably from an illustrated manuscript of the *Dashavatara*
Northern India, Punjab Hills, possibly at Chamba; c. 1760–65
Opaque watercolor and gold on paper
7 5/16 x 11 3/16 in. (18.6 x 28.4 cm)
Brooklyn Museum. A. Augustus Healy and Frank L. Babbott Funds, 36.250

These paintings, from roughly the same area but made several decades apart, represent the deed for which Balarama is best known, the diversion of the river Yamuna. The scriptures place this story in Balarama's adulthood,[105] although it certainly harks back to the pastoral antics of his youth. Varuna, the god of waters, caused a wonderfully fragrant liquor to flow from a tree on the banks of the river, so Balarama—never one to turn down a drink—established himself there with a group of adoring gopis. After some time, Balarama began to sweat so he called on the Yamuna to come closer so he could bathe at greater convenience. The *Bhagavata Purana* says, "Since he was drunk, Balarama was furious when she did not come, and thought: 'She has shown disrespect for my personal command.' Then he dragged the river with the tip of his plow."[106] In this version, the river goddess begged for mercy but remained in the new location so Balarama could enjoy himself in her cool waters. In the *Vishnu Purana*, Balarama later compelled the river to follow him "in a thousand directions," only allowing her to rest after he had plowed and "watered the whole country."[107]

While the story illustrates Balarama's great strength, it also portrays him as something of a selfish brute. Such thoughtlessness on the part of a deity is in keeping with the notion of *lila*, or divine play, in which the world is nothing more than a toy for the gods. The earlier *Vishnu Purana* paints the god in a more beneficent light, having him use his plow to irrigate the land. The story recalls his association with serpents, who in ancient traditions were thought to control ground water.

Although a comparison of these images reveals the rapid change in prevalent painting styles in the Punjab Hills in the eighteenth century, what is perhaps most interesting

is the features they share, including the tall outcropping of stylized rock with the overhanging tree at the top. It is also worth noting that both depict Krishna present at the plowing, contradicting the scriptural accounts, in which Krishna is definitely not present.[108] The one-handed plowing stances assumed by the Balarama figures are also interesting in their similarity, especially given that in both versions the god raises a distinctively shaped mace in the other hand. These parallels suggest a regional convention for the depiction of the episode, perhaps the product of a younger generation learning from the drawings or finished paintings of their predecessors. ✻

The Buddha Avatar

Following the death of Krishna, the cosmos entered a new time period, the *Kali Yuga*, the last phase in the great cycle of existence, during which everything will gradually degenerate and then end in complete annihilation. The essential pessimism of the *Kali Yuga* is reflected in Vishnu's final major avatars.[109] The Buddha, who lived in eastern India in the fifth century BCE, is the only avatar for whom we have a relatively firm date. He is also perhaps the least celebrated by Vaishnavas.[110] The Buddha (an honorific or title meaning "Awakened One") was a prince, Siddhartha. Buddhist accounts tell of his birth under miraculous circumstances, his departure from the palace in search of answers about life's greatest questions, and his discovery and dissemination of the truths that would become the foundation for the Buddhist religion. Many Buddhists believe that Siddhartha (also called Shakyamuni) was something like an avatar—an eternal and all-pervading spiritual being who was incarnated on earth to lead its people toward enlightenment—but they do not associate him with Vishnu.

At first glance, the inclusion of the Buddha among Vishnu's avatars would seem to be a recognition and absorption of Buddhist ideals by the rival religion of Hinduism. In its first thousand years, Buddhism was indeed a force to be reckoned with for the Vaishnava elite.[111] Hindus used the story of the Buddha avatar to retain those who might be attracted to the new religion's teachings, but not by acknowledging that the Buddha was right. Instead, most Hindu accounts of the Buddha's life posit that the Buddha's teachings were purposefully wrong.

In its account of the Buddha avatar, the *Agni Purana* (a relatively late Purana compiled from the eighth to the eleventh centuries) describes Vishnu responding yet again to a plea from the gods, who are perpetually out-fought by a group of particularly mighty demons: as the Buddha, Vishnu assumed "the form of illusory delusion" and taught the demons a new religion, encouraging them to reject the Vedas and other Hindu teachings that were the source of their extreme power. By turning the demons into heretics, he weakened them.[112] In the eyes of Puranic Vaishnavism, Buddhism is a weapon in the form of a lie, used to mislead the enemies of the true religion. The Buddha's teachings are, however, seen as symptomatic of the widespread devolution of morality and wisdom that is inevitable in the *Kali Yuga*. As the Buddha, Vishnu hastens the end of the world.

In light of this essentially negative conception of the Buddha's role, it is interesting to note that in the *Gita Govinda*, the devotee-poet Jayadeva celebrates the Buddha avatar as follows:

Moved by deep compassion, you condemn the Vedic way
That ordains animal slaughter in rites of sacrifice.
You take form as the enlightened Buddha, Krishna.
Triumph, Hari, Lord of the World![113]

The poet's stance is radically different from that of the *Agni Purana*: he praises the Buddha's anti-Vedic teachings for their promotion of nonviolence, a sentiment that appealed to many Vaishnavas of a later period. It is hard to imagine such a dramatic shift in interpretations of this avatar's role; perhaps it was difficult for some to accept the notion of an avatar as deceptive and deluding. If nothing else, the *Gita Govinda* verse reveals how radical and nearly heterodox later Krishna Bhakti could be—to praise anyone for condemning the Vedas would have been unthinkable in an earlier period.

141 | **The Buddha Avatar** (*previous page, above*)
Page probably from an illustrated *Dashavatara* series
Northern India, Punjab Hills, Basohli or Nurpur; c. 1700
Opaque watercolor, gold, and beetle wings on paper
8 1/32 x 11 13/16 in. (20.4 x 30 cm)
The San Diego Museum of Art. Edwin Binney 3rd Collection,
1990:1048

142 | **The Buddha Avatar** (*previous page, below*)
Attributed to Nainsukh (c. 1710–1778)
Page probably from an illustrated *Dashavatara* series
Northern India, Punjab Hills, probably Jammu; c. 1760
Opaque watercolor and gold on paper
6 5/32 x 8 11/32 in. (15.6 x 21.2 cm)
The San Diego Museum of Art. Edwin Binney 3rd Collection,
1990:1216

Vaishnava iconographic texts agree about the proper representation of the Buddha avatar: he should be seated in meditation with his legs crossed, with short curly hair, pendant earlobes, and lotus marks on the palms of his hands and feet. Images of the Buddha avatar rarely appear in any great size or detail in Vaishnava contexts, and they are always at the periphery. In stone sculptures, as on the wall of the eleventh-century Rani-ki-Vav, or "Queen's Well" in Patan, Gujarat (fig. 141–1) the Buddha avatar often looks much like Buddhist representations of Shakyamuni from the same period. This suggests that sculptors were at least somewhat familiar with the subject from Buddhist contexts. However, when we look at paintings from the seventeenth century and on, we find little that is recognizably Buddhist about Hindu representations of the Buddha. Without the *ushnisha*, the cranial bump that marks most uncrowned Buddha images, the avatar looks like any Vaishnava figure, seated on a lotus

throne, receiving worship. With his unusual stiff, frontal pose and a shrinelike setting, he is easily mistaken for a temple icon—or perhaps the figure is an icon, both worthy and unworthy of our respect, for the Buddha is both Vishnu and a misleading prophet. Among all the avatars of the *Dashavatara* series, the Buddha is usually the least-compelling, least-lively focus for devotion, and that is perhaps as it should be.

With their strong iconographic similarities, these paintings (141, 142) offer a fascinating glimpse into the change in painting styles in the Punjab Hills over the course of the eighteenth century. The earlier example (141), with its highly decorated surface, including beetle-wing casings adhered to the surface to mimic sparkling emeralds and a silver backdrop, is closely related to the early manuscripts created for the court at Basohli. The later painting, attributed to the artist Nainsukh,[114] offers a relatively radical departure from the decorative flatness of the earlier tradition, placing the figures within a deep, well-defined space and more closely observant of the physiognomy and proportions of the human form. Nainsukh and his family were largely responsible for stimulating this transformation in painting styles, from ornamental to representational, and once they had seen Nainsukh's revolutionary approach to image-making, the artists and patrons of the Punjab Hills never turned back. ✻

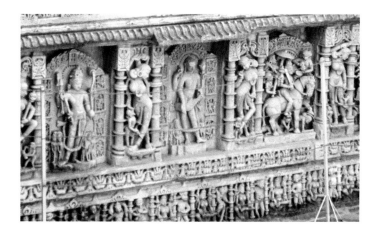

Figure 141–1 | Images of the avatars of Vishnu, including Rama, the Buddha, and Kalki, north interior wall, Rani-ki-Vav (Queen's Well), Patan, Gujarat, 11th century.
Photograph by Joan Cummins

The Kalki Avatar

The tenth incarnation of Vishnu, Kalki, is the incarnation in the future and has not yet been born. He will appear at the end of the *Kali Yuga*, the present and most degenerate of all the ages, and lead the world into the *Satya Yuga*, or Age of Truth. There is no developed mythology about this incarnation as there is for the other nine; nevertheless, his name appears in all the lists and depictions of Vishnu's avatars.

Texts provide a vivid description of the moral lassitude and evils of the *Kali Yuga*, when "a person with a lot of money will naturally be respected as a great soul," "people will simply become hypocrites, liars, and cheaters," "even married women will behave little better than prostitutes," and "kings will whimsically torture and kill their subjects, and burden them with excessive taxes."[115] The age is personified as Kali, the son of Envy and Anger, who is described as having a black complexion and always holding his genitals in his left hand. "His appearance is very fearful and a bad smell emanates from his body. Kali is very fond of playing chess, drinking wine, enjoying the company of prostitutes, and associating with gold merchants."[116]

In order to destroy Kali, Vishnu will be born in the village of Shambhala to the Brahmin Vishnuyasha and his wife Sumati. Like any ordinary Brahmin boy, Kalki will go to live at the hermitage of his preceptor. Kalki's guru will be none other than the great warrior Parashurama, the sixth incarnation of Vishnu, who will teach him to use weapons. After his training with Parasurama is complete, Kalki will propitiate Shiva, who will grant him a magical white horse that can assume any form; a parrot who knows past, present, and future; and a bejeweled sword. Kalki will then return to Shambhala.

On the island of Simhala (modern Sri Lanka), the princess Padmavati, an incarnation of Vishnu's consort Lakshmi, will also receive a benediction from Shiva that she will obtain Vishnu as her husband. If any other man should look at her lustfully, he will instantly be transformed into a woman. Hence all the kings who will come to seek her hand will be transformed into women, and Padmavati will lament that Vishnu has not come to claim her. Ultimately, Kalki will go to Simhala and marry Padmavati changing all the kings back into their male form. Kalki will then return to Shambhala with Padmavati.

Kalki's purpose is to restore righteousness and wipe out the evils of *Kali Yuga*. To this end he will fight against the Buddhists, who are here considered nonbelievers even though the Buddha is also an incarnation of Vishnu, and defeat them. "Just as a lion, the king of the jungle, attacks a female elephant, Lord Kalki, the life and soul of all living entities, attacked the army of the Buddhists."[117] He will also defeat Kali and his followers in a terrific battle. "His [Kali's] entire body was soaked with blood, the smell of a decaying mouse emanated from his body, and his face appeared fraught with fear."[118] Kalki will marry another princess, fight many battles, defeat multiple foes, and rescue people who are cursed. He will then appoint righteous kings to rule the various kingdoms. He will usher in *Satya Yuga*, when "pure religious principles are observed and protected"[119] and having completed his appointed task, Kalki will return to his heavenly abode in Vaikuntha. [NP]

143 | Kalki Avatar

North India, Delhi-Agra region; late 16th century
Opaque watercolor on paper; 6 ¾ x 9 ¼ in. (17.1 x 23.5 cm)
Private collection

This image of the blue-hued, yellow-garbed Kalki with its luxurious vegetation and bird-filled sky evinces iconographic similarities with those of Krishna and recalls the verdant environs of Braj. However, the figure is recognizable as Kalki because of the sword and the magical horse, whereas Krishna would carry a flute and be accompanied by cattle. Kalki is shown leading his winged horse through a forest accompanied by another man. This is possibly a depiction of the island of Simhala, where Kalki goes to marry Padmavati. The identity of the accompanying figure is unknown: perhaps he is one of Padmavati's kinsmen. Texts do not mention a specific companion of Kalki except the all-knowing parrot, yet in both paintings here, Kalki is depicted with an attendant figure.

The Delhi-Agra attribution of this painting suggests a subimperial style, which refers to the work being done at courts that came under the sphere of Mughal overlordship or influence. Undoubtedly most workshops were influenced in some way by the Mughal style, and paintings often show individualized local characteristics, so this appellation does not refer to a unified style. [NP]

144 | *Kalki Avatar*

Northern India, Punjab Hills, Mankot; c. 1700
Opaque watercolor on paper; 8 1/16 x 11 in. (20.5 x 28 cm)
Museum Rietberg, Zurich. Former Collection Alice Boner,
RVI 1213

This painting from the Punjab Hills state of Mankot depicts a figure dressed in armor and carrying a sword and a shield, sitting on a throne. His blue coloring identifies him as Kalki, an incarnation of Vishnu. At the same time, his appearance is like that of a "keen-eyed, mustachioed Rajput lord."[120] A Rajput ruler would often be portrayed in a painting as blue-skinned so that his kingly virtues could be conflated with those of Krishna. It may be that, in this case, a ruler identified himself with Vishnu's future incarnation Kalki in order to evince military prowess. An attendant raises his hand in salute as he leads Kalki's magical horse to him. Again, the attendant's identity can only be guessed at, though in the Rajput context, rulers were often depicted with many attendant figures. The horse is caparisoned with a decorative saddle, ready to be ridden into battle.

This martial painting from Mankot with its empty background has a very different feel from the subimperial painting with its stylized trees (cat. 143). The background in eighteenth-century Mankot paintings is often blank and done in a vivid non-naturalistic color like yellow, with a very thin strip of sky at the top. [NP]

Multifaced Vishnu Images

In Hindu imagery, there are several deities who are routinely depicted with multiple heads or faces—Brahma usually has four, Shiva's son Karttikeya often has six. As with arms, the multiplication of faces represents the ability to play many roles at once, and indeed this notion is taken to an extreme in the form of Vishvarupa, in which Krishna reveals that he is and does everything. The Vishvarupa manifestation proves too difficult, too overwhelming, for humanity to absorb because it is too many things at once.

Standing in striking contrast to the all-encompassing Vishvarupa is a group of other multifaced manifestations of Vishnu that represent very particular or subtle aspects of the god, usually reflecting philosophically sophisticated teachings.[121] Vishnu's multiheaded form almost always consists of a placid, anthropomorphic face at the center, flanked by the faces of a lion and a boar, and sometimes including a fierce face at the back.[122] Scholars of religion and art history have long called this form Vaikuntha Vishnu (see fig. 145–1 for such an icon, identified as Vaikuntha in an ancient inscription).[123] Whether this name is in fact appropriate, especially for earlier images, has been a matter of debate.[124] Alternate names for this type include Chaturanana, Chaturmukha, or Chaturmurti (all meaning "Four Faces"), or Chaturvyuha (Four Emanations). These multifaced images are not simply known by multiple names, they also conveyed multiple meanings.

Worship of multifaced Vishnu is mostly associated with the beliefs of a Vaishnava sect known as Pancharatra, which rose in popularity in the first centuries of the Common Era. For followers of Pancharatra, four-faced Vishnus represent four steps of spiritual simplification, from the Absolute to something more fathomable. The front, central face is that of Vasudeva, who has emerged from the very highest being, which is formless and without any qualities or actions. From Vasudeva is said to come forth another, less transcendent being (shown to Vasudeva's right), who then puts forth another being, who then puts forth another. Each successive emanation of the four, known as a *vyuha*, embodies an ideal quality—strength, knowledge, lordship, and potency—each is responsible for creating additional manifestations of the god Vishnu (including his avatars), and each is represented in one of the faces. The four *vyuha*s share the same names as members of Krishna's family, but in Pancharatra philosophy, they are not earthly heroes, but great intermediaries through whom the purely abstract power of the Supreme Being transforms into the more manifest worlds of god and man.

*Vyuha*s are entirely different from avatars: they are perpetual, generative forces, whereas avatars are temporary manifestations or protagonists in a narrative. So it can be confusing to

the novice viewer that two of the four *vyuha*s are represented in the exact same guises (the lion and the boar) as two of the most popular avatars. Adding to the confusion is the fact that alongside the *vyuha* interpretation there appears to have existed an understanding, at least in later times, that the four faces were actually avatars. Iconographic texts often refer to the lion and boar faces as Narasimha and Varaha, and a famous inscription indicates that such images represented Vishnu as an enemy to demons, a function served by avatars but not by *vyuha*s.[125] Like many aspects of Hindu belief, these two readings of the image appear to have existed simultaneously and without much conflict. Some people may well have seen both the *vyuha* and the avatar ideals embodied within a single image.

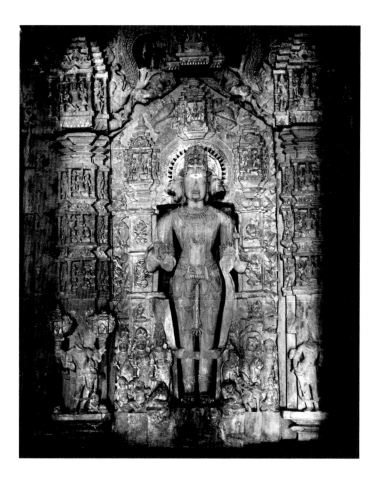

Figure 145–1 | Icon of Vaikuntha Vishnu, sanctum, Lakshmana Temple, Khajuraho, Madhya Pradesh, c. 954.
Photograph courtesy of Digital South Asian Library, American Institute of Indian Studies

145 | Four-Faced Vishnu
Northern India, Uttar Pradesh, Mathura area; Kushana period,
3rd century
Sandstone; 13 x 8 x 4 ⅜ in. (33 x 20.3 x 11.1 cm)
Samuel P. Harn Museum of Art, University of Florida. Museum
purchase, acquired with the generous support of Ed and Doris
Wiener, S-82-1

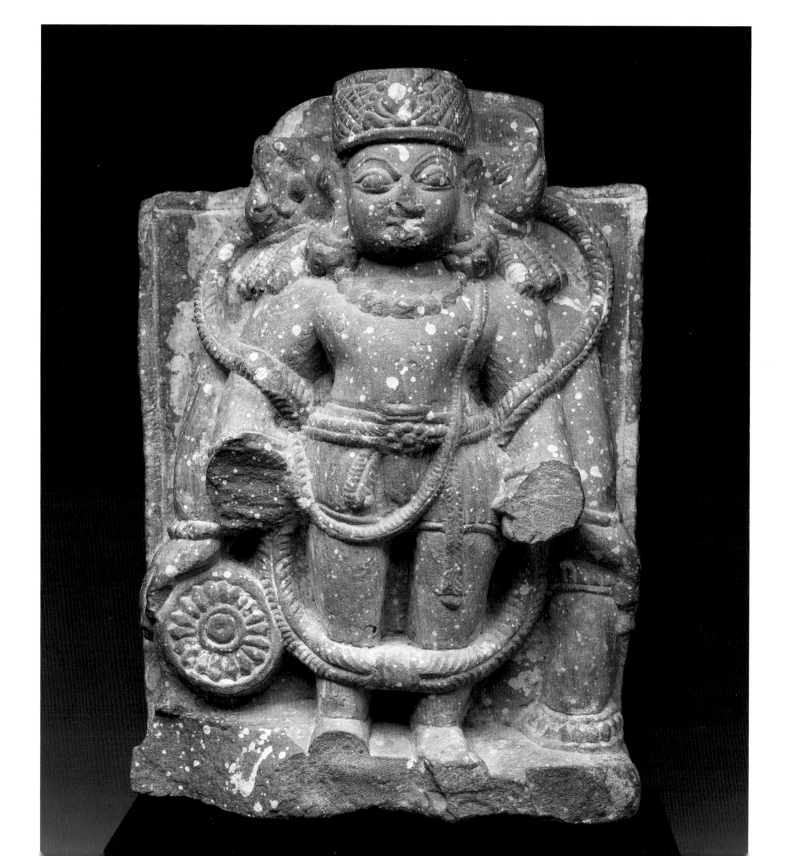

146 | Four-Faced Vishnu

Northern India, Uttar Pradesh, Mathura area; Gupta period,
4th–5th century
Sandstone; 10 x 5 ½ x 2 ½ in. (25.4 x 14 x 6.4 cm)
Brooklyn Museum. Gift of Marilyn W. Grounds, 79.260.12

The earliest surviving images of Vishnu with multiple faces appear to have been carved during the late Kushana period, around the end of the third century. If we look away from the extra faces for a moment, we notice that the two early images illustrated here (145, 146) are very similar in form and iconography to several other icons in the exhibition (see cats. 1, 2, 12), with four hands held low, two of them resting on large weapons (some of them personified), and a prominent garland hanging from around the shoulders to in front of the knees. The Harn Museum image (145) may be dated to an earlier period than the other icons of this type in this exhibition on the basis of its low-profile crown and somewhat squatter proportions.[126] All of these images are in slightly different styles, with variations in body proportions and degrees of ornament, and are probably the work of different stone-carving workshops, but they reflect the widespread communication of iconographic guidelines among sculptors of the period.

Such is the case in these two images. Both are relatively small, with differences lying in the proportions and crown styles. The side faces are also different: the Brooklyn example (146) is badly worn but it is still possible to make out the pronounced snout of the boar on the figure's right (the viewer's left), whereas that face on the Harn image is clearly a lion. The latter configuration is far more typical and in keeping with iconographic prescriptions, in which the central face is supposed to face east, with the lion facing south and the boar facing north.[127] This is the arrangement that will be found in later Kashmiri examples (see cats. 148, 149). However, there are other early representations in which the positions are switched, as in the Brooklyn piece, including a very similar image in the Government Museum, Mathura.[128] It would appear that the rules for representation had not been fully established—or well communicated—in this early period. ✳

147 | **Four-Sided Vishnu Stele**
Central India, Uttar Pradesh, Mathura area; 7th century
Sandstone; 17 ¾ x 8 7/16 x 8 5/8 in. (45 x 21.4 x 22 cm)
Museum für Asiatische Kunst, Berlin. I 10110

A variation on the four-faced image can be found in single objects that represent four images of Vishnu in full. Four-sided steles like this one can be found with images of four different gods on them, or with images of the same god four times. The most common example of the latter is the *chaturmukha lingam*, or four-faced phallic emblem of Shiva. The message these four-sided images convey is one of unity in diversity: a monolithic force can have many faces. At their core, all are the same.

Like the representations of four-faced Vishnu, this vertical element has a figure of Vishnu in relief on the front, flanked by figures of Narasimha, here on his right (our left), and Varaha on his left (our right). On the reverse is the horse-headed manifestation, Hayagriva, who is included in lists of Vishnu's minor avatars. Hayagriva is sometimes treated as a demon who steals the Vedas from Brahma and must be vanquished by the Matsya avatar. But in other versions of the story, he replaces Matsya as the hero, slaying a different Veda-stealing demon and returning the books to Brahma. Because he rescued the Vedas Hayagriva is considered a god of knowledge and scholarship, and he enjoys a relatively active following, especially in the South. One account tells that Hayagriva was created when Vishnu's head was severed by a snapping bowstring; the head of a horse was used to replace the god's missing head when someone was needed to save the Vedas. As a result, Hayagriva always looks like a man with a horse's head, rather than a horse in full.

The inclusion of Hayagriva, with his somewhat demonic reputation, is in keeping with the use of the wrathful face of Kapila on the rear (which we will see in a Kashmiri piece, cat. 149). It is also identical to the arrangement of icons on the Lakshmana Temple at Khajuraho, in which an image of Hayagriva appears on the rear wall of the inner ambulatory, with images of Varaha on the south wall and Narasimha on the north wall, all surrounding a centrally enshrined image of Vaikuntha,

or multiheaded Vishnu. The interpretation of the iconography on that temple remains unclear, but it has a counterpart in this single stele.

One interesting visual feature of this piece is the subsidiary or attendant figures; they are treated differently on each side, giving some variety to the overall composition. Kneeling figures (apparently Garuda and Lakshmi) flank Vishnu; *nagas* adore Varaha from the watery depths; and one male and one female figure each attend Hayagriva and Narasimha. The gods rest their hands on these last figures, suggesting that they are personified weapons. ✲

148 | Vaikuntha Vishnu

Northern India, Kashmir; 8th–9th century
Bronze; 13 ½ x 7 1/16 x 3 ⅛ in. (34.3 x 18 x 8 cm)
Asia Society, New York. Mr. and Mrs. John D. Rockefeller 3rd
Collection, 1979.043

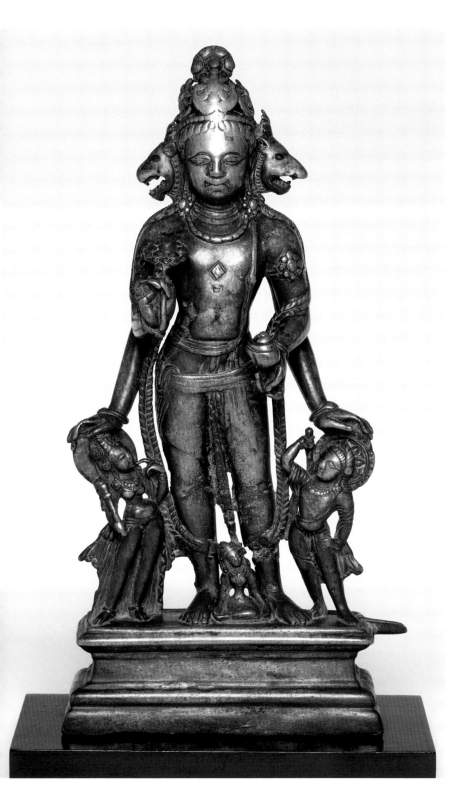

The three- or four-headed Vishnu was particularly popular in Kashmir, where a branch of the Pancharatra sect flourished throughout the medieval period (c. seventh–twelfth centuries). It is unclear if Kashmiris would have viewed the faces as *vyuha* emanations or avatars or both (see the discussion at the beginning of this section), but iconographic texts certainly referred to the faces by their avatar names. Although common practice today is to call these Kashmiri figures Vaikuntha, some iconographic texts indicate that multiheaded Vishnu should only be called Vaikuntha if he is seated with Lakshmi on Garuda, as in the stone piece shown here (149).[129]

The bronze image of three-faced Vishnu (148) shows the god holding a lotus and a conch and resting his lower hands on his personified mace (the female Gadadevi) and chakra (the male Chakrapurusha) This arrangement, and the long garland hanging to his knees, recalls the Kushana- and Gupta-period icons from central India seen elsewhere in this catalogue and indicates the degree to which early Kashmiri sculptors looked south for inspiration. A more typically Kashmiri element is the tiny figure of the earth goddess, who appears between the god's feet. She and the personified weapons look up adoringly at Vishnu.

The stone piece is far more elaborate, with Vishnu holding an unusual sword-shaped weapon in his upper right hand. His chakra is visible only from the side, and is next to Lakshmi's head. Lakshmi sits on Vishnu's knee, and a squatting figure of Garuda holds both of them up, his hands in the gesture of respect and an unusual lotus medallion topping his head. From the back we can see that Garuda's tail feathers create a throne for Vishnu, a charming detail.

Both of the Vishnu figures wear a four-part crown composed of upward-pointing crescent-shaped elements, with a blooming lotus on top. Both wear diamond-shaped *shrivatsa* marks on their chests.

149 | Vaikuntha Vishnu with Lakshmi on Garuda

Northern India, Kashmir; 11th century

Phyllite; 23 x 11 ½ x 5 ½ in. (58.42 x 29.21 x 13.97 cm)

Los Angeles County Museum of Art. From the Nasli and Alice
Heeramaneck Collection, Museum Associates Purchase, M.72.53.1

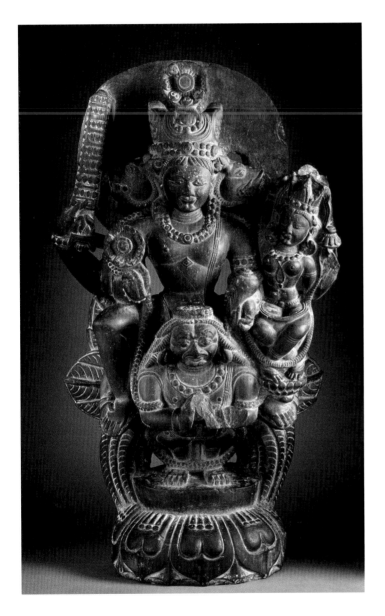

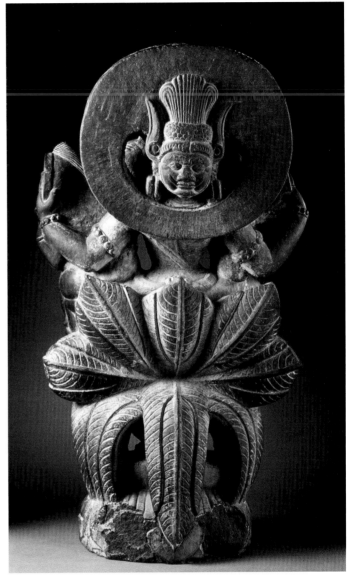

Each multiheaded Vishnu has the lion head at his right (our left) and the boar head at his left. The bronze does not have a fourth face, but the stone sculpture does, visible from behind at the center of the halo. This face has bulging eyes, bushy eyebrows, and stylized fangs/tusks at either side of the mouth. Such fierce faces are often found on the backs of Kashmiri Vaikuntha images, and they are usually identified as Kapila, a Vedic sage with a short temper who is sometimes treated as a minor avatar of Vishnu. This face is associated with the energetic, or potent, aspect of the god, which is volatile and therefore represented as demonic in appearance. ✳

Notes: The Avatars of Vishnu

1 The other examples are in the Indian Museum, Kolkata (found at Radhanagar, West Bengal, and illustrated in the digital Huntington Archive, no. 0003278) and in the Norton Simon Museum, Pasadena, published in Pratapaditya Pal, *Asian Art at the Norton Simon Museum, Volume 1: Art from the Indian Subcontinent* (New Haven, CT: Yale University Press; Pasadena, CA: Norton Simon Foundation, 2003), 187–88. For a full account of related objects, see Gerd J.R. Mevissen, "Corpus of Visnu Images with dasavataras, predominantly from Bengal," *Berliner Indologische Studien* 19 (2010), 171–286.

2 A stylistically dissimilar but iconographically identical Vishnu image in a New York private collection has been published by Vishakha N. Desai and Darielle Mason in *Gods, Guardians, and Lovers: Temple Sculptures from North India A.D. 700–1200* (New York: Asia Society Galleries; Ahmedabad: Mapin, 1993), 262–63. The suggestion that the Crow Collection Vishnu once held a mace is based on comparison to that object. He would have been holding the very top of the weapon, which was completely undercut along its shaft and rejoined the stele behind Vishnu's lower right hand.

3 Vishakha Desai and Darielle Mason suggested that this frame once surrounded an image of an avatar, possibly Varaha or Narasimha, in which case the vertical elements would have depicted an even number of avatars on each side. See *Gods, Guardians, and Lovers*, 252. This is a very plausible explanation, but in several known icons the problem of symmetry has been addressed by having Matsya and Kurma share a space.

4 Nalini Kanta Bhattasali, *Iconography of Buddhist and Brahmanical Sculptures in the Dacca Museum* (Dacca: Sreenath Press, 1929), 89–93 and related plates.

5 His lower right hand is somewhat damaged, making it difficult to discern if it ever held a lotus. More likely it was in the "do not fear" gesture.

6 A bronze image of Shiva and his family in the Los Angeles County Museum of Art is also attributed to the Western Chalukyan realm. It is somewhat different in style but has a similar flaming altar back on rearing *yalis* with an arched array of small subsidiary figures (in this case, probably the nine planetary deities, or *navagrahas*) immediately over the head of Shiva. See Pratapaditya Pal, *Indian Sculpture, A Catalogue of the Los Angeles County Museum of Art Collection, Volume 2: 700–1800* (Los Angeles: Los Angeles County Museum of Art; Berkeley and Los Angeles: University of California Press, 1988), 249.

7 Rosemary Crill, "Vrindavani Vastra: Figured Silks from Assam," *Hali* 62 (April 1992), 78–83.

8 As the original generation of Mithila painters has retired and died, both supply and demand for quality work has dried up, but there are still artists active in the area.

9 Stella Kramrisch, *Indian Sculpture in the Philadelphia Museum of Art* (Philadelphia: University of Pennsylvania Press, 1961), 102.

10 Philadelphia Museum of Art label.

11 English-language identifications of the Kurma avatar appear to be split between "turtle" and "tortoise" and indeed, Sanskrit seems to have used the same words (*kurma, kamatha, kacchapa*) for both sea-dwelling turtles and land-dwelling tortoises. Given his association with the ocean of milk, it might be tempting to identify Kurma as a sea turtle. However almost all artistic representations of Kurma depict him as a land-dwelling tortoise, with tall, domed shell and clawed feet. Indeed, if one is looking for an animal to serve as a base for a mountain, a heavy, slow-moving tortoise would seem a better candidate than a slimmer, more hydrodynamic turtle.

12 *Bhagavata Purana,* 11.4.18, translated by C. L. Goswami and M. A. Shastri, *Srimad Bhagavata Mahapurana* (Gorakhpur: Gita Press, 1971), 532.

13 *Bhagavata Purana,* 7.12.19, Goswami and Shastri translation (1971), 876.

14 *Bhagavata Purana,* 8.32.18, Goswami and Shastri translation (1971), 878.

15 *Bhagavata Purana,* Book 3, chapter 13, line 30, translated by Ganesh Vasudeo Tagare, in Ancient Indian Tradition and Mythology Series, vols. 7–11 (Delhi: Motilal Banarsidass, 1999), 293.

16 Most Varaha temples are located close to, or within the complex of, temples dedicated to Vishnu. This is the case at Eran and Khajuraho in Madhya Pradesh, and Tirumala in Andhra Pradesh.

17 Kalpana S. Desai, *Iconography of Visnu (In Northern India, Up to the Mediaeval Period)* (New Delhi: Abhinav Publications, 1973), 73. The texts where the story is mentioned are the *Satapatha Brahmana* and the *Taittiriya Aranyaka*.

18 *Varaha Purana,* chapter 1, lines 16–17. See S. Venkitasubramonia Iyer translation and annotation, in Ancient Indian Tradition and Mythology Series, vols. 31–32 (Delhi: Motilal Banarsidass, 1985). This incident is nearly identical to the moment (recounted in the *Bhagavata Purana,* 10.8) when infant Krishna's adopted mother looks into his mouth and is awestruck to find the cosmos inside. It is also reminiscent of the incident in which the sage Markandeya enters the mouth of the infant to find all creation within. That incident is further discussed in cats. 32 and 33 herein.

19 *Bhagavata Purana,* III.13.19–22, Tagare translation, 292–93.

20 Jayadeva, *Gita Govinda,* part 1, verse 7, edited and translated by Barbara Stoler Miller, *Love Song of the Dark Lord: Jayadeva's Gita Govinda* (New York: Columbia University Press, 1977), 70.

21 *Bhagavata Purana,* 7.2.7–8, Goswami and Shastri translation (1971), 727.

22 *Bhagavata Purana,* 7.8.13, Goswami and Shastri translation (1971), 761.

23 Michael Meister, "Man and Man-Lion: The Philadelphia Narasimha'" *Artibus Asiae.* 56, no. 3/4 (1996), 291.

24 *Bhagavata Purana,* 7.8.20–21, Goswami and Shastri translation (1971), 761.

25 Meister, "Man and Man-Lion," 291.

26 Ibid., 292.

27 Ibid.

28 Pratapaditya Pal, *Indian Sculpture: A Catalogue of the Los Angeles County Museum of Art Collection, Volume 1, Circa 500 B.C.–A.D. 700* (Los Angeles: Los Angeles County Museum of Art; Berkeley and Los Angeles: University of California Press, 1986), 252.

29 Joanna Williams in a review of J.C. Harle's book on Gupta sculpture, *The Art Bulletin* 59, no. 1 (March, 1977), 119–21.

30 Technical Examination Report by Pieter Meyers, obtained from Stephen A. Markel, department head of South and Southeast Asian Art, LACMA.

31 Thomas E. Donaldson, *The Iconography of Vaisnava Images in Orissa* (New Delhi: D.K. Printworld, 2001), 132–38.

32 Ibid.

33 *Bhagavata Purana*, 8.18.12, Tagare translation, 1089.

34 Vamana is one of only three Brahmin avatars, the second being Parashurama. After him Vishnu will be born into the Kshatriya or princely caste until the Brahmin Kalki arrives in the future.

35 *Bhagavata Purana*, 8.20.21, Tagare translation, 1100.

36 *Bhagavata Purana*, 8.20.33–34, Tagare translation, 1102.

37 Perhaps the best known Vamana temple is at Khajuraho, in Madhya Pradesh. It is no longer in use. Another is at Thrikkakara, near Kochi (Cochin) in Kerala.

38 One scholar has suggested that the option to present Vamana carrying the attributes of a young Brahmin student would have made the image more approachable to its audience, which could well have consisted of Brahmins. Indeed, among Brahmins, there is a sense that Vamana is one of "their" avatars. See Heino Kottkamp's entry in Saryu Doshi, ed., *Treasures of Indian Art: Germany's Tribute to India's Cultural Heritage* (New Delhi: National Museum; Berlin: Staatliche Museen Preussischer Kulturbesitz, 1998), 58–59.

39 In the case of the Buddha, the bump is usually understood to be the *ushnisha*, a protrusion from his skull that distinguishes him from other mortals, rather than a topknot of hair. However, sculptural representations of the Buddha often treat the *ushnisha* as such a topknot, which would have been familiar from the traditional Brahmin tonsure of closely cropped hair with a single long lock hanging from the upper back of the head, often worn in a knot.

40 For a brief discussion of this relief, including the mention of Rahu, see *Museum für Indische Kunst Berlin: Katalog 1986, Ausgestellte Werke* (Berlin: Staatliche Museen Preusslischer Kulturbesitz, 1986), 40. The head, presumably of Rahu, is present at the lifted foot of all three representations of Trivikrama on the temples at Osian, a site in Rajasthan that boasts several sandstone temples that are roughly contemporaneous to the Berlin relief of Trivikrama (see p. 20 above for one of these, although Rahu is not visible in the image). The Osian images are on Harihara temples I and III and on the Vishnu I temple. Asha Kalia, *Art of Osian Temples: Socio-Economic and Religious Life in India, 8th–12th Century* (New Delhi: Abhinav, 1982), 76–77.

41 *Bhagavata Purana*, 9.16.19, Goswami and Shastri translation (2005), 64.

42 *Bhagavata Purana*, 9.16.12, Goswami and Shastri translation (2005), 63.

43 *Bhagavata Purana*, 1.3.20, Goswami and Shastri translation (1971), 10.

44 Nanditha Krishna, *The Book of Vishnu* (New Delhi: Viking, 2001), 69.

45 *Bhagavata Purana*, 9.15.33–34, Goswami and Shastri translation (2005), 61.

46 Scholars disagree bitterly on Valmiki's dates. However, most posit that Valmiki gave form to stories that had already been told for centuries, and almost all agree that Valmiki's *Ramayana* is earlier in date than the *Mahabharata*.

47 Most illustrated manuscripts made for Rajput patrons appear to be based on the sixteenth-century Hindi telling of the *Ramayana* written by Tulasi Dasa (Tulsidas).

48 Most of the vernacular versions of the *Ramayana* date from after this period. For a thorough discussion of the evolution of the Rama cult and its corresponding temples, see Sheldon Pollock, "Ramayana and Political Imagination in India," *Journal of Asian Studies* 52, no. 2 (May 1993), 261–97. Pollock argues that the promotion of Rama as a divine ruler was largely a reaction to the presence of foreign (Central Asian, Muslim) rulers in India from the twelfth century on.

49 In Valmiki's *Ramayana*, Rama's divinity is revealed to him very late in the story, after he has defeated Ravana, and it comes as a surprise.

50 The Rama images are all apparently from Thanjavur district. R. Nagaswamy has argued that they date from the first half of the tenth century, which he described as a brief period of devotional enthusiasm for the Rama avatar, following the release of a Tamil-language version of the *Ramayana* by the poet Kamban. During this period, the Chola ruler Aditya I (875–906) referred to himself as "Kodandarama," or "Rama with the Great Bow." See R. Nagaswamy, *Masterpieces of Early South Indian Bronzes* (New Delhi: National Museum, 1983), 157. The Philadelphia image has more recently been re-attributed to the eleventh century based on stylistic comparison to other images of that period.

51 This image could easily represent Lakshmana rather than Rama, as the brother is usually depicted in almost identical manner, albeit in a smaller image.

52 Valmiki, *Ramayana*, Forest chapter 1, translated by Arsia Sattar, *The Ramayana—Valmiki* (New Delhi: Penguin Books, 1996), 210–11.

53 Tulsidas, *Ramacharitamanasa*, Forest *caupat* 13, translated by F.S. Growse, *The Ramayana of Tulasidasa* (Delhi: Motilal Banarsidass, 1998), 434.

54 An extensive series of *Ramayana* paintings was made for Maharana Jagat Singh I (reigned 1628–52) in Mewar in the second quarter of the seventeenth century. This page appears to come from a smaller, somewhat later series, probably made for Raj Singh I (reigned 1653–80) or Jai Singh (reigned 1680–98).

55 The inscription at the top indicates that the painting illustrates passages in chapter 56 of the Ayodhya Kanda, in which Rama, Lakshmana, and Sita arrive at Chitrakuta. In these passages (lines 22–28), Rama instructs Lakshmana to sacrifice a black antelope—illustrated at the lower left—as part of the ritual to purify and sanctify the small hut that will be their new home.

56 Scholars have argued convincingly that the series was not actually painted in Shangri, but in the small court of Bahu, near Jammu in the western Punjab Hills. See B.N. Goswamy and Eberhard Fischer, *Pahari Masters* (Zurich: Artibus Asiae, 1992), 76–93.

57 Valmiki, *Ramayana*, Kishkindha chapter 2, Sattar translation, 281–82.

58 Sugriva's speech is one of the oldest geographies of India. Valmiki, *Ramayana*, Kishkindha chapter 7, Sattar translation, 320–29.

59 Tulsidas, *Ramayana*, Lanka Chaupai 101, Growse translation, 604–5.

60 As half-god, half-monkey, Hanuman is a hybrid, like the god-man Rama.

61 Most Hanuman temples date from after the thirteenth century Two articles by Philip Lutgendorf trace the rise of Hanuman: "My Hanuman is Bigger Than Yours," *History of Religions* 33, no. 3 (February, 1994), 211–45; and "Five Heads and No Tale: Hanuman and the Popularization of Tantra," *International Journal of Hinduism* 5, no. 3 (December, 2001), 269–96.

62 Lutgendorf notes that texts and temple settings dedicated to Hanuman are often Shaiva and Tantric in nature and that the monkey god is sometimes called an avatar of Shiva. "Five Heads and No Tale," 272.

63 The modern-day town of Hampi in northern Karnataka was the capital of the great Vijayanagar kingdom. It is also said to have been the site of Kishkindha, the kingdom of monkeys. The landscape of Hampi is strewn with large boulders, many of them in surprising locations, suggesting that it was the site of such monkey warfare.

64 Valmiki, *Ramayana*, War chapter 8, Shattar translation, 517.

65 The Museum of Fine Arts, Boston, has at least one of these designs, acquired from the Punjab Hills by Ananda K. Coomaraswamy prior to 1917. See MFA Boston, inv. no. 17.2630.

66 W. G. Archer, *Indian Paintings from the Punjab Hills: A Survey and History of Pahari Miniature Painting* (London: Sotheby Parke Bernet, 1973), 68.

67 Jyotindra Jain, *Kalighat Painting: Images from a Changing World* (Ahmedabad: Mapin, 1999), 20.

68 Lutgendorf traces the first textual reference to this story to a Bengali elaboration on the *Ramayana* by the fifteenth-century poet Krittibasa. "My Hanuman is Bigger Than Yours," 229.

69 *Bhagavata Purana*, Book 10, Part 1, Chapter 8, lines 29–31, translated by Edwin F. Bryant, *Krishna: The Beautiful Legend of God* (London: Penguin Classics, 2003), 42–43.

70 Surdas, translated by Kenneth Bryant, *Poems to the Child-God: Structures and Strategies in the Poetry of Surdas* (Berkeley and Los Angeles: University of California Press, 1978), 180.

71 Surdas, K. Bryant translation, 152.

72 *Bhagavata Purana,* 10.12.17, Goswami and Shastri translation (2005), 153.

73 *Bhagavata Purana*, 10.1.16,26,28,29, E. Bryant translation, 84–85.

74 *Bhagavata Purana*, 10.1.16, E. Bryant translation, 83.

75 Surdas, K. Bryant translation, 186–87.

76 Surdas, K. Bryant translation, 189.

77 Krishna's advice to cease worship of Indra underscores the tendency, especially among Krishna-worshippers, to reject select aspects of ancient, Vedic Hinduism. In the Vedas, Indra is the most powerful and heroic of deities, but in later traditions he is described as a mere figurehead and even a trouble-maker, often requiring Vishnu or Shiva to bail him out

78 Mirabai, "The Playing of the Flute," translated by A.J. Alston, *The Devotional Poems of Mirabai* (Delhi: Motilal Banarsidass, 2005), 102.

79 *Bhagavata Purana*, 10.1.29,4–7 See E. Bryant translation, 125.

80 Bilvamangala, *Balagopalastuti*, hymn 54, translated by Frances Wilson, *The Bilvamandalastava* (Leiden: Brill, 1973), 107. The *Balagopalastuti* is also known as the *Bilvamandalastava*.

81 Jayadeva, *Gita Govinda*, 1.33, Miller translation, 75.

82 *Bhagavata Purana*, 10.1.20,36–39, E. Bryant translation, 133–34. The difference between the text and the image is that Krishna offers his shoulders for a ride in the text whereas in the textile he is carrying the woman in his arms.

83 Bilvamangala, *Balagopalastuti*, 33, Wilson translation, 152.

84 Antal (also spelled Andal), "Give Back Our Clothes," verse 7, translated by Vidya Dehejia, *Antal and Her Path of Love* (Albany: State University of New York Press, 1990), 85.

85 *Bhagavata Purana*, 10.1.22, E. Bryant translation, 105.

86 Bihari, *Sat Sai*, verse 310, translated by Krishna P. Bahadur, *Bihari: The Satasai* (London: Penguin Classics, 1992), 161.

87 Bihari, *Sat Sai*, 316, Bahadur translation, 163.

88 Ananda K. Coomaraswamy, *Rajput Painting, Being an Account of the Hindu Paintings of Rajasthan and the Panjab Himalayas from the Sixteenth to the Nineteenth Century* (New York and London: H. Milford, Oxford University Press, 1916), 1:43.

89 *Bhagavad Gita*, teaching 11, verses 9–13, translated by Barbara Stoler Miller, *The Bhagavad-Gita: Krishna's Counsel in Time of War* (New York: Bantam, 1988), 98–99.

90 This painting on cloth was probably created within the same sectarian context as the paintings of Shrinathaji in cats. 157–60 herein, although it may not have been made in the same city or workshop. There is a good chance that this painting is from the area around Kota—the attribution is based on comparison of the *Rasamandala* groups to similar subjects made by Kota artists—whereas many paintings of Shrinathaji were made in Nathadwara, the town where the image is housed.

91 Catherine Glynn, "Evidence of Royal Painting for the Amber Court," *Artibus Asiae* 56, no. 1/2 (1996), 67–93, 93.

92 Ibid., 93.

93 He is described (*Bhagavata Purana,* 10.1.1.2 E. Bryant translation, 8, and elsewhere) as an *amsha*, or partial incarnation of Vishnu, to distinguish him from Krishna, who is Vishnu in totality.

94 Doris Meth Srinivasan, *Many Heads, Arms, and Eyes: Origin, Meaning, and Form of Multiplicity in Indian Art*, Studies in Asian Art and Archaeology 20 (Leiden: Brill, 1997), 214.

95 See Doris Meth Srinivasan, "Samkarsana/Balarama and the Mountain: A New Attribute," in Claudine Bautze-Picron, ed., *Religion and Art: New Issues in Indian Iconography and Iconology* (London: British Association for South Asian Studies, 2005), 96.

96 The verb root, *samkrsh*, also means "to drag along," suggesting that the name makes reference to Balarama's dragging of the Yamuna river with his plow.

97 *Bhagavata Purana*, 10.1.18.25, E. Bryant translation, 93.

98 *Vishnu Purana*, Book 5, Chapter 9, translated by H.H. Wilson, *The Vishnu Purana: A System of Hindu Mythology and Tradition* (Calcutta: Punthi Pustak, 1961), 415.

99 *Bhagavata Purana*, 10.1.18.29, E. Bryant translation, 94.

100 That relief, found at Ahichchhatra, Uttar Pradesh, is horizontal in format and shows Krishna running to Balarama's assistance. See S.C. Kala, *Terracottas in the Allahabad Museum* (New Delhi: Abhinav, 1980), fig. 280.

101 *Vishnu Purana*, 5.9, Wilson translation, 416.

102 *Vishnu Purana*, 5.37, Wilson translation, 480.

103 It is almost unheard-of for a Hindu icon to have an odd number of hands. However, the strange placement of the arm that points up to the snake hoods, and the lack of anything at the other side to support the notion of a comparable arm to balance it out,

suggests that this may have been a subsidiary arm, used purely for pointing.

104 Claudine Bautze-Picron, "The 'Vishnu-Lokeshvara' Images from Bengal, An Eastern Version of Vishvarupa According to the Pancharatra?," in N. Balbir and J.K. Bautze, *Festschrift Klaus Bruhn* (Reinbeck: Wezler, 1994), 147–49.

105 The story appears in the *Harivamsha*, the *Vishnu Purana*, and the *Bhagavata Purana*, as part of the episode in which Balarama returns to Vrindavan for a two-month visit with his adoptive family.

106 *Bhagavata Purana*, 10.1.65.23, E. Bryant translation, 282.

107 *Vishnu Purana*, 5:25, Wilson translation, 455.

108 In fact, in both the *Harivamsha* and the *Bhagavata Purana*, the story of Balarama's visit to the area includes the gopis bemoaning Krishna's absence (*Harivamsa Purana*, Vishnu parva, chapter 46, lines 28–50, translation by Bhumipata Dasa, edited by Purnaprajna Dasa [Vrindaban: Rasbihari Lal and Sons, 2005], 210–17; *Bhagavata Purana*, 10.1.65.9–15, E. Bryant translation, 281). The presence of Krishna in both paintings might point to their original placement in *Dashavatara* series, in which these single-episode depictions would have stood in for the entire life of Balarama. In attempting to capture the importance of the Balarama avatar, the artist may have felt compelled to acknowledge the god's relationship to Krishna, even though it meant ignoring the details of the story.

109 It is important to note that while the *Kali Yuga* leads up to total destruction, in the Hindu conception of time as cyclical, destruction is the first step toward rebirth.

110 Earlier accounts do not include the Buddha among the avatars. He seems to have entered the standard list of ten only after Krishna was elevated above avatar status.

111 After about 500 CE Buddhism gradually lost popularity in its homeland.

112 *Agni Purana*, Book 1, chapter 16, translated by N. Gangadharan, in Ancient Indian Tradition and Mythology Series, vol. 27–30 (Delhi: Motilal Banarsidass, 1984), 27:38. The passage also equates the teachings of Jainism, another South Asian religion that developed in the fifth century BCE, with Vishnu's mission to delude the demonic element. An earlier identification of Vishnu with the Buddha appears in one recension of the epic *Mahabharata* (but not in others), see Wendy Doniger, *The Origins of Evil in Hindu Mythology* (Berkeley: University of California Press, 1976), 188.

113 Jayadeva, *Gita Govinda*, 1:13, Miller translation, 71.

114 This image of the Buddha avatar is nearly identical to an image of Vishnu ascribed to Nainsukh by B.N. Goswamy in Goswamy and Fischer, *Pahari Masters*, cat. no. 129. That page is similar in its dimensions to the page illustrated here although a definitive comparison is impossible because the San Diego painting has lost its borders. The two paintings may come from the same series, possibly a *Dashavatara*, for which the Vishnu image would have been the opening leaf. For a lengthy discussion of the contributions and biography of Nainsukh, see B.N. Goswamy, *Nainsukh of Guler: A Great Indian Painter from a Small Hill-State* (Zurich: Artibus Asiae, Museum Rietberg, 1997). Another painting by the artist illustrated here is cat. 18.

115 All from *Sri Kalki Purana*, chapter 1, translated by Bhumipati Das, edited by Purnaprajna Das (Mathura: Jai Nitai Press, 2006), 8-11.

116 *Sri Kalki Purana*, chapter 1: lines 18–19, Das translation, 6.

117 *Sri Kalki Purana*, 14.1, Das translation, 148.

118 *Sri Kalki Purana*, 21.3, Das translation, 231.

119 *Sri Kalki Purana*, 19.17, Das translation, 217.

120 Andrew Topsfield, *In the Realm of Gods and Kings: Arts of India* (London: Philip Wilson, 2004), 121.

121 The use of multiplicity to represent specificity is common in esoteric teachings, both in Hinduism and in Buddhism. Often if a deity is represented with more heads (or arms) than usual, these features identify him or her as the embodiment of a particular teaching, one that is usually not available to the uninitiated. Like a highly detailed schematic drawing, the extra body parts offer additional, and more subtly nuanced, information than one would find in a simpler rendering, but this information is more difficult to read and understand.

122 The presence of a rear face is implied even where it does not appear; this occurs more often than not because most images are carved in relief, with no attempt or opportunity to depict the rear of the figure.

123 Vaikuntha is also the name of Vishnu's paradise, where the god resides and to which his most devoted followers hope to ascend after death. The connection between the notion of paradise and the role of the four-faced icon, if any, is unclear.

124 Some iconographic texts indicate that multifaced Vishnu should only be called Vaikuntha if he appears seated on Garuda, but other historical evidence indicates that standing figures were often called Vaikuntha as well. Extensive discussion of the naming and interpretation of this form can be found in Doris Srinivasan, "Early Vaisnava Imagery: Caturvyuha and Variant Forms," *Archives of Asian Art* 32 (1979), 39–54; Devangana Desai, "Vaikuntha as Daityari at Khajuraho," in Ratan Parimoo, ed., *Vaisnavism in Indian Art and Culture* (New Delhi: Books and Books, 1987), 254–60; and Adalbert J. Gail, "On the Symbolism of Three- and Four-Faced Visnu Images: A Reconsideration of Evidence," *Artibus Asiae* 44, no. 4 (1983), 297–307.

125 The inscription appears on the Lakshmana temple at Khajuraho, datable to 954 CE. It refers to a four-faced icon enshrined in the temple, calling it Vaikuntha, and indicating that Vaikuntha assumed the many forms in order to slay demons. A translation and interpretation of the inscription appears in Devangana Desai, *The Religious Imagery of Khajuraho*, Project for Indian Cultural Studies Publication 4 (Mumbai: Franco-Indian Research, 1996), 99–105.

126 Srinivasan, *Many Heads, Arms, and Eyes*, 255.

127 See Srinivasan, "Early Vaisnava Imagery."

128 Illustrated by Srinivasan, "Early Vaisnava Imagery," 45, fig. 14. Also illustrated in the digital Huntington Archive, no. 0000963. This piece is very similar in size to the Brooklyn image, and its personified weapons are in better condition, allowing us to see that Brooklyn's weapons were probably the chakra at Vishnu's left (with round wheel behind the personified weapon's head) and the mace at Vishnu's right (the weapon protruding upward to the god's hand).

129 See T.A. Gopinatha Rao, *Elements of Hindu Iconography* (Delhi: Motilal Banarsidass, 1993), vol. 1, part 1, 256.

The Worship of Vishnu

Introduction

There are even more ways of worshiping Vishnu than there are manifestations of the god. There are people who prefer to worship the god through one avatar or another, but beyond the face one puts on God, there are multiple interpretations of important scriptures, multiple theories about the most expedient route to salvation, and multiple ritual practices. In some cases the distinctions between Vaishnava sects are very subtle, and the choice to follow one or the other will be a matter of regional or linguistic affiliation, the style of the sect's leader, or family tradition. In other cases, sects will disagree adamantly about major points of theology or practice. The teachings to which one adheres, combined with potentially more nuanced personal belief, might radically affect the way that one perceives any of the imagery illustrated in previous parts of this catalogue.

This section begins to introduce several aspects of Vaishnava ritual and sectarian tradition. It touches briefly on the people who worship and the materials and emblems they use. It includes examples from two of the major art-producing traditions of northern Indian Vaishnavism, as well as new developments in the representation of the gods in the twentieth century. In short, it provides a jumble of information and approaches, all relating to worship, and is admittedly too brief to do justice to the complexity and wealth of the Vaishnava tradition. It is hoped that those who are intrigued by any particular aspect of this brief overview (or infuriated that an important facet of the tradition has been omitted) will investigate further into the rich matrix of belief, practice, and imagery that Vaishnava tradition has offered over the millennia.

150 | Vishnupada (*facing page*)
Western Himalayas, probably Northern India or Pakistan; c. 500
Lapis lazuli; 2 x 4 ³/₈ x 3 ³/₄ in. (5 x 11 x 9.5 cm)
Collection of Anthony d'Offay, London

151 | Vishnupada
India; 17th–18th century
Gold; ¹³/₁₆ x ⁹/₁₆ in. (2 x 1.5 cm)
Collection of Susan L. Beningson

Feet and footprints play interesting roles in Vaishnava myth and practice. Human feet are considered quite filthy in Indian tradition, so to touch someone's feet is a powerful gesture of humility and respect. Devotees will touch the feet of their preceptor, subjects touch the feet of their ruler, and wives and children touch the feet of the family patriarch. The feet of a god are not dirty, but touching them is still a way of paying homage.

Footprints, known as *padukas*, are an important emblem in Indian religion. The idea of worshipping and reproducing sacred footprints appears to have originated in Buddhism, probably with actual footprints of the historical Buddha that were preserved by his followers. Later, footprints were reproduced to remind worshippers of the Buddha's presence and influence, even after his physical departure from earth. Various sites boast the footprints of Hindu deities, including Vishnu, and these footprints are worshipped much the way that the Buddha's are, with the belief that the gods have sanctified any site where they were present.[1]

Feet enjoy unusual prominence in Vaishnava legends because Vishnu is Trivikrama, or the Taker of Three Steps. He lays claim to his domain with the touch of his feet. As a result, Vishnu is more likely than other Hindu deities to be worshipped in the form of feet or footprints. These emblems, known as *Vishnupada*s, can be enshrined for worship or worn like an amulet; in either context they represent the presence and authority of the god.

The earliest example of a Vishnupada included here (150) dates from the Gupta period (but probably came from outside Gupta domains) and depicts the god's actual feet, rather than his footprints. The rest of the god's body is

152 | Vishnupada

Pakistan, Punjab, Lahore area; early 19th century
Opaque watercolor and gold on paper
13 ½ x 11 ⅜ in. (34.5 x 29 cm)
Museum für Asiatische Kunst, Berlin. I 5072

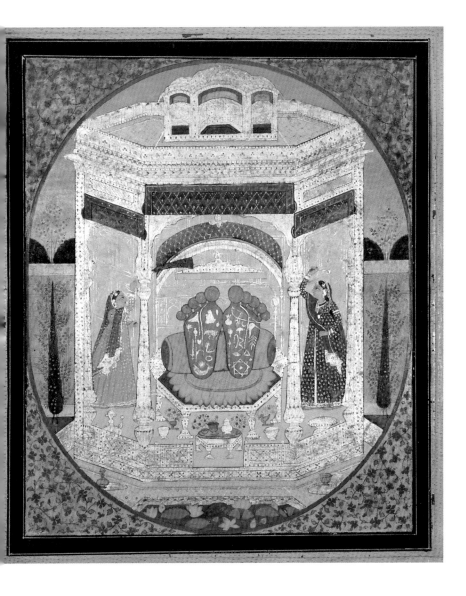

represented by a lotus flower. It is surrounded by Vishnu's attributes: another lotus and the conch shell immediately flanking the feet, with the mace and the chakra behind them. An inscription on the front of the platform has been read as either "*sya-Shri-rasa-sya*," meaning something like "the essence of Shri [Lakshmi]," or as "*Zarzharasa*," which could be understood as the name of the object's owner, presumably someone of Shaka or Central Asian origin.[2] In either case, the unusually large piece of lapis from which

this enigmatic object is carved, along with the style of the script, indicates that it came from an area in the northwest of the Indian subcontinent, closer to the Central Asian source for lapis, possibly the ancient Gandhara region (northwest Pakistan and Afghanistan) or Kashmir.[3]

The Vishnupada depicted in the painting (152) consists of a pair of blue feet with the soles facing us. They are enthroned on a lotus on a low seat with a cushion, much like a figural icon, suggesting that the feet are interchangeable with the deity as a whole. The many weapon/attributes, including Vishnu's mace, Vamana's parasol and Rama's bow, as well as other auspicious emblems such as a cow and a female figure who may be Lakshmi, remind the viewer of Vishnu's many roles and contributions. The throne is in an open pavilion with vessels of offerings presented before it and two female attendants with a peacock-feather fan and a yak-tail flywhisk serving the *pada* (literally, "feet"); a golden parasol above the throne reinforces the sanctity of the occupant even though no parasol would have been required under the roof of the pavilion.

The small golden Vishnupada (151) was almost certainly worn as an amulet. The feet of Vishnu are a common emblem for small pendants worn around the neck (and therefore close to the heart) of devotees. The Vishnupada shows that the god has made an impression—both literally and figuratively—on the wearer. It is not clear if these *pada* were worn as a pendant, but even if carried in a pocket they would have served to protect and bring blessings to the owner. They are formed from an unusual combination of granulation (beading), cast forms, and braided gold wire. ❀

153 | Vaishnava Teachers in Front of a Temple

Northern India, Rajasthan, Kishangarh; c. 1800
Opaque water on paper; 16 ¼ x 12 ⅞ in. (41.3 x 32.7 cm)
Collection of Ramesh and Urmil Kapoor

This painting depicts a group of teachers, high priests, and devotees of a Vaishnava sect known as the Radhavallabhas (see the Packert essay for a description). They are sitting in front of a temple dedicated to Radha and Krishna, who are represented in the form of footprints.[4] The inscription above the footprints is the slogan of the sect.[5]

There are a number of other inscriptions throughout the painting that give us the identity of the figures depicted here. The most important figure, indicated by the halo, is "Gosain [or Goswami] Hitaruplal," where Gosain/Goswami is the honorific title of a teacher or high priest among the Vaishnavas.[6] Near his right hand is "Kisorilal," and the figure in red is "Vrindavandas," a prolific writer of the eighteenth century.[7] There is a distinction between these three clothed and turbaned figures and the other six bare-chested and shaven-headed devotees. Perhaps they played different roles within the sect? The names of four figures in the second group are given as (clockwise) "Gopaldas," "Krishnadas," "Premdas," and "Kasiram," while the two younger initiates are not identified.[8] Of these last two, one is stretched out on the floor in pose of extreme obeisance. Two of the figures hold musical instruments, suggesting the performance of devotional songs, which is an integral part of Vaishnava worship.

This is one of few paintings from India where the artist has "signed" his work—his name is given at the bottom of the painting as "Vichitra."[9] By including his name in the same circular space occupied by the other devotees, the artist subtly implies his own status as one of them, even though we do not presumably have an image of him. [NP]

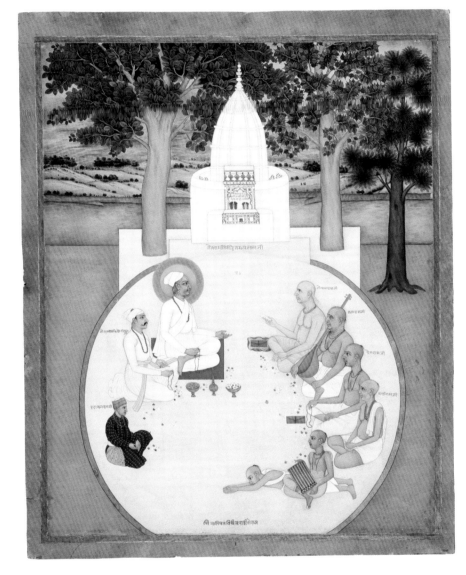

154 | Vallabhacharya High Priest Gosain-ji

Ragunath (dates unknown)
Northern India, Rajasthan, Nathadwara; late 19th century
Opaque watercolor and gold on paper
25 x 18 ⅝ in. (63.5 x 47.5 cm)
Collection of Subhash Kapoor

This painting is a portrait of one of the priests of the Pushtimarg sect who served the icon of Shrinathaji at Nathadwara (see cats. 157–60). The traditional concept of portraiture in the Indian context is different from that in European-derived traditions: making the portrait look identical to the subject is not the principal concern. While some aspects will resemble the individual, it is more important to evoke the idea of the person by using symbolic objects, clothing, accoutrements, and external trappings. This portrait, however, made after the advent of photography in India, takes greater pains to capture the physical appearance of the sitter.

The U-shaped red mark or tilak on the priest's forehead identifies him as a Vaishnava. He wears a number of pearl necklaces, and the pearl earrings on the upper part of his ear are typical of the region. He would have had a knot or pigtail of hair behind his head. The priest's right hand is holding rosary beads, which he counts within the blue-and-gold rosary pouch.

The bejeweled, richly dressed, and corpulent figure of the high priest might seem at odds with his role as a man of god. Head priests in Nathadwara were often the recipients of substantial land grants, making them men of great individual wealth.[10] It is therefore possible that high priests were also wealthy and not expected to lead a frugal existence. [NP]

155 | Forehead Ornament in the Shape of a Tilak Mark
India; 19th century
Gold with rubies and diamonds; 1 ³/₁₆ x ¹³/₁₆ in. (3 x 2 cm)
Collection of Susan L. Beningson

156 | Picchawai for a Krishna Image, To Be Used during the Rainy Season (*following page*)
Northern India, Rajasthan; 18th century
Gold, silver, and opaque watercolor on dyed cotton
92 x 121 ³/₄ in. (233.7 x 309.3 cm)
Arthur M. Sackler Gallery, Smithsonian Institution. Gift of Karl B. Mann, S1992.38

The more avid members of various Hindu sects apply marks (tilaks) to their foreheads to represent their sectarian affiliation. They sometimes put the marks on other parts of their bodies as well. Vaishnavas use fragrant sandalwood paste to paint a vertical mark, sometimes consisting of a single line running from hairline to nose, or sometimes consisting of three parallel lines, but most often in the shape of a U, occasionally with a line running upward through it. These vertical lines distinguish them from worshippers of Shiva, who wear a trio of horizontal marks made with ashes.

The marks are more than mere indicators; forehead tilaks are believed to help focus mental energy, creating a third eye that offers intuition or insight. The sandalwood paste used by Vaishnavas has cooling properties and is thought to offer health benefits to the wearer.

A quick perusal of the other objects in this exhibition, particularly the images of priests in the previous catalogue entries, reveals many ways of wearing the Vaishnava tilak mark. This jeweled pendant probably replaced a drawn tilak, a nontraditional substitution. It was probably worn on the forehead or turban of a temple priest or maharaja for special ritual occasions. It is unclear how it was originally attached. ✳

In most Hindu temples, the icon remains on the altar and is available for viewing for a set period of time each day, during which one can visit for personal worship, and there are scheduled public rituals led by temple priests. The altar is cleaned and restocked regularly, but little changes from day to day. In some busier, more important temples, the daily and annual routines are far more elaborate and the icon is regularly re-clothed and even moved from site to site according to the time of day and year. In these temples, the altar accoutrements and decoration are also changed regularly.

In temples dedicated to Krishna, particularly those affiliated with the Pushtimarg sect, it became common to periodically redecorate the shrine interior through use of *picchawai*s or painted wall hangings. Picchawais were originally designed to create backdrops for the enshrined Krishna icon.[11] They provide a sense of context, visually transporting the visitor to the idyllic setting of Krishna's youth, with verdant landscapes, adoring cows, and attendant gopis.

Most surviving picchawais were made and used in Rajasthan (see the Packert essay and cats. 157, 158). This early example was once attributed to the Deccan, an area in southern central India where dyed textiles were often decorated with gold and silver paint, however we have little or no evidence for the use of picchawais in the Deccan, and Pushtimarg practice was not particularly prevalent in that region. The depiction of the women in this hanging— with their high-cut tops and relatively long faces—closely resembles those in eighteenth-century paintings from Bikaner and Jodhpur (see cat. 17 for comparison), indicating a Rajasthani origin.

We can assume that the icon stood in front at the center, and that the cows and the female figures, who are

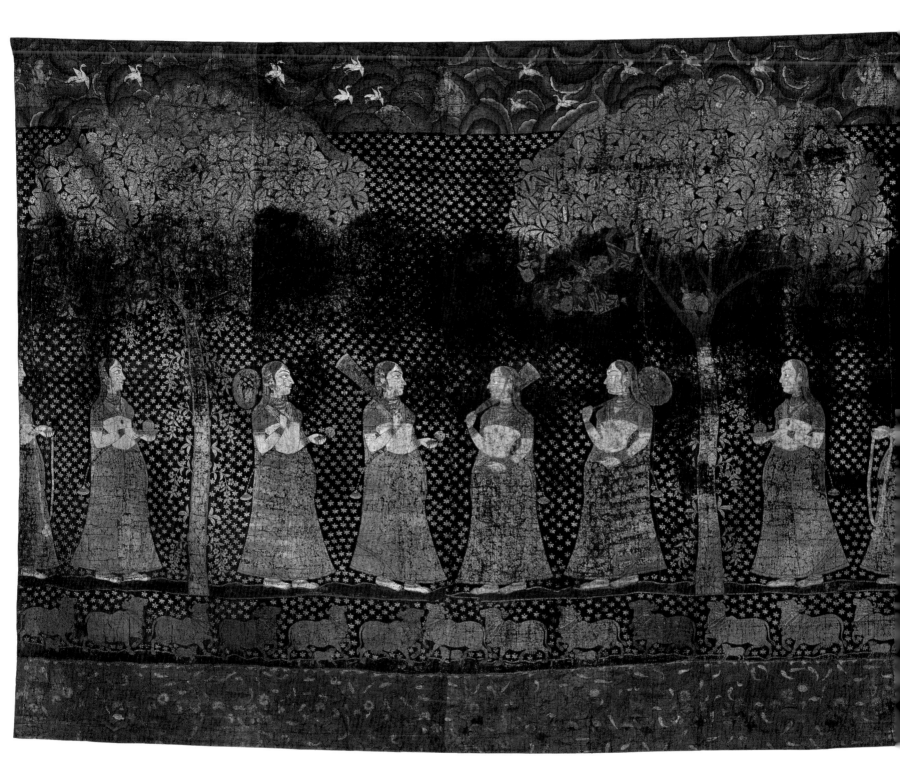

holding fans and offerings, were facing inward to adore it. The artist has depicted the river Yamuna, full of fish and lotuses, in the foreground, and tiny vessels float in the clouds above, holding deities who shower the scene with golden flowers.

It is likely that this hanging was reserved for use during the monsoon. The clouds are churning and cranes fly this way and that, both indicators that it is the rainy season, Varsha, a time of passion and rebirth. The dark blue of the background also evokes stormy weather. The gold and silver paint would have reflected the flickering lamplight in an otherwise dark shrine, creating an opulent, sparkling effect. ❊

157 | Picchawai Depicting the Annakut Festival
Northern India, Rajasthan, Nathadwara; mid 19th century
Opaque watercolor on cotton
99 ¹³/₁₆ x 96 ¹/₁₆ in. (253.5 x 244 cm)
Arthur M. Sackler Gallery, Smithsonian Institution. Gift of
Karl B. Mann, S1992.38

158 | Picchawai Depicting the Festival of Sharada Purnima
(*following page*)
Northern India, Rajasthan, Nathadwara; late 19th century
Opaque watercolor on cotton; 74 ³/₄ x 69 in. (190 x 175 cm)
The Denver Art Museum. Funds in honor of Mary Lanius,
1998.40

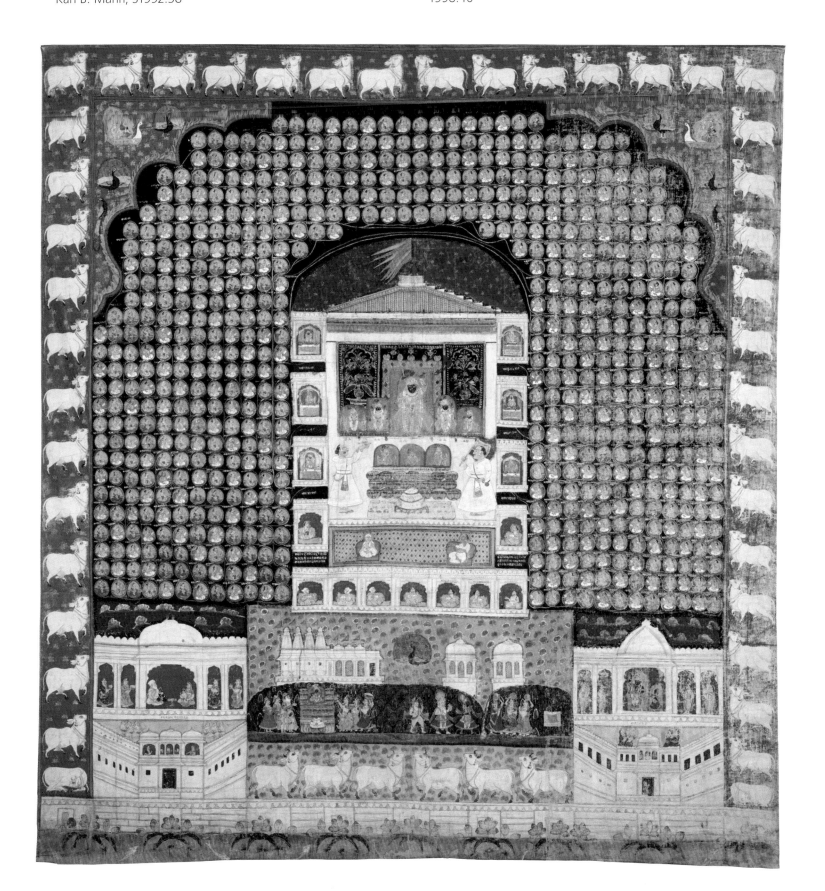

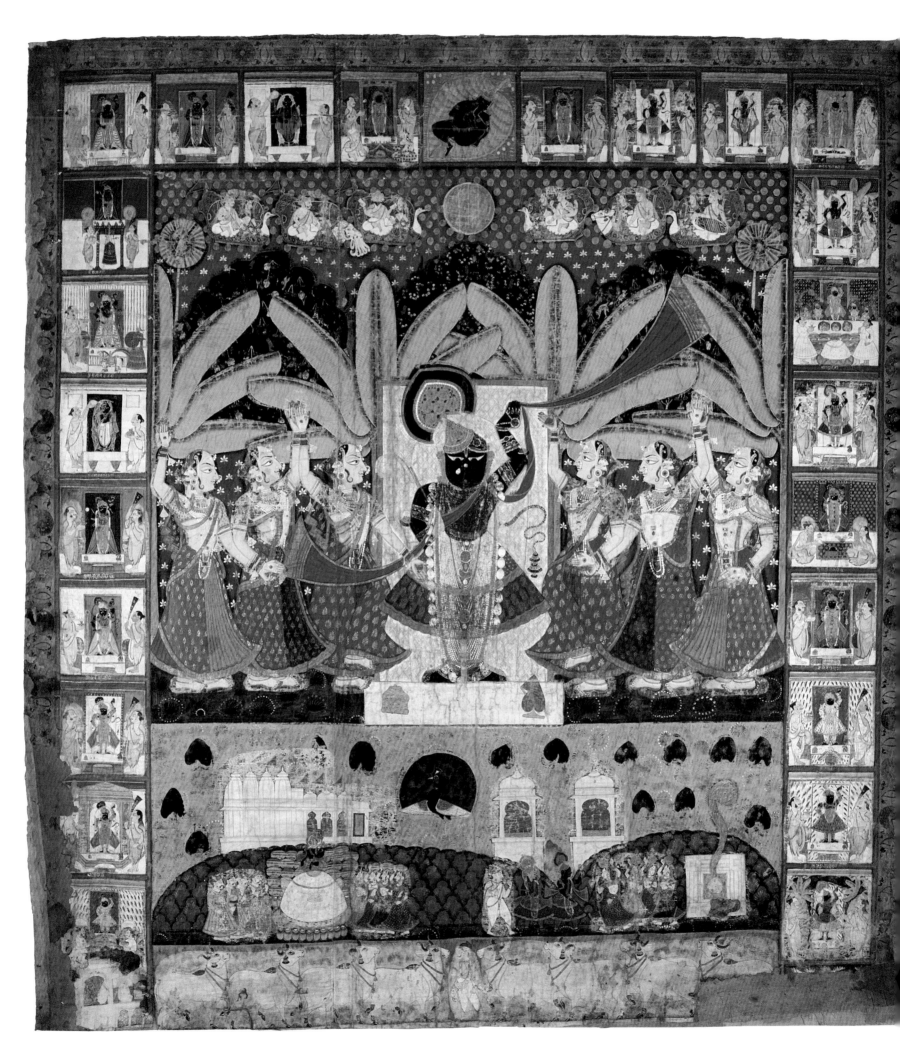

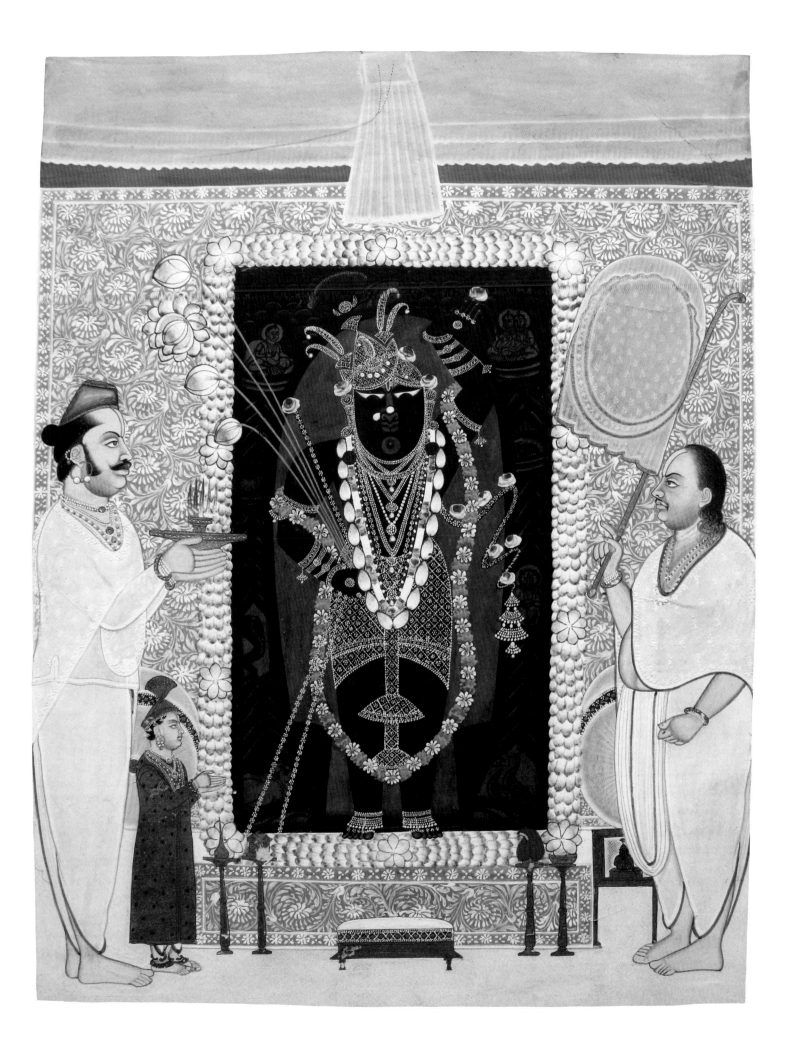

159 | **Priest Govardhanlalji Making Offerings to Shrinathaji during a Flower Festival** (*previous page*)
Attributed to Ghasiram Sharma (1868–1930)
Northern India, Rajasthan, Nathadwara; c. 1890
Opaque watercolor and gold on paper
11 ¼ x 8 ¹¹⁄₁₆ in. (28.6 x 22 cm)
Catherine and Ralph Benkaim Collection

160 | **A Family Worshipping Shrinathaji**
Khubiram (active second quarter of 20th century)
Northern India, Rajasthan, Nathadwara; 1944
Opaque watercolor on paper; 16 x 21 ⅝ in. (40.6 x 54.9 cm)
Collection of Kenneth and Joyce Robbins

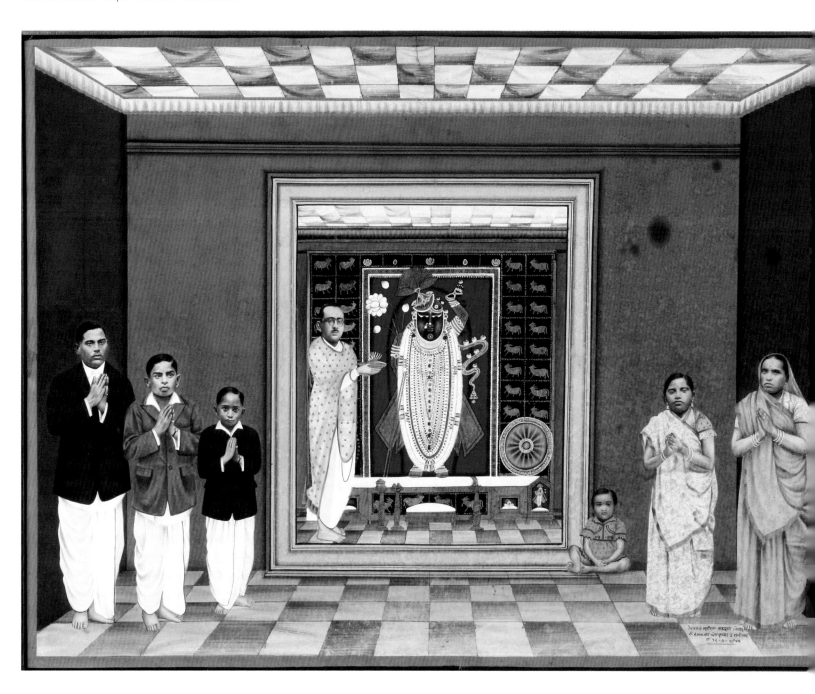

The vast majority of temple hangings of painted cloth were made in the Rajasthani temple town of Nathadwara, just north of the important Rajput city of Udaipur. As described in detail in Cynthia Packert's essay, Nathadwara is home to a miraculous image of Krishna, which is enshrined within a palace-like complex that continues to attract large numbers of pilgrims. The image, known as Shrinathaji, cannot be photographed, but its image has been captured in many, many paintings, so we know that it shows the god, in dark stone, holding one hand up as if raising Mount Govardhana. The icon never leaves the sanctum of the temple, but his environment is radically altered almost every day to reflect the active schedule of festivals and seasonal observances celebrated by the temple priests. Among the important methods of changing the sanctum atmosphere is the hanging of picchawais, some representing specific mythological moments, and others more generally seasonal (such as the monsoon-themed picchawai discussed in the previous entry).

The two large picchawais illustrated here (157, 158) mark important annual ceremonies and were probably made for sale or gift to visitors to the shrine, who would take them back to their home temples and display them on the appropriate dates. Both illustrate the icon at the center (this representation would not be necessary at the temple itself, where the space that would be behind the icon is more likely to be left empty); in the image for the Sharada Purnima festival (158), Shrinathaji is dressed for the season with chest bare for a warm October night, and in the Annakut festival picchawai (157), the icon is dressed with a full *jama,* or skirted cloak, in thin white cotton for the somewhat cooler November weather. The Annakut festival celebrates Krishna's raising of Mount Govardhana (see cat. 105), the episode depicted in the Shrinathaji icon and therefore one of the most important for his followers. It is celebrated with the presentation of a huge mound of rice (shown on a platter at the center of the picchawai), mimicking the shape of the mountain and making reference to the traditional offerings that Krishna's friends stopped making to Indra at Krishna's suggestion, thereby bringing the storm god's wrath. Annakut is a great feast for all, with large quantities of other food presented before the god and then shared by participants.

The other picchawai would have been used in the nights leading up to Sharada Purnima, the celebration of the night of Krishna's *Rasamandala* dance with the gopis (see cats. 113, 114), when he miraculously replicated himself so he could be with each of them alone. This image shows the icon/god at the center, flanked by groups of celebrating gopis, and with the many gods watching from above in the night sky. On the night of the full moon it would have been replaced with a picchawai depicting the actual circle dance of the *Rasamandala*.[12]

Both the Annakut and Sharada Purnima festival picchawais contain information beyond the depiction of the festival at the center. Packert describes the peripheral material in greater detail in her essay, but in short, both paintings include numerous small vignettes: the Annakut image has small portraits of the major priests of the shrine below, with a very large number of even smaller images depicting the lineages of teachers and students in the Vallabhacharya sect, with tiny red lines tracing their connections to the eight other miraculous icons celebrated by the tradition. It also has images of Krishna's youth in Braj in the lower register, as well as an image of Balarama being worshipped at the lower right. Smiling cows provide a charming frame, reminding us of the pastoral setting of Mount Govardhana. The slightly less elaborate imagery of the Sharada Purnima *picchawai* shows many other festivals set within square frames around the top and sides of the composition, each with the appropriately dressed icon of Shrinathaji at the center, worshipped by priests in the prescribed manner.

The two smaller paintings on paper from Nathadwara illustrated here represent instances of worship by specific individuals. The image from the Benkaim collection (159) depicts one of Nathadwara's most powerful and influential head priests, Govardhanlalji (1862–1934), presiding over observance of a spring festival, possibly Gulabi Gangaur, for which the priests dressed the icon in flowers (in this depiction all of the god's jewelry and clothing is apparently composed of jasmine buds), decorated the interior of the shrine with roses and a flowered, nonfigural picchawai,

and used pink shrine accoutrements such as the canopy and large fan shown in this image.[13] Spring is of course the season of rebirth and fertility, and many of Krishna's great *rasalila* evenings with the gopis took place in spring, but this festival appears to be more purely seasonal, celebrating the blossoming of flowers more than any particular moment in mythology.[14]

With its sensitive portrayal of the priest and its delicate attention to the details of costume and shrine objects, the painting appears to be the work of Ghasiram, one of Nathadwara's most celebrated artists (it is not signed). Ghasiram was born into an artist family and served as the chief painter for the Shrinathaji temple, where he was charged with painting innumerable portraits such as this, capturing the likenesses of important priests before the icon during special festivals. Late in his career, in the 1910s and '20s, Ghasiram provided painted images that would become the basis for innumerable chromolithographic prints, the new medium that had taken India by storm.[15]

Many Hindu rulers had themselves portrayed standing in worship before the image of Shrinathaji and other important icons. Although artists from the rulers' home regions were sometimes recruited to make these images, it was often easier to have one of the many Nathadwara painters depict the visit. Later, less exalted patrons followed the example of maharajas, requesting visual records of their worship before the famed icon. This practice continued well into the twentieth century. Because photography is not allowed inside the shrine, painting has remained the sole means of such documentation even though cameras had replaced painters in almost every other situation. An unusual image of a family worshipping at the shrine from the Robbins collection (160) illustrates, however, that photography came to influence painting styles as patrons desired the record of their visit to assume a more modern, documentary quality.

Khubiram, the artist who signed this image, was well known for his paintings in the photographic style. Some of his paintings were made directly onto photographs, by tinting the faces and then adding in an image of Shrinathaji; others simply mimicked photographs; while a few were paintings with photographs of faces glued onto them.[16] This image of a patriarch worshipping the icon with his family in attendance is probably representative of the second approach. It is strange for an image of *puja* (ritual worship) because all of the participants are looking at the artist/camera instead of at the powerful icon. Of note is the inclusion behind the icon of a gold-painted, dark-ground *picchawai* of adoring cows, reminiscent of the one in catalogue 156. ✺

161 | Jagannatha Triad

Eastern India, Orissa; late 19th–early 20th century
Wood with pigment; Left to right: 4 3/16 x 1 5/8 x 2 1/4 in.
(10.6 x 4.2 x 5.7 cm); 3 9/16 x 1 5/16 x 1 3/4 in. (9 x 3.4 x 4.5 cm);
3 15/16 x 1 7/8 x 1 15/16 in. (10 x 4.8 x 5 cm)
American Museum of Natural History. Courtesy of the Division
of Anthropology, cat. no. 70.2/5213 ABC, acc. no. 1965-50

Jagannatha, literally meaning "Lord of the World," is a form of Krishna worshipped in eastern India with the main seat at a temple in Puri, Orissa. He is worshipped along with his brother Balarama and sister Subhadra. The three figures here imitate the forms of the main temple icons. The dark figure to the right is Jagannatha/Krishna, the bigger one on our left is his elder brother Balarama, while between them stands their little sister Subhadra.

The unusual, limbless appearance of the figures is explained by two different myths. The first mentions how the king Indradyumna was instructed by Vishnu to create an image for worship. In one version of the story, he was asked to use a log washed up from the sea and in the other he was asked to make this image to house the bones of Krishna's human body. The task of carving was taken up by Vishvakarman, the architect of the gods, who asked

to be left undisturbed for the entire duration and worked behind closed doors. However, the impatient king could not contain himself and walked in on Vishvakarman, who disappeared, leaving the idol unfinished without hands and feet. The distraught Indradyumna was reassured by the god Brahma (or the sage Narada in another version) that the image would nevertheless be regarded as an important form of the god.

The other myth narrates how all the gopis were once gathered together, discussing the pastimes of Krishna and how much they loved him. They left Subhadra on guard to warn them if Krishna was approaching. But Subhadra was engrossed in their tales and failed to notice Krishna and Balarama. As the brothers listened to the stories, their hair stood on end, their arms retracted, their eyes grew larger and they smiled broadly in ecstasy. The images here representing them in this state have no arms, large eyes, and huge grins.

Images of Jagannatha, Balarama, and Subhadra are housed inside the Jagannatha temple at Puri and worshipped with due pomp and ritual. Once a year during the Car Festival, or *Ratha Yatra*, they are taken outside the temple in enormous chariots drawn by devotees and become visible to those not allowed access inside the temple. [NP] ✽

162 | Image of the Jagannatha Temple
Eastern India, Orissa, Puri; c. 1900
Pigment on incised palm leaves; 10 ¼ x 9 ¹³/₁₆ in. (26 x 25 cm)
Museum Rietberg, Zurich. Gift of Dr. Georgette Boner, RVI 1709

163 | Image of the Jagannatha Temple (*facing page*)
Eastern India, Orissa, Chandanpur village; early 20th century
Opaque watercolor on cloth; 29 ¹³/₁₆ x 14 ³/₈ in. (76 x 36.5 cm)
American Museum of Natural History. Courtesy of the Division
of Anthropology, cat. no. 70.3/4882, acc. no. 1986-2

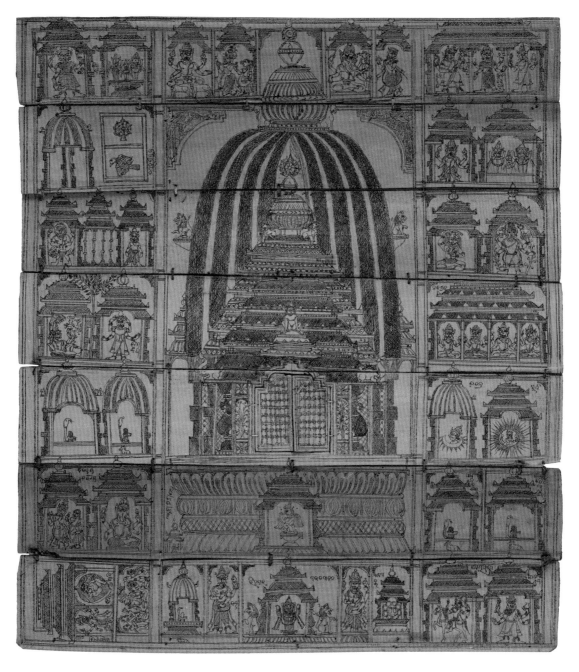

In addition to the Car Festival, the Jagannatha icons also participate in the Bathing Festival, or *Snana Yatra*, in which the triad is bathed. The drenching causes peeling of the painted surface and the images must be repainted. The images are removed from their main throne for the refurbishment, and during this time, it is said that they are suffering from fever and need a fortnight to recover. A dividing wall of bamboo is set up, and on this are hung consecrated paintings of the triad that have the validity of icons. These paintings are painted by hereditary artists attached to the Jagannatha Temple.

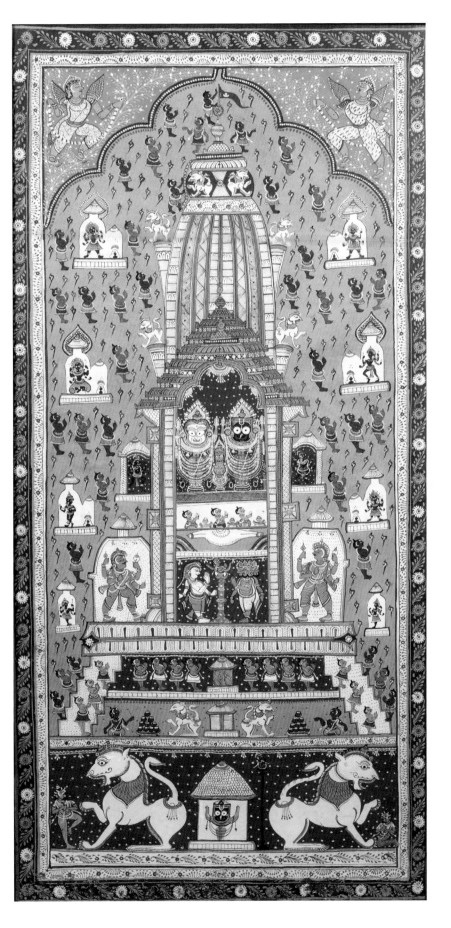

Such paintings are also associated with other festivals and rituals at the temple and are a popular tourist souvenir.[17]

The painting on cloth (163) is a typical depiction of the temple itself with a frontal view of the triad of Jagannatha, Subhadra, and Balarama. The temple is recognizable by the distinctive bell-shaped tower of its sanctum and the pyramidal roof of the *mandapa,* or hall in front of the sanctum. The triad is depicted inside the sanctum, worshipped by priests in the register immediately below and further down by Brahma, Shiva, and Garuda. Garuda is seated on a pillar, and it could be a representation of the Garuda *stambha* at the temple. At the bottom of the painting is a representation of the Lion Gate entrance to the temple precinct.

The sides of the temple are elaborately sculpted and a number of subsidiary shrines can be found inside the temple precinct. These elements have been depicted in the painting along with numerous devotee figures. On either side of the temple base and attached to it are larger shrines for doorkeepers; the subsidiary shrines all around the temple include one dedicated to Krishna (second from bottom left) and on either side of the temple wall are two red shrines, the one on the left containing Narasimha and the one on the right, Varaha. These last are depictions of two of the three principal niches on the sanctum wall of the actual temple that contain sculptures of incarnations of Vishnu, including Narasimha and Varaha.

The palm leaf painting (162) also depicts the Jagannatha Temple surrounded by a number of its subsidiary shrines and the Lion Gate. However, greater attention is paid to the faithful representation of the temple's architecture with its distinctive moldings and protrusions. The deities within the subsidiary shrines are also more easily identifiable than they are in the cloth painting, and probably imitate the actual temple very closely. The use of palm leaves as a surface for writing and painting is of ancient origin; even after paper became widely available in India, artists in Orissa continued to use palm leaves for illustrated manuscripts of sacred subjects, incising the surface with a sharp stylus and then filling the lines with pigment. Palm leaves are inherently narrow; in order to offer a faithful, detailed rendering of the temple, the artist needed to use several leaves that he then attached at the edges using thread. [NP]

164 | Small Shrine with the Avatars of Vishnu
India, probably Deccan; c. 18th–19th century
Bronze; 7 11/16 x 10 13/16 x 9 9/16 in. (19.5 x 27.5 x 24.3 cm)
American Museum of Natural History. Courtesy of the Division
of Anthropology, cat. no. 70.3/5139, acc. no. 1989-28

While most devotees of Vishnu visit large, public temples on a relatively regular basis, a large percentage of Vaishnava worship actually takes place at home, at small shrines set up in a special corner or room of a family house or apartment. At least once a day, devotees offer food, lamplight, incense, and prayers to the god or gods installed on domestic altars. Icons and accoutrements for home use are usually smaller and made of more humble materials than those used in temples (some deluxe exceptions follow). Markets set up around major temples sell the materials and images needed to support domestic worship, and many home shrines boast icons purchased at pilgrimage sites, which bring a bit of the sanctity of the site to an otherwise average location.

This unusual metal shrine (164) was conceived like a miniature temple, with an entrance and images of various deities and avatars around the periphery and a finial at the back, serving like a tower. As one mentally climbs the tiny stairs, one encounters images of the elephant-headed god Ganesha and the warrior goddess Durga flanking the doorway.[18] Ganesha assists in overcoming obstacles, so he is usually the first god worshipped in Hindu rituals. It is very appropriate that he would appear at the door. Traveling clockwise around the interior, we see images of all ten avatars, albeit not in the usual order: Matsya with his fish tail, Parashurama raising his axe, and Kalki with his horse on the left side wall (detail on left), Vamana with the water jar, Kurma rising from the tortoise shell, boar-snouted Varaha, and Narasimha on the rear wall, and on the right side wall (detail on right) Rama (with his bow) with Sita, fluting Krishna with Radha, and the Buddha.

This shrine could have been used in a variety of ways: it may have served as a platform for a small icon of Vishnu that was installed at the center with the small images facing it, or it may have served as a tray onto which one put offerings, with the intended recipients depicted around the periphery. Either way, the complex iconography of the shrine would have allowed for a full course of worship, much like experiencing the elaborate sculptural program on a larger temple's exterior. �֎

165 | **Miniature Shrine for an Icon or Ritual Object**
Southern India; 19th century
Gold, rubies, emeralds, diamonds, and pearls
5 ⅛ x 3 ⅝ x 3 ⅛ in. (13 x 9.3 x 7.9 cm)
Collection of Susan L. Beningson

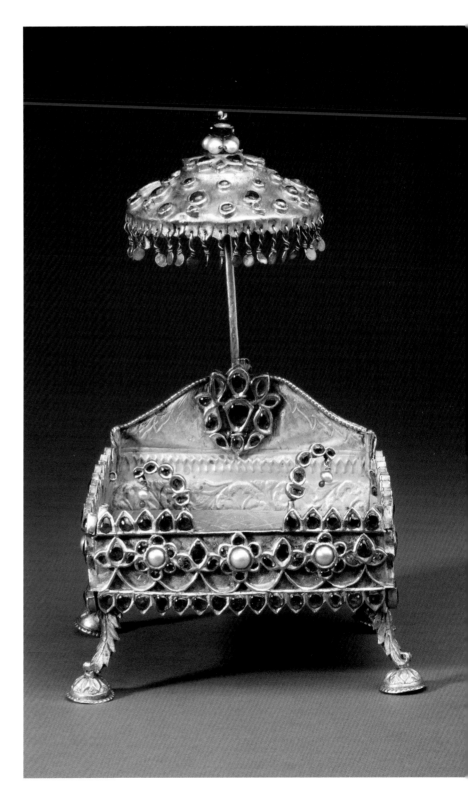

This precious object was probably made for the domestic shrine of a wealthy family. It is in the shape of a traditional Indian throne: when holding court, rulers sat cross-legged on low platforms while all others sat on the floor. The low walls surrounding the platform serve no purpose except to delineate the glorified space around the occupant. The parasol is an ancient emblem of royalty and often appears above thrones. Enshrined icons were perceived as kings holding court within their temple/palaces, so many types of royal regalia were created in miniature for use in worship. Several paintings reproduced in this catalogue represent Vishnu, his avatars, and even a set of Vishnupada enshrined on thrones with parasols above. The sanctity of this seat is underscored by the presence of a lotus in relief on the base (detail below); the lotus is an even more common choice for divine seating, as seen in several sculptures and paintings in the catalogue.

The intended occupant for this throne is unclear. There is some reason to argue for it being from a Vaishnava context: its courtly opulence would be better suited to Vaishnava than to Shaiva practice, although it would also be appropriate for other popular deities such as Ganesha and Devi. The tufted motif on the petals of the lotus seat is the eye of a peacock feather, an emblem closely associated with Krishna because he wears peacock feathers in his crown, but the emblem is also more broadly associated with beauty and virility, so it would not have been out of place in any number of temple settings. Given the low, wide space between the parasol and seat, it is unlikely to have been designed for a standing figure. Among iconic representations, crawling or prone images of infant Krishna would fit nicely, as would representations of Vishnu reclining on Shesha, or a pair of Vishnupada. One of the most likely candidates is a sacred object known as a *shaligram*, the fossil of the lobed, spiraling shell of an ammonite. Dark black and shaped like Vishnu's chakra, the only ammonite fossils that qualify to serve as *shaligrams* are found in the Gandaki River in Nepal. They are believed to be concrete traces of Vishnu's presence and are collected and enshrined, often on special pedestals or thrones, in Vaishnava temples.[19] The delicacy and opulence of the shrine would have been even more pronounced if and when it supported a black, virtually amorphous *shaligram* stone.

The throne is decorated with a combination of repoussé, cast, soldered, and linked gold elements and is set with gemstones and pearls. The parasol and the two emerald finials at the front (which are in the curving form known in India as a *boteh*, precursor to Western "paisley") are separate pieces, slotted into small tubes. Additional tubes on the four corners of the throne suggest that at one time there were more finials. ✺

166 | Crown for the Image of a Deity, Probably Krishna

Northern or central India; early 19th century
Gold with gemstones and pearls; 1 9/16 x 1 15/16 in. (5 x 4 cm)
Collection of Susan L. Beningson

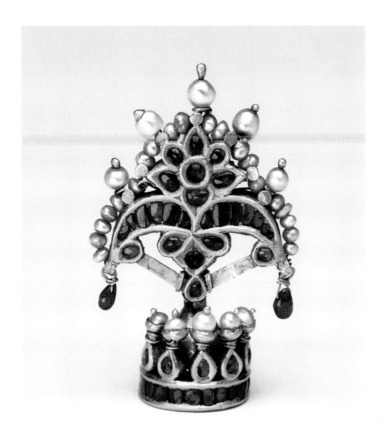

The icon enshrined within a temple is understood to be a living, sentient being, at least during the time of worship. The sculpture is a vessel or embodiment for the divine, who is more fully present, and more fully attentive, within the temple than he or she would be in the cacophony of the outside world. A relatively large part of *puja*, or ritual worship, before the icon is therefore given over to efforts to honor and please the god within through gifts, anointment, and even entertainment. As seen in the picchawais and shrine depictions from Nathadwara, temple icons often lead busy lives much like those of kings, with considerable pomp and ceremony and numerous changes of clothing and accoutrements to suit the occasion. A well-endowed temple will have a large store of materials—miniature clothing, jewelry, special vessels and lamps, litters or carts for transport of icons, subsidiary images, as well as flowers, incense, and a wide array of edible offerings—all awaiting ceremonial use.

The precious objects depicted here (166, 167, 168) were made for the use of enshrined icons. Wealthy temple patrons may have commissioned the objects for donation to major temple complexes, or they may have had them made for use in their own domestic shrines.

The latter is probably true of the small crown (166), which has the diameter of a finger ring. It probably stood on the head of a small bronze icon of the god Krishna, who is described as wearing a crested crown in this shape while living in Braj, although the crest in that crown is made of peacock feathers whereas here it is composed of rubies, emeralds, and pearls. It is not clear if the crown would have been used on special occasions, or if it permanently adorned the image.

The exquisite miniature swing (167) was also designed for a small image. Swings are a common feature in traditional Indian homes, first in the form of cradles, which can be swayed to keep babies calm, then as larger platforms suspended from ceilings (or support frames as seen here) for the use of family members who wish to enjoy the relaxing movement and slight cooling breeze they offer. Poets have long celebrated the erotic rhythms and action of swinging; Krishna is often depicted on a swing with Radha in Indian paintings. The fact that the platform has sides (instead of an open platform or chair-shape) makes it likely this silver-and-gold model of a swing was used as a cradle for an image of the infant Krishna. The T-shaped sticks were used for pushing the seat, and the bells along the horizontal beam could be jingled to delight the child icon. The peacock figures at the top refer to the feathers in Krishna's crown, and the elaborate ornamentation on the supports recalls motifs found on luxury furniture made in India in the eighteenth century, including full-sized thrones covered in silver.

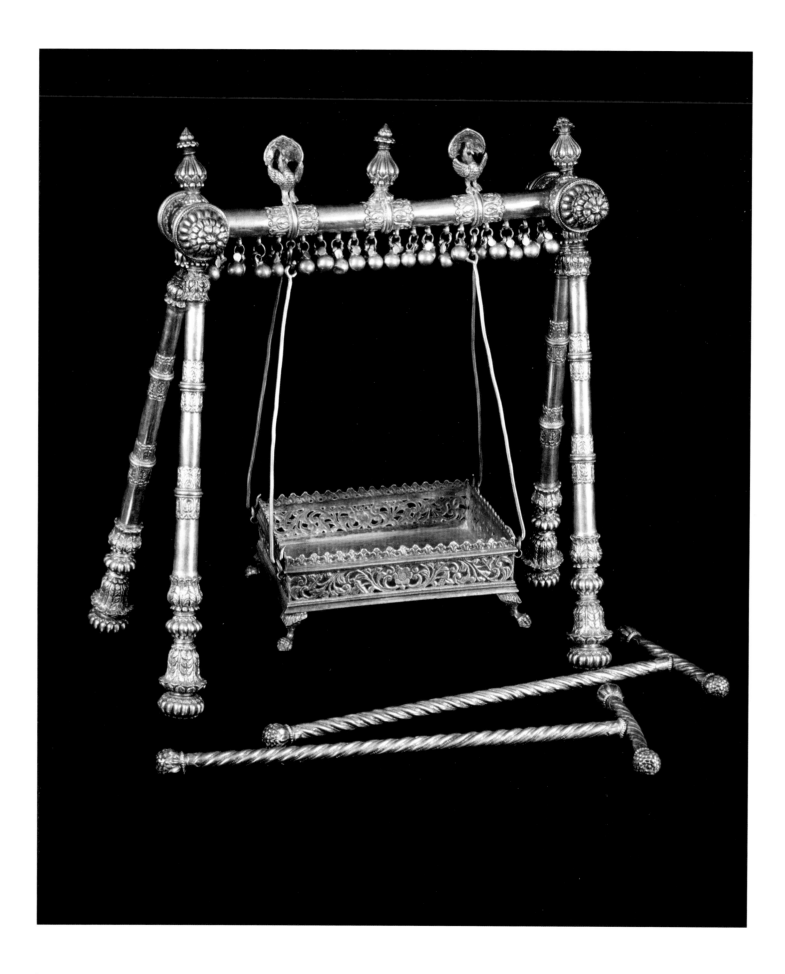

167 | **Swing for an Image of Krishna** (*facing page*)
India; 18th century
Silver and gold; 13 $^{15}/_{16}$ x 15 $^{3}/_{4}$ x 5 $^{1}/_{2}$ in. (35.4 x 40 x 14 cm)
Collection of Susan L. Beningson

168 | **Pair of Rattles for a Krishna Shrine**
Western India; 18th century
Gold; Length: 5 $^{1}/_{2}$ in. (13 cm) each
Collection of Susan L. Beningson

The openwork gold rattles (168) were likewise created for the entertainment of the infant god Krishna. They come from a large set of gold accoutrements, now widely dispersed, made for an opulent personal shrine in Gujarat.[20] Among the objects in this set were small figures of animals and small vessels for offerings, but perhaps the most delightful pieces were the toys: balls and rattles that remind us that worshipping Krishna in his infant form can be much like doting on a human infant. ✻

169 | **Mask of Ravana** (*following page*)
Northern India, probably Uttar Pradesh, Varanasi area;
c. 1900–1950
Painted papier-mâché; 21 $^{1}/_{2}$ x 43 in. (54.6 x 109.2 cm)
Samuel P. Harn Museum of Art, University of Florida. Gift of Mr. and Mrs. Thomas Needham, S-82-54

Visual and performing arts often serve similar functions in a sacred context: giving form to the divine, telling mythic tales, and offering delight to their audiences, both heavenly and human. Music, dance, and theater were very much intertwined in the Indian tradition—they still are, as seen in Bollywood productions—and in the premodern period, these art forms most frequently took religious subjects as their inspiration.

Religious performance can take the form of recitation, storytelling, mime, even puppetry, but the pageant—the re-enactment of a mythological tale as part of a special holiday observance—is probably the most celebrated, and certainly the best-attended, form of live theatrical performance in northern India.

Although there are various pageants relating to the *rasalila* of Krishna's youth, performed primarily in the Braj area where the original episodes took place, the most popular and extravagant of the Hindu pageants are the many *Ramlila*s, multiple-day re-creations of the battle between Rama and Ravana, which are staged annually, in late September and early October, in villages and towns throughout northern India. These spectacles involve casts of hundreds, elaborate costumes and props, and a giant effigy of Ravana, sometimes accompanied by his closest demon allies, which is burned in a celebratory bonfire with fireworks at the end.[21]

Some *Ramlila*s are professional productions, using trained actors and attracting an audience of thousands, but most are neighborhood or village events, enlisting members of the community—especially children—to play the various roles. These shows serve a didactic function (acquainting the community with important episodes from the Hindu epics), and a devotional function (the entire production could be dedicated to the god as an offering, and actors were sometimes treated as temporary embodiments of the

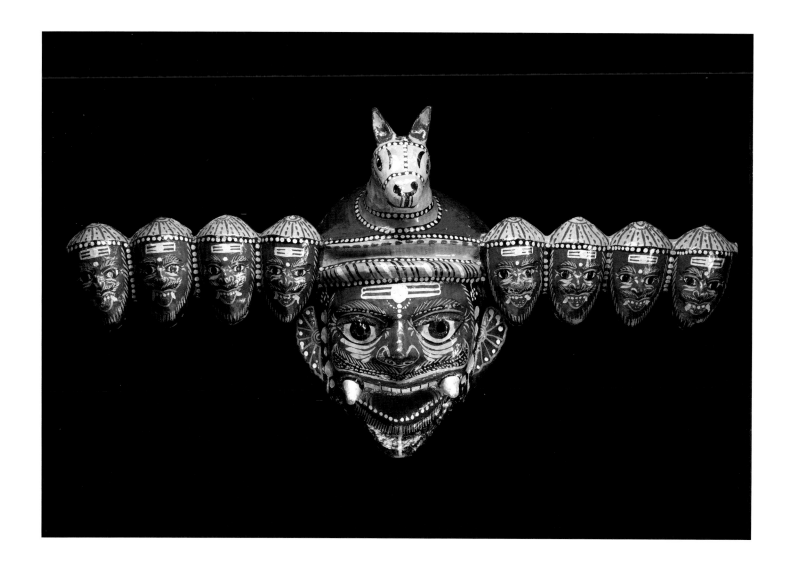

divine, as seen in fig. 169–1). In moments of civil strife the *Ramlila* has often served a political function, as Ravana stands in for the perceived enemy and Rama for the cause of righteousness.

This mask depicting multi-headed Ravana may have been made for a small-scale production, or as a toy for a child who wanted to play-act at home. Given that the armies consist of demons, monkeys, and bears, a typical *Ramlila* production requires many masks. Papier-mâché has long been the preferred material for *Ramlila* masks because it is lightweight, inexpensive to produce, and can be painted in eye-catching colors. However, masks survive in a variety of other media, most notably copper. As the *Ramlila* season approaches, stores around northern India begin to carry the costumes and fireworks needed for preparation. ❈

Figure 169–1 | Actors dressed as Rama and Hanuman bless a baby, with effigies of Ravana and Kumbhakarna in the distance, at a *Ramlila* performance in Chandigarh, Punjab, September 28, 2009. © Ajay Verma/Corbis

170 | Hanuman

Ghoting (dates uncertain)
Published by The Modern Picture Publishers of India,
Maharashtra (Bombay); 1927
Chromolithograph on paper; 20 ⅛ x 14 ⅜ in. (51.1 x 36.5 cm)
Robert J. Del Bontà Collection, CP 098

171 | Rasamandala

Mahadev Vishvanath Dhurandhar (1867–1944)
Published by Ravi Varma Press, Maharashtra (Malavli–Lonavla);
1928
Chromolithograph on paper; 20 ⅛ x 14 ¼ in. (51.1 x 36.2 cm)
Robert J. Del Bontà Collection, CP 024

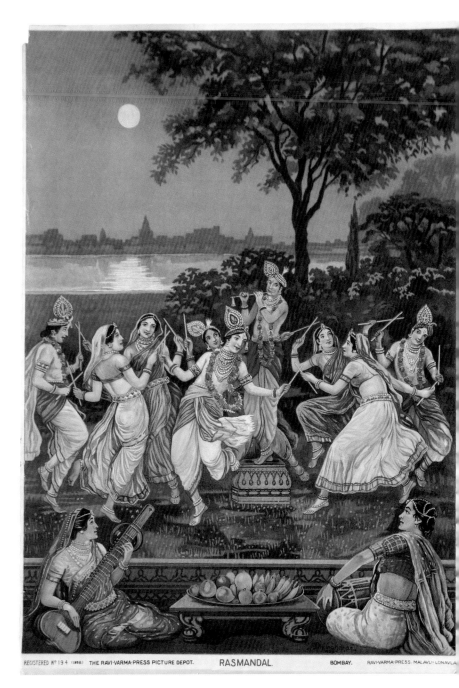

172 | Krishna and Yashoda

M. Abbayi (dates uncertain)
Published by Brijbasi F.A.O. Works, Uttar Pradesh, Mathura;
c. 1920–30
Chromolithograph on paper; 19 ⅞ x 13 ¾ in. (50.5 x 34.9 cm)
Robert J. Del Bontà Collection, CP 028

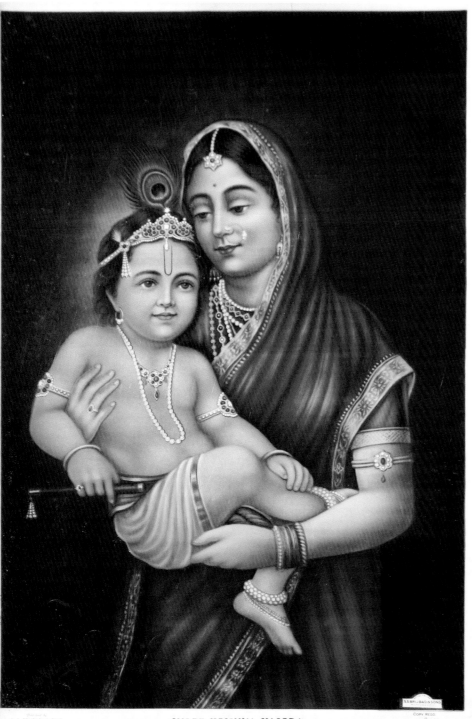

SHREE KRISHNA YASODA

Figure 172–1 | Raphael (Italy, 1483–1520).
Sistine Madonna (detail), 1513–14. Oil on canvas,
104 x 77 in (264.2 x 195.6 cm) Gemäldegalerie, Dresden.
© *Gemäldegalerie Alte Meister, Staatliche Kunstsammlungen
Dresden*

173 | Vishvarupa

K.G. Khatri (dates uncertain)
Published by Anant Shivaji Desai Picture Publishers,
Maharashtra (Bombay); 1933
Chromolithograph on paper; 20 ⅛ x 13 ⅞ in. (51.1 x 35.2 cm)
Robert J. Del Bontà Collection, CP 078

विश्वरूप दर्शन (विराट स्वरूप)

Vishnu is still very avidly worshipped in the twenty-first century, and just as the desire to pray to the god continues, so does the desire to see and be seen by him in physical form. Sculptors continue to create stone and bronze images for temples and domestic shrines, and painters make some religious imagery, but a new medium has taken over as the predominant form for depictions of the gods. This is the color print, mass-produced and sold at low cost in bookshops and temple markets throughout India and abroad.

The religious-themed color print was first introduced to India in the late nineteenth century. These prints were designed by painters, but mostly not by the traditionally trained families of manuscript illustrators and muralists who had so long served the courts and temples of India. Instead, early color prints reflected a rising taste for Western-style imagery of sorts being taught at Western-style art schools in India's big cities.[22] From the very beginning, Hindu imagery in color prints drew on European conventions, as seen in this small sampling (170, 171, 172, 173): the pose of Krishna held by Yashoda is a direct quotation from the Sistine Madonna by Raphael (see fig. 172–1),[23] while the image of the *Rasamandala* more indirectly cites the tradition of the pastoral, with comely youths frolicking in a park-like setting not far from civilization.[24] Such prints were framed and installed in home shrines as icons, but they were also glued to calendars and advertising flyers, so they enjoyed a strange dual existence, alternately treasured and ephemeral.

The Hanuman (170) is the earliest of this group, but in some ways the most modern. The well-muscled monkey stands with his mace, the Indian peninsula clearly visible at his feet. He wears a Vaishnava tilak mark and jewelry that harks back to antiquity, but with his small trunks and hairless body he looks very much like a modern wrestler. This ancient sport remains popular in India, where wrestlers have long worshipped Hanuman as a model of strength, speed, and self-discipline.[25] Indian wrestlers even exercise by swinging large clubs like the one held by the monkey god. Here, Hanuman's association with India has nationalist overtones: the monkey stands ready to fight for his country, much as he did for Rama; the viewer is invited

to draw a comparison between the British colonials and Ravana's demon forces.[26]

The *Rasamandala* (171) was published by the print house founded by Raja Ravi Varma, the most influential of all the artists involved in printmaking, although Ravi Varma died long before this image was made. The artist, M.V. Dhurandhar, was the first Indian director of the prestigious Sir J.J. School of Art in Mumbai (Bombay);[27] he was a celebrated illustrator who worked in oil and watercolor. His version of the *Rasamandala* is so insistent on providing a naturalistic view of the dance that the symbolic essence of the image—the eternal perfection of the circle formed by the mingling of devotee and divinity—is almost completely lost. Instead, the *rasalila* becomes a well-choreographed dance party. The iconic role of the picture remains, however, in the placement of the central, fluting Krishna on a pedestal, the viewer's situation at a lower level, and the offering of fruit at the lower center.

The European source for the image of Krishna and Yashoda (172) has already been noted. This image borrows not only from Madonna and Child imagery, but also from Western painting conventions, especially chiaroscuro lighting. The blue infant holds a little flute, and neither he nor his mother looks directly at the viewer, a departure from Indian iconic norms that might also be the product of European influence (although it is interesting to note that the print's primary prototype, the Sistine Madonna, looks out at the viewer).

The Vishvarupa here, subtitled *Virad Svarupa* or Self-Manifested Macrocosm (173), represents a far more frightening vision of the god than seen in the earlier paintings (cats. 131–33). The image appears to draw on Arjuna's frightened description of Vishvarupa's destructive aspect:

> As moths
> in the frenzy
> of destruction
> fly into a blazing flame,
> worlds
> in the frenzy
> of destruction
> enter your mouths.
>
> You lick at the worlds
> around you,
> devouring them
> with flaming mouths;
> and your terrible fires
> scorch the entire universe,
> filling it, Vishnu
> with violent rays.[28]

Unlike the earlier images, which are set against a plain ground, this version shows a backdrop of teeming masses of warriors, a reference both to the battlefield of Kurukshetra, where the *Bhagavad Gita* is delivered, and to all humanity, which is encompassed within the great being of Vishnu. ✺

174 | Poster for *Balram Shri Krishna*
Published by J.P. Printers
Northern India, Delhi; 1968
Lithograph on paper; 29 15/16 x 20 1/16 in. (76 x 51 cm)
Private collection

175 | Poster for *Bajrangbali*
G.R. Kareker (dates uncertain)
Published by Poster Centre Bombay
Western India, Maharashtra, Mumbai; 1976
Lithograph on paper; 40 3/16 x 29 15/16 in. (102 x 76 cm)
Private collection

Shortly after the introduction of color prints as a new forum for representation of the divine, another medium was introduced that offered greater narrative possibilities as well as considerable challenges for the depiction of the supernatural. The first Indian-made feature-length film, *Raja Harishchandra* (1913), re-created a story from Hindu mythology. In its wake, Indian filmmakers vied to retell the epics and Puranas in as vivid, dramatic, and credible a fashion as possible. Hindu-themed theater had existed since at least the start of the first millennium CE, and community-based pageants such as the *Ramlila* brought Vaishnava stories to life for less elite viewers long before the advent of cinema. But film offered an opportunity for broader audiences, larger budgets and new special effects, and it quickly overshadowed live performance as the primary means by which most people experienced the gods in action.

The mythological genre was not embraced by India's intelligentsia and it rarely attracted any critical acclaim. There was never quite enough money to create convincing costumes, sets, or stunts, and after Independence (1947) Hindu-themed cinema was mostly relegated to B-movie status.[29] Despite this, the two movies whose posters are reproduced here (174, 175) enjoyed large audiences, including many families who used cinema as a way to teach fundamental stories to children.[30] *Balram Shri Krishna* (1968) told of dissent between the divine brothers in their adulthood, after their defeat of the evil Kamsa. *Bajrangbali* (1976) re-created the story of the *Ramayana* with an emphasis on the heroism of Hanuman (whose alternate name is Bajrangbali). Both starred Dara Singh, the world wrestling champion whose name remains synonymous with strength and muscularity in the Indian pop vocabulary.

Movie poster art is a genre unto itself in India, with styles going into and out of fashion. The collage-like sampling of imagery found in the *Bajrangbali* poster (175) is a common feature of Indian movie advertising, which strives to offer a taste of the many pleasures to be had in a single film. The broad, somewhat painterly strokes used to depict the chariot and the sketchy treatment of the background mimic (and were mimicked by) the hand-painted billboards that continue to appear throughout India's cities and towns. This *Bajrangbali* poster (there were several) is noteworthy for its use of Ravana's multiple heads as a sort of frieze at the top and for its frame composed of the repeated Sanskrit mantra "*Shri Ram.*"[31]

The *Balram Shri Krishna* poster (174) is somewhat unusual, with its tinted photographs of the stars altered to look like icons on lotus pedestals and the line drawing of a *parikara* (see cat. 7), or a carved temple doorway, serving as a frame for the central figures. This poster presents the film as a devotional experience whereas the other—despite its mantra—aims to offer adventure and even a touch of romance.[32]

The mythological genre experienced a major rebirth in the 1980s and '90s when the Indian state television channel, Doordarshan, aired lengthy serialized versions of the *Ramayana* and *Mahabharata*.[33] The epic series, which were in Hindi, attracted unprecedented viewership, even among Muslims and non-Hindi speakers, and some Hindu viewers are reported to have treated the airings as sacred events, with offerings presented before the television set.[34]

Notes: The Worship of Vishnu

1 The most famous of the Vaishnava footprint sites is the Vishnupada temple at Gaya, in Bihar, where Vishnu is believed to have stepped when defeating Gayasura, a demon who had been granted a boon that his body would become a sacred site, but who then refused to lie still when priests wished to use it for their rituals. Vishnu stepped on him to kill him, thereby rendering permanent the sacred site. The primary focus for worship at the Vishnupada temple is a pair of stone feet that lie on a platform, surrounded by a silver frame.

2 Many thanks to John Eskenazi for providing the two transliterations.

3 A more vertically oriented but iconographically similar image of Vishnu's feet, flanked by mace and conch but topped with a crown instead of a lotus, has been attributed to tenth-century Kashmir by Pratapaditya Pal in *The Arts of Kashmir* (New York: Asia Society, 2007), 73, 83.

4 Pratapaditya Pal, *Painted Poems: Rajput Paintings from the Ramesh and Urmil Kapoor Collection* (Pasadena: Norton Simon Museum, 2004), 164.

5 Ibid., 186.

6 Ibid., 164.

7 Ibid., 186.

8 Ibid.

9 Ibid.

10 Tryna Lyons, *The Artists of Nathadwara: The Practice of Painting in Rajasthan* (Bloomington: Indiana University Press in association with Mapin, Ahmedabad, 2004), 11.

11 The term *picchawai* comes from the Sanskrit verb root *pich*, which means "to spread," but it is more closely related to the words used in northern Indian dialects for the tail feathers of a peacock. The *picchawai* spreads out to create a decorative backdrop for the icon, much as the peacock's tail spreads out to frame his head.

12 Many thanks to Cynthia Atherton for providing this and other information about the *picchawais* in the exhibition.

13 The image, with the altar framed with pink roses, does not correspond precisely to descriptions or images of the Gulabi Gangaur observance, in which a whole pavilion is built for the god from flowers, but it comes close. For discussion of the festival and a single image of it, see Amit Ambalal, *Krishna as Shrinathji: Rajasthani Paintings from Nathdvara* (Ahmedabad: Mapin, 1987), 34 and 122.

14 Ambalal indicates that the festival is based on Rajasthani tradition and is of relatively recent origin, having been introduced into the Nathadwara devotional calendar around the turn of the twentieth century. Ibid., 34.

15 For extensive anecdotal information about Ghasiram and a photograph of the artist, see ibid., 85–90.

16 Lyons, in *The Artists of Nathadwara*, 295, discusses the success enjoyed by Khubiram's painting business and the disapproval more traditional artists expressed for his approach. Christopher Pinney, in *Photographs of the Gods: The Printed Image and Political Struggle in India* (London: Reaktion Books, 2004), 157 and passim, discusses Khubiram's influence on the look of chromolithographic prints.

17 O.M. Starza, *The Jagannatha Temple at Puri: Its Architecture, Art, and Cult*, ed. Janice Stargardt, Studies in South Asian Culture 15 (Leiden: Brill, 1993), 34.

18 As we have seen in the section on goddesses, Durga was often conceived of as Vishnu's sister, especially in the South, where this shrine was probably made.

19 I am indebted to Robert L. Skelton for his write-up of the throne, which appeared in a sale catalogue for Simon Ray Indian and Islamic Works of Art, London, March 2004, 88.

20 Molly Emma Aitken reproduces an old photograph of the shrine with much of its regalia in place, as well as several other objects from the group now in the Beningson collection, in *When Gold Blossoms: Indian Jewelry from the Susan L. Beningson Collection* (New York: Asia Society, 2004), 58–59.

21 Other Ramayana-inspired pageants, including the birth of Rama and the marriage of Rama and Sita, are re-enacted at other times of year at locations sacred to the events, but the *Ramlila*, which is performed first and foremost at Ramnagar, near Varanasi, is also performed in many other cities. See Philip Lutgendorf, *The Life of a Text: Performing the* Ramacaritmanas *of Tulsidas* (Berkeley and Los Angeles: University of California Press, 1991), chapter 5.

22 An exception to the emulation of Western style in early Indian color prints can be found in a relatively large body of prints, presumably made for a southern market, that copy the forms found in Thanjavur paintings (see cat. 91 herein for an example of Thanjavur painting, although some of the the prints appear to be based more closely on the paintings on glass made in the region in a somewhat later period). At various moments in the history of color prints, distributors have promoted imagery based on traditional painting styles, most notably that of the Punjab Hills state of Kangra, but this material is definitely in the minority.

23 Many thanks to Bob Del Bontà for indicating the source.

24 See Kajri Jain, *Gods in the Bazaar: The Economies of Indian Calendar Art* (Durham, NC: Duke University Press, 2007), particularly chapter 2, for a discussion of the complex concerns that may have led Indian publishers and consumers to prefer European-style imagery in the late nineteenth century.

25 For a discussion of the importance of Hanuman worship in Indian wrestling culture, see Joseph S. Alter, *The Wrestler's Body: Identity and Ideology in North India* (Berkeley and Los Angeles: University of California Press, 1992), chapter 8.

26 Kajri Jain writes about the periodic rise in popularity of prints depicting well-muscled gods, coinciding with moments of nationalist pride and communalist unrest. See *Gods in the Bazaar*, chapter 7.

27 The Sir Jamsetji Jeejeebhoy School of Art was founded by a Parsi patron of the arts in 1857. It remains the best-known art school in Mumbai.

28 *Bhagavad Gita*, teaching 11, verses 29–30, translated by Barbara Stoler Miller, *The Bhagavad-Gita: Krishna's Counsel in Time of War* (New York: Bantam, 1988), 103.

29 For an in-depth examination of the history of the mythological genre in Indian film, see Rachel Dwyer, *Filming the Gods: Religion and the Indian Cinema* (London: Routledge, 2006). Dwyer points out that while Hindu themes lost top billing in the Hindi-language market, they retained large audiences among those who spoke South Indian languages.

30 The other dominant medium that served this purpose in the twentieth century, a medium not represented here, is the comic book.

31 Additional posters for the film can be found in the collections of the Victoria and Albert Museum, London, some of which are illustrated in the museum's online collections database, see http://www.vam.ac.uk.

32 A far more dramatic, and typical, poster for the film, created by G.K. Kareker, the prolific artist of the *Bajrangbali* poster, is reproduced in Jerry Pinto and Sheena Sippy, *Bollywood Posters* (London: Thames and Hudson, 2008), 133.

33 Dara Singh reprieved his role as Hanuman for the television *Ramayana*.

34 Dwyer, *Filming the Gods*, 53.

Suggested Reading

Primary Texts in Translation

Alston, A.J. *The Devotional Poems of Mirabai*. Delhi: Motilal Banarsidass, 2005.

Bihari: The Satasai. Translated by Krishna P. Bahadur. London: Penguin Classics, 1992.

The Bhagavad-Gita: Krishna's Counsel in Time of War. Translated by Barbara Stoler Miller. New York: Bantam, 1988.

Bhagavata Purana. Translated by Ganesh Vasudeo Tagare. Ancient Indian Tradition and Mythology Series, Volumes 7–11. Delhi: Motilal Banarsidass, 1999.

The Bilvamangalastava [Bilvamangala's *Balagopalastuti*]. Translated by Frances Wilson. Leiden: Brill, 1973.

Bryant, Kenneth. *Poems to the Child-God: Structures and Strategies in the Poetry of Surdas*. Berkeley and Los Angeles: University of California Press, 1978.

Dehejia, Vidya. *Antal and Her Path of Love: Poems of a Woman Saint from South India*. Albany: State University of New York, 1990.

Hymns for the Drowning: Poems for Visnu. [by Nammalvar] Translated by A.K. Ramanujan. London: Penguin Classics, 1993.

Krishna: The Beautiful Legend of God [Book 10 of the *Bhagavata Purana*]. Translated by Edwin F. Bryant. London: Penguin Classics, 2003.

Love Song of the Dark Lord: The Gita Govinda of Jayadeva. Edited and translated by Barbara Stoler Miller. 20th anniversary edition, New York: Columbia University Press, 1998.

The Ramayana of Tulasidasa. Translated by F.S. Growse. Delhi: Motilal Banarsidass, 1998.

The Ramayana—Valmiki. Translated by Arshia Sattar. New Delhi: Penguin Books, 1996.

The Rig Veda. Translated by Wendy Doniger. London: Penguin Classics, 2005.

The Vishnu Purana. Translated by Horace Hayman Wilson. London: Ganesha Publishing, 2001.

Hinduism and Vishnu

Bryant, Edwin F. *Krishna: A Sourcebook*. New York: Oxford University Press, 2007.

Desai, Kalpana. *Iconography of Vishnu*. New Delhi: Abhinav Publications, 1973.

Doniger, Wendy. *The Hindus: An Alternative History*. New York: Penguin, 2009.

Dwyer, Rachel. *Filming the Gods: Religion and the Indian Cinema*. London: Routledge, 2006.

Eck, Diana L. *Darsan: Seeing the Divine Image in India*. New York: Columbia University Press, 1998.

Flood, Gavin. *An Introduction to Hinduism*. Cambridge: Cambridge University Press, 1996.

Fuller, C.J. *The Camphor Flame: Popular Hinduism and Society in India*. Princeton: Princeton University Press, 2004.

Krishna, Nandita. *The Book of Vishnu*. New Delhi: Viking, 2001.

Lutgendorf, Phillip. *Hanuman's Tale: The Messages of a Divine Monkey*. New York: Oxford University Press, 2007.

Pollock, Sheldon. "Ramayana and Political Imagination in India." *The Journal of Asian Studies* 52, no. 2 (May 1993), 261–97.

Waghorne, Joanne Punzo, and Norman Cutler, editors. *Gods of Flesh, Gods of Stone: The Embodiment of Divinity in India*. Chambersburg, PA: Anima, 1985.

The Art of India

Aitken, Molly Emma. *When Gold Blossoms: Indian Jewelry from the Susan L. Beningson Collection*. New York: Asia Society, 2004.

Ambalal, Amit. *Krishna as Shrinathji: Rajasthani Paintings from Nathdvara*. Ahmedabad: Mapin, 1987.

Archer, W.G. *The Loves of Krishna in Indian Painting and Poetry*. New York: Dover, 2004.

Blurton, T. Richard. *Hindu Art*. Cambridge, MA: Harvard University Press, 1994.

Cummins, Joan. *Indian Painting from Cave Temples to the Colonial Period*. Boston: Museum of Fine Arts, 2006.

Dehejia, Vidya. *Indian Art*. Art and Ideas series. London: Phaidon, 1997.

Dehejia, Vidya, et al. *The Sensuous and the Sacred: Chola Bronzes from South India*. New York: American Federation of Arts, 2002.

Dehejia, Vidya, editor. *The Legend of Rama: Artistic Visions*. Bombay: Marg, 1994.

Desai, Devangana. *Religious Imagery of Khajuraho*. Delhi: Franco-Indian Research, 1996.

Desai, Vishakha N., and Darielle Mason. *Gods, Guardians, and Lovers: Temple Sculptures from North India A.D. 700–1200*. New York: Asia Society Galleries; Ahmedabad: Mapin, 1993.

Goswamy, B.N., and Eberhard Fischer. *Pahari Masters*. Zurich: Artibus Asiae, 1992.

Harle, J.C. *Gupta Sculpture: Indian Sculpture of the Fourth to Sixth Centuries A.D.* London: Oxford University Press, 1974.

Huntington, Susan L., and John C. Huntington. *The Art of Ancient India: Buddhist, Hindu, Jain*. New York: Weatherhill, 1985.

Huntington, Susan, and John Huntington. *Leaves from the Bodhi Tree: The Art of Pala India (8th–12th Centuries) and Its International Legacy*. Dayton: The Dayton Art Institute, 1990.

Michell, George. *The Hindu Temple: An Introduction to Its Meaning and Forms*. Chicago: University of Chicago Press, 1977.

Packert, Cynthia. *The Art of Loving Krishna: Ornamentation and Devotion*. Bloomington: Indiana University Press, 2010.

Pinney, Christopher. *Photographs of the Gods: The Printed Image and Political Struggle in India*. London: Reaktion Books, 2004.

Poster, Amy G. *From Indian Earth: 4,000 Years of Terracotta Art*. Brooklyn: Brooklyn Museum, 1986.

Rossi, Barbara. *From the Ocean of Painting: India's Popular Paintings, 1589 to the Present*. New York: Oxford University Press, 1998.

Srinivasan, Doris Meth. *Many Heads, Arms, and Eyes: Origin, Meaning, and Form of Multiplicity in Indian Art*. Studies in Asian Art and Archaeology 20. Leiden: Brill, 1997.

Starza, O.M. *The Jagannatha Temple at Puri: Its Architecture, Art, and Cult*. Studies in South Asian Culture 15. Leiden: Brill, 1993.

Glossary

Abhaya mudra – Hand gesture, made with palm facing outward and fingers pointing up, seen on Hindu and Buddhist icons, giving reassurance and meaning "fear not."

Acharya – Vaishnava teacher/philosopher of southern India.

Aditi – Goddess who is mother to many of the major Hindu deities.

Agama – Sanskrit text prescribing ritual behavior, yogic meditation, and iconography.

Aghasura – Giant serpent that disguises itself as a mountain—with its mouth as a cave—in order to swallow Krishna and his companions; killed by Krishna when he bursts through the top of the snake's skull.

Agni – Hindu god of fire; very important in the Vedic period.

Alvar – One of several Vaishnava saints in Tamil country who composed devotional hymns to Vishnu and his avatars in the second half of the first millennium CE.

Amrita – Nectar of immortality; generated by the gods and demons when they churn the primordial ocean; taken from the demons by Vishnu disguised as the lovely Mohini; stolen by Garuda to save his mother.

Ananta – Giant serpent, *see* Shesha.

Anantashayana – "Lying on Ananta," epithet of Vishnu and description of the god when he is the Creator, reclining on the great serpent Ananta, or Shesha.

Andal / Antal – Ninth-century South Indian female saint who composed many poems about her love for Vishnu and particularly for Krishna.

Anjali mudra – Gesture of greeting, homage, or respect, made by joining the palms together with fingers pointing up.

Aniruddha – Grandson of Krishna who is kidnapped by the demoness Usha; worshipped in an early period as one of the five Vrishni Viras deities.

Annakut – Festival commemorating Krishna's insistence that the cowherds worship Mt. Govardhana instead of Indra; celebrated at the Shrinathaji temple in Nathadwara with a great feast.

Arjuna – Hero of the *Mahabharata*, whose chariot is driven in battle by Krishna; the *Bhagavad Gita* is Krishna's response to Arjuna's questions, posed immediately before the battle.

Avatar – Temporary, earthly manifestation, usually of the Hindu god Vishnu, who descends in various forms to save the world from chaos; avatars are divine but usually understood to be somewhat more limited in power and prevalence than Vishnu in his cosmic forms.

Ayudhapurusha – Vishnu's personified attributes, or weapons in figural form, sometimes worshipped as subsidiary deities by Vaishnavites, often represented in pairs flanking a central image of the god.

Bakasura – Demon who disguises himself as a crane to kill Krishna but is torn in two by the god.

Balakrishna – Infant form of the god Krishna, usually shown holding a butter ball, his favorite snack.

Balagopalastuti – Series of verses about Krishna, written around the early fourteenth century by the South Indian poet Bilvamangala.

Balarama – Older brother and lifelong companion of Krishna, often treated as an avatar of Vishnu.

Bali – Demon, great-grandson of Hiranyakashipu, who enlisted the assistance of a group of Brahmins to conquer the kingdom of the gods; was tricked by the Vamana avatar into giving his domain away.

Banasura – Demon whose daughter, Usha, kidnaps Krishna's grandson, Aniruddha; Krishna goes to battle against Banasura in order to rescue Aniruddha.

Banke Bihari – Self-manifest icon of Radha and Krishna in a single form; now installed in its own temple in Vrindavan.

Bhagavad Gita – Teaching delivered by Krishna to the warrior Arjuna in the *Mahabharata*, discussing such important topics as duty and devotion; one of the most influential scriptures in Hinduism.

Bhagavata – Early form of Krishna worship, practiced in the Mathura area by the Vrishni clan.

Bhagavata Purana – Lengthy scripture dedicated to Vishnu, primarily in the form of Krishna; includes the most detailed account of the earthly life of Krishna. Compiled around the ninth–tenth century CE.

Bhakti – Approach to Hindu worship that emphasizes devotion in the form of an intense, personal relationship with god; practiced most avidly by worshippers of Krishna.

Bhu Devi – Earth goddess, saved by Varaha from drowning in the primordial ocean, often represented as one of Vishnu's two consorts, together with Shri Devi.

Bihari – Seventeenth-century poet and Krishna-devotee who wrote the *Sat Sai*.

Bilvamangala – South Indian poet who wrote the *Balagopalastuti*, probably in the early fourteenth century.

Brahma – Major Hindu god; created mankind after he emerged from the lotus that grew from Vishnu's navel; speaker and protector of the Vedas; often the god who grants boons to individuals who later become corrupt and over-powerful, necessitating conquest by Vishnu's avatars.

Brahmacharin – Young Brahmin student, usually following a particularly ascetic lifestyle; one of the more pious and respected types of Hindu holy man.

Brahmin (Brahman) – Member of the priestly caste, the highest of the traditional Hindu social classes.

Braj – Rural region outside the city of Mathura where Krishna and Balarama grew up; now a center for Krishna worship; also refers to the dialect spoken in this region.

Buddha – Founder of the Buddhist religion, sometimes treated as the ninth avatar of Vishnu; in Vaishnava accounts, the Buddha comes to earth in order to mislead the unrighteous with false teachings.

Chaitanya – Fifteenth-century Bengali saint who inspired the Gaudiya sect of Vaishnavism in eastern India.

Chakra / Chakrapurusha – Chakra is Sanskrit for wheel or disc and in a Vaishnava context it refers to the discus wielded by

Vishnu as one of his primary attributes. Wheels are potent emblems in ancient Indian culture, representing cyclical progression as well as political power. *Chakrapurusha* is the figural form of Sudarshana Chakra, Vishnu's discus.

Chaturanana / Chaturmukha / Chaturmurti – Terms for icons of Vishnu that have four faces (or three with the fourth one not visible but implied).

Chaturvyuha – The four *vyuhas*, or emanations of Vishnu; term for an icon representing the four *vyuhas*, either separately or combined into a single, multi-headed figure.

Chauri – Flywhisk, usually made of hairs from a yak's tail; commonly held by attendants in religious icons.

Chola period – Reign of the influential Chola dynasty, from the ninth through the thirteenth century, over a domain that spread across southern India and into Sri Lanka.

Daitya – A class or species of beings, usually identified as demons.

Darshan – The act of seeing, and being seen by, the deity within an enshrined icon during worship.

Dashavatara – Descriptive list of the ten avatars of Vishnu; the most celebrated, and concise, *Dashavatara* text appears at the beginning of Jayadeva's *Gita Govinda*.

Devaki – Krishna's birth mother.

Devanagari – Script used for Sanskrit and several related languages, including Hindi.

Devi – The Great Goddess of the Hindu tradition; an umbrella term for all goddesses as well as the name of the feminine force from which all goddesses are thought to emerge.

Dhoti – Wrapped loin cloth, usually draping well below the knees to resemble a skirt, worn by men.

Divyadesha – Sacred site, one of 108 mentioned by the *alvars* as being Vishnu's abodes.

Dundubhi – Demon in the *Ramayana* who had been killed by the monkey king Vali; his body is kicked by Rama as a demonstration of strength.

Durga – Important Hindu warrior goddess sometimes understood to be Vishnu's sister.

Durvasa – Short-tempered Hindu sage whose curse led to the churning of the ocean.

Eastern Ganga period – Reign of the Eastern Ganga dynasty, approximately eleventh to early fifteenth century, over much of northeastern India, including Bengal, Orissa, and parts of Andhra Pradesh and central India.

Ekanamsha – Sister of Krishna and Balarama; represented together with the brothers in very early icons but rarely mentioned in literature after the period of the *Harivamsha*.

Gada / Gadadevi – *Gada* is Sanskrit for "mace," a club-like weapon that serves as one of Vishnu's primary attributes. Gadadevi ("Mace Goddess") is the female personification of the mace; she appears at the base of many Vishnu icons.

Gajendra Moksha – Story of Vishnu's salvation of the elephant king, who was being pulled to his death by a sea monster.

Gandharva – Heavenly musician, often part of the entourage of figures surrounding an icon, usually shown flying above with musical instruments.

Ganesha – Hindu god, the son of Shiva, identified by his elephant head; much worshipped by members of various sects for assistance in overcoming obstacles.

Garuda – Avian vehicle of Vishnu, usually described as half-man, half-eagle.

Gaudiya – Literally, Bengali; the name of an eastern Indian Vaishnava sect devoted primarily to Krishna.

Gita Govinda – Twelfth-century poem by Jayadeva, describing the ups and downs of the relationship between Krishna and his beloved as an analogy for the relationship between God and devotee.

Gopa / gopi – Cowherds / milkmaids who enjoy the company of Krishna in his infancy and youth.

Gopuram – Large gateway leading to a temple complex; a feature of South Indian Hindu temple architecture, especially in Tamil Nadu, especially after about 1100.

Gosain / Goswami – Title for a high priest, used primarily by Vaishnava bhakti sects.

Govardhana – Mountain in the Braj area, lifted by Krishna when he wished to shelter his friends from a storm sent by Indra; an important site for Krishna worship.

Govardhanlalji – Influential priest who led the Shrinathaji temple at Nathadwara in the early twentieth century.

Govinda – Name for Krishna, especially in his role as cowherd.

Govindadeva Krishna – Miraculously occurring icon of Krishna, now worshipped in Vrindavan.

Gupta period – Reign of Gupta dynasty, from roughly 320 to 550 CE, over a domain that covered most of northern India and some of the eastern coast as well; considered by classical scholars of Indian history to be the "golden age" of Sanskrit literature, religious thought, and sculptural achievement.

Hanuman – Monkey follower of Rama; son of the wind god, Vayu, and therefore magical and invincible; now worshipped as a god in his own right.

Hari – Alternate name for Vishnu or Krishna.

Harivamsha – Appendix to the *Mahabharata*, compiled around 100 CE, telling the life story of Krishna, also called Hari.

Haveli – Urban palace or mansion; name used for the temple of Shrinathaji in Nathadwara, which is understood as the icon's palace rather than a mere shrine.

Hayagriva – Horse-headed figure who is said to be either a demon or an avatar of Vishnu; when he is a demon, he steals the Vedas from Brahma and must be killed by Matsya; when he is an avatar, he assumes Matsya's role and returns the Vedas to Brahma.

Hiranyakashipu – Powerful demon who became virtually indestructible after he was granted a boon; brother of Hiranyaksha and father of Prahalada; he questioned his son's dedication to Vishnu and was subsequently killed by the Narasimha avatar.

Hiranyaksha – Demon who attacked Varaha as he pulled the earth goddess out of the ocean and was subsequently killed by the avatar; brother of Hiranyakashipu.

Hit Harivansh – Sixteenth-century saint, worshipper of Krishna, who founded a sect around the image of Radhavallabha.

Holi – Raucous spring holiday celebrated with a mock battle of thrown, squirted, and poured pigment and dye.

Hoysala dynasty – Political entity that ruled much of southwestern India from 1026 to 1343; celebrated for its patronage of elaborately-carved stone temples.

Indra – King of the gods; often imperiled by over-powerful demons and in need of

Vishnu's aide; threatens Krishna and his friends when they stop worshipping him.

Jagannatha – Form of Krishna, worshipped primarily in eastern India, usually represented in a distinctive, rudimentary form without arms or legs.

Jamadagni – Father of the Parashurama avatar, who asked his son to behead his mother and then granted a wish that she be revived; killed by the sons of Kartavirya.

Jambavan – King of the bears in the *Ramayana*.

Jatayu – Heroic vulture who dies attempting to save Sita from kidnapping in the *Ramayana*.

Jayadeva – Twelfth-century poet-saint; worshipper of Krishna; best known for his poem, *Gita Govinda*.

Kadamba – Tree into which Krishna climbed after stealing the *gopis*' clothes.

Kadru – Wife of the sage Kashyapa, greedy sister of Vinata, and mother of one thousand serpents; the aunt of Garuda, who seeks vengeance against her by targeting all snakes.

Kaitabha – One of the demons who, together with Madhu, threatened Brahma at the time of Creation; they were killed by Vishnu with his discus.

Kali – Despicable embodiment of the Kali Yuga, the son of Envy and Anger, who will be killed by Kalki at the end of this era; also the name of an important Hindu goddess (spelled differently in Sanskrit).

Kali Yuga – The present era, the last in the cycle of time before the great destruction of the cosmos; characterized by decadence, ignorance, and wickedness.

Kalighat – Name of an important temple to the goddess, located in Kolkata (Calcutta); also the name for mass-produced paintings on paper, sold in the bazaars around this and other Bengali temples in the late nineteenth and early twentieth century.

Kaliya – Giant, poisonous, aquatic serpent who is killed by Krishna.

Kalki – Vishnu's future avatar, tenth in most lists; Kalki will descend at the end of this era to usher in the destruction of the universe.

Kamsa – Evil uncle of Krishna, ruler of Mathura, who was fated to be killed by the god; made many attempts to kill his nephew but was eventually slain by him.

Kannan – Tamil name for Vishnu.

Kapila – Short-tempered Hindu sage, sometimes represented as the fourth face in four-headed images of Vishnu.

Kartavirya – Multi-armed, arrogant king who stole the magical cow from Renuka and was killed by her son, the avatar Parashurama, in retaliation.

Karttikeya – Multi-headed son of the god Shiva.

Kayastha – High-ranking caste, sometimes equated with Brahmins but often treated as the highest ranking of sub-Brahmins; traditionally associated with writing and scholarship.

Kinnari – Heavenly musician.

Kirtimukha – Monstrous face that appears at the top of doorways and steles, usually understood to ward off danger. Also called a face of glory.

Kodanda – Rama's celebrated bow, given to him by Parashurama.

Krishna – Important Hindu god, sometimes considered an avatar of Vishnu; Krishna is born a prince but raised in a pastoral community; later in life he rules over a kingdom from his capital at Dwarka.

Kshatriya – The caste of warriors and kings, ranked below Brahmins.

Kubera – Ancient Indian god of wealth.

Kurma – Second avatar of Vishnu, in the shape of a tortoise; he serves as the support for Mt. Mandara when it is used as the spindle or paddle in the churning of the ocean.

Kurukshetra – Town in the modern state of Haryana, site of the great battle in the *Mahabharata*.

Kushana period – Reign of Central Asian Kushana kings over a broad area of northern India, Pakistan, and Afghanistan in the first, second, and third centuries CE.

Lakshmana – Brother of Rama; he follows his brother into exile and assists him in the battle with Ravana's demon forces.

Lakshmi – Hindu goddess of wealth and plenty; one of the fourteen auspicious things created by the churning of the ocean of milk; Vishnu's primary consort who appears on his chest as the *shrivatsa* mark; she manifests herself on earth as the consorts to the avatars.

Lalitasana – Sitting position with one leg pendant, used to indicate grace and ease.

Lampas – Weaving technique using extra sets of weft threads so that colorful patterns can be woven into a plain ground; a specialty of the Assam region of eastern India.

Lanka – Mythic kingdom of the demons, ruled by Ravana in the *Ramayana*; usually associated with the island of Sri Lanka although this identification has been questioned.

Lila – Sanskrit word for play; describes Krishna's amusing youthful pastimes, especially with the milkmaids at night; used also to describe the good-natured carelessness with which gods sometimes treat mankind.

Lila Hava – Term for the moment in love play when Krishna and Radha exchange clothes and mimic one another.

Lingam – Phallic emblem of Shiva, installed in Shaiva temples as the primary focus for worship.

Madhava – Alternate name for Krishna.

Madhu – One of the demons who, together with Kaitabha, threatened Brahma at the time of the Creation; they were killed by Vishnu.

Madhubani painting – Traditional art form, usually practiced by women in the area around Madhubani village in the Mithila region, also known as Mithila painting; formerly restricted to interior walls, Madhubani/Mithila painting is now made on paper.

Mahabharata – Lengthy epic describing the conflict and eventual battle between rival branches of the same family; includes one of Vaishnavism's most important texts, the *Bhagavad* Gita; thought to have been compiled in the second half of the first millennium BCE.

Maharaja – High level of Hindu ruler; for most of its history, India was divided into many different kingdoms, so there were several maharajas ruling at any given time.

Makara – Sea monster, usually similar in form to a crocodile.

Mal – Early Tamil name for Vishnu.

Mandapa – Hall, often with a pyramidal roof, that stands in front of the entrance to the sanctum in a typical Hindu temple.

Mandara – Mountain used as a spindle when the gods and demons churned the ocean; said to be located on the border between the modern states of Bihar and Jharkhand in eastern India.

Mantra – Prayer or simple series of sounds that is believed to be inherently powerful when spoken out loud or heard.

Manu – One of the earliest beings to live on earth, the ancestors of all mankind; there are several generations of Manus, who are protagonists in many legends about the earliest stages following Creation.

Markandeya – Great Hindu sage, granted immortality for his piety so he is the only being ever to survive the great Destruction at the end of one cycle of existence and the Creation at the beginning of the next; witnessed Vishnu floating on a leaf during the process and was granted shelter in the god's body; is said to have caused the invention of weaving when he expressed a desire to create clothing for the gods.

Matsya – Vishnu's first avatar, in the form of a fish; he rescues the Vedas from Hayagriva and/or saves Manu and the seven sages from a great deluge.

Matsya Purana – Early scripture dedicated to Vishnu, dating to about 400 CE.

Mirabai – Sixteenth-century female saint who wrote an extensive body of bhakti-inspired romantic poems to and about Krishna.

Mohini – Vishnu's only female incarnation, sometimes listed as an avatar; used her beauty to trick the demons into giving her the nectar of immortality, then was pursued by the enamored god Shiva.

Mudra – Hand gesture conveying symbolic meaning.

Mughal – Dynasty of Central Asian, Muslim emperors who ruled much of India and Pakistan from the sixteenth century into the nineteenth century; their power was largely diminished by the early eighteenth century.

Mulamurti – Primary icon or focus for worship in a temple; often accompanied on the altar by smaller, subsidiary images of the same god or others.

Naga / nagini / nagaraja – Serpent deities, largely associated with water and hence with fertility. *Naga*s are male, *nagini*s are female: both are usually represented with a human upper body, cobra hood behind their head, and snake tail instead of legs; their rulers, *nagaraja*s, have multiple cobra hoods.

Nammalvar – South Indian saint whose poems are known as the "Tamil Veda;" one of the *alvar*s.

Nanda – Adopted father of the Hindu god Krishna, who raises him in a pastoral village.

Nappinnai – Female cowherd whose romantic relationship with Krishna is celebrated in Tamil literature.

Narasimha – Vishnu's fourth avatar, half man, half lion; the hybrid form is designed to fall outside of the list of beings who could not kill the demon Hiranyakashipu.

Narayana – Name for Vishnu; in earliest texts, Narayana appears to be separate deity with an ascetic character; later, the name is associated primarily with Vishnu in his role as Creator, reclining on Shesha on the primordial ocean.

Narayani – Name for the warrior goddess Durga when she is being celebrated as Vishnu's sister.

Navagrahas – Nine celestial deities, often called planets although they include the sun, moon, and two figures who cause eclipses; they often appear on the lintels of temple doorways.

Navanidhi – The nine self-manifested icons of Krishna acknowledged and worshipped by members of the Vallabhacharya sect.

Nayaka – Any of several dynasties who ruled various regions of southern India after the fall of the Vijayanagara empire; the Nayakas of Thanjavur (Tanjore) ruled southeastern India from the sixteenth through the nineteenth century.

Nayika – Romantic heroine, the topic of a genre of literature that categorizes, analyzes, and predicts romantic behavior according to personality types.

Padma / Padmapurusha – *Padma* is Sanskrit for lotus, one of Vishnu's primary attributes and an emblem of transcendence in several Indian religions. The lotus appears in figural form in some Vishnu icons; in this form it is known as Padmapurusha.

Padmavati – Wife of the Kalki avatar; a Sinhalese princess.

Paduka – Footprints; an emblem used by both Hindus and Buddhists to represent the presence and influence of gods and spiritual leaders.

Pala period – Reign of the Pala dynasty (750–1174) over a broad domain covering Bihar and West Bengal in eastern India and most of Bangladesh; the Pala rulers were Vaishnavas but also supported Buddhist institutions; a period of considerable sculpture production in both stone and bronze.

Pallava period – Reign of the Pallava dynasty, from the sixth to ninth century, over much of southeastern India.

Panchajanya – Name for Vishnu's conch shell, one of the god's primary attributes. It was named after the demon Panchajana, who was its original owner.

Pancharatra – Early Vaishnava sect that promoted the use of icons; their beliefs included the concept of *vyuha*s or emanations of Vishnu.

Parashurama – Vishnu's sixth avatar; a Brahmin who sought revenge on the Kshatriya caste after mistreatment of his own family and after general poor behavior on behalf of the entire caste.

Parikara – Separately-carved, arched frame for a shrine icon, usually containing small images of subsidiary deities and attendant figures.

Parvati – Hindu goddess; wife of the god Shiva and mother of Ganesha and Karttikeya.

Pata – Painting on cloth, a traditional art form made in the eastern Indian states of Bengal and Orissa.

Picchawai – Large painting on cloth, made for display behind an icon, usually of Krishna; made primarily in Rajasthan, especially for temples and shrines of the Vallabhacharya sect.

Prahalada – Righteous son of the demon Hiranyakashipu; his father failed to kill him and was then slain by the Narasimha avatar.

Pralamba – Demon who attempted to abduct Balarama by flying away with him on his shoulders.

Prithvi – The earth goddess, also known as Bhu Devi, who is rescued from drowning by the Varaha avatar.

Puja – Ritual worship, often before an icon or other enshrined object; *puja* usually includes an invocation, offerings, prayers of praise, requests, and a dismissal.

Puranas – Lengthy compendiums of Hindu knowledge, mostly sectarian, touching on everything from mythology to ritual techniques to philosophical matters.

Purusha – The cosmos as contained within a person; a visualization of all existence as the limbs and organs of a giant man.

Pushtimarg – Vaishnava sect dedicated to Krishna, founded by Vallabha and also known as Vallabhacharya.

Putana – Demoness who disguises herself as a woman to poison nursing infants; she is suckled to death by the infant Krishna.

Radha – Young Krishna's favorite gopi, milkmaid; much celebrated in later bhakti literature as his greatest and most blessed devotee; often described as an incarnation of the goddess Lakshmi.

Radharamana Krishna – Miraculously occurring icon of Krishna, now worshipped in Vrindavan.

Radhavallabha – Vaishnava sect dedicated to the worship of Krishna and Radha, founded by Hit Harivansh; also the name of the sect's primary icon, which is believed to be self-manifest.

Raga / ragini / ragamala – *Raga*s and *ragini*s are classical music themes, groups of tonal, rhythmic, and emotive guidelines that are performed in improvisation; *raga*s are categorized as male; *ragini*s are female. *Ragamala*s are collections of poetry and/ or paintings illustrating the scenarios traditionally discerned in the music of *raga*s and *ragini*s.

Rahu – Celestial deity who causes eclipses by swallowing the sun or moon; an immortal disembodied head; one of the *navagraha*s.

Rajput – Class of northern Indian warrior, including most of the Hindu rulers of Rajasthan, the Punjab Hills, and central India beginning around the thirteenth century; the primary patrons for single-leaf or manuscript paintings with Hindu subject matter, especially after 1600.

Rakshasa – Type or species of demon; Ravana is their king at the time of the *Ramayana*.

Rama – Vishnu's seventh avatar; born a prince but then exiled to the forest with his wife and brother, Rama must battle Ravana, the king of the demons, after Ravana kidnaps Rama's wife; held up by Hindus as the model ruler.

Ramayana – Epic recounting the story of Rama, written in Sanskrit by Valmiki between the seventh and fourth centuries BCE; other versions, including one in Hindi by Tulsidas, enjoy similar popularity.

Ramanuja – Eleventh-century philosopher, extremely influential on southern Indian Vaishnavism.

Ramlila – Annual pageant re-enacting the battle between Rama with his monkey army and Ravana with his demon army, culminating in the burning of an effigy of Ravana; large- and small-scale *Ramlila*s are performed throughout northern India in the fall.

Ranganatha – Vishnu lying on the serpent Shesha, as embodied in the primary icon at Srirangam, the most celebrated Vaishnava temple in southern India.

Rasa – Sanskrit term, used in aesthetic treatises, to describe the expressive impact of a work of art or performance.

Rasalila – The delightful play of young Krishna and his companions; usually refers specifically to the nocturnal romantic and sexual frolic of the god with the milkmaids in the countryside outside the village.

Rasamandala – Circle made by Krishna and the gopis during their nocturnal dance; usually the god duplicates himself so he appears between each pair of milkmaids; represents the perfect bliss of the union of human and divine.

Ras Purnima – Night of the autumn full moon, believed to be the night when Krishna danced the *Rasamandala* with the milkmaids.

Ravana – Multi-armed, multi-headed king of the demons, who kidnaps Rama's wife and takes her to his kingdom at Lanka; killed by Rama.

Renuka – Mother of the Parashurama avatar; beheaded and then revived by her son; had her wish-granting cow stolen by Kartavirya.

Rig Veda – The most ancient and most important of the Vedas, scriptures of the earliest recorded form of Hinduism.

Rohini – Adoptive mother of Balarama.

Rukmini – One of Krishna's favorite wives; often worshipped together with Krishna and another wife, Satyabhama, in a trio of images.

Rumal – Decorated textile, usually embroidered, used as a wrap or drape to cover gifts on special occasions and offerings at rituals; produced primarily in the Chamba region of the Punjab Hills.

Rupa Goswami – Sixteenth-century saint, follower of Chaitanya, whose writing would influence the Gaudiya sect of Krishna worshippers.

Sakhi – Female confidante; a key figure in romantic literature relating to Krishna, as the *sakhi* serves as a messenger and mediator between the god and his beloved, Radha.

Samkarshana – Alternate name for Balarama; used especially in the pre-Puranic period.

Sampradaya – Lineage of teacher/priests associated with one of the devotional sects of Krishna.

Sangam – Large body of early poetry, written in Tamil, on a wide array of topics.

Sanskrit – Ancient language of northern India, developed by scholars in the second half of the first millennium BCE, and used in most Hindu literature until the rise of vernacular languages after the fourteenth century; rarely spoken today except in ritual contexts.

Sat Sai – Series of poems describing the relationship of Krishna and Radha, written by Bihari in the seventeenth century.

Satapatha Brahmana – Ancient text describing Vedic rituals and some ritual and theological innovations that post-date the Vedas.

Satya Yuga – Era immediately after Creation, when righteousness reigns.

Satyabhama – One of Krishna's favorite wives; she helped him slay the demon Naraka.

Shaiva/Shaivite – Relating to worship of the Hindu god Shiva.

Shaivism – Sectarian worship of the Hindu god Shiva; similar in complexity, popularity, and antiquity to sectarian worship of Vishnu, known as Vaishnavism.

Shaka – Indic term for the people and culture of regions to the northwest, particularly Iran and Afghanistan.

Shakti – Feminine energy; the term for the female counterpart of a god, usually representing his passionate, physical aspect.

Shankha – Sanskrit for chank shell, one of the attributes usually held in the hands of Vishnu icons; routinely translated into English as "conch."

Sharada Purnima – Festival commemorating the night when Krishna and the gopis danced the *Rasamandala*; celebrated at the Shrinathaji temple at Nathadwara.

Shesha – Giant serpent, the support for Vishnu as he floats in the primordial ocean

and creates all existence; also known as Ananta. Balarama is an avatar of Shesha.

Shikhara – Temple tower, rising over the sanctum of a typical Hindu temple.

Shiva – Important Hindu deity; god of Destruction.

Shri Devi – Goddess, often equated with Lakshmi, the consort of Vishnu. Shri Devi often appears together with Bhu Devi as the two consorts of Vishnu.

Shrinathaji – Important icon of Krishna lifting Mt. Govardhana; much revered by members of the Vallabhacharya sect, who believe that it is a miraculously-occurring embodiment of the god rather than a man-made image; enshrined at Nathadwara, in Rajasthan.

Shrivaishnavism – Important Vaishnava sect, active primarily in southern India.

Shrivatsa – Mark on the chest of Vishnu, above his heart, that represents the perpetual presence of Lakshmi.

Shukra – Chief preceptor of the demon Bali who warns his master that he should not grant the three steps of land to the dwarf Vamana.

Shyam – Alternate name for Krishna, meaning "Dark."

Sita – Wife of Rama; kidnapped by Ravana but ever true to her husband; often considered an avatar of the goddess Lakshmi.

Stambha – Tall column used as the support for a sculpture, especially of Garuda.

Subhadra – Younger sister of Krishna and Balarama; worshipped primarily in conjunction with the brothers in Jagannatha shrines and temples.

Sudarshana Chakra / Sudarshana Purusha – Name for Vishnu's discus, with Sudarshana Purusha denoting the discus' personified, or figural, representation.

Sugriva – Monkey who becomes king with the assistance of Rama; one of Rama's most loyal allies.

Surdas – Sixteenth-century saint who composed an extensive body of bhakti-inspired poetry celebrating the childhood of Krishna.

Surpanika – Demon sister of Ravana in the *Ramayana*; insulted after making romantic overtures toward Rama and Lakshmana, Surpanika incites her brother into kidnapping Sita, thereby initiating the epic conflict.

Surya / Surya-Narayana – Surya is the sun god, who attracted a sectarian following in the first millennium CE; Surya-Narayana is Vishnu in the role of the sun, a form that developed relatively late, mostly as a means of absorbing Surya into Vaishnava practice.

Sutra – Religious text, traditionally written on palm leaves or long, narrow pages mimicking palm leaves.

Svarupa – Self-manifested; term for any of several icons or ritual objects that are believed to be divinely made as opposed to sculpted by an artist.

Swami Haridasa – Sixteenth-century saint, worshipper of Krishna, who found the self-manifest icon called Banke Bihari.

Taittiriya Samhita – Ancient text containing very early hymns to post-Vedic deities, especially Shiva.

Tantra – Esoteric form of Hinduism or Buddhism, offering alternate forms of worship and meditation that are considered dangerous or misleading unless practiced by those who are properly initiated.

Tilak – Mark, usually made on the forehead but sometimes on other parts of the body, indicating the sectarian affiliation of the wearer; Vaishnava *tilak*s are vertical, often in the shape of a long "U."

Tirumal – Early Tamil name for Vishnu.

Tribhanga – Three-bend posture; the swaying stance assumed by most deities (but usually not by Vishnu) in Hindu sculpture.

Trivikrama – Triumphant form of Vishnu as the "Taker of Three Steps," referring to his conquest of earth, sky, and heaven; sometimes represented making one of the three strides.

Tulasi Das (Tulsidas) – Poet-saint who composed a version of the *Ramayana* in Hindi in the sixteenth century; his version provided the primary inspiration for northern Indian miniature paintings and most *Ramlila* pageants.

Upanishads – Ancient Hindu scriptures, in the form of dialogues, offering an early discussion of the nature of reality and other important philosophical questions.

Usha – Demon princess who kidnapped Krishna's grandson, Aniruddha, provoking a battle between her father, Banasura, and Krishna.

Ushnisha – The bump, or cranial protuberance, on the top of the Buddha's head; a congenital mark of the Buddha's specialness.

Vahana – Animal vehicle for a god; every Hindu deity is said to ride on a specific animal that reflects some aspect of his or her personality; the *vahana* is usually worshipped as the god's most loyal devotee.

Vaikuntha – Name for the heaven where Vishnu resides and where his devotees hope to be reborn; also a form of Vishnu, usually represented with four faces.

Vaishnava/Vaishnavite – A worshipper of Vishnu; or pertaining to the worship of Vishnu.

Vaishnavi – Goddess who is the female manifestation of Vishnu; often appears as one of the Saptamatrikas, or Seven Mothers.

Vaishnavism – Broad term for the sectarian worship of Vishnu or any of his avatars.

Vali – Leader of the monkeys in the *Ramayana*; he is shot by Rama at the urging of his brother, Sugriva, who becomes the next leader of the monkeys.

Vallabha – Vaishnava saint (lived 1479–1531) who founded a major sect dedicated to worship of Krishna.

Vallabhacharya – Vaishnava sect, founded by Vallabha, that is responsible for the worship of the icon of Shrinathaji at Nathadwara; also known as Pushtimarg.

Valmiki – Poet-sage who composed the *Ramayana*.

Vamana – Vishnu's fifth avatar; takes the form of a dwarf Brahmin in order to fool Bali into granting him as much land as he can cover in three steps; morphs into massive Trivikrama form in order to cover all of earth, sky, and heavens in three steps.

Vanars – Species of powerful human-like creatures, usually identified as monkeys, who assist Rama in the Ramayana.

Varada Mudra – Hand gesture made with palm facing outward and fingers pointing down, seen on Hindu and Buddhist icons, meaning "your wish is granted."

Varaha – Vishnu's third avatar; he descends in the form of a boar to retrieve the earth goddess from the primordial ocean so that mankind will have a place to live; he also kills the demon Hiranyaksha.

Varuna – Hindu god of waters.

Vasudeva – Ancient hero god, first worshipped by the Vrishni clan and later absorbed into Vaishnavism; identified primarily with Krishna, but also used as an alternate name for Vishnu; the first of the *chaturvyuha*s or four emanations of Vishnu; Vasudeva is also the name of Krishna's birth father.

Vasuki – Giant serpent who served as the cord tying Manu's boat to Matsya during the deluge; also the cord for the tug-of-war between gods and demons during the churning of the ocean of milk; offered shelter and cover for Krishna's father as he transported the divine infant away from his evil uncle.

Vayu – Hindu god of wind; father of the monkey god Hanuman.

Vedas – Group of four ancient texts, consisting of hymns to various deities, to be performed during rituals of sacrifice; Hinduism's oldest scriptures, compiled around 1000 BCE, the Vedas are said to have been spoken by the god Brahma; the most ancient and celebrated is the *Rig Veda*.

Venkateshvara – Incarnation of Vishnu, worshipped primarily in the south, who descended to earth in the current era to save mankind from sin.

Venugopala – Iconic form of Krishna, shown standing and playing his flute.

Vijayanagar period – Reign of the Vijayanagar dynasty (1336–1646); based at Hampi in modern-day Karnataka, the Vijayanagar empire stretched across all of southern India.

Vina – A stringed instrument, played by strumming or plucking, held by various deities, including Shri Devi, and by the sage Narada.

Vinata – Wife of the sage Kashyapa and mother of Garuda, who was rescued by her half-eagle son when she was enslaved by her own sister.

Vishnu – One of the most prominent Hindu gods, worshipped for his role as preserver and creator, distinguished by his tendency to descend to earth in the form of avatars.

Vishnu Purana – Important text describing the ten avatars of Vishnu as well as other aspects of Vaishnava worship and belief; compiled around 500 to 700 CE.

Vishnudharmottara Purana – Scripture best known for its lengthy section on iconography and art-making techniques; compiled around 600 CE.

Vishnupada – The feet or footprints of Vishnu; an emblem representing the god's presence.

Vishnupatta – Square plaque covered on both sides with representations of Vishnu and his avatars; thought to have been used as portable icons.

Vishvakarma – Architect and sculptor of the gods; responsible for building Dwarka and for sculpting the Jagannatha trio.

Vishvarupa – Massive, frightening, all-encompassing manifestation of Krishna in his true form, revealed to Arjuna on the battlefield in the *Bhagavad Gita* section of the *Mahabharata*.

Vittalnath – Son of Vallabha; second in Vallabha lineage of teacher/priests who attend the icon of Shrinathaji.

Vrishni Viras – Ancient name for the divine hero Vasudeva and his family; worshipped in the Mathura area by members of the Vrishni clan in a religion that came to be known as Bhagavatism and was later absorbed into Vaishnavism.

Vyuha – Emanation of Vishnu as posited by the Pancharatra sect of Vaishnavism; one of four consecutive emanations (Vasudeva/Krishna, Samkarshana/Balarama, Pradyumna, and Aniruddha), each one more limited and conceivable than the previous, that radiated out from the Supreme God in preparation for the act of Creation.

Western Chalukyan period – Reign of the Chalukya dynasty (c. 957–1189) in the western Deccan, an area covering most of the modern states of Maharashtra and Karnataka, and the western half of Andhra Pradesh; one of several dynasties known as Chalukya.

Yajna-Varaha – The boar avatar Varaha as the embodiment of sacrifice (*yajna*); in this form, Varaha appears fully as a boar.

Yali – Mythic beast, similar in form to a western griffin, often depicted on the periphery of icons as part of a god's auspicious entourage.

Yama – Hindu and Buddhist god of death.

Yantra – Mystic diagram used by Tantric initiates in worship and meditation.

Yashoda – Krishna's adoptive mother, who raises him in the cowherding community with her husband, Nanda.

Yoga – Wide range of practices, from meditation to physical exercises to dietary restrictions, designed to utilize both the body and the mind as sources of strength and insight in spiritual quests.

Credits for Catalogue Illustrations

Index